ART AND FEMINISM

ART AND FEMINISM

EDITED BY HELENA RECKITT

WORKS page 50

TOO MUCH page 51

PERSONALIZING THE POLITICAL page 68

DIFFERENCES page 110

IDENTITY CRISES page 134

CORPOREALITY page 156

FEMMES DE SIÈCLE page 176

PRE-
FACE

BY HELENA RECKITT

The title *Art and Feminism* suggests a relationship between the demands of feminist politics, the debates of feminist theory and the explorations of artists informed by these concerns. The project tracks that which lies 'between' feminism and art, surveying what these categories have, and had, in common. In focusing on artists' responses to feminism the book sets up a series of tensions — between politics and poetics; content and form; feminists and women; feminism and 'the feminine'. It also reflects the tension between those who define feminism in terms of the concerns of women exclusively and those who see it as an enquiry into sexual difference that challenges gender distinctions.

One of my aims in this collection has been to identify struggles and differences between feminist artists of different generations. With this in mind the collection has been organized into broadly historical sections in order to present the experiences, ideas and voices of key practitioners within their original time frame. I have also tried to show how certain art historical clichés — that all feminist art in the early 1970s celebrated 'central core' imagery, that the 1980s were concerned exclusively with strategies of appropriation — do not reflect the diversity of artistic responses at any given time. The book's extensive Works section juxtaposes projects by many artists who are not usually shown or discussed together. This offers the chance to open up new connections between key figures and to capture a cross-section of formal strategies pursued by women artists in different times and places.

In the mid 1970s and 1980s, many feminist artists who were influenced by poststructuralism, psychoanalysis and subaltern theory distanced themselves from aspects of the early women's art movement. They criticized the celebration of innate femininity, and the retrieval of traditional female culture, for confining women to separate biological and cultural spheres. They doubted the subversive potential of the 'feminine', fearing that women would be placed on the negative side of language at their peril. And they criticized the emphasis on personal experience as narrowly individualistic and lacking an account of the unconscious.

In the 1990s, however, a subsequent generation of feminists started to rediscover women's work of the 1960s and 1970s. This revival of interest was stimulated in part by the conservative political climates in 1980s Britain and the United States which feminist theory had apparently done little to counter. This 'return' can also be seen as a reaction against the work of artists influential in the 1980s, such as Mary Kelly, Barbara Kruger and Sherrie Levine. '1980s' artists who, among other things, critiqued phallocentric bias within figurative and gestural traditions, and exposed masculine investments in representations of the female body, were now criticized for their didacticism and emotional restraint. Looking back to feminist art's originators, young women in the 1990s discovered a refreshing spirit of political radicalism, a visceral pleasure in images and materials, and a direct articulation of subjective experience.

Interest in the early women's art movement informed numerous curatorial and critical projects in the 1990s. The British 'Bad Girls' show of 1993 traced a lineage in the work of contemporary women artists to precursors such as Louise Bourgeois and the Surrealist Meret Oppenheim, and to the 'aggressive camp' of Judy Chicago's monumental collaborative sculpture *The Dinner Party* (1974–79). The exhibition 'Sexual Politics: Judy Chicago's *Dinner Party* in Feminist Art History' provoked both praise and dissent for placing Judy Chicago centre stage.[1] Critic and curator Laura

Cottingham explored the legacy of feminist art from the 1970s in two exhibitions in Denmark and France,[2] a comprehensive video essay, *Not For Sale: Feminism and Art in the USA During the 1970s* (1998), and a collection of texts, *Seeing Through The Seventies: Essays on Feminism and Art* (2000).

In the 1990s, feminist art historians and critics including Jane Blocker and Mira Schor re-examined the debate on essentialism that had divided the women's movement. They argued that many feminists dismissed as 'essentialist' had in fact employed a knowing form of strategic essentialism that was far from straightforward. In discussing Ana Mendieta's use of identity categories, Blocker noted that she played 'between the one and the many, between essence and inessence. Rather than positioning the self on one side or another, she worked strategically with the inherent contradiction of the essential.'[3]

These revisionist projects give a vivid sense of the audacity, complexity and diversity of the early women's art movement, of a feminist art 'that is not one'. I hope that they also help put an end to one especially crude version of American feminist art history which suggests that all the conceptual (read 'smart') work was made on the East coast, and all the intuitive and activist (read 'non-intellectual') work on the West coast. There are, however, some potential pitfalls for feminists seeking to retrieve the work of earlier generations. There's the danger of creating a version of the star system so beloved of the art market, which prizes individual 'genius' and ignores dialogue and collaboration between women. And there's the trap of heroine worship, in which the achievements of women are uncritically celebrated in an understandable but counterproductive effort to compensate for years of neglect.

This collection reflects the diversity of feminist art from the 1960s to the end of the twentieth century. Some of the work included gives striking aesthetic form to political imperatives. Suzanne Lacy and Leslie Labowitz' *In Mourning and in Rage* (1977) and the Guerrilla Girls' accusatory graphic activism of the late 1980s and early 1990s mark moments of protest against the oppression and marginalization of women, and the demand for political change. Other works, while less obviously didactic, also expose the politics of the personal: the therapeutic photo works of Jo Spence and street performance actions of Mona Hatoum in the 1980s employ first person narratives to conceptually sophisticated ends. The impetus to retrieve female cultural histories is visible in the work of artists such as Christine and Irene Hohenbüchler, Betye Saar and Miriam Schapiro. Others, from Eva Hesse to Ana Mendieta and Susan Hiller, seek less to express overt political concerns than to articulate the experience of living in a particular body – coded as female – in a specific time and place. Some of the work from the 1990s included in this collection, while not appearing overtly political, can be seen within a feminist lineage. Rachel Whiteread's sculpture, for example, addresses issues of private, domestic and public space, forgotten and negative space, which have been important feminist concerns. Her work evidences an implicit debt to feminism.

A number of prominent women artists – from Louise Bourgeois to Chantal Akerman – have at times denied being feminists. This should not mean, however, that their work is necessarily 'not-feminist', that it has not influenced feminist artists, or cannot be interpreted within a feminist perspective. Sometimes the work's implicit feminism

contradicts the artist's words. Why might a woman artist whose work shows affinities with feminism want to distance herself from the category? For some black women artists, the label 'feminist' is so caught up with the history of white women that they don't wish to be associated with it. For other artists the feminist label is restrictive, threatening to overshadow other elements in their work.

From Simone de Beauvoir to Germaine Greer, Luce Irigaray to Julia Kristeva, Audre Lorde to Judith Butler, feminist theorists have variously influenced, inspired and infuriated women artists. Art historians and critics such as Lucy R. Lippard, Linda Nochlin, Griselda Pollock and Rozsika Parker have provided both critical frameworks for the consideration of art made by women in history and critical commentary on contemporary work. Some of the strongest texts of feminist aesthetics are written by visual artists who are also writers and theorists, such as Judy Chicago, Susan Hiller, Mary Kelly, Barbara Kruger, Laura Mulvey, Trinh T. Minh-ha, Adrian Piper and Martha Rosler.

The focus of this volume is primarily on artworks and texts that have made a critical impact in Britain and the US. When artists from beyond these geographical limits are included this reflects the influence their work has had on British and US artistic and critical practice. To further expand the geographical scope would, I felt, have diluted its focus.

In presenting a range of art informed by feminism it's possible to identify a distinctly female art history: what Mira Schor calls 'matrilineage'. However, it would be a mistake to see feminist art as an entirely separate category, outside the trajectory of art history. The art world has been transformed by feminists at the same time as feminists have been among its chief critics. Indeed, feminism has redefined the very terms of late twentieth-century art: from exposing cultural assumptions about gender to politicizing the link between public and private, to exploring the nature of sexual difference, to stressing the specificity of bodies marked by gender, race, age and class.

Although the prospects for women artists have improved to some extent during the period surveyed, feminist artists still face numerous prejudices and obstacles. Their work is generally considered to be less marketable and collectable than men's. All too many of the major artists in this book are not adequately represented commercially and are unable to make a living from their art. Female artists are frequently expected to perform 'attractive' and 'youthful' personae, in a reductive equation of hot artists with hot art. The art world continues to be sparsely populated by artists of colour. There is evidence that when women and artists of colour are selected for shows or publications it is often out of tokenism or to meet funders' demands for representative cultural diversity. This suggests that the arts still need feminism, perhaps more than certain women artists suspect. As I hope this book shows, aesthetic responses to feminism have produced what is perhaps the most far-reaching artistic movement since World War II. And I hope the book brings pleasure too, for I agree wholeheartedly with Emma Goldman: 'It's not my revolution if I can't dance to it.'[4]

1 Amelia Jones, ed., *Sexual Politics: Judy Chicago's* Dinner Party *in Feminist Art History*, (Berkeley: University of California Press, in association with UCLA at the Armand Hammer Museum of Art and Cultural Center, 1996).

2 'NowHere', Louisiana Museum, Humlebaek, Denmark,1996; 'Vraiment feminisme et art', Magasin, Centre d'art contemporain, Grenoble, France, 1997.

3 Jane Blocker, *Where Is Ana Mendieta? Identity, Performativity and Exile* (Durham: Duke University Press,1999) 34.

4 Emma Goldman quoted by Susie Bright, *Angry Women*, ed. Andrea Juno and V. Vale (San Francisco: Re/Search Publications, 1991) 201.

SUR-
VEY

BY PEGGY PHELAN

A ferocious desire for independence is present in all the work ... a determination to survive at what-ever fragile level you can achieve.

Louise BOURGEOIS, *Louise Bourgeois*, The Museum of Modern Art, New York, 1982

Alluringly open, deceptively simple, art and feminism is a seductive subject. Among the most provocative of words for critical writing, the conjunction *and* compels an associative logic: art and feminism encompasses the radiating circles of Aboriginal Australian painter Emily Kame Kngwarreye and the 'dream-songs' of feminist manifesto writers; the potent political installations of Renée Green and the hauntingly flickering flames of Ana Mendieta's earthworks; the slow drip of blood leaking in Orlan's video documentation of her plastic surgery, and the quick dripping blood oozing from the injured arm of the ageing angel in Cecilia Edefalk's *Elevator Paintings* (1998); the exuberantly sexy sculptures

of Louise Bourgeois and the melancholy wit of Pipilotti Rist's videos; the animation of still life in Pat Steir's *Waterfalls* (1990) and the fatal stillness of Chantal Akerman's film *Jeanne Dielman, 23 Quai du commerce, 1080 Bruxelles* (1975); the guerrilla thrills of Valie Export and the stabbing statistics of the Guerrilla Girls. I realized I would need to limit, indeed radically short-circuit, some of the possibilities of the word *and* if I were ever to fashion an essay short enough to publish. I began to think more carefully about failure and feminism, the brutal betrayal and the still alluring promise of that seductive *and*. When exactly were the possibilities of romancing feminism and art abandoned, in favour of the theoretical condensations of feminist art?

Writing about art has traditionally been concerned with that which is interior to the frame, whereas feminism has focused primarily on what lies outside the frame of patriarchal logic, representation, history and justice – which is to say the lives of most women.[1] Feminist writing about art has tried, with varying degrees of success, to forge a language alert to the movement at the edge of the frame, across the hybrid border that marks the distinction between the visible and the invisible, the known and the unknown. *Art and Feminism* presents key works, both visual and

written, that have advanced the possibilities of feminism and art. From the 1960s to the end of the twentieth century, the works assembled here range across several generations, media, countries and political frameworks. The troublesome question emerges: what is feminism? When faced with such an amorphous and ambivalent term, the shrewd often answer that it must be plural – not feminism but feminisms. This would also be an accurate response to a similarly structured question: what is mannerism? But we rarely hear pleas for the plurality of mannerism. The ideological stakes in the question 'what is feminism?' have often led to increasingly sophisticated but, it must be admitted also, increasingly evasive responses. I prefer a bold, if broad, definition: *feminism is the conviction that gender has been, and continues to be, a fundamental category for the organization of culture. Moreover, the pattern of that organization usually favours men over women.*

Such a definition will not suit everyone who claims the identity 'feminist'. Nonetheless, it helps clarify the role of the writer in shaping the interpretation of predominantly non-verbal artworks. While the very act of creating verbal categories for artwork risks deforming and consolidating the art itself, the particular risks in invoking the term 'feminist art' expose the often hidden ideologies at work in the formation of art disciplines. Although there are nascent ideological meanings in descriptive terms such as neo-realist or Abstract Expressionist, the effect of the term 'feminist artist' is quite different. Moreover, the appellation 'feminist' is sometimes spurned by artists whose work seems sympathetic with a feminist project. The word suffers a certain critical opacity as well. Is feminist a meaningful conceptual or aesthetic category when applied to artworks that range from Rona Pondick's needlepoint to Helen Chadwick's *Piss Flowers* (1991–92)? From performance rituals dedicated to the Great Goddess to Adrian Piper's *Funk Lessons* (1982–84)? From work whose emotional range encompasses the gravity of vocalist Diamanda Galas' *Plague Mass* (1991) to the witty insouciance of Nicole Eisenman's painting *Betty Gets It* (1992)? Is feminism a useful descriptive term for art that employs radically different modes of address, aspiration and genre? The difficulty of answering these questions helpfully reminds us of the sharp difference between the conceptual possibilities and limitations of art discourse and the often anarchic specificity of art. Or to put it slightly differently, these persistent questions remind us that rationality gives us ways to make categories while art gives us ways to resist them.

Nonetheless, 'feminist artist' remains a useful term, in part because it allows us to see

connections across some of the most interesting work composed in the past four decades. Compare, for example, the work of the Aboriginal Australian painter Emily Kame Kngwarreye (c. 1910–96) to the photographic performances of United States artist Cindy Sherman. Both women have frequently been described as feminist artists. Framing them together allows us to see an immense range of geopolitical and aesthetic responses to the traditional conception of woman-as-nature.

For thousands of years Aboriginal dot paintings have recorded the dreamsongs – stories of the origin and history of the world – from the point of view of some of the most economically impoverished but enduring people on earth. The tradition of dot painting has been re-appropriated by some contemporary Aboriginal feminist artists such as Kngwarreye and Kathleen Petyarre to plot the ritual and performative practices of women's communities in the outback, and to address the violent history of colonialism.

comparisons are made by non-Australians, however, they can take on the perspective of visual anthropology, rather than art history. A supple definition of feminist art allows us to see connections across media and cultures that we might otherwise miss.

Full of strange overlays and shadows, the history of feminist art is often recited but still perplexing. Emerging in the 1960s and 1970s, feminist art was itself framed by simultaneously occurring art movements and by the discourses that surrounded it. Pop and Conceptual art, Minimalism, Happenings, body art, Land art, photography, experimental film and public art were all vying for attention when feminist art began to be recognized as a specific aesthetic practice, a recognition that was rooted in a political awakening. Sparked by the Civil Rights and anti-war movements in the US and the student demonstrations in France, the Women's Liberation Movement gave the first sustained momentum to the development of feminist art.

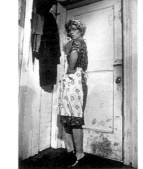

<div style="writing-mode: vertical">Kathleen PETYARRE Storm in Atnangker= Country II, 1996
Tracy MOFFATT Up in the Sky (detail), 1997
Cindy SHERMAN Untitled (Film Still), 1979</div>

These historical categories and aesthetic labels are what we might call fictions of the frame; nonetheless, these frames focus what comes to define, for better or worse, a complex history.

In her video documentation of the New York and Californian feminist art movement in the 1970s, *Not for Sale* (1998), Laura Cottingham suggests that the only thing that feminist artists in the 1970s agreed on was the conviction that sexism distorted all aspects of art – from the writing of art history to the economy of the art market, to the blind spots of curators who seemed quite literally unable to see, never mind exhibit, art made by women.[3] Influenced by geographically and politically diverse situations, what constitutes feminist work is hard to pin down. Creating feminist art in Beijing is a radically different undertaking from making feminist art in London. As Griselda Pollock has argued, the shifting geographies of feminism must be taken into account in any history of feminist art.[4] At this point in history, however, it does seem possible to identify significant stages in the conjunction between feminism and art. Undoubtedly, the period from the late 1960s until the late 1980s in the US and Britain has been the most fecund of the areas I will consider here. Women artists prior to that period

These paintings can illuminate Sherman's work, especially her celebrated *Untitled (Film Still)* works (1977–80). In these photographic documents of Sherman posed in cinematic *mise en scènes*, Hollywood film functions in one sense in the manner of the dreamsongs; both artists render mythological schemas as natural. Artists such as Kngwarreye, or Petyarre, and Sherman have used the most powerful imagistic systems in their respective cultures, dot painting and photography, to frame the logic of what we might call 'women's role'. These representational systems, and the ideological forces behind them, are staggeringly different, even at odds. Nonetheless, one can discern a similar habit of mind at work.

Admittedly, it might be more productive to think of Kame Kngwarreye's paintings in relation to other Aboriginal Australian feminist artists, such as filmmaker and photo-grapher Tracy Moffatt, or the urban Aboriginal artist rea, whose Pop-inspired works revisit the idea of the multiple in a context of radical political difference.[2] When such

cannot be described as 'feminist artists' although in the context of feminism *and* art their work is significant. As psychoanalytic and poststructuralist theory became the lingua franca of the academy in the late 1970s and throughout the 1980s, some feminist art and thinking of the early 1970s began to be seen as naive, narcissistic, *passé*. This accusation is a curious one, for even while feminist art historians and theorists were urging a more sophisticated reading of representational codes, many were denouncing, with a breezy simplicity, the art which made possible many of their own insights. In the 1990s, a new 'postfeminist' phase emerged. This is a complicated moment, and one not in any way past as I write in the early days of the twenty-first century. Some feminist theorists and artists have begun to re-examine the work of 1970s feminists, while others have joined feminism with other projects, most notably those inspired by post-colonial theory and trauma studies. This moment can also be understood as the next step in feminist poststructuralist logic. If the poststructuralist claim that all binary oppositions are in fact hierarchies is correct, then the structural oppositions which underwrite the sex/gender system must be abandoned before a non-sexist culture can be created. The first hierarchy to do away with, then, is male/female.[5] This aspect of postfeminism, a futuristic vision of a world where men and women are just two of many sex/gender possibilities, *in theory* comes a little closer every day. Risking setting up another hierarchy, I will simply note that *in practice*, however, exhilarating and catastrophic experiences of embodiment (in terms of gender, race, class *and* ...) continue to seek expression, even while the artistic and conceptual resources for such expression continue to be redefined.

Defining feminism as a conviction, I am trying to accent the notion that it is also a way of interpreting the world and the work. Lucy R. Lippard, one of the most prescient of feminist art theorists, has argued that feminist art is 'neither a style nor a movement' but rather 'a value system, a revolutionary strategy, a way of life'.[6] While feminism is a conviction, feminist criticism, as cultural theorist Tania Modleski has argued, is a promise.[7] As a promise, feminist criticism is structured like a performative speech act, an utterance that instantiates the thing being said. In his 1955 lectures at Harvard, *How to Do Things with Words*, the English philosopher J.L. Austin claimed that there are two kinds of speech act: constatives and performatives.[8] For Austin,

performative speech acts cannot be evaluated according to their truth or falsity, but only by their success or failure; what he terms their felicities or infelicities.[9] Abandoning the traditional question philosophy proposes to language – is a statement true or false? – Austin opens up a new category for thinking about language and action. Following Austin, art can be understood as a specific kind of action and feminism a specific form of language. The promise of feminist art is the performative creation of new realities. Successful feminist art beckons us towards possibilities in thought and in practice still to be created, still to be lived.

The Well-rehearsed Plot

The story is well known but it is useful to trace it again in broad outlines; complications in this very neat narrative will follow. In the 1960s, inspired by the Civil Rights Movement and anti-war movements in the US, the student uprisings in Europe, and the intellectual and aesthetic stirrings of what has come to be called poststructuralism and Postmodernism, women woke up. Prompted by both Simone de Beauvoir's cold-eyed claim in *The Second Sex* (published in France in 1949 and translated into English in 1953), that women are not born but made, and Betty Friedan's analysis of 'the problem that has no name' in *The Feminine Mystique* (1963), women began consciousness-raising groups in which collective convers-ations began to illuminate broader patterns of discrimination. No longer seen in isolation, patterns in what had hitherto been understood as 'personal stories' began to be interpreted as the logical consequence of larger political structures. Sensing the possibility of becoming emancipated from the burden of their personal particulars, women began to work together to protest against the ways in which political systems deformed women's lives, aspirations, dreams. Awakened, in short, to activism, feminists soon began to 'talk back' to oppressive institutions and to create worlds more inclusive of the lives of women. In 1966, the National Organization of Women was founded; it helped give the women's liberation movement a symbolic and political legitimacy in the US.

Artists were especially inspired by de Beauvoir's analysis of 'made' reality. If the lives of women were not the result of some intractable 'natural law', then they could be remade, revised, altered and improved. Such transformations would require imagination, determination, will: habits of mind well known to most artists. As feminist artists took up the tenets

Judy CHICAGO Menstruation Bathroom, Womanhouse, 1972
Sandy ORGEL Linen Closet, Womanhouse, 1972
AIR Gallery, New York, 1972; l. to r. from back, Mary Beth Edelson, Sarah Draney, Nancy Spero, Donna Byers, Rachel Bas-Cohain, Dotty Attie, Anne Healy, Pat Lasch, Clover Vail, Ana Mendieta, Daria Dorosh

of women's liberation, they found in it a rationale and inspiration for a new art practice. While the Civil Rights and anti-war movements in the US and the student movement in Europe had also inspired political awakenings, they had tended to employ art as a way of advertising their political arguments rather than as an arena for the visceral expression and exploration of those convictions. But for feminists, art became the arena for an enquiry into both political and personal revision; art was both extraordinarily responsive to political illumination and productive of it.[10]

From protest at the lack of inclusion of women artists in galleries and museums, to resuscitation of the degraded languages of decorative and craft-based arts, the first phase of feminist art making was activist, passionate and especially concerned with altering art history. Early achievements included the establishment of the Feminist Art Program by Judy Chicago, first at Fresno, California, in 1970, and then, with the collaboration of Miriam Schapiro, at Cal Arts in

 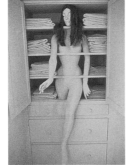

Valencia, California, in 1971. The first programme devoted to the making of art by and about women, the Feminist Art Program also produced a well-publicized exhibition entitled Womanhouse in 1972. Organized by Faith Wilding, Schapiro, and Chicago, along with Feminist Art Program students, including the painter and theorist Mira Schor, twenty-four women refurbished a house in Los Angeles. Radically revising the line between public and private, the exhibition space was domestic space, and conventional assumptions about suitable artistic subject matter were discarded; the bathroom and the dollhouse were appropriated as 'appropriate' exhibition spaces for feminist art. Womanhouse celebrated what had been considered trivial: cosmetics, tampons, linens, shower caps and underwear became the material for high art.[11] Covered extensively and often sensationally by the mainstream media, Womanhouse made it clear that there was a wide and passionate audience for feminist art.[12]

The exhibition included Chicago's Menstruation

Bathroom, Robin Schiff's Nightmare Bathroom and a witty but chilling installation by Sandy Orgel, Linen Closet. Orgel posed a female mannequin stepping out of a closet filled with carefully pressed and folded sheets. The mannequin, with long black hair and a plastic doll-like dead gaze, seemed herself caught in the threshold of a door – neither fully empowered to leave the closet (one of her legs is actually enclosed in a set of drawers), nor fully content to stay where she is (her neck is bisected by a horizontal shelf that has the effect of a guillotine) Linen Closet astutely consolidated the psychic architecture in which many early feminists found themselves caught. The closet was too confining, but what was outside lacked the secure comforts of well-pressed linen. Other students in the exhibition and the Feminist Art Program, most notably Schor and Wilding, went on to have important and influential careers as artists. Schapiro and Chicago remained figures central to the development of feminist art in the US throughout the 1970s and most of the 1980s, especially on the West Coast. Additionally, the creation of The Women's Building in Los Angeles in 1973 helped ensure and extend the work that Schapiro and Chicago had begun.

In New York, the inauguration of the women's art co-operative AIR (Artists-in-Residence) in 1972 provided an exhibition space for women's work in the tumultuous art scene there. In addition to exhibiting work, AIR also hosted a series of important talks that helped forge a language for feminist art that reflected the influence of the academy, the market and the studio. Together all of these institutional efforts helped create a new space for the development of feminism and art.[13]

Linda Nochlin's 1971 essay 'Why Have There Been No Great Women Artists?' plays, as we shall see, the role of 'progenitor' for the first phase of feminist art criticism and theory. Importantly, it assesses the political interests at work in the constitution of art history, a discipline predicated on implicit economic and ethical inequities, whose negative consequences for women are not far to seek. The flowering of this historical interest in art and the lives of women bloomed in Judy Chicago's ensemble piece The Dinner Party (1974–79), a large installation that advances a particular ideological and aesthetic relationship to the histories of art and of women. Astoundingly popular, The Dinner Party

provoked controversy in the feminist art world: were vulva-based dinner plates women's kitsch? Did Chicago exploit the work of the other artists who helped create the installation? Between the late 1960s and late 1970s, questions about who and what was responsible for systematic violence towards women had moved from an analysis of patriarchal history to the nitty-gritty of women's own collective public work.

While much of the art that emerged from the feminist movement in the US in the late 1960s and early 1970s tended to focus on and make use of women's bodies, the art that followed, much of which was created in Britain, tended to be rooted in debates about psychoanalysis and Marxism. The artist and theorist Mary Kelly's *Post-Partum Document* (1973–79) made a bid to shift feminist art making into an explicit conversation with Lacanian (and therefore necessarily Freudian) theories of sexual difference. Using her son's diapers as visual traces of the continuity and discontinuity between mother/creator and child/object, Kelly's installation

revisionism; *Thriller*, the ideological and economic under-pinnings of opera; *Jeanne Dielman*, the terrifying relationship between the banality of everyday domestic life and the violent pleasure of fatally shattering orgasm;[14] and *Journeys* considered movement as a kinaesthetic, political and psychoanalytic act. Eroding the difference between theory and practice, feminist filmmakers and theorists also initiated a responsive conversation across activities that had often been seen as distinct. Feminist film theory became the subject of many feminist films, and thus contributed to what came to be called 'the new talkie', the most influential aspect of avant-garde film practice in the 1970s and 1980s. In addition to Mulvey's essays, the work of Teresa de Lauretis, Mary Ann Doane, Linda Williams, Valerie Smith, Annette Kuhn and E. Ann Kaplan became central to this conversation.[15]

The erosion of the distinction between feminist film theory and practice helps illuminate one of the more distorting but nonetheless persistent features of the well-

Laura MULVEY, Peter WOLLEN Riddles of the Sphinx, 1976
Sally POTTER Thriller, 1979
Yvonne RAINER Journeys from Berlin/1971, 1979

created a space for a radical and intellectually rigorous interpretation of motherhood. In her extraordinarily influential 1973 essay (published 1975) 'Visual Pleasure and Narrative Cinema' Laura Mulvey explicitly declares that she is employing 'psychoanalysis as a political weapon'. Her work, like Kelly's, is both theoretical and practical. Collaborating with Peter Wollen, Mulvey made a series of films advancing avant-garde film practice that intersected with strong and interesting work being done by feminist filmmakers in Europe, Britain and the US. Experimenting with camera rotation, narrative deconstruction and the fetishistic allure of the female screen star, films such as Chantal Akerman's *Jeanne Dielman, 23 Quai du commerce, 1080 Bruxelles* (1975), Mulvey and Wollen's *Riddles of the Sphinx* (1976), Sally Potter's *Thriller* (1979), Yvonne Rainer's *Journeys from Berlin/1971* (1979) and Margarethe von Trotta's *Marianne and Julianne* (1980), made feminism a point of departure for far-reaching topics. *Marianne and Julianne* examined German political

rehearsed story of feminist art's emergence. The story usually claims that artists in the US were allergic to theory, while those in Britain were Marxist-Althusserian-Lacanians before they became feminists. But the theory/practice divide is a false one: poststructuralist theory and feminism were taught and discussed frequently in both the US and Britain; by the end of the 1970s, theory and practice were explicitly entwined, producing the third phase of the emergence of feminist art.

The two most potent influences on feminist visual art in the early 1980s came from feminist literary criticism, heavily influenced by poststructuralism and French feminism, and psychoanalytically based feminist film theory. The art historians Rozsika Parker and Griselda Pollock explored some of the consequences of this theoretical work for art history in their still influential textbook *Old Mistresses: Women, Art and Ideology* (1981). This work helped articulate a growing discomfort with some feminist art made in the 1970s, especially work about women's bodies and

experiences of embodiment, whether erotic, abusive or metaphorical. In a nutshell, the claim was that such art was insufficiently savvy about the complex codes of representation that framed the female body; the work was declared 'essentialist'. But one of the unwitting consequences of this argument was that it produced false polarities. Body art had, like all expressive media, a theory. But what it did not have, perhaps, was an academic language. As critical writing became more theoretical, it also became (unwittingly) more monolingual in its approach to art; work that did not easily lend itself to established paradigms of poststructuralist thought was often dismissed as naive. Ironically, however, the most appealing aspect of poststructuralist thought came from its critique of hegemonic and elitist power structures.

Additionally, the early 1980s were dominated by the return of political conservatism in the form of Ronald Reagan's government in the US and Margaret Thatcher's in Britain. These stalled, if not completely halted, public funding for exhibition spaces, performance venues and alternative presses that had been instrumental in the development of feminist work in previous years.

While the conservative turn was taking hold in mainstream politics, the dominance of white women within feminism, especially within academic feminist theory, began to be denounced as its own form of conservatism. In 1981, *This Bridge Called My Back: Writings by Radical Women of Color* was published in the US. The anthology opened up the dialogue on race which had been dominated by a binary model of racial difference (whites and non-whites). It included writing by Third World women who were more interested in relationships between women than between the sexes, writing that moved between English and Spanish without translation, and from poetry to prose to prayer without stopping to explain.[16] A decade earlier, in 1971–72, significant exhibitions of the work of women of colour had been mounted. 'Where We At Black Women Artists' was shown in New York in 1971 and included work by Faith Ringgold, Kay Brown, Pat Davis, Jerrolyn Crooks, Dindga McCannon and Mai Mai Leabua, among others.[17] When AIR gallery and Soho 20 were founded, members said they were committed to eliminating both the sexism and racism characteristic of art galleries at the time. Howardena Pindell, an African-American feminist and an original founder of AIR, eventually grew disenchanted with feminism's persistent

racism and helped organize an important 1980 show at AIR: 'Dialectics of Isolation: An Exhibition of Third World Women Artists of the US'. In the catalogue introduction, the Cuban-born artist Ana Mendieta flatly stated what many women of colour had concluded after a decade of activism: 'American feminism is basically a white middle class movement.'[18]

Many also viewed it as basically heterosexual. The National Organization for Women was beginning to feel the deep fractures of the sexuality debates that had been percolating throughout the 1970s. Shere Hite's controversial study of female sexual practices in the US had appeared in 1976.[19] It brought mainstream attention to 'the myth of the female orgasm' and rekindled the debate about what was better: clitoral or vaginal stimulation before orgasm? This debate in turn highlighted other aspects of women's sexuality that had often been misunderstood. While often summarily described as a debate about lesbianism and heterosexuality in which the slogan 'feminism is the theory, lesbianism is the practice' collided with the perceived need to create a 'presentable' image for mainstream feminism, in fact the sexuality debates were more complicated. Ranging from arguments about whether or not pornography was (criminal) sexual abuse or a radical form of sexual pleasure, to anxieties about whether or not sadomasochistic relationships could be consensual, the sexuality debates reflected some of the most challenging aspects of women's liberation.[20] In 1980, NOW adopted their first 'gay and lesbian rights' platform. But the policy attempted to demarcate sex practices the organizers thought were compatible with feminism, and those they believed were harmful to women. Since the reasoning seemed largely to be based on the comfort zones of white heterosexual feminists, the platform was widely denounced by lesbians to whom it had been 'offered'. In the controversy that ensued, NOW overtly aligned itself with the aspirations of liberal feminism – to organize in order to produce specific legislative and economic changes that would ensure equal rights for women. While there was an air of *realpolitik* about this decision, many feminists who sought to question the very idea of economic equality under capitalism, or the concept of equal rights under patriarchy, felt betrayed by NOW's 'sell-out'.[21]

Another consequence of the argument about sexual practices was a new interest in developing a politically inflected psychoanalysis. Psychoanalysis had forged a language

to articulate links between sexual difference and sexual desire; feminists hoped it might provide an interpretive method for understanding the complexity of the recognition that for many heterosexual women life with men often produced both political domination and sexual pleasure. Psychoanalytic theories of sexual difference within representation dominated feminist art practice and theory in the early 1980s.

A slightly more explicit, if still not exactly efficacious, attention to issues of racial difference also began to be articulated more consistently in both discourse and exhibitions. Mona Hatoum, Adrian Piper, bell hooks, Lorna Simpson, Renée Green, Trinh T. Minh-ha, Coco Fusco and other theorist-artists explored the intertwining forces of racism and sexism. While Faith Ringgold, Michele Wallace, Judy Baca, Audre Lorde, Adrienne Rich and many others had insisted on this intersection from the earliest days of feminism, artists and theorists in the 1980s attempted to view race as something more than an 'additional' category

of difference to be appended to a list of qualifiers – 'class, gender and racial differences' as the litany often went. Kimberlè Williams Crenshaw, a legal theorist and cultural critic, helpfully suggested that a concept of 'intersectionality' might be employed as a way to understand the overlapping influences

of racism and sexism.[22] Moving away from the false choice of analysing which was worse, Crenshaw's insistence on the simultaneity of both sexism and racism also opened up ways to think about heterosexism, classism, ageism and other 'isms' that continue to play a part in maintaining the status quo. Instersectionality became a keystone for the development of a rigorous intellectual, political and aesthetic critique of the structure of oppression, the imperialist conquest of space and an investigation of masquerade, parody, repetition and mimicry as ways to intervene in the logic of representation. This critique was at the centre of much of feminist art criticism and theory in the 1990s.

In the early 1990s, feminism also began to be repositioned as something to be 'combined with' other political and theoretical projects. Important collaborations were undertaken with gay men who, in part because of the eviscerating epidemic of HIV infection and AIDS, recognized both that they had much to teach and much to learn from feminists and

the history of feminism. The critical writing of Craig Owens, Douglas Crimp, Simon Watney and Kobena Mercer was especially noteworthy.[23] Cindy Patton's two important books, *Inventing AIDS* (1990) and *Last Served?* (1994) helped keep the gender politics of the growing AIDS epidemic in focus.[24] The AIDS quilt, one of the most inspired works of collective art of the late twentieth century, brought focus to the fact that in the face of the epidemic and the hostility it generated, feminists, people of colour and gay men often found themselves on the same side of the battle lines.

Additionally, collaborations were forged between white feminists and people of colour who were articulating a theory of post-colonialism and hybridity. Common to these collaborative projects was a focus on the abjected body, the human body as a site of waste, abuse, disease, trauma.[25] Jana Sterbak's *Vanitas: Flesh Dress for Albino Anorexic* (1987), a red dress composed of sixty pounds of raw steak, Sue Williams' 1992 painting *A Funny Thing Happened* and Kiki Smith's wax and papier mâché sculpture *Tale* (1992) are especially resonant meditations on the visceral strength of the female body's abjective force. Risking replicating the structures of victimization and disease that haunt women in patriarchy, these works also offer an important rejoinder to the assumption that abjection produces only passivity and silence.

'The AIDS body' and 'the racialized body' both had significant overlaps with and differences from 'the woman's body' as it had been articulated and instantiated in feminist art theory and practice in the 1970s. The binary of sexual difference, once central to feminist psychoanalytic thought, began to be seen in the early 1990s as too simple an intellectual tool for understanding racial and sexuality differences. Not surprisingly, some of these recognitions prompted a much heralded 'return to the body'. A new generation of feminist artists attempted to unite the theoretical sophistication of feminist art of the 1980s with the passionate engagement with the question of embodiment that was the hallmark of feminist art of the 1970s. But whereas the dominant interpretative frame of the 1980s had been a politically inflected psychoanalysis, in the 1990s, political theory as such seemed to have collapsed into an exhausted heap. With the cold war 'won' by capitalism, international politics seemed increasingly to be a kind of rough drama of embodied economics. Women of the former Yugoslavia and

Jana STERBAK Vanitas: Flesh Dress for Albino Anorexic, 1987

elsewhere became enfleshed weapons in wars run by men: while there was much debate about military rape, both in the media and in war tribunals, the women themselves were often written off as anonymous victims of 'ethnic conflicts'.[26] The most searching writing being done by intellectuals in the 1990s might be best described as ethical rather than political. Attention to the traumatic force of the twentieth century's genocidal history, to the ethical responsibilities and challenges of witnessing, and to testimony as a specific kind of performative speech act, has been especially pronounced in the late 1990s.[27]

This abbreviated story conceals as much as it reveals. I want to return to several important and compressed details within this framework.

The History Before Us

World War II changed history in ways we are only now beginning to comprehend. A catastrophe of unspeakable

magnitude, the war, among other things, eroded beliefs in the autonomy of nation states, increased the importance of media production and circulation, and expanded the stage for representation more generally. In terms of art history, the post-war period is usually understood as the time when Abstract Expressionism emerged as a dominant advance in painting. Faced with the incoherence and incomprehensibility of massive death, a story in which the authenticity of images, the risks and responsibilities of seeing and the ethics of knowledge play an immense part, artists lost faith in the prospect of figuration in general. While Cubism had refracted the spatial plane of the canvas, after the war the line itself underwent a series of breakdowns, perhaps best dramatized by Jackson Pollock's all-over drip paintings. Pollock and the critic Clement Greenberg (with critic Harold Rosenberg playing the role of the *agent provocateur*) became the avatars of a new language, both visual and conceptual, for painting. Greenberg argued that Pollock's paintings were 'about' painting: flatness, opticality, colour. While this art historical era has attracted

much critical attention, the enormity of the transformation in the role and function of art criticism has been insufficiently remarked.[28] Part of the achievement of Pollock's drip paintings stemmed from the demands they made on the viewer; without figuration to ground the plot of painting, the art critic became an often essential mediator between the work and the viewer. In his celebrated 1952 essay 'The American Action Painters', Harold Rosenberg reflected on the interdependence of new art and new languages: '*To form a School in modern times not only is a new painting consciousness needed but a consciousness of that consciousness – and even an insistence on certain formulas. A School is the result of the linkage of practice with terminology – different paintings are affected by the same words.*'

Part of what a school requires, then, is the conscious decision to be one, a decision made possible by the resources of critical language. Rosenberg's coining of 'action painting' created the conceptual event that made it possible to consider painting as a performance, even while it inaugurated the need for a performance-minded criticism more broadly. While some disagree about the value of Pollock's innovations, most assent to the fact that his work inaugurated a different set of possibilities for post-war art practices and discourse in the US. These possibilities, as we shall see, both helped and hindered the reception of feminist art in the 1960s and 1970s.

Abstract Expressionism was not instantly dominant, however, nor was it the only game in town. Indeed in 1946, The Museum of Modern Art in New York for the first time in its history exhibited a retrospective of a woman artist, Georgia O'Keeffe (1887–1986). O'Keeffe's work was to some degree abstract, but there was a large figurative element to her painting. In her long relationship with the photographer Alfred Steiglitz, O'Keeffe had been both a captivating model and a keen observer of photography's possibilities and limitations. O'Keeffe did not aspire to photography's empirical verisimilitude in her painting. She wanted rather to find a visual language for emotion; her remarkably precise handling of colour was motivated by a desire to follow the way in which, say, the full purple feeling of satisfaction becomes diffused into the bruise of blue as the feeling fades. O'Keeffe's intense interest in colour as something living and ever in motion lent many of her paintings the aura of portraits. Her renderings of cala lilies and peonies, for example, are perhaps best understood as exploring a botany of the emotions,

showing a detailed study not so much of flowers' structures as of the dimensions of feelings provoked by flowers.[29]

Painting is one way to trace a falling towards and away from emotional insight; colour one way to express its force and its loss. O'Keeffe's pursuit of the colour of oscillating emotion contrasted sharply with the more hermetic struggles of artists such as Pollock and Willem de Kooning. Whereas their painting surfaces tended to be dense, layered and almost attacking, O'Keeffe's surfaces conveyed a sense of expanse, breath and musicality within the natural world. Some of these same lyrical qualities informed the work of Grace Hartigan, Elaine de Kooning, Helen Frankenthaler, Joan Mitchell and Lee Krasner, who are usually described as second generation Abstract Expressionists, which is somewhat false in terms of chronology but accurate in terms of the secondary treatment their work received. Elaine de Kooning and Lee Krasner, married to two of the superstars of Abstract Expressionism, de Kooning and Pollock

Wagner's argument in her essay 'L.K.' that Broude and Garrard ostensibly summarize in the introduction to their important 1989 anthology, *Expanding the Discourse*.[32] Wagner refuses to judge Krasner's choice to destroy so many of her canvases. 'I do not wish to end by adjudicating the rightness or wrongness of that move', Wagner concludes, 'but [Krasner's] entry into public identity as a painter ... happened in ways that are poignant and still problematic.'[33] Indeed. It's possible that Krasner's decision to destroy (or in fact to recycle, to paint over her paintings) had the opposite psychic valence than an act of 'critical self-erasure'. Might it be that the act of showing her paintings (and selling one of them to The Museum of Modern Art in New York) led Krasner to feel supremely confident in her own ability to create more and 'better' paintings? Perhaps her first solo show allowed her to take her painting as seriously as they each took his, and to refuse to settle for work that she viewed as short of her best. Thus destroying twelve paintings does not seem to me

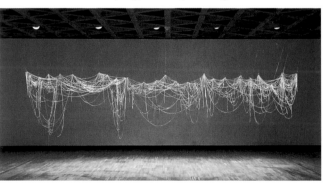

respectively, pursued different lyrical possibilities within abstraction. In Krasner's *The Seasons* (1957–58), there are echoes of Pollock's *Mural* (1943), although the sense of rolling interiority expanding across a horizontal landscape is more optimistic than Pollock's haunted vertical swirls.

The work of these women Abstract Expressionists has been treated sensitively by feminist art historians, but the difficulty of seeing their work independently of the achievements of their husbands continues to be a problem. Some feminist art historians have argued that Krasner's decision to destroy twelve of the fourteen paintings she exhibited in her first solo show in 1951 at Betty Parsons' gallery, where Pollock was also scheduled to show the following month, was a self-destructive act.[30] Norma Broude and Mary Garrard, for example, describe it as 'an act of critical self-erasure, a refusal of self-definition, that conflicts oddly with her intense ambition to position herself outside Pollock's orbit'.[31] However, their description 'conflicts oddly' with Anne

to be *necessarily* a gesture of 'critical self-erasure'. It's also plausible that it was a gesture of optimistic self-confidence.

The legacy of the second-generation Abstract Expressionists can be seen in the paintings of Agnes Martin and the sculptures of Eva Hesse, which are related to Minimalism. Born in Canada, Martin came to the US in her late teens. After studying painting and art education at Columbia University, Martin, like O'Keeffe, moved to New Mexico. Martin's paintings are elegant meditations on colour and time. Conveying an almost magisterial sense of calm, Martin's canvases suggest a kind of object-less still life, as if paint itself could be slowed in the manner of a photographic aperture, far enough to convey not only the expiration of light, but indeed the expiration of sight, breath, life. Rescued from morbidity by the distracting elegance of mathematics, Martin's paintings have a fierce courage. They invite the viewer to go to the very edge of stillness, to feel the eye's most protective blindness. What one finds

in Martin's paintings is not so much the absence of figure but the palpable presence of invisible but controlling number. Martin's surfaces are akin to equations that solve and dissolve time and space across a grid composed of lines one can count.[34]

Eva Hesse, whose art was at once mournful and radically expansive, jotted down a curious phrase on a dance programme in 1967: 'A girl being a sculpture.' Both Lippard and Anna C. Chave have read the sentence as a slip, suggesting that Hesse was actually thinking about her own femininity and its relationship to her decision to become a sculptor. They have demonstrated the importance of the question for Hesse throughout 1965 to her untimely death from a brain tumor in 1970 at the age of thirty-four.[35] But it might also be the case that Hesse wrote what she meant, that she was indeed thinking about a girl being a sculpture. If a sculpture gains its monumentality by holding still, and a girl registers her girlishness by dancing, then perhaps 'a girl

being a sculpture' might be a note about teaching a sculpture to dance – a much more engaging project than teaching a girl how to hold still. This girlish dancing can be seen in Hesse's sculptures made of rope, twine or fibreglass cord, in which gravitational force slowly erodes the sculpture's stillness.

This slow dripping away from stillness represents Hesse's attempt to accommodate accumulating loss, the central achievement of both her work and life. Born a Jew in Hitler's Germany in 1936, Hesse led a life dramatized by the terror of remaining still. Rosalind Krauss has suggested that Hesse's *Contingent* (1969) countered the formalist discourse of Minimalism with the message of expressionism: 'Hesse's expressionism carried the message that by kicking hard into the stone of inert matter, one would break through to an experience of self, a self that will imprint its image into the heart of that matter.'[36] Far removed from the conventions of portraiture, the 'sheets' of resin that comprise *Contingent* resemble immense pages of a blank book, a wordless letter

cloven from impassive, illegible silence.

Speaking with Cindy Nemser in 1970, who was asking Hesse about femininity and feminism in her art, Hesse was hesitant to claim any labels or categories for her work. She told Nemser: 'I don't value the totality of the image on these abstract or aesthetic points. For me, it is a total image that has to do with me and my life.'[37] Hesse's firm articulation of what she felt to be the complete integration between art and life was consonant with what came to be the major epistemological and aesthetic force of feminist art in the 1970s.

While post-Minimalist art was forging a new form of personal expressiveness, other artists provoked by the memory of World War II, the US invasion of Cambodia and the violence of military dictatorships in South America began to develop an aesthetic vocabulary to respond to state violence. Employing industrial materials like wire and burlap, Lee Bontecou's creations, which critic Carter Ratcliff aptly dubbed 'organic machines', were conceived as sculptures but were designed to hang on walls like paintings. Bontecou's *Flit* (1959), made of welded iron, canvas and black velvet, emerged from the wall like a toxic assault. *Untitled* (1961), made from welded steel and canvas, featured an enormous orifice that looked like a cross between a steel toothy mouth and an exposed industrial shredder. Menacing and bracing, Bontecou's work was instrumental in establishing an aesthetic of rage that was developed further by other artists as the decade continued.

Niki de Saint-Phalle, in her 1961 piece *Tir à volonté (Fire at Will)*, made the connection between art, violence and war extraordinarily literal. Having attached bags of paint to large canvases, Phalle shot the bags with a .22 calibre rifle. She later commented:

'*I shot because it was fun and made me feel great. I shot because I was fascinated watching the painting bleed and die [...] Red, yellow, blue. The painting is crying the painting is dead. I have killed the painting. It is reborn. War with no victims.*'[38]

Yoko Ono's *Cut Piece* (1964), a performance in which audience members were invited to approach a passive Ono and cut away her clothes, helped initiate a language for the exploration of victimization and, perhaps more importantly, for survival, which began to sound the deepest notes in the next phase of feminist art.[39] Martha Rosler's series of photomontages, *Bringing the War Home* (1967–72), in which she

took photographs documenting the war from mainstream US magazines and re-photographed them within photographs of the interior of middle-class homes, also helped initiate the deconstructivist logic of representation that dominated feminist art practice and theory in the 1980s.

Lygia Clark and Lygia Pape, working in Rio de Janeiro, began to devise important performance pieces in which a resistant political collectivity could be reanimated. Borrowing the grid and the over-all from painting, Pape made a vast cloth with regularly placed openings for heads. Entitled *Divisor* (1968), it becomes a kind of embodied sculpture when participants step into the cloth and create its form. Nancy Spero, throughout the 1960s and 1970s, was especially perceptive about the gendered nature of war. Her 1975 work *Torture of Women* also helped focus interest in covert US policies in South America.[40]

Minimalist performance art, especially the movement performances and dance pieces of Yvonne Rainer, Lucinda

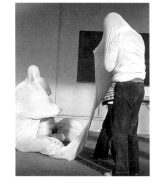 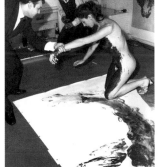 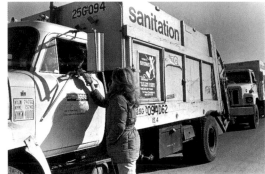

Childs and Trisha Brown in the 1960s, together with the commentary they inspired in writers such as Jill Johnston, laid the groundwork for more overtly political performance in the 1970s.[41] Painting and sculpture, the revered forms of high art, began to be increasingly jostled by the more unruly forms of photography, installation, film, video and electronic art and most especially performance art, sometimes called Happenings or Actions, in the next decades.

In the 1970s, Happenings and performance art were seen by women artists as new forms for the exploration of the intersection between the political and the personal. This is somewhat surprising given the sexism that marked the first manifestations of Happenings. Following up on Rosenberg's claim that painting had become an arena for action, Yves Klein, Alan Kaprow, the members of Fluxus and others had originally staged Happenings to enhance the performative dimensions of painting. In 1958, Klein first presented his *Anthropometry* performances in Paris. Employing three naked

women as his paintbrushes, Klein, dressed in a tuxedo, 'conducted' the composition of the painting, in which the women first sponged blue paint on their naked bodies and then imprinted their bodies onto the paper according to a rehearsed and choreographed plan. Klein later wrote: '*My models became living brushes! I had rejected the brush long before. It was too psychological ... Now, like a miracle, the brush returned, but this time alive. Under my direction, the flesh itself applied the colour to the surface ... I could dominate my creation continuously throughout the entire execution. In this way I stayed clean. I no longer dirtied myself with colour, not even the tips of my fingers.*'[42]

Klein's exuberant, clean domination of dirty women was not especially exceptional in 1958. It was not long after, however, that women themselves became interested in thinking through the politics of cleanliness and dirt more carefully. Feminist artists in the US were especially eager to redirect performance art's links with painting and actionism. A decade after Klein's performance, Mierle Laderman Ukeles wrote her *Manifesto for Maintenance Art*, which served as a map for the investigation of maintenance as a largely unseen but crucial set of acts.[43] Two years later, working with a map of New York, Ukeles began a multi-year performance piece entitled *Touch Sanitation*, in which she shook hands with 8,500 sanitation workers in New York. Often unseen and under-appreciated, the sanitation workers were similar to women in the domestic sphere. *Touch Sanitation* celebrated this labour and created a point of contact between the working class and women, an infrequent connection in the US, where the illusion of a classless society remains a dominant fiction.

Adrian Piper, a Conceptual artist deeply opposed to the US military campaign in Vietnam, began a series of street performances in 1970 that she collectively called *Catalysis*. In *Catalysis III*, she painted her clothes with sticky white paint and wore a sign saying 'WET PAINT' over them. She then went to Macy's, shopping for gloves and sunglasses. At once an allusion to Klein's use of white naked women as his wet paintbrushes, and a comment on the amnesia provoked by consumerism, Piper's art was both arch and pointed.

Lygia CLARK Tunnel, 1973
Yves KLEIN Anthropometry of the Blue Epoch, 1960
Mierle Laderman UKELES Touch Sanitation, 1979-81

In *Catalysis IV*, the artist recalls:
'I dressed very conservatively but stuffed a large white bath towel into the sides of my mouth until my cheeks bulged to about twice their normal size, letting the rest of it hang down my front and riding the bus, subway and Empire State Building elevator.'[44] In 1970, such aberrations in the social field were less common than they are today. Piper's performance is a catalyst that seeks to inspire a new perception of what constitutes the order of the social field, at the level of dress, sanity and the distinction between private and public acts. In 1973, Piper developed the *Mythic Being* series, a transforming performance in which the artist, in the guise of a 'third world, working class, overtly hostile male', gave vent to her 'feelings of macho masculinity towards my male friends that even the women's movement hadn't facilitated'.[45] She made these feelings public art by taking out ads in the *Village Voice*. Photographing herself as the Mythic Being (wearing an afro wig and moustache), Piper's ads are witty 'masculinist'

Adrian PIPER Catalysis IV, 1970–71
Linda MONTANO Mitchell's Death, 1978

fantasies of ambition, competition and compliment. In 1975, Ntozake Shange's 'choreopoem', *for coloured girls who have considered suicide/when the rainbow is enuf ...* , a dramatic performance in seven voices, opened at the Public Theater in New York and transferred to Broadway the following year. To this day, it remains one of the few Broadway shows in history to give the stage to an ensemble of performers who are all women of colour.[46]

Shange's play also showed some of the more exciting possibilities of performance art in the mid 1970s. Abandoning the traditional staple of character development, psychological development and narrative coherence that had been the hallmark of modern drama, performance art kept the intimacy of live art and moved outside of the conventions of naturalism and realism to express new forms of dramatic subjectivity and emotional encounter. Performance art does not create a discrete physical form; the acts that comprise it have no independent status as objects; the art of performance exists

only as it is enacted. Performance, as object-less art, works against (if never fully eliminating) the commodification of the art object and the socio-economic and psychic violence the object often fosters.[47] In the 1970s, Martha Wilson, Linda Montano, Hannah Wilke, Carolee Schneemann, among many others, began to explore performance as a way to remove the metaphorical structure of art and to make it more direct.[48] Montano, who began performing in 1971, has been devoted to erasing the boundaries between art and life, suggesting that art is not a matter of technique, or the mastery of the history of formal innovations in the realm of the visual, but rather a state of mind. Focusing on different mental processes, from attitude to awareness of accent, posture and gesture, Montano has created an enduring body of art across several media: video, photography, performance art, ritual performance and book making. Her 1978 performance, *Mitchell's Death*, consists of a video monitor showing Montano's face beneath a cross or plus sign, as she applies white make-up and inserts acupuncture needles in her face. While doing these acts, Montano also chants the story of the death of Mitchell Payne, who was her ex-husband. He died of a gunshot wound; Montano wonders whether it was an accident or a suicide. Pauline Oliveros, playing a Japanese bowl gong, and Al Rossi, playing a sruti-box, amplify Montano's mourning. In the 1980s when AIDS was wreaking havoc in the art world, many returned to *Mitchell's Death* and came to regard it as a powerful instance of the art of mourning.

Operating on the border between performance, sculpture and photography, Eleanor Antin's *Carving: A Traditional Sculpture* (1973) makes use of one of art history's favourite tropes: the sculptor chiselling away at ill-shaped marble until beautiful form emerges. Antin put herself on a diet for thirty-six days and took Polaroid photographs of herself naked, carefully noting the time of day each photograph was taken. Composed of 144 of these photographs arranged in chronological sequence, *Carving* presents Antin's body in the same four poses day after day. As the photographs accumulate and give body to the sculpture called *Carving*, the artist's own form diminishes. A comment on the ideology of dieting, the combined force of aesthetic and social conventions about the 'attractive' female, the piece has also been more recently read as a response to the specific violence of the message of 'thinness' to Jewish women. The dwindling, vanishing body

of Antin might be seen as a response to the history of the catastrophic disappearance of Jewish bodies during World War II.[49] *Carving* also stages the crossing of the trajectories of photography and performance that has been decisive for the development of both feminist and postmodern art.

At the heart of consciousness-raising was a belief in the power of repetition as a way to revise life stories. Personal experiences, many of which had been the source of personal shame, were seen anew as symptoms of larger political factors. Susceptible to revision, these experiences became inspirations for artwork as well. Underlying this belief in revision was a faith in the possibility of change – indeed, a belief in changing the world. This change, however, was seen to require going over the past rather than abandoning it in a courageous jump towards the new. In addition to fostering a focus on art history, this attitude also encouraged a sense of solidarity among women, especially in relation to suffering and abuse. Among the most important conse-

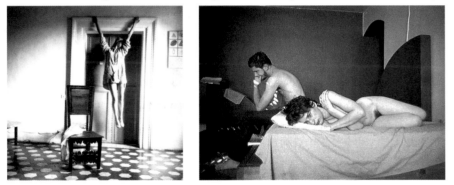

quences of this collective historical consciousness were the politically charged collective performances protesting against rape and other sanctioned forms of sexual terrorism towards women, such as Suzanne Lacy and Leslie Labowitz's 1977 performance *In Mourning and in Rage*. This piece helped inspire 'take back the night' marches and other political demonstrations against rape.

But as the often messy hurly-burly action of performance art entered the frame of art history, it was converted first into photography. This conversion is often overlooked.[50] Given the ephemeral nature of performance art in relation to the staying reproductive power of print, performance art was especially dependent on 'good pics' for photographic documentation.[51] While video, and now also the World Wide Web, can accurately record the temporal dimension of live performance, still photography frames its visual potency. Thus, for example, Carolee Schneemann's 1975 performance *Interior Scroll* has entered art history through the photograph Anthony McCall

took of it. Many more people have seen the photographic reproduction of *Interior Scroll* than saw the 'original' performance. The photograph, depicting a statuesque naked white woman, is unable to convey the central jolt that the performance enacted: a woman reading from a text that, like an encrypted umbilical cord, emerged from her vagina. Witty, sarcastic, and above all literate, Schneemann's performance dramatized what might be required for an audience to absorb the force of a paint-smeared naked white woman *reading* in public; it upset the traditional patriarchal assumption that women are those who must be read, interpreted, understood. As Moira Roth notes, the audiences were almost all women.[52] But the photograph cannot amplify the dramatic sound of Schneemann reading: instead, it renders the scroll as a kind of mirror. Reframed by photography, performance becomes an exclusively visual event. Ephemeral art becomes commodified by the photograph; photographic documentation displaces performance and becomes something more than a transparent index of an event.[53]

This supplement within the photograph allowed the eventness of performance, in its turn, to help dramatize the performative dimensions of photography, especially portrait photography. Francesca Woodman's photographic enquiries into the erotic-spiritual in her series *On Being an Angel* (1977) mined some of the possibilities of photography as a tool for capturing the expanding space between documentary and fantasy, history and dream. Nan Goldin transferred her photographs, which explore the rich space between documentary record and personal diary, into a slide show, set it to music and exhibited it under the title *The Ballad of Sexual Dependency*, in a great variety of venues, from seedy bars to respected galleries and museums from 1981 to the present.[54] The live presentations vary, but in 1986 she published it in book form, establishing one 'definitive' version of the work.

Cindy Sherman's *Untitled (Film Still)* series (1977–80) and *History Portraits* (1989–90) helped to suggest that memory itself might be an edited version of a picture never made. Alluding to a well-known image, either in celluloid or paint, Sherman's photographic performances are never exact replications. Altered, distorted, theatrical, her photographs return to events that did not occur in empirical history, yet somehow possess the charge of vivid memories.

Francesca WOODMAN Untitled (from On Being an Angel), 1977
Nan GOLDIN Couple in Bed, Chicago, 1977 (from The Ballad of Sexual Dependency), 1977

A photograph refers to a moment distinct from the one in which the image is seen. Photography's intimacy with the past tense has been (and remains now) both a lure and a problem for feminist art and theory. In so far as the photograph refers back to an 'original' – however staged or phantasmatic that original might be – photography supports the metaphysics of presence and original source. But in so far as the photograph is the effect of the copy, subject to edits, cropping and other manipulations, it works to erase the security of the original, the normative, the natural. This dilemma served as the impetus for critical discussion of Cindy Sherman's photographic performances in the late 1970s and early 1980s, but the themes and tensions of the problem emerged earlier.

Joan Riviere's essay, 'Womanliness as a Masquerade', written in 1929, suggested that: '*Womanliness [...] could be worn as a mask [...] The reader may ask where I draw the line between genuine womanliness and the masquerade. My suggestion is [...] that there is no such difference; whether radical*

Claude CAHUN Self-portrait, c. 1928

or superficial, they are the same thing.'[55] The writer, photographer and performance artist Claude Cahun (born Lucy Schwob, 1894–1954) devoted her art to forging a response to the consequences of such masking for a French Jewish lesbian. Much of her work was destroyed by Nazis during World War II, but what remains reminds us of the psychic and aesthetic possibilities photography and collage offer for an investigation of the authentic and the copy, for genuine performances and coercive masquerades.[56] Too often in the US, gender masquerade is seen as voluntary. Cahun's work reminds us of the cost of the performance. Part of what is striking about Cahun's photography is the eroticism of her pose. Cahun's photographs of herself, dressed sometimes as a man and sometimes as a woman, expose the density of women's sexuality for both viewers and models.[57] Dramatizing the difficulty of the distinction between desire and identification that informs the ways in which women approach images of women, Cahun's photography anticipates some of the trickiest conversations feminists have had about sexual pleasure and the visual. Does visual pleasure for women come from the desire to be the woman in the image? Or does it come from the desire to desire her, as Mary Ann Doane put it?[58] Do heterosexual women spectators

perform a kind of identificatory transvestism when they view images of sexually alluring women? Do they become temporary lesbians in the moment of visual pleasure produced by looking? Or do women, comparing themselves to the image, suffer or delight in their own intimacy or distance from it? These questions were (and are) extraordinarily vexing and helped heighten the reception of feminist psychoanalytic theory as it emerged in the mid 1970s.

Feminist artists in the 1970s began to consider the proposition that if women were associated with the sexual above all else, how might this association be used to serve, rather than to oppress women? While the ability to control pregnancy became widespread after the invention, approval and widespread dissemination of the birth control pill in 1960, it took a while before women's sexuality itself became a zone for creativity, play and reinvention. Feminism in the 1970s propelled a new interest in women's sexual pleasure and with it a new interest in both the image of the female body and the politics of embodiment. Feminist erotic art, heterosexual, lesbian and bisexual, became one of the arenas in which this interest was most explicitly expressed.[59]

In her 1976 book *Of Woman Born*, lesbian poet and theorist Adrienne Rich argued, 'The repossession of our bodies will bring essential change to human society. We need to imagine a world in which every woman is the presiding genius of her own body.'[60] To claim this genius, however, new conceptualizations of what the erotic might be were needed. Audre Lorde's 1978 essay 'Uses of the Erotic' defined the erotic as 'a sharing of joy', and suggested that the assumption that the erotic was merely another word for the physically sexual limited the expansive possibilities of women's erotic lives. 'There is', Lorde wrote, 'for me no difference between writing a good poem and moving into the sunlight against the body of a woman I love.'[61] Harmony Hammond was one of the first to begin to craft lesbian desire in her fabric pieces. Joan Semmel and Sylvia Sleigh composed figurative erotic paintings from a heterosexual woman's point of view.

Fuelled by the energy of new vision, much feminist art of this period was deeply witty and bitingly satirical, especially in relation to images of women in popular culture. Alice Neel, Ida Applebroog and others poked fun at the visual stereotypes that conveyed women as mother, as prostitute, as asexual – sometimes all in the same image. Additionally, art forms that had previously been seen as 'craft' rather than 'high art',

forms such as weaving, quilting and embroidery, were reclaimed as fluent and accessible languages for seriously pointed art making. Known as the Pattern and Decoration Movement, the work moved across painting, design and fabric architecture. Kim MacConnel, Amy Goldin, Miriam Schapiro, Valerie Jourdain and Joyce Kozloff were among the most significant feminist artists doing this work in the 1970s and early 1980s. Kozloff's well known public art, which now adorns subways, train stations and the San Francisco Airport, grew out of her earlier passion for pattern and decoration.[62]

In addition to exploring the intricate artifice of the Pattern and Decoration Movement, feminist artists of the 1970s were also fascinated by the connections between women and nature. Ana Mendieta, a Cuban-born artist living in the US, performed a series of actions she called earthworks throughout the 1970s. For Mendieta, the female body was deeply connected to the eternal grandeur of the land. Believing that Western capitalist culture was in danger

of losing this connection, Mendieta traced the outline of her body 'attached' to the earth, using mud, fire and blood to leave traces of this fading connection. These tracings, a kind of earth writing, were in turn documented in photographs which framed the trace of that trace. Mendieta's art pointed to animating systems of beliefs, indeed convictions, about geophysical and spiritual history. 'My works', she said, 'are the reactivation of primeval beliefs at work within the human.'[63] Often described as 'essentialist', Mendieta's works are actually powerfully astute gestures that comment on the nature of reactivating nature, elegant responses to the longing to return to a past that can only be reanimated through absence.

Mary Beth Edelson and other artists associated with what has come to be called eco-feminism – a term used for convictions ranging from native beliefs about the divinity of the earth as mother to Jungian-based notions of anima and psyche – pursued connections between femininity, the earth

and 'the Great Goddess'.[64] Some of these ideas were explored in Susan Griffin's widely read 1978 book, *Woman and Nature: The Roaring inside Her*. Griffin explored patriarchy's desire to tame both women and nature and suggested the political and ethical importance of insisting on honouring the connections between women and nature.[65] Edelson used her own investigations in matriarchal traditions to compose ritual performances in which women chanted and spoke of their ties to nature, to time and 'the spirit of the earth'. Similarly, Yolanda Lopez, Betye Saar, Nancy Azara and Judy Baca investigated spiritual and folk narratives about women with special powers, from the Virgin of Guadalupe to Kali, whom Azara used as the inspiration for wood sculpture. Saar was interested in following connections between Haitian and African traditions of black women's power. Her *Voo Doo Lady with Three Dice* (1973), a collage on red fabric, suggests that the 'Voo Doo Lady' plays with the sea, the sun and the stars. Saar's most famous piece is *The Liberation of Aunt Jemima* (1972). Placing a rifle and a black fist within the traditional iconographic representation of Aunt Jemima with her broom and head rag, Saar's mixed media portrait also wryly alludes to Warhol's silkscreens of Marilyn Monroe, replacing copies of the Hollywood star with images of Aunt Jemima's smiling face. Faith Ringgold similarly commented on the flags of Jasper Johns in her 1969 painting *Flag for the Moon: Die Nigger*. Best known now for her extraordinary quilts chronicling black life in Harlem, Ringgold was also a tireless advocate of racial equality in the art world throughout feminism's first decade.

Deeper Awakening

Central to the story of the birth of feminism is a kernel of the myth of Sleeping Beauty, except rather than a prince's kiss awakening a single protagonist, the force of a thundering insight makes many women bolt upright at the same time. As a generative myth, this history of collective wakening can also be understood as a revolutionary change in the frame of reference. A Foucauldian theorist, for example, might treat this historical moment in quite a different way, suggesting that in the tumult of the new world order that emerged in the post-war period, a dialectical turn from an international, external focus towards an awareness of the challenges of the domestic and internal occurred.[66] Common to both the Sleeping Beauty story and the Foucauldian fairy tale is a new

Mary Beth EDELSON See for Yourself, from the Goddess series, 1977
Betye SAAR The Liberation of Aunt Jemima, 1972

framing of the relationship between the public and the private. This new framing underscores the porosity of the border between two modes of being, two kinds of reference that converge in a generative vision. The ooze between the public and the private, in other words, resembles something like the shift from waking to sleeping that characterizes everyday human activity. What helped make this shift revolutionary, rather than everyday, was precisely the doubling of awareness that made it possible. Women awakened, in other words, to the consciousness of their own awakening consciousness. (Rosenberg: 'To form a School in modern times not only is a new painting consciousness needed but a consciousness of that consciousness.') Thus feminist awakening was something fundamentally personal and social at once; it was a kind of mutual understanding of what it had meant to feel oneself alone, and a declaration of a new collectivity. Sleeping Beauty was transformed from her self-reference as 'woman' to her self-reference as 'feminist'.

And this changed, among other things, the history and theory of contemporary art.

Fairy tales have played a large role in feminist theory and art practice, becoming rewritten as a way to imagine myths contemporary women might live by. One of the more salient treatments of myth's centrality to feminist art history is Janine Antoni's *Slumber*. In this piece, performed in various galleries between 1994 and 1996, Antoni spent the night in the gallery space, covered by a very long white blanket extending across the floor to a loom 'custom designed to enable the weaving of a potentially endless blanket'.[67] Before she sleeps, she attaches herself to a medical device that records her rapid eye movement. During the day, she uses coloured strips from her nightgown to weave the REM pattern recorded by the machine into the blanket. A performance dedicated to what it might mean to make art from a woman's dreams, *Slumber* also meditates on the frame between private and public consciousness and unconsciousness, between

historical forgetting and contemporary REMembering.

Antoni's performance alludes to Robert Morris' 1963 *Self-portrait (EEG)*, as art historian Ewa Lajer-Burcharth has noted, and 'inject[s] the idea of sexual difference into the problematic of body/object relation that concerned Morris in the mid-1960s'.[68] Additionally, Antoni's interest in sleep echoes Susan Hiller's 1974 piece *Dream Mapping* (first exhibited in 1986) in which the artist invited ten participants to develop a 'graphic system for writing their dreams'.[69] Then the group slept outside in the Hampshire countryside for three nights. They slept in visual patterns that, it was thought, might influence the patterns of their dreams. Employing the graphic system they had learned, upon awakening the participants recorded their dreams, attempting to discern patterns and repetitions. *Slumber* implicitly maps the political and historical journey from Hiller's group campsite to Antoni's single bed. It invites the viewer to contemplate the history of her own awakenings. Antoni's response to the question, 'What will I do when I wake up?' reminds the viewer of the political risks in dedicating, or failing to dedicate, oneself to weaving and/or recording dreams. The dream pattern being woven into the blanket increases in complexity, while its source, Antoni's nightgown, becomes increasingly threadbare. Antoni asks her viewers to return to the dreams we often lose when we are too rushed to remember them. *Slumber* reframes the awakening of feminism as something still to be interpreted, as a dream that is still being woven, although perhaps without the collectivity it once had.

What women awakened to in the late 1960s and early 1970s was the consciousness of misogyny; of cultural frameworks in which their labour was devalued, their art largely ignored and their bodies overly idealized, systematically abjected and/or subject to intense policing. Literary critic Cathy Caruth has suggested that sudden awakenings can themselves become traumatic.[70] All these women waking up and realizing all together that they had been sleeping for years, if not centuries, might best be addressed as an experience of collective trauma. It rarely is, however. Why did so many women have the conviction that art could be a politically useful response (and perhaps a psychically reassuring one) to the experience of awakening? 'Why art?' seems a far more baffling question than 'why feminism?'

The 'raising' of women's consciousness, it seems clear now, although perhaps it could not quite be articulated or grasped then, had something of Hegel's *aufhebung* about it. *Aufhebung* connotes simultaneously a lifting and a renunciation. This double process has often been obscured in histories of the feminist movement, in part because we tend to think of lifting and renouncing as opposing acts. The German word usefully reminds us that openings and closings, saying yes and saying no, can occur in the same event. Indeed, it is perhaps this doubleness that produces the formations and deformations that constitute epistemological and psychic change. The 'raising' in consciousness-raising involves an elevation and lifting of awareness, even as it also entails a renunciation of passive acceptance, a new intolerance towards unconsidered 'going along'. Part of the hostility feminists met with stemmed from the threatening nature of the renunciations integral to consciousness-raising. This hostility was not only directed at feminists by men, some of

whom saw the ways in which the refusal of women to go along might influence their own lives, but also from women who benefited, explicitly and implicitly, from going along with the structure of sexist society. The hostility that greeted feminists needs to be analysed more carefully.

The 1968 protest against the *Miss America* contest in Atlantic City, for example, became a particularly haunting image for conservatives. Near the end of the march down the boardwalk, feminist protesters took off various sartorial symbols of women's submission – bras, girdles, stockings, shoes – to protest against narrow but violently enforced notions of physical beauty. They threw these articles into a trash container labelled 'Freedom', then burned the trash container. By today's standards, a fairly mild protest. But the demonstration became a fixed and fearsome image. In the popular media, feminists became 'bra-burning women's libbers'. From that image, it was a short step to the others: feminists are against beauty, are all lesbians, are trying to destroy the family. Some feminists are, but such conclusions reveal more about how deeply feminism panics mainstream culture than the demonstration revealed about the connection between sartorial constraints and political oppression.

A significant part of that threat is rooted in the ideologies within images, particularly images of women's bodies.

Most people who write about feminism and art do so from a celebratory perspective. The few who do not are lamenting the fact that high art lost its dignity (that is to say, some of its elitism) because of feminism. But thinking of the second phase of feminism as a traumatic awakening enables a more honest response to the history of violence and vilification that is woven into the legacy of the feminist art movement. Quite apart from the inevitable 'personality conflicts' that dog any social and political group, the trauma that helped initiate the awakening of feminist consciousness was, in and of itself, wounding. Psychoanalysis reminds us that traumas produce distortions, repression, fictions of various sorts. Repressed traumas often inspire repetitions. Therefore, rather than sticking to the smooth narratives offered by either celebratory or denunciatory attitudes towards the history of feminism, it would be useful to develop the capacity to fashion a more complicated, indeed a more honestly ambivalent perspective upon this history.

To think of the history of feminist awakening in terms of trauma might also help illuminate the strangely persistent fascination with art history as a discourse. Trauma is a break in the mind's experience of time. History writing seems to promise a way to suture events that might initially appear to be ruptures. In 1974, Julia Kristeva wrote, 'I would call "feminine" the moment of rupture and negativity which conditions the newness of any practice.'[71] Thus the newness of a specifically feminist movement might well have been perceived as doubly negative: for if newness in general is a mark of the feminine, new practices of femininity are especially rupturing. The consolations of histories that promise continuities, rather than ruptures, become then especially prized. Linda Nochlin's essay 'Why Have There Been No Great Women Artists?' scans the history of art, looking for a place to begin writing a history of great women artists. Ironically, Nochlin's essay itself now serves as the origin, the place to begin writing the history of feminist art history.

Greatness

While 'the personal is the political' was the rallying cry for feminist politics in the broadest sense, Nochlin's 1971 essay was its scholarly articulation.[72] Indeed, in their superb review of the development of feminist art history, Thalia Gouma-

Robin <u>MORGAN</u> throwing away a bra, Miss America Pageant, Atlantic City, New Jersey, 1968

Peterson and Patricia Matthews bluntly declare that 'feminist enquiry in art history began' with the publication of Nochlin's essay.[73] Answering her own question, Nochlin coolly asserts that indeed 'the fact of the matter is that there have been no supremely great women artists, as far as we know, although there have been many interesting and very good ones who remain insufficiently investigated or appreciated'. Illustrating the institutional and structural forces, from the lack of access to nude models, to the patriarchal system of education and patronage fundamental to the history of high art, that made it exceedingly difficult, if not impossible, for individual women to achieve greatness, Nochlin concluded:

'The fault lies not in our stars, our hormones, our menstrual cycles or our empty internal spaces, but in our institutions and our educations – education understood to include everything that happens to us from the moment we enter, head first, into this world of meaningful symbols, signs and signals.'

Appearing the year after such ground-breaking texts as

Shulamith Firestone's *A Dialectic of Sex*, a fiery manifesto proclaiming a world in which reproduction was not tied to women's bodies, Kate Millet's *Sexual Politics*, a study of the ways in which literature aided and abetted sexism, and the wide-ranging anthology *Sisterhood Is Powerful*, edited by Robin Morgan, Nochlin's essay helped demonstrate how important art and its interpretation are to the politics of culture.

'Greatness', Nochlin claimed, is 'an honourific attested to by the number of scholarly monographs devoted to the artist in question.' On the one hand, Nochlin's definition is a candid assessment of the interplay between artwork and commentary, a kind of pragmatic assessment of the ways in which the image is dependent upon the word. On the other, it does little to advance a more radical, less institutional set of possibilities about what artistic achievement might mean or come to mean. Behind the idea of greatness lies a complex nexus of ideas about production and visibility that are in keeping with traditional ideas of artistic development and exhibition related to traditional models of artistic success.[74] Dora Carrington, for example, as Mary Ann Caws has shown, was a painter who did not want to show her work.[75] Her works have survived and we consider some of them 'great', but their claims to greatness are of a remarkably subtle kind.

The question of greatness in relation to art tends to be bound up with the logic of the market. The Marxist feminist art historian Carol Duncan, in her witty and smart 1975 essay, 'When Greatness Is a Box of Wheaties', wrote perceptively about the muddle concepts of greatness can produce.[76] For Nochlin in 1971, however, it seemed clear that if feminist art history were to be taken seriously as a discipline, it first needed to find its history; nascent feminist art historians, in other words, should produce scholarly monographs devoted to discovering or reclaiming neglected women artists of the past. Following this logic, Nochlin, in collaboration with Ann Sutherland Harris, curated the exhibition 'Women Artists: 1550–1950'. The show, which opened in Los Angeles in 1976, travelled to Austin, Texas, Pittsburgh, Pennsylvania and Brooklyn, New York. The exhibition introduced many people to the work of Artemisia Gentileschi, Angelica Kauffman and Rosalba Carriera, among others. The catalogue complemented previous efforts to unearth and consider carefully hitherto neglected women artists undertaken by Eleanor Tufts, Hugo Münsterberg, Germaine Greer, Karen Peterson and J.J. Wilson.[77] These early efforts gave a new legitimacy to the work of neglected women artists and enriched the canon of Western art history.

Institutionalization, however, is rarely benign. Implicit in Nochlin's argument was another more deeply rooted assumption: that art history is itself a 'great' way to discuss art. Many people think this, perhaps especially art historians. But like all genres of writing, art history carries meanings in excess of its ostensible subject matter. For example, at the level of the subtle language of pronouns, Nochlin's essay skitters back and forth between 'us' and 'they'. Great artists are excluded from the 'we' who confer and adjudicate greatness. The fault is not in 'our' stars; women artists have not been great because 'they' have not been given access to institutional power.[78] This kind of splitting also informed the ways feminist artists approached traditional art history – sometimes it was a source of inspiration, at other times it was a chronicle of oppression and misogyny.

Re-reading and revising great masterpieces, feminist artists in the 1970s illuminated the power of the past to shape the development of contemporary art. Mary Beth Edelson's poster *Some Living American Women Artists/Last Supper* (1972) replaces the apostles and Jesus with artists ranging from Lee Krasner to Yoko Ono. O'Keeffe has pride of place.

Similarly, describing her work as 'femmage', to invoke the Matisse-like possibilities of collage in the service of a new approach to women's art, Miriam Schapiro returned to other neglected art traditions and created aprons, fans, doll houses and in 1976 her fifty-foot *The Anatomy of a Kimono*. Her *Collaboration* series of 1975–76 is perhaps best understood as visual performances in which Schapiro restages the quality and feeling of paintings by Gauguin, Delacroix, Courbet, Berthe Morisot and Mary Cassatt (among others), through her own feminist artwork.[79]

Schapiro's work suggests that (art) history is something one enters, as one might enter a room, from a door within the present. As the work of alternative art historical traditions began to emerge in the early 1970s, feminist artists, logically enough, wanted to learn ways to think and speak about it. Was there, as Judy Chicago put it, a female core imagery in women's artwork? Was there something 'uniquely' feminine in the work of women artists that made it fundamentally different from the work of male artists? Chicago, Schapiro and Lippard, among others, thought there might be.

Essentialism: Language and the Body

'In the beginning was the word
And the word became flesh
And it never healed.'
– Benjamin Breytenbach

What has come to be called the essentialism debate might be better understood as a series of investigations into the relationship between female bodies and subjectivity, a relationship that is enframed by language. At the heart of the language of feminism is a complicated attempt to address embodiment, politically, aesthetically, historically, psychoanalytically. Interest in the body of the woman, as image, as icon, as goddess, as worker, as mother, as daughter, as narcissist, as martyr, has been central to both feminist art making and to feminist art theory and criticism. Behind this interest there lies an often noted but infrequently examined relationship, the one between language and the body. This relationship, as the literary critic Shoshana Felman puts it, 'consists at once of incongruity and inseparability'.[80] Bodies and languages constitute each other even as they miss one another. Rushing to make points about the specificity of female embodiment, feminist art theorists

have tended to gloss over the deeply paradoxical relationship between language and the body.

Describing her painting series *The Pasadena Lifesavers* (1969–70), Judy Chicago says it is an attempt to make visible 'the dissolving sensation that occurs during orgasm'.[81] Trying to create a visual image for dissolution is an interesting and complicated visual (and psychic) ambition. Unencumbered by Lacan's seminars on *jouissance*, Chicago confidently assumes her interlocutors can grasp her language of 'dissolving sensation' without difficulty. Going further too, Chicago not only wants to build her own art projects around her somatic-eroticism, she also wants to create a general theory of women's art. Dedicated to developing imagery 'organized around a central core, my vagina, that which made me a woman',[82] Chicago attempted to examine how this central core is the hidden content in the work of other women artists. Working with Miriam Schapiro in 1970, Chicago declared Georgia O'Keeffe's flower paintings as 'the first recognized step into the darkness of female identity'.[83] They also placed their own work in the tradition of O'Keeffe, and saw Lee Bontecou, Louise Nevelson and Deborah Remington as part of a lineage of women artists who had 'defined a central orifice whose organization is often a metaphor for a woman's body'.[84] Lippard concurred with Chicago and Schapiro, and proposed Eva Hesse as another artist who was engaged in creating core images and forms as a way to express her femininity. She called these 'eccentric abstractions'.[85]

Nochlin argued that O'Keeffe's flower paintings are 'strong schematic metaphors for female sexuality, universalized by their separation of any locale or visual context'. However, Nochlin also noted, this separation tends to make O'Keeffe's paintings:
'basically apolitical, if not downright conservative [...]
Paradoxically, however, in the context of today's feminist
activism, such imagery has acquired potent political implications
[...] Nothing could better demonstrate the complexity, and the
basic ambiguity, of what constitutes a valid 'feminist imagery'
than the recent transformation of [O'Keeffe's] placid iris into
a fighting symbol.'[86]
O'Keeffe, still alive and well, had already been through this eroticization of her paintings. She did not like it when it happened in the 1920s, nor had she changed her mind when it was repeated in the 1970s. O'Keeffe's resistance to being

read as a feminist artist has been perceptively discussed by Barbara Buhler Lynes.[87] Part of what O'Keeffe objected to was what she took to be an effect of minimizing and limiting the meaning of her art. She was more concerned with colour and form, she maintained, than with depicting 'a central orifice' as a metaphor for a woman's body. But for Chicago, the notion of a central connection between women was the motivation for feminist art.

This epistemology organizes the logic of *The Dinner Party* as well. An installation centred on thirty-nine dinner plates arranged on top of a triangular table covered with embroidery recounting the history of the lives of thirty-nine great women of history, *The Dinner Party* renders women's history as variations on forms of the vulva. Severely criticized for its racist and heterosexist view of history,[88] *The Dinner Party* was also one of the most popular feminist installations of all time, attracting one thousand visitors in San Francisco, and 'tens of thousands' throughout Europe.[89] But the installation,

and its fourteen showings to date, set off a backlash against 'essentialist' art within feminist art theory.

Griselda Pollock and Rozsika Parker's 1981 book *Old Mistresses* argued that images of women can be 'easily retrieved and co-opted by a male culture [if] they do not rupture radically meanings and connotations of woman in art as body, as sexual, as nature, as an object for male possession'.[90] They illustrate their claim by placing a photograph from the 'men's magazine' *Penthouse* beneath one of Chicago's flowers. Parker and Pollock joined Judith Barry and Sandra Flitterman-Lewis' call the previous year for a feminist art alert to the logic of representation.[91] They proposed a 'feminist re-examination of the notions of art, politics, and the relations between them, an evaluation which must take into account how "femininity" is itself a social construction with a particular form of representation under patriarchy.'[92] Influenced by Lacan's theory of the Symbolic – the network of myths, linguistic, visual *and* ideological codes through which we experience 'reality' – feminist art and theory in the 1980s set about critiquing how the Symbolic systematically deformed the psychic and political realities of women.

At the heart of this deformation was a fundamental lack

between the affective force of experience and the capacity of language (verbal, visual, mythic, somatic) to express, or to comprehend fully, that experience. The relationship between verbal language and visual image played a crucial, but still often unmarked, antagonistic role in the essentialist debates. The accusation 'essentialism' was mounted in the 1980s, when theory displaced history as the dominant discourse of feminist writing. Having duly observed this lag time, however, historians then ignore it, and go on to talk about the logic of representation, a logic that makes a statement like Chicago's 'a vagina, that which makes me who I am', seem naive, even embarrassing. But the lag time is crucial to the accusation, both in its content and in its desire to be distant from and superior to 'feminist essentialists'. The accusation, in other words, has a quality of Freudian afterwardness about it, suggesting that there may well have been something traumatic in the original source. In a misogynistic culture, especially one like academia in the early 1980s, it behoves us to consider carefully the vehemence of the denunciation of this work, if only as a symptomatic repression of something threatening. The repetitious references to the essentialism debates within the critical literature also suggest that something still-to-be-interpreted remains.[93]

The initial critique of essentialism in the early 1980s rested on the impossibility of a 'universal' feminine, a central system of expression that could be discerned across culture and across media. This seems absolutely true and valid. But the critique in the 1980s, like the rescue attempt in the 1990s, misses what remains interesting about the questions posed by 'the essentialists' who had the temerity to insist that it was possible to make a connection between visual images and the experience of embodiment. Quite apart from the universalizing aspect of the search for a specifically feminine art (an aspect of the project that I agree is unsustainable and symptomatic of cultural arrogance) there is an intriguing return, an incessant worrying over the difficulty of bringing language and embodiment into alignment. While some have come to be comfortable with the recognition that the relationship between the body and *verbal language* consists at once of incongruity and inseparability, it has been harder to acknowledge that this might be the case with *visual language* as well. Just as the verbal signifier pre-exists an individual speaker's use of it, so too does the visual image frame feminists' response to it.

Judy CHICAGO Judith plate, from The Dinner Party, 1974-79

In her 1998 book *Body Art: Performing the Subject*, the art historian Amelia Jones revisits feminist body art and the essentialist debate.[94] Jones gives a vivid and persuasive account of the work of many body artists. Her discussion of Hannah Wilke is especially inspired. But Jones sometimes misses the drama between the complexity of verbal language and a still-not-interpreted language of the body. I am not suggesting that there is some deep occult somatic language that we can somehow translate and employ. Rather, I am trying to frame the space that slips away, the words that fail and the images that melt, when one attempts to represent embodiment. As early as 1947, the seemingly indefatigable Louise Bourgeois began to frame this elusive space for a specifically feminist art.

He Disappeared into Complete Silence, Bourgeois' 1947 print series, is a brilliant response to the gap between words and images. Composed as facing panels, one side text, one side image, *He Disappeared* frames the space between words

and images as the vanishing point of Bourgeois' own art. There is no logical explanation of the relationship between the text and the image, and this slippage has led Rosalind Krauss to describe the artist as a Surrealist. But she is not one. Bourgeois' works are at least as deeply philosophical, indeed existential, as they are aesthetic or psychoanalytic. In a remarkable self-appellation, Bourgeois claimed: 'I am Descartes' daughter: I think therefore I am, I doubt therefore I am, I am disappointed therefore I am.'[95] What she doubts most, most inspires her: the space between the word and the sculptural form, the form that cannot be made solid by the deceptive promises of words. The titles of Bourgeois' works often stage the paradox of the gap between the artwork and the signifier with astonishing precision. *Fillette,* for example, French for 'little girl', is the title of a sculpture that resembles a large phallus. The little girl is not the same as the phallic sculpture, but maybe the act of calling the phallus a little girl can disempower the force of the phallic signifier. The tender place between the little girl and the heavy phallus is the space that

the sculpture, sheathed by its title, animates. The disjoin between the title and work induces a certain doubt about the stability of both word and form. People who write about art often prefer to be certain, rather than daunted by all there is to doubt. Writing about art often prefers to coddle the phallic signifier in its own hands rather than expose it as the fiction it is. Like the accomplices of the Wizard of Oz, art critics and theorists sometimes want to stand behind a curtain generating clouds that might or might not allow the Cowardly Lion to take heart. What would art writing not employed by the Wizard look like?

A Digression on Wishes

Language that calls attention to itself, like a flirty girl, is called catachresis. It has been defined as 'abusive or far-fetched metaphor, like "leg of a table" or "face of a mountain". [I]t is at once a "figurative" expression because it is transferred from elsewhere and "literal" because there is no other way to say it, it is the "proper name" of the thing.'[96] *Catachresis, in other words, is that funny turn in language when it joins art and yells, 'Look Mom, no hands!'*

Faced with the catachresis that art is, writers elucidate the reasons why a leg belongs on a table, and why a mountain needs a bit more make up, often called, in the language of the philosophical sublime, clouds. Of course, very often this is immensely useful. But it is also fundamentally distorting. Robert Frost claimed that 'all that gets lost in the translation of poetry is the poetry'. I sometimes fear that art criticism and theory want to take the art out of art. I want less writing about art, more writing with art. OK, enough. I once again step behind the curtain and rejoin the ranks of the Wizard's accomplices. (But how I dream of another frame to write in, to sleep and dream in …)

The charge of essentialism might well have stood in for the other disappointments feminists felt at the beginning of the 1980s. The conservative retrenchment undertaken by Reagan, Thatcher and other world leaders hit the Left and the alternative art world hard, at a time when it was also being ravaged by the AIDS epidemic. *The Dinner Party* was repudiated for its racism, its heterosexism and its vulva imagery, but it may well be that what most rankled was Chicago's sense that her installation was a 'celebration' of women's history. Thirty-nine women, thirty-eight of whom were white, regardless of whether one viewed them

'as metaphors' or 'as real (dead) women' hardly seemed like a satisfying contribution to history's long banquet. If this were the best feminist *history* could do after a decade of support, then why not give it up for the heady promises of seductive critical *theory*? Of course history is theoretical, and theories are inevitably historical, but history and theory at the beginning of the 1980s seemed to promise different ways to nurture feminist work. Most academic feminists picked the theory behind door number one.

In Theory

Laura Mulvey's essay 'Visual Pleasure and Narrative Cinema', published in *Screen* in 1975, had an enormous influence on the development of feminist theory. Analysing the structure of the male gaze in cinema in psychoanalytic terms, Mulvey introduced a shift away from historical research into the lives of women, to a more explicitly theoretical inquiry into the logic of representation. Mulvey argued that within Hollywood film

the woman is constructed as spectacle and symptom; she is, in Mulvey's formu-lation, the passive object of an active and powerful male gaze. Moreover, Holly-wood film revealed and left intact the logic of sexual difference as elucidated by Lacanian and Freudian psychoanalysis: '*Woman [...] stands in patriarchal culture as signifier for the male other, bound by a symbolic order in which man can live out his fantasies and obsessions through linguistic command, by imposing them on the silent image of woman still tied to her place as bearer of meaning, not maker of meaning.*' Mulvey's argument, and the responses it generated, particularly in relation to questions of women's pleasure and cross-gendered spectatorial identification, helped focus both art making and art theory for the next decade around the psychoanalysis of desire, a new erotics of pleasure, the problems and possibilities of the visual, politically and aesthetically.

Primarily rooted in psychoanalytically based readings of representation, which had developed its deepest roots in England and France through theorists such as Jacqueline Rose, Juliet Mitchell, Hélène Cixous, Julia Kristeva and Luce Irigaray, feminist artists in the 1980s were praised for intervening in the complex codes of representation. As psychoanalysis became a primary interpretative metho-

dology, renderings of the partial object, and especially of the genitals, that had been crucial to the work of Chicago and others, were seen more often than not to play into the logic of the fetish, whether they were composed by men or women.

Mary Kelly's *Post-Partum Document* (1973–79) intimated the turn towards theory so central to contemporary art in the 1980s. Kelly's installation recorded her first encounters with her own maternity and in this sense was 'historical'. Framed by Lacanian theory, especially his concept of the mirror phase, *Post-Partum Document* emphasized the importance of interpretation and mediation as the key to transforming the Symbolic.[97] By focusing on her experience as a mother, Kelly pointed to the dearth of artworks exploring the mother/son relationship undertaken by mothers themselves. This is one of *Post-Partum Document*'s most important insights, for it underscores how little attention we give to the ties that are familial and yet not quite familiar. Faith Ringgold and Michele Wallace have reflected on the mother/daughter relation, as have Allison and Betye Saar, and Hannah Wilke's homage to her mother, in both her life and death, is writ large in her photographic series *So Help Me Hannah Series: Portrait of the Artist with Her Mother, Selma Butter* (1978–81), and more subtly in her 1991–92 *Intra-Venus* series, which included photographs, works on paper and sculpture documenting the end of her own life. The sisters Mira and Naomi Schor have worked brilliantly, but separately, on issues of essentialism, while the art historians Amelia and Caroline Jones are doing much to transform interpretations of post-war art history.[98] The performance artist Diane Torr has suggested that her brother inspired her to develop her Drag King performances in the mid 1990s; the filmmaker Jennie Livingston dedicated her study of urban cultures of cross-dressing, *Paris Is Burning* (1994), to her brother; and the vocalist Diamanda Galas performed *Plague Mass* (1991) in memory of her brother. Sonia Lins, the Brazilian writer, made an evocative memoir/artist's book, *Artes,* upon the death of her sister, the artist Lygia Clark, in 1988.[99] The photographer Nan Goldin has frequently spoken of her sister's suicide and how it prompted her to begin taking photographs.[100] The mourning at the heart of familial love (especially as it inspires collaboration and/or rivalry) is an important and underappreciated force in the production of art. Feminist artists' emphasis on the everyday, the familiar and the emotional helped create an important discussion about the

complexity of this love in both psychic and creative life. Kelly's *Post-Partum Document* boldly underlined just how how rich the familial field is.

Luce Irigaray's suggestion that 'women's desire does not speak the same language as men's' has been taken up by feminist literary theorists to help translate and promote the idea of *écriture feminine*. Irigaray called for a feminine writing that mimicked the patriarchal Symbolic so aggressively that its sheer repetitive miming might begin to destabilize reality itself. In her evocative paintings, especially *Light Flesh;* (1994) and *Slit of Paint* (1994), Mira Schor illuminates some of the complex intersections between painting, writing and embodiment for women. Her book *Wet: On Painting, Feminism and Art Culture* is among the most provocative, useful collections of feminist art writing published in recent years.[101]

At the root of the appeal of mimicry for feminist art was a shift away from the 'originality' of painting and sculpture, to the repetitions of photography, film and video. This

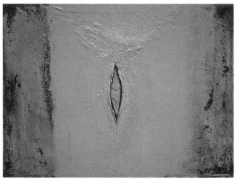
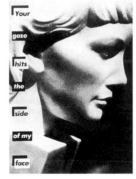

Mira SCHOR Light Flesh;, 1994
Barbara KRUGER Untitled (Your gaze hits the side of my face), 1981
Lynn HERSHMAN Roberta Breitmore's Driver's licence, 1974
Cindy SHERMAN Untitled 211, 1989

shift was in keeping with Postmodernism more generally. As theorists from Walter Benjamin to Fredric Jameson have demonstrated, the 'aura' of the original wanes in an age of mechanical reproduction; Postmodernism is the recognition that representations of the real have become more powerful than the real precisely because of the density of their repetitions.[102] Thus the four most critically celebrated women artists of the 1980s, Sherrie Levine, Barbara Kruger, Jenny Holzer and Cindy Sherman, tend to be labelled 'Postmodernists' rather than 'feminists' – presumably because their work 'transcends' the putatively narrow frame of feminism. But as Laura Cottingham has demonstrated, their work emerged amid the feminist art of the 1970s:
'If their works do not formally resemble the raw, visceral, emotive practices most often associated with 1970s feminist art, their strategies are nonetheless derived from intellectual and aesthetic concerns that preoccupied first-generation feminist artists.'[103] The text-based strategies of Holzer and Kruger, and the

appropriations of Levine, emphasized the reproductive and iterative properties of speech acts, advertising and photographic posing. Kruger's short, bold-faced statements laid out like the typeface of advertisements, attempted to 'talk back' to dominant culture. In her untitled work of 1981, a text reading 'Your gaze hits the side of my face' marches down the left side of a photographed stone carving of a woman's face, effectively animating the lifeless and formerly mute effigy.

But the most important shift in feminist art in the 1970s and 1980s was rooted in a recognition that no single act or 'original' artwork could be interpreted without recourse to the frames in which it was enacted and made. This shift can be illustrated by considering Lynn Hershman's alter ego of the 1970s, Roberta Breitmore, in relation to the masquerades of femininity that Cindy Sherman captured in her photographs of the late 1980s, particularly the *History Portraits*. Hershman created Roberta Breitmore as a distinct social agent; she went for job interviews and even filed for her own identification number. Hershman's performance eroded the line between the artistic and the real. It was an important predecessor for other feminist performance artists: a decade later, Orlan's serial plastic surgeries make literal a morphological design derived from art history's beliefs about women's beauty.[104]

Sherman's work examines the line between the real and the representational within photography. Posing for a photographic shoot of a dissection is a different kind of performance than undergoing plastic surgery. While all three artists are concerned with different forms of inscription and the body, Sherman's work is about a kind of textualization and mode of reading art, while Orlan's and Hershman's works attempt to move outside the frame of 'art' towards 'reality'. Sherman's photographic performances suggested that there is no way to be outside the frame of representation.

The possibility that representation was often responsible for women's oppression was originally greeted with a kind of optimism. It seemed much easier to intervene in the

conventions of representation than to overthrow a form of scientifically 'factual' or 'natural' set of laws. This initial optimism, however, led to political divisiveness within feminism in general. Gone were the days of talking about 'the personal' without quotation marks. Instead, difficult texts of Lacan, Derrida and other (often French) theorists were parsed for what insight they might offer on the condition of women within what came to be called phallogocentrism. This new emphasis initiated a change in the frame of reference of art history, although for the first time the historical period up for a revisionary interpretation was not only the canon of Western art, but also the work of 1970s feminists. Upholding the dominant notion that history is ever advancing, feminist work of the 1980s was celebrated as 'greater' than the work of the preceding decade. The irony of this is worth underlining: in order to proclaim the radicality and sophistication of the more explicitly theoretically informed work of the 1980s, feminist art critics (perhaps unwittingly) assented to the narrative of linear progress characteristic of the most conservative beliefs about history and historiography.

In the midst of the discourse on deconstructing the regime of the visual, however, an ever more powerful critique of whiteness as the unmarked category of feminism and feminist theory began to bear fruit. The 1981 publication of the angry, lyrical and deeply passionate *This Bridge Called My Back* had an enormous influence on subsequent dialogues about race and racism, especially the racism within the feminist movement. Edited by Cherríe Moraga and Gloria Andzaldúa, with a foreword by Toni Cade Bambara, *This Bridge* brought together writing by Chrystos, Audre Lorde, Barbara Smith, Cheryl Clarke and other women of colour whose work inspired some of the best subsequent political writing in the US. The voices of Native Americans, Filipinos, Cuban Americans and Asian Americans added much complexity to the conversation about racism in the US, which had tended to be seen as a conversation primarily between African Americans and whites. Organized in six sections, one of which was called 'And when you leave take your pictures with you: racism in the women's movement', *This Bridge* examined class, homophobia and first and third world politics; it was an extremely influential anthology throughout the decade.

Gayatri Spivak's helpful phrase, 'strategic essentialism', the notion that one might in some circumstances insist on

the force of a consolidated political identity such as 'the subaltern' or 'the lesbian', also helped to reanimate some of the activist elements of feminism that had become latent when theory was the main game in town. Trinh T. Minh-ha's 1991 book *When the Moon Waxes Red: Representation, Gender and Cultural Politics* usefully helped unsettle the ease of a too simple litany of 'race, class, gender and sexuality differences', which was iterated more often than analysed. Lucid, theoretically sophisticated and politically astute, Trinh's work provided a context for Coco Fusco's important 1995 book *English Is Broken Here: Notes on Cultural Fusion in the Americas*. Whereas some women of colour in the 1970s often felt they were asked to choose between their identifications as women and their racial identifications, Fusco, along with bell hooks, Kimberlè Williams Crenshaw, Valerie Smith, Patricia Williams, Toni Morrison, Adrian Piper and others, worked to show the ways in which racism and sexism are intertwined pathologies which have distorted our lives.

Central to this work has been a significant rethinking of the binary habits of racial difference. While it was pretty easy to see that the habitual white/non-white would not be sustainable, it was harder to notice that the ubiquitous 'third term' that structures critical theory is problematic as well. Thinking about the possibilities of interracial and inter-ethnic alliances and tensions has been difficult in part because logic tends to be dialectical. Interracial and inter-ethnic analysis and activism, often called critical race theory in the academy, pushes conceptual habits to develop new logics. Moving away from the consolidations of identity politics, to consider shifting politics of alliance, critical race theory reminds feminists why we still need to rethink the binary of masculinity and femininity, without concluding the problem is 'solved' via the invocation of transsexuality.

Drawing on the important work of the Sankofa film and video collective in the 1980s, which included the historically resonant films of Isaac Julien and of Martine Attille, in the 1990s visual artists such as Zarina Bhimji, Sutapa Biswas, Sonia Boyce, Mona Hatoum and Pratiba Parmar have helped keep the intersectionality of race, sex, class and gender at the forefront of progressive contemporary art in Britain. Cultural theorists Stuart Hall, Homi K. Bhabha, Jean Fisher and Kobena Mercer, among others, have provided an important critical frame for this work.[105]

The destructive explosions of 'the culture wars' in the late

1980s and early 1990s in the US remind us what is still at stake in the debate over high and popular culture, dominant and marginal art practices and public policy for the arts – all issues first framed by the feminist art movement. The Guerrilla Girls, who dubbed themselves the 'conscience of the art world', continue to insist on pointing out the mutually determining forces of sexist and racist structures in art exhibitions and theory. Kara Walker, an African-American artist whose silhouette black cut-outs of stereotypical imagery of African Americans have been heralded by some as profound exposures of the shadowy legacy of slavery beneath contemporary racism, and denounced by others as insufficiently critical about precisely that legacy, has been the target of an alarming new censorship. While it seems possible that Walker's art might be vulnerable to racist readings, it is also possible that the Walker debate is a repetition of the essentialist feminist debate – although this time played out in relation to the historical trauma of slavery. The best response to allegedly

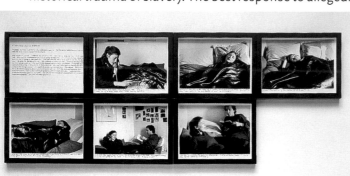

offensive art can only be better art. Education alert to the nuances of the histories of art, racism and sexism needs to be joined with theories of representation. Censorship is dangerous not only because it can so easily produce chilling effects that far exceed the initial target, but also because censorship produces a kind of sensational journalistic attention and does little to address the complexity provoked by powerful art.

An important aspect of feminist art in the 1980s was the investigation of what might be called the trace of absence that constitutes the illusion of presence. The French artist Sophie Calle made a beautiful series of photographs entitled *The Sleepers* (1979) in which the pleats and folds left in the bedclothes after the sleeper wakes and leaves register the melancholic trace of the repeatedly missed figure. Artists such as Nan Goldin, Felix Gonzalez-Torres and Peter Hujar used photography to capture the traces of friends and lovers who were dying from AIDS in the epidemic of the 1980s.

Rachel Whiteread's 'inversion' of houses and libraries, casts that both evoke and haunt the absent object, similarly makes vivid what is normally lost to sight. Rosalind Krauss' 1986 essay on Bataille, 'Antivision', proposes that disruption of the prerogatives of the visual system fundamental to art theory and criticism would yield 'another description of the goals of representation, another ground for the very activity of art'.[106]

After Irigaray suggested that 'women's desire most likely does not speak the same language as man's desire', she went on to claim that it 'probably has been covered over by the logic that has dominated the West since the Greeks. In this logic, the prevalence of the gaze, discrimination of form and individualization of form is particularly foreign to female eroticism.'[107] If the gaze is not the erotic drive for women, what other senses might be? The notion of a haptic art began to emerge in the 1990s. A more intimate and tactile address between viewer and artwork is part of the achievement of Helen Chadwick's *Loop My Loop* (1989), a soft sculpture that renders hair a kind of formal grammar for female connection itself. Maureen Connor's *The Senses* (1991), a five-part installation that addresses the logic of each of the senses, displaces the singularity of the visual in the act of beholding. In the installation devoted to sight, *Limited Vision*, a wall covered with Mylar emerges from behind a curtain. Each time the looker 'sees', what she confronts is her own gaze.

Sound art, from all-girl garage bands and 'riot grrls', to the more sophisticated technological performances of Laurie Anderson, has not been given sufficient attention in accounts of feminism and art. Kaja Silverman, a feminist film theorist, has explored the possibilities of identification with the female voice, rather than the body, in the films of Yvonne Rainer and Chantal Akerman.[108] As electronic-based forms of art become prevalent, this kind of thinking will become more central for understanding feminist art. Pipilotti Rist, one of the most talented new artists to emerge in the 1990s, spent six years (1988–94) playing in the rock band Les Reines Prochaines, and has made beautiful, melancholy works in a pop video style, such as *I'm Not the Girl Who Misses Much* (1986) and *Ever Is Over All* (1997). A more sophisticated analysis of sound art and haptic theory will need to be developed in order to assess these new forms.

Sophie CALLE The Sleepers (X. Baby-sitter), 1979
Maureen CONNOR The Senses (detail), 1991

Up to and Including Our Limits [109]

In the early 1990s, queer theory emerged as one of the most innovative and exciting disciplines in contemporary thought. The work of writers and theorists such as Eve Kosofsky Sedgwick, Judith Butler, Judith Halberstam, Lynda Hart, Catherine Lord, Terry Castle, Mandy Merck, Elisabeth Grosz, Liz Kotz, Laura Cottingham and others helped to bring new attention to the work of lesbian artists. The photographic work of Catherine Opie, Nan Goldin, Della Grace, the paintings of Nicole Eisenman and perhaps most especially the performance work of Holly Hughes, The Five Lesbian Brothers and Split Britches helped to foster the development of lesbian and queer art in many guises. Moreover, it also helped to clarify some of the less helpful impasses within feminist theory. Butler's influential book *Bodies That Matter: On the Discursive Limits of 'Sex'* (1993), for example, returned to the essentialism debate in a way that might finally allow people to let it go. [110] Jane Gallop's 1988 *Thinking through the*

exposed by the similar erosion of the line between reality and representation central to Postmodernism. Compulsively engaged in copying, postmodern representation lends the real a density it previously lacked. Thus what gives gender performances their almost ontological force is precisely their ability to be recited, repeated, reproduced. Women, as the agents of reproduction, are thus at once both the avatars and the objects of the logic of repetition and reproduction utterly central to Postmodernism. Photography was especially fluent in making this connection apparent.

In addition to the work of Cindy Sherman and Nan Goldin, important photographic work in the 1980s and 1990s included Carrie Mae Weem's photographic short stories devoted to framing the miscommunications which characterize romance and racism; Lorna Simpson's police-like photographic interrogations of 'guarded conditions' around racial categories and loaded phrases; Zoe Leonard's medico-erotic photographic investigation of lesbian desire;

<div style="writing-mode: vertical">Pipilotti RIST I'm Not the Girl Who Misses Much, 1986
Carrie Mae WEEMS Woman with Chicken, 1987
Zoe LEONARD Pin-up 1 (Jennifer Miller Does Marilyn Monroe), 1995
Laura AGUILAR In Sandy's Room (Self-Portrait), 1951</div>

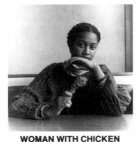

WOMAN WITH CHICKEN

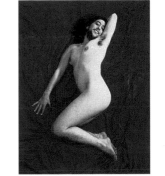

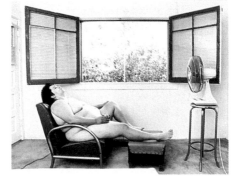

Body, Diana Fuss' 1989 *Essentially Speaking* and Naomi Schor's detailed re-examination of Irigaray's writing in her essay 'The Essentialism Which Is Not One' helped pave the way for the reception of Butler's argument. [111] Crucially though, Butler accented the language of performance and performativity more loudly than the accents of psychoanalysis which had been fundamental to the arguments of the 1980s. Placing her emphasis on the process of enactment and iteration, Butler demonstrated that gender identity was necessarily unstable and unfinished, a performance forever in process. Therefore dis-identification with representational history could be rethought as a politically effective strategy for interventions in cultural interpellation. This of course is what feminist artists had demonstrated in the 1980s.

Extending Joan Riviere's insight about the lack of distinction between 'genuine femininity' and the 'masquerade' of femininity, feminist performance artists and photographers suggest that the erosion of that line is itself

Sheree Rose's passionate documentation of body artists and s/m practitioners; Catherine Opie's documentary portraits of drag kings in the series *Being and Having* (1990–91) and Laura Aguilar's *Latin Lesbian Series* (1990–91). All of these artists use photography to frame the crossings between the public and the personal, the theatrical and the real, in order to complicate ideas about race, romance and sexuality.

While feminist theorists in the 1980s were especially interested in the psychoanalytic work of Freud and Lacan, in the 1990s the work of Melanie Klein began to be reinvestigated by feminist art historians. Mignon Nixon, for example, offered a provocative reading of Janine Antoni, Louise Bourgeois and Eva Hesse, which employed Klein's ideas about the oral drive and transitional objects. [112] Nixon's essay suggests a generative way to move beyond the analysis of the gaze, while retaining the crucial role of the unconscious in the creation and interpretation of art.

Attempts to revise art history have continued in

exhibitions of the 1990s. Several coincidentally titled 'Bad Girls' exhibitions in 1993–94, one curated by Marcia Tucker at the New Museum of Contemporary Art, New York,[113] another curated by Emma Dexter and Kate Bush at the Institute of Contemporary Arts, London, sought to survey the diversity of current practice in its own terms but attracted some negative critical responses. The 1996 'Inside the Visible' exhibition attempted to contextualize work of the 1990s by setting it alongside two germinal periods in the development of art by women in the twentieth century: the 1930s to 1940s and the 1960s to 1970s.[114] The show was curated by M. Catherine de Zehger of the Kanaal Art Foundation, Kortrijk, Belgium; when it travelled to the Institute of Contemporary Art, Boston, the director, Milena Kalinowska, commissioned programmes of poetry readings and film screenings to extend the parameters of the exhibition. The catalogue, subtitled *an elliptical trace of 20th century art: in, of, and from the feminine,* demonstrates the continuing need for combining both theoretical and historical accounts of feminism and art. *Stopping the Process? Contemporary Views on Art and Exhibitions* (1998), published in Helsinki, took up the increasingly important role of curators in the development of contemporary art.[115] Both publications suggest that the US and Britain may no longer be the dominant centres for innovative thinking about feminism and art.

In the mid 1990s some feminist writers began to feel the constraints of art history as a discourse and began to create a slightly different scholarly project, one usually called 'visual culture'. Lisa Bloom's 1999 edited anthology *With Other Eyes: Looking at Race and Gender in Visual Culture* is one of the more exciting volumes to emerge from this project.[116] The distinction between the discipline of art history and visual culture has to do not only with the object of study – visual culture ruminates on such disparate topics as comic books, advertising images and national guidebooks – but also with the mode of address to the reader. This address is more intimate and, while critically informed, tends to be less determined (or perhaps less desperate) to display its theoretical mastery. Influenced by Patricia Williams' brave and brilliant book *The Alchemy of Race and Rights: A Diary of a Law Professor,* the exemplars of this new work, who include Irit Rogoff, Carol Becker, Jane Blocker, Moira Roth, Carol Mavor, Della Pollock, Joanna Frueh, Lucy R. Lippard and Hélène Cixous, do not honour the distinctions between 'theoretical' and 'personal' knowing.

In 1995, *October* magazine published a round table discussion on feminism, responding to the growing sense that feminism and feminist theory had been played out.[117] For readers of *October,* what was worth remarking was critical theory's own apparent disenchantment with theories of sexual difference as a mode of analysis for cultural representation. A shift seemed to have taken place in which questions of the political had been subtly surmounted by questions of the ethical.

One of the main motivations for this shift came from the emerging field of trauma studies. An interdisciplinary and international attempt to return to some of the questions raised by World War II quickly led to a wider inquiry into the nature of trauma and its reverberations in both psychic and cultural history. As information and documentation of subsequent genocides in Cambodia, Rwanda, East Timor, Kosovo, Bosnia *and ...* accumulate, questions of trauma and catastrophe become ever more urgent. Judith Lewis Herman's 1992 *Trauma and Recovery,* Shoshana Felman and Dori Laub's 1992 *Testimony* and Cathy Caruth's edited 1995 collection *Trauma: Explorations in Memory* are among the most germane texts in this literature.[118] Much of this theory is derived from clinical psychoanalysis or psychoanalytically minded interpretations of literature, but it has serious implications for feminist art history. Not only because, as I suggested earlier, one theme of the notion of a collective feminist awakening allows us to see that awakening as traumatic, but also because so much powerful feminist art has been devoted to the examination of pain and trauma. From Suzanne Lacey and Leslie Labowitz's *In Mourning and in Rage* to some of the experiments in 'ordeal art' undertaken by artists such as Gina Pane, Linda Montano, Marina Abramovic, Angelika Festa and Orlan, feminist art has been dedicated to exploring the consequences of the specific forms of physical violence women experience in a world run by men. Pane's body art in the 1970s, for example, involved cutting her skin with knives, razor blades or glass in gallery settings. Commenting on this work in 1985, Pane remarked: 'We live in continuous danger, always. So [my body art investigates] a radical moment, the moment most loaded with tension and the least distant from one body to the other, the [moment] of the wound.'[119] Crucial to this investigation is the presence of the spectator. Carefully choreographed and performed in the

company of witnesses, Pane's body art solicits a call for compassion and response. Linda Montano and Tehching Hsieh's performance work *A Year Tied Together at the Waist*, also known as *Rope Piece* (1983–84), is often described as 'ordeal art'. The two artists were tied together at the waist by an eight-foot rope for a year while they observed a strict 'no touching' rule the whole time.[120] Usually associated with acts of physical pain and difficulty, 'ordeal art' does not fully capture the emotional and political drama of intimacy and repulsion, co-operation and resistance that this work makes vivid. Tehching Hsieh's experience as a Cambodian refugee who speaks English only with difficulty, seen in relation to Montano's eloquent feminism, makes the power dynamics at the heart of the performance richly complicated and extremely difficult to address critically. Resisting the easy conclusion that it illuminates what it means for women to be tied to men, the performance invites a more patient view of the ties that bind and blind us to each other's dramas.

expressive system often overlooked by philosophers attempting to account for the capacities and incapacities of language.[123] The increasingly theatrical flair of contemporary installation, painting and sculpture might be understood as an attempt to make this pain something to be shared. Theatre exists for a witness. In returning to the agony of trauma, art might provide a means to approach its often radical unknowability, in part because art does not rely exclusively on rational language, narrative order or naive beliefs in therapy. Moreover, art theorists might remind theorists of trauma that creativity is central to any theory of survival.

The realization, slow but decisive, that worlds outside major urban centres are culturally rich, complicated and much neglected in terms of critical attention, is finally beginning to take hold. Seeing the multiple blindnesses that framed Western art history, some feminists began to explore art forms from other cultures. Joyce Kozloff's *Patterns of Desire* (1990), a book of thirty-two watercolours copying

Linda MONTANO (with Tehching Hsieh) A Year Tied Together at the Waist, 1983-84
Magdalena ABAKANOWICZ Backs, 1981
Joyce KOZLOFF Pornament Is Crime No. 12: Revolutionary Textiles, 1987
Cecilia EDEFALK Elevator Painting, 1998

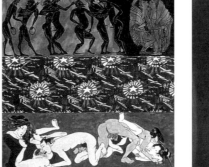

In a less literal way, Marlene Dumas' early paintings, such as the self-portrait *Evil Is Banal* (1984), which reflected upon South African apartheid; Magdalena Abakanowicz' burlap *Backs* series of the early 1980s; and Mona Hatoum's sculpture *Silence* (1994), a crib for an infant made of glass, represent important responses to political violence. Abakonowicz' *Backs* is at once theatrical and traumatic. In 1977 she showed twenty of them together under the title *The Session*. The installation staged a Nietzschean and psychoanalytic attention to political life's *hinterfrage*, the 'back-question' that is not only collectively historical but also intensely private, indeed, utterly agonizing.[121] As Elaine Scarry has argued:

'*Pain is resistant to language; to move out beyond one's body to share is that which pain is incapable of. It is not of or for anything. It is precisely because it takes no object that it, more than any other phenomenon, resists objectification in language.*'[122]

Performance, which also 'takes' no object, is an important

and transposing famous erotic iconographies from Japan and China, from gay and lesbian art sources, audaciously employs these erotic couplings as decorative elements in her own works. Subtitled *Pornament Is Crime*, Kozloff's series of watercolours represents one of the richest responses to the often contradictory 'perspectives' Western feminists take up in relation to the dense and varied history of erotic art.[124] Similar projects undertaken by non-Western artists still need more critical attention.

Additionally, artists working outside the main centres of international art are beginning to receive critical attention. Cecilia Edefalk, a painter from Stockholm, has extended interest in figuration, repetition and size to a consideration of that which cannot be measured. Her *Elevator Paintings* (1998) examine the space between fullness and emptiness, between the lost wooden arm of a statue of an ancient angel and the suturing possibility of paint as replacement. The angel with the wounded arm pivots in a white dress

dotted with blood within and across the frames of five paintings composed as a series of the 'same' painting, done in different sizes and with differing amounts of detail. The whitish brushstrokes on the bottom of the paintings move upwards and stop at the angel's outstretched arms. What would it take to perform once again the double lifting and dropping action conveyed by the German *aufhebung*, even with a broken arm? The attempt, Edefalk gently reminds us, will take time as well as space.[125]

Denise Stoklos, the Brazilian performance artist, has recently completed an important theatre piece entitled *Louise Bourgeois: I Do, I Undo, I Redo* (2000). Stoklos' performance challenges the hierarchies of first world art commentary. Her Bourgeois is very far from Rosalind Krauss' and the future of that difference will be telling. For Krauss, Bourgeois is, supremely, a master of sculpture, who uses her history as inspiration. For Stoklos, Bourgeois is, primarily, a woman trying to survive (her own) history, who uses her art as a way to

record and advance that survival.

The questions that have been at the heart of art commentary have been fundamentally rooted in an

assumption about the link between the artist and the made thing, be it as ephemeral as performance or as solid as a monument. But as concepts of identity become increasingly less stable, the assumption that gender identity is itself fixed enough to become oppressive *seems* to disappear. In my view, we are a long way from such a sense of lived instability – the psyche is a well-practised resister – although I think we have arrived at a theoretical one, buttressed by the terrain of the virtual and the electronic. Del LaGrace Volcano, the female to male transgendered photographer formerly known as Della Grace, articulates the gap between what is conceptually and technologically possible in regard to gender transformation, and what is still messy at the level of lived experience.[126] Describing the experience of modelling for the painter Jenny Saville, Del LaGrace remarked:

'*Jenny Saville paints women. I no longer identify as "woman" and feel uncomfortable being read as female. I am intersex by design, an intentional mutation, and need to have my gender specified*

as existing outside of the binary gender system, rather than [as] an abomination of it […] My fear is that I will be read as only female and this painting may have the power to dislocate and /or diminish my transgendered maleness in the eyes of others and quite possibly my own.'[127]

This is a bold and honest statement. It's also exceedingly complicated. Having decided no longer to 'identify' as 'only female' which is not the same thing as having chosen to identify as a man, Del LaGrace worries s/he will somehow be re-gendered as a woman, because Saville paints women. Not only is s/he at risk from the mis-seeing eyes of anonymous spectators of Saville's paintings of women, but also Del LaGrace is 'quite possibly' at risk of being betrayed by his/her own eyes.

Saville's paintings inscribe her models into an economy we can call 'Saville's women' (quite often her models are her sister or herself). But Saville's work is framed by the history of high art; her paintings refer to gestures of the figure undertaken by artists from Gustave Courbet to Lucian Freud. As Johanna Burton has pointed out, the intertext of Saville's *Matrix* (1999) is Gustave Courbet's *L'Origine du monde* (*The Origin of the World* , 1866),[128] a painting that Nochlin, in a virtuoso display of her 'greatness' as an art historian, discusses in relation to its provenance. It was owned for a time by the great theorist of sexual difference Jacques Lacan.[129] As Saville makes her bid to enter the pantheon of great figurative painters, she returns to Courbet's *Origin* and paints it again. But Saville, unlike Courbet, includes her model's face, and the catalogue of the show contains an interview about the model's experience of her performance. Saville's model, in short, is not art history's nude woman, but contemporary art's former-woman.

Those of us lucky enough to have endured the trauma and the possibility of feminist awakening have a particularly charged, and decidedly ambivalent, response to becoming (again) former-women. In memory of that history still before us, I hereby put these words to bed, still muttering *and, and, and* …

Jenny SAVILLE Matrix, 1999

1 For interesting discussion of the frame see Jacques Derrida, *The Truth in Painting*, trans. Geoffrey Bennington and Ian McLeod (Chicago and London: The University of Chicago Press, 1987) 37–82; *The Rhetoric of the Frame: Essays Towards a Critical Theory of the Frame*, ed. Paul Duro (New York and Cambridge: Cambridge University Press, 1997). See especially Amelia Jones' essay 'Interpreting Feminist Bodies: The Unframeability of Desire' (223–41).

2 Anne Marsh, *Body and Self: Performance Art in Australia: 1969–1992* (Sydney: Oxford University Press, 1993) is the best work on Australian contemporary art and feminism. While the 'ordeal artist' Stelarc remains Australia's best known performance artist, Marsh makes clear that the work of feminist artists, especially the captivating and challenging work of Jill Orr, is stunningly powerful. See Marsh's chapter 'Ritual Performance and Ecology: Feminist and Activist Performance', 141–83. A good discussion of the development of nineteenth- and twentieth-century Australian women painters can be found in *Strange Women: Essays in Art and Gender*, ed. Jeannette Hoorn (Carlton, Vicoria: Melbourne University Press, 1994). Feminist theatre and performance are usefully documented and analysed in Peta Tait's *Converging Reality: Feminism and Australian Theatre* (Sydney: Currency Press, 1994) and in Tait's *Australian Women's Drama: Texts and Feminisms* (Sydney: Currency Press, 1997).

3 Laura Cottingham, *Not for Sale: Feminism and Art in the USA during the 1970s*. Video, 90 mins., colour (New York: Hawkeye Productions, 1998).

4 Griselda Pollock, *Generations and Geographies in the Visual Arts: Feminist Readings* (New York and London: Routledge, 1996).

5 After the elimination of the male/female opposition, the even more fundamental opposition between life/death comes into view as the next project. For a full discussion of the often repressed relationship between sex and death see Jean Laplanche, *Life and Death in Psychoanalysis*, trans. Jeffrey Mehlman (Baltimore and London: The Johns Hopkins University Press, 1976; original publication in France, 1970).

6 Lucy R. Lippard, 'Sweeping Exchanges: The Contribution of Feminism to the Art of the 1970s', *Art Journal* (Fall–Winter 1980) 362.

7 See Tania Modleski, 'Some Functions of a Feminist Criticism, or the Scandal of the Mute Body', *October*, 49 (Summer 1989) 3–24.

8 J.L. Austin, *How to Do Things with Words*, ed. O.J. Urmson and Marina Sbisà (Cambridge, Massachusetts: Harvard University Press, 2nd edition 1975). This text is based on Austin's 1955 lectures at Harvard.

9 The best reading of *How to Do Things with Words* is Shoshana Felman's *The Literary Speech Act: Don Juan with J.L. Austin, or Seduction in Two Languages*, trans. Catherine Porter (Ithaca, New York: Cornell University Press, 1983).

10 See Griselda Pollock and Roszika Parker, ed., *Framing Feminisms: Art and the Women's Movement, 1970–85* (London: Pandora Press; New York: Routledge & Kegan Paul, 1987) for a fuller discussion of the particular uniqueness of feminist art as a movement. Socialist Realism is sometimes proposed as an art movement comparable to feminist art.

11 There are many discussions of Womanhouse but perhaps the most interesting is Miriam Schapiro's 'The Education of Women as Artists: Project Womanhouse', *Art Journal*, 32: 4 (Summer 1973). It is clear from her account that a new pedagogy was also (perforce) being created in these collaborative projects. This aspect of feminist history and art needs more attention. Arlene Raven's 'Womanhouse' in Norma Broude and Mary D. Garrard, eds., *The Power of Feminist Art: The American Movement of the 1970s, History and Impact* (New York: Abrams, 1994) 48–65, is also an excellent documentation and analysis of the exhibition.

12 The reverberations of this exhibition continue to this day: Womenhouse, a site on the World Wide Web, was inspired by it. See http://www.cmp.ucr.edu/womenhouse. Faith Wilding is a participant.

13 For more on the history of galleries and other feminist spaces see Judith K. Brodsky, 'Exhibitions, Galleries and Alternative Spaces', in *The Power of Feminist Art*, op. cit., 104–19.

14 For an excellent discussion of Akerman's work see Ivone Margulies, *Nothing Happens: Chantal Akerman's Hyperrealist Everyday* (Durham, North Carolina: Duke University Press, 1996).

15 The work of feminist film theorists indebted to Mulvey is far too extensive to cite here. But some of the most influential books would include: E. Ann Kaplan, *Women and Film: Both Sides of the Camera* (New York and London: Methuen, 1983); Linda Williams, *Hard Core: Power, Pleasure, and 'The Frenzy of the Visible'* (Berkeley: University of California Press, 1989); Judith Mayne, *The Woman at the Keyhole: Feminism and Women's Cinema* (Bloomington: Indiana University Press, 1990); Teresa de Lauretis, *Alice Doesn't: Feminism, Semiotics, Cinema* (Bloomington: Indiana University Press, 1984); Mary Ann Doane, *The Desire to Desire: The Women's Film of the 1940s* (Bloomington: Indiana University Press, 1987) and *Femmes Fatales: Feminism, Film Theory and Psychoanalysis* (New York and London: Routledge, 1992); Valerie Smith, *Not Just Race, Not Just Gender: Black Feminist Readings* (New York and London: Routledge 1998). Additionally, popular books such as Molly Haskell's *From Reverence to Rape: The Treatment of Women in the Movies* (New York: Holt, Rinehart and Winston, 1974) and Jeanine Basinger's *A Woman's View: How Hollywood Spoke to Women, 1930–1960* (New York: Alfred Knopf, 1993), helped articulate the powerful role films, especially Hollywood films, played in both influencing and reflecting public imagination. B. Ruby Rich, *Chick Flicks: Theories and Memories of the Feminist Film Movement* (Durham, North Carolina: Duke University Press, 1998) is a lively history of the development of both the academic and journalistic history of the field.

16 Cherríe Moraga and Gloria Anzaldúa, ed., *This Bridge Called My Back: Writings by Radical Women of Colour* (Watertown, Massachusetts: Persephone Press, 1st edition 1981; New York: Kitchen Table: Women of Colour Press, 2nd edition 1983).

17 The exhibition was held at Acts of Art Gallery, 15 Charles Street, New York. The show led to an organization of seventeen women under the name 'Where We At'. For a fuller discussion see Kay Brown, 'Where We At Black Women Artists', *Feminist Art Journal*, 1 (April 1972).

18 Quoted in Brodsky, op. cit., 118.

19 Shere Hite, *The Hite Report: A Nationwide Study on Female Sexuality* (New York: Macmillan, 1976). She did a follow-up study that appeared in 1987.

20 For a good overview of the sexuality debates in the early 1980s, see Carol S. Vance, ed., *Pleasure and Danger: Exploring Female Sexuality* (Boston: Routledge and Keagan Paul, 1984).

21 The best discussion of this complicated story can be found in Lynda Hart's *Between the Body and the Flesh: Performing Sadomasochism* (New York: Columbia University Press, 1998) 36–82. See also Lisa Duggan and Nan Hunter, *Sex Wars: Sexual Dissent and Political Culture* (New York and London: Routledge, 1995).

22 Kimberlè Williams Crenshaw, 'Beyond Racism and Misogyny: Black Feminism and 2 Live Crew', for a shrewd discussion of structural, political and representational intersectionality, in Mari J. Matsuda et al., eds., *Words that Wound: Critical Race Theory, Assaultive Speech and the First Amendment* (Boulder, Colorado: Westview Press, 1993) 111–32.

23 Craig Owens, *Beyond Recognition: Representation, Power and Culture*, ed. Scott Bryson, Barbara Kruger, Lynne Tillman and Jane Weinstock, (Berkeley and Oxford: University of California Press, 1992); see especially his important essay, 'The Discourse of Others: Feminists and Postmodernists', published in *The Anti-Aesthetic: Essays on Postmodern Culture*, ed. Hal Foster (Seattle: Bay Press, 1983) 57–82. Douglas Crimp, *On the Museum's Ruins* (Cambridge, Massachusetts and London: MIT Press, 1993); Crimp, *AIDS Demo Graphics*, with Adam Rolston (Seattle: Bay Press, 1990); and Crimp, ed., *AIDS: Cultural Analysis/Cultural Activism* (Cambridge, Massachusetts, and London: MIT Press, 1988). Simon Watney, *Policing Desire: Pornography, AIDS and the Media* (Minneapolis: University of Minnesota Press, 1987); and Watney, *Practices of Freedom: Selected Writings on HIV/AIDS* (Durham, North Carolina: Duke University Press, 1994). Kobena Mercer, *Welcome to the Jungle: New Positions in Black Cultural Studies* (New York and London: Routledge, 1994).

24 Patton, *Inventing AIDS* (New York and London: Routledge, 1990) and *Last Served? Gendering the HIV Pandemic* (Bristol, Pennsylvania: Taylor & Francis, 1994).

25 The 'abject', a term derived from Julia Kristeva's important discussion in *The Powers of Horror: An Essay on Abjection*, trans. Leon S. Roudiez (New York: Columbia University Press, 1982), was the point of departure for two fascinating exhibitions and catalogues in the early 1990s: *Dirt & Domesticity: Constructions of the Feminine* (New York: Whitney Museum of American Art at the Equitable Center, 1992) and *Abject Art: Repulsion and Desire in American Art* (New York: Whitney Museum of American Art, 1993).

26 See Gertrud Koch's 'Blood, Semen, Tears', an important and complicated commentary on Helke Sander's film *Liberators Take Liberties: War, Rapes, Children* (1992), in *October*, 72 (Spring 1995) 27–41. Koch astutely connects the crisis in contemporary Eastern Europe with the history of racism in the US. With a somewhat surprising optimism, she also suggests that the anti-racist and feminist theory that emerged from that struggle might be applicable to the situation in Kosovo.

27 For discussion on these difficult subjects I am especially indebted to Robert Sember and Chris Mills.

28 Some of the most influential post-

Greenberg writing about Pollock includes: Francis Frascina, ed., *Pollock and After: The Critical Debate* (New York: Harper & Row, 1985); Michael Leja, *Reframing Abstract Expressionism: Subjectivity and Painting in the 1940s* (New Haven: Yale University Press, 1993); and Kirk Varnadoe and Pepe Karmel, ed., *Jackson Pollock: New Approaches* (New York: The Museum of Modern Art, 1999).

29 In a 1915 letter to her good friend Anita Pollitzer, O'Keeffe asked, 'Do you feel like flowers sometimes?' Reversing conventional attempts to anthropomorphize the natural world, O'Keeffe's startling question suggests that flowers, with their alternating blushing and fading, might be human emotional mirrors, thereby suggesting that flowers comprehend human life more precisely than humans see flowers. Quoted in *Lovingly, Georgia: The Complete Correspondence of Georgia O'Keeffe and Anita Pollitzer*, ed. Clive Giboire (New York: Simon and Schuster, 1990) 46.

30 Anne W. Wagner's 'L.K.' is the best writing on Krasner and feminism I know. *Representations*, 25 (Winter 1989) 42–56. It was reprinted in Norma Broude and Mary D. Garrard's anthology, *The Expanding Discourse: Feminism and Art History* (New York: Icon Editions, Harper Collins, 1989) 425–36.

31 Broude and Garrard, *The Expanding Discourse*, op cit., 16.

32 This volume is the sequel to their first anthology, *Feminist Art History: Questioning the Litany* (New York and London: Harper & Row, 1982). See also the excellent volume *Feminist Art Criticism: An Anthology* ed. Arlene Raven, Cassandra Langer and Joanna Frueh (Michigan: UMI Research Press, 1988).

33 Wagner, 'L.K.' in *Expanding the Discourse*, op. cit., 434.

34 Rosalind Krauss has a nice essay on Agnes Martin in *Bachelors* (Cambridge, Massachusetts: MIT Press, 1999).

35 See Lucy R. Lippard, *Eva Hesse* (New York: De Capo Press, 1992; originally published in 1976). Anna C. Chave's article 'Eva Hesse: A Girl Being a Sculpture', in *Eva Hesse: A Retrospective* (New Haven: Yale University Press, 1992) 99–118, is also excellent, particularly in regard to the connections between Hesse's illnesses and art making. Both Lippard and Chave quote extensively from Hesse's diaries. In them, Hesse has some wonderful reflections on reading *The Second Sex*.

36 Rosalind Krauss, 'Eva Hesse: Contingent', *Bachelors, op. cit.*, 91–100, 94. (Reprint of an essay that appeared first in 1979.) This is the best discussion of the force of death in Hesse's art I've read: 'Hesse is not

focused on the boundaries within a painting or a sculpture, but rather on the boundary that lies between the institutions of painting and sculpture [...] We are positioned at an edge from which the meaning of death is understood literally as the condition of the world disappearing from view' (100). But for Hesse, it is necessary to repeat that the accumulation of these disappearances was fundamental to the way she understood the meaning of her life and art.

37 Hesse, quoted in Lippard, *Eva Hesse*, *op. cit.*, 5.

38 Quoted in Carla Schulz-Hoffman, *Niki de Saint-Phalle* (Bonn: Prestel Verlag, 1987) 53.

39 For an excellent analysis of the development of painting and performance art in relation to World War II see Paul Schimmel, ed., *Out of Actions: Between Performance and the Object, 1949–1979* (Los Angeles: The Museum of Contemporary Art, 1997). Note especially the essay by Kristine Stiles, which has a long discussion of feminist art, pain and survival: 'Uncorrupted Joy: International Art Actions', 227–329.

40 See Benjamin H.D. Buchloh's 'Spero's Other Traditions' for a shrewd reading of Spero's *Codex Artaud*, in *Inside the Visible: an elliptical traverse of 20th Century Art/in, of, and from the feminine*, ed. M. Catherine de Zegher (Cambridge, Massachusetts: MIT Press, 1996) 239–46. Additionally, see Jo Anna Isaak, 'Notes toward a Supreme Fiction: Nancy Spero's Notes in Time on Women', in Maurice Berger, *Notes in Time: Leon Golub and Nancy Spero* (Baltimore County: Fine Arts Gallery, University of Maryland, 1995) which has an especially useful account of Spero's early work. Finally, see Jon Bird, Jo Anna Isaak, Sylvère Lotringer, *Nancy Spero* (London: Phaidon Press, 1996).

41 For a fuller discussion of the Judson Dance Theater see Sally Banes, *Democracy's Body: Judson Dance Theater, 1962–64* (Ann Arbor, Michigan: UMI Research Press, 1983). For more on Yvonne Rainer see her *Work: 1961–73* (Halifax, Nova Scotia: Nova Scotia College of Art and Design, 1974) and my essay 'Yvonne Rainer: From Dance to Film', in *Rainer, A Woman Who ... Essays, Interviews, Scripts* (Baltimore: Johns Hopkins University Press, 1999) 3–21. Jill Johnston's reviews of the new dance were mainly published in the *Village Voice*. Some of the best were reprinted in Johnston's *Marmalade Me* (New York: Dutton, 1971).

42 Yves Klein, from an essay originally published in *Zero*, 3 (July 1961) and quoted in Sandra Stich, *Yves Klein* (Stuttgart: Cantz Verlag, 1994) 176–77.

43 Mierle Laderman Ukeles, 'Manifesto for Maintenance Art', in Gregory Battcock, ed., *Idea Art* (New York: E.P. Dutton, 1973).

44 Adrian Piper, *Out of Order, Out of Sight, Vol. 1: Selected Writings in Meta-Art, 1968–1992* (Cambridge, Massachusetts: MIT Press, 1996) 43.

45 *Ibid.*, 147. *The Mythic Being* series has a complicated evolution. See Piper's own documentation and interpretation. *Ibid.*, 91–150.

46 Anna Deavere Smith's *Twilight, Los Angeles 1992* went to Broadway in 1994, but it is a solo piece.

47 See my *Unmarked: The Politics of Performance* (New York and London: Routledge: 1993), Schimmel's *Out of Actions* (*op. cit.*) and Henry M. Sayre's *The Object of Performance: The American Avant-garde since 1987* (Chicago: University of Chicago Press, 1989) for a fuller discussion of performance and the object.

48 See Moira Roth's *The Amazing Decade: Women and Performance Art in America, 1970–1980* (Los Angeles: Astro Artz, 1983). This is a valuable resource of primary material for the explorations of performance art undertaken by feminists throughout the 1970s.

49 Lisa Bloom suggests that feminist art historians have consistently overlooked Antin's Jewishness in discussions of *Carving*. 'Contests for Meaning in Body Politics and Feminist Conceptual Art: Revisioning the 1970s through the work of Eleanor Antin', in Amelia Jones and Andrew Stephenson, ed., *Performing the Body/Performing the Text* (London and New York: Routledge, 1999) 153–69.

50 See my *Unmarked: The Politics of Performance* (*op. cit.*) for a discussion of these transformations and their epistemological and aesthetic consequences. See especially 'Developing the Negative' and 'The Ontology of Performance'.

51 See Amelia Jones, '"Presence" in Absentia: Experiencing Photography as Documentation', *Art Journal*, 56: 4 (Winter 1997) 11–18, for a good discussion of photographic documentation of performances one has not witnessed.

52 Moira Roth, *The Amazing Decade* (*op. cit.*) 14. See Rebecca Schneider for an interesting discussion of Schneemann and Annie Sprinkle (among others), *The Explicit Body in Performance* (New York and London: Routledge, 1997).

53 For good illustrations of the complex relationship between performance and photography see *Photography as Performance: Message through Object and Picture* (London: Photographers' Gallery, 1986) and *Photography & Performance* (Boston: Photography Resource Center, 1989).

54 The slide show is now linked with rock music on a computerized disk. It also exists in book form: Nan Goldin, *The Ballad of Sexual Dependency* (New York: Aperture Foundation, 1986).

55 Joan Riviere, 'Womanliness as a Masquerade', *The International Journal of Psychoanalysis*, 9; 303–13, reprinted in *The Inner World and Joan Riviere: Collected Papers, 1920–1958*, ed. Athol Hughes (London and New York: Karnac Books, 1991) 90–101.

56 For more on Cahun's life and work see *Inverted Odysseys: Claude Cahun, Maya Deren, Cindy Sherman*, ed. Shelley Rice (Cambridge, Massachusetts: MIT Press, 1999).

57 Diana Fuss has taken up this aspect of women's eroticism in her essay 'Fashion and the Homospectatorial Look', *Critical Inquiry*, 18 (Summer 1992) 713–37.

58 Mary Ann Doane, *The Desire to Desire, op. cit.*

59 Joanna Frueh's *Erotic Faculties* (Berkeley: University of California Press, 1996) is one of the most interesting performative and theoretical responses to this work.

60 Adrienne Rich, *Of Woman Born: Motherhood as an Experience and Institution* (New York: Bantam Books, 1976) 292.

61 Audre Lorde, 'Uses of the Erotic: The Erotic as Power' in *The Audre Lorde Companion: Essays, Speeches, Journals* (New York and London: Harper Collins, 1978) 106–12; quote from 110–11.

62 Norma Broude's essay, 'The Pattern and Decoration Movement', has a nice discussion of the continuities between Minimalism and the Pattern and Decoration Movement. In *The Power of Feminist Art, op. cit.*, 208–25.

63 Mendieta quoted in Jane Blocker, *Where Is Ana Mendieta? Identity, Performance and Exile* (Durham, North Carolina: Duke University Press, 1999) 61. This is a useful history of Mendieta's work and considers carefully the challenge of her death.

64 See Gloria Feman Orenstein, 'Recovering Her Story: Feminist Artists Reclaim the Great Goddess', in Garrard and Broude, *The Power of Feminist Art, op cit.*, 174–89.

65 Susan Griffin, *Women and Nature: The Roaring inside Her* (New York: Harper & Row, 1978).

66 See Michel Foucault, *The Order of Things: An Archaeology of the Human Sciences* (New York: Random House, 1971) for an account of historical transformation in human perception and epistemology.

67 Jennifer Fisher, 'Interperformance: The Live Tableaux of Suzanne Lacy, Janine Antoni and Marina Abramovic', *Art Journal* (Winter 1997) 27–33.

68 Ewa Lajer-Burcharth, 'Antoni's

Difference', *Differences*, 10: 2 (Summer 1998) 129–70.

69 Rebecca Dimling Cochran, 'Catalogue', in *Susan Hiller* (Liverpool: Tate Gallery, 1996) 52.

70 Cathy Caruth, *Unclaimed Experience: Trauma, Narrative, History* (Baltimore: The Johns Hopkins University Press, 1996). See especially the chapter entitled 'Traumatic Awakenings (Freud, Lacan, and the Ethics of Memory)', 91–112.

71 Kristeva, quoted in *Inside the Visible*, *op. cit.*, epigraph.

72 Nochlin's essay originally appeared in a special issue of *Art News*, 69: 9 (January 1971). It included the response of ten contemporary 'great' women artists including Elaine de Kooning, Louise Nevelson, Eleanor Antin and Lynda Benglis. The issue was reprinted in book form as *Art and Sexual Politics: Women's Liberation, Women Artists and Art History*, ed. Thomas Hess and Elizabeth C. Baker (New York: Macmillan, 1971; reprinted 1973). A shortened version of Nochlin's essay was published in *Woman in Sexist Society: Studies in Power and Powerlessness*, ed. Vivian Gornick and Barbara K. Moran (New York: Basic Books: 1971).

73 Thalia Gouma-Peterson and Patricia Matthews, 'The Feminist Critique of Art History', *The Art Bulletin*, 69: 3 (September 1987) 326–57. This is the most even-handed and detailed analysis of the history of the field I've seen. It took until 1987, however, for *The Art Bulletin* to include feminist art history in their annual 'state of the field' reviews. Griselda Pollock takes issue with this summary of the field in the introduction to her *Generations and Geographies in the Visual Arts: Feminist Readings* (London and New York: Routledge, 1996).

74 For Nochlin's own version of the history of this essay and her subsequent readings of it see her essay 'Starting from Scratch', in *The Power of Feminist Art, op cit.*, 130–39.

75 Mary Ann Caws, *Women of Bloomsbury: Virginia, Vanessa and Carrington* (New York and London: Routledge, 1990).

76 Carol Duncan, 'When Greatness Is a Box of Wheaties', *Artforum* (October 1975) 60–64. Reprinted in Duncan, *The Aesthetics of Power: Essays in Critical Art History* (New York and Cambridge: Cambridge University Press, 1993) 121–34.

77 Eleanor Tufts, *Our Hidden Heritage: Five Centuries of Women Artists* (New York: 1974); Hugo Münsterberg, *A History of Women Artists* (1975) and Petersen and Wilson, *Women Artists: Recognition and Reappraisal from the Early Middle Ages to the Twentieth Century* (New York: 1976).

78 Nochlin understands that she, unlike 'them', does have such access. To her great credit, Nochlin spent the next three decades working from within the academy to revise traditional accounts of male artists ranging from Courbet to Warhol, and inspiring generations of younger art historians to pursue feminist inquiries.

79 See Thalia Gouma-Peterson, *Miriam Schapiro: Shaping the Fragments of Art and Life* (New York: Harry N. Abrams, Inc; Lakeland, Florida: Polk Museum of Art, 1999), for an excellent analysis of Schapiro's work, with a welcome emphasis on its relationship to feminist theory.

80 Felman, *op. cit.*, 96.

81 Chicago, *Through the Flower: My Struggle as a Woman Artist* (New York: Anchor Books, 1982) 55.

82 *Ibid.*

83 Judy Chicago and Miriam Schapiro, 'Female Imagery', *Womanspace Journal*, 1 (Summer 1973) 26.

84 *Ibid.*

85 Lippard, 'Eccentric Abstraction', *Art International*, 10:9 (20 November 1966) 28; 34–40.

86 Linda Nochlin, 'Introduction', Ann Sutherland Harris and Linda Nochlin, ed., *Women Artists: 1550–1960* (New York: Alfred A. Knopf; Los Angeles: Los Angeles County Museum of Art, 1977) 67.

87 Barbara Buhler Lynes, 'Georgia O'Keeffe and Feminism: A Problem of Position', in Norma Broude and Mary Garrard, ed. *The Expanding Discourse: Feminism and Art History, op. cit.*, 437–50.

88 See Alice Walker, 'One Child of One's Own', *Ms* (July 1979); reprinted in *In Search of Our Mother's Gardens* (San Diego and New York: Harcourt, Brace, Jovanovitch, 1983) 383–84.

89 The best treatment of *The Dinner Party* is Amelia Jones, ed., *Sexual Politics: Judy Chicago's Dinner Party in Feminist Art History* (Los Angeles: UCLA at the Armand Hammer Museum of Art, 1996). See especially Amelia Jones' essay, 'The Sexual Politics of *The Dinner Party*: A Critical Context', for a careful discussion of all of the issues concerning the Chicago conundrum. On the popularity of the installation see Annette Kubitza, 'Re-reading the Readings of *The Dinner Party* in Europe', 148–76.

90 Parker and Pollock, *Old Mistresses: Women Artists and Ideology* (London: Routledge and Kegan Paul, 1981): 130.

91 Judith Barry and Sandra Flitterman-Lewis, 'Textual Strategies: The Politics of Art-making', *Screen*, 21: 2 (1980) 35–48.

92 *Ibid.*

93 Amelia Jones, ed., *Sexual Politics: Judy Chicago's Dinner Party in Feminist Art History, op.cit.*, Viki

Wylder, *Judy Chicago: Trials and Tribulations* (Florida State University Museum of Fine Arts, 1999); Broude and Garrard, *The Power of Feminist Art*, op. cit.

94 Amelia Jones, *Body Art/Performing the Subject* (Minneapolis: University of Minnesota Press, 1998).

95 Louise Bourgeois, *Destruction of the Father, Reconstruction of the Father: Writings and Interviews: 1923–1997*, edited and with texts by Marie-Laure Bernadac and Hans-Ulrich Obrist (Cambridge, Massachusetts: MIT Press, 1998).

96 Andrej Warminski, *Readings in Interpretation: Holderlin, Hegel, Heidegger* (Minneapolis: University of Minnesota Press, 1987) liii–liv.

97 See Griselda Pollock, 'Screening the Seventies: Sexuality and Representation in Feminist Practice – a Brechtian perspective', *Vision and Difference: Femininity, Feminism and Histories of Art* (New York and London: Routledge, 1988) 155–199. See also Margaret Iverson, Douglas Crimp, Homi K. Bhabha, *Mary Kelly* (London: Phaidon Press, 1997). Kelly's own writings also usefully illuminate her art. See especially her *Imaging Desire* (Cambridge, Massachusetts: MIT Press, 1996).

98 See Caroline Jones, *Machine in the Studio: Constructing the Post-war American Artist* (Chicago and London: The University of Chicago Press, 1996). See the works by Amelia Jones cited above.

99 Sonia Lins, *Artes* (Belgca: Sroeck Ducaju, 1996). In Portuguese with English translation.

100 Goldin dedicated the catalogue *I'll Be Your Mirror*, compiled for the 1996–97 retrospective of her work at The Whitney Museum of American Art, to her sister, Barbara Holly Goldin.

101 Mira Schor, *Wet: On Painting Feminism and Art Culture* (Durham, North Carolina: Duke University Press, 1997).

102 Walter Benjamin's crucial 1936 essay, 'The Work of Art in the Age of Mechanical Reproduction', is reprinted in his *Illuminations*, ed. Hannah Arendt, trans. Harry Zohn, (New York: Schocken Books, 1968): 217–25. Frederic Jameson's important essay 'The Cultural Logic of Late Capitalism' originally appeared in *New Left Review* (July–August 1984), but has been reprinted in his influential study *Postmodernism, or, The Cultural Logic of Late Capitalism* (Durham, North Carolina: Duke University Press, 1991) 1–54.

103 Laura Cottingham, 'The Feminist Continuum: Art after 1970', in *The Power of Feminist Art, op cit.*, 278.

104 See Orlan, 'Intervention' and Tanya Augsburg, 'Orlan's Performative Transformations of Surgery', both in *The Ends of Performance*, ed. Peggy

Phelan and Jill Lane (New York and London: New York University Press, 1998) 285–327.

105 See especially Kobena Mercer, ed., *Black Film, British Cinema* (London: Institute of Contemporary Arts, 1988); David Morley and Kuan-Hsing Chen, eds., *Stuart Hall: Critical Dialogues in Cultural Studies* (London and New York: Routledge, 1996). Jean Fisher is former editor of the journal *Third Text* and editor of *Global Visions: Towards a New Internationalism in the Visual Arts* (London: Kala Press, 1994) In the US context see Valerie Smith, ed., *Representing Blackness: Issues in Film and Video* (New Brunswick, New Jersey: Rutgers University Press, 1997).

106 Rosalind Krauss, 'Antivision', *October*, 36 (Spring 1986) 147–54.

107 Luce Irigaray, 'This Sex Which Is Not One', first translated by Claudia Reeder in *The New French Feminisms*, ed. Elaine Marks and Isabelle de Courtivron (New York: Schocken Books, 1981) 101. See also Irigaray's book of the same name, trans. by Catherine Porter with Caroline Burke (Ithaca: Cornell University Press, 1985), originally published as *Ce Sexe que n'en est pas un* (Paris: Editions de Minuit, 1977).

108 Kaja Silverman, 'Dis-embodying the Female Voice', in *Re-Vision: Essays in Feminist Film Criticism* (Los Angeles: The American Film Institute, 1984) 131–49.

109 'Up to and Including Our Limits' is a reference to the title of Carolee Schneemann's retrospective at the New Museum of Contemporary Art, New York, 1996: 'Up to and Including Her Limits'.

110 Judith Butler, *Bodies That Matter: On the Discursive Limits of 'Sex'* (New York and London: Routledge, 1993).

111 Jane Gallop, *Thinking through the Body* (New York: Columbia University Press, 1988); Diana Fuss, *Essentially Speaking: Feminism, Nature and Difference* (New York and London: Routledge, 1989). Mira Schor's essay 'The Essentialism Which Is Not One' originally appeared in the journal *differences*. It has been reprinted in *Engaging with Irigaray: Feminist Philosophy and Modern European Thought*, ed. Schor, Carolyn Burke and Margaret Whitford (New York: Columbia University Press, 1994).

112 Nixon, 'The Gnaw and the Lick: Orality in Recent Feminist Art', *October* (1996)

113 Marcia Tucker, *Bad Girls: Grasp Cord and Pull from Wrapper* (New York: New Museum of Contemporary Art; Cambridge, Massachusetts: MIT Press, 1994).

114 *Inside the Visible, op. cit.*

115 *Stopping the Process? Contemporary Views on Art and Exhibitions*, Mika Hannula, ed. (Helsinki: Nordic Insti-

tute for Contemporary Art, 1998).

116 Lisa Bloom, ed., *With Other Eyes: Looking at Race and Gender in Visual Culture* (Minneapolis: University of Minnesota Press, 1999).

117 *October* 71 (Winter 1995).

118 Judith Lewis Herman, *Trauma and Recovery* (New York: Basic Books, 1992); Shoshana Felman and Dori Laub, *Testimony: Crises of Witnessing in Literature, Psychoanalysis and History* (New York and London: Routledge, 1992); Cathy Caruth, ed., *Trauma: Explorations in Memory* (Baltimore: The Johns Hopkins University Press, 1995).

119 Gina Pane, *Partitions: Opere Multimedia 1984–85* (Milan: Mazzotta; Padiglione d'Arte Contemporanea, 1985) 50.

120 John Cage's influence is strong here. Cage's scores for performances are sets of rules that frame the activities and sounds that the musician orchestrates. Performance artists were inspired by these scores to create similar scores for their own pieces.

121 See Barbara Rose, *Magdalena Abakonowicz* (New York: Harry N. Abrams, Inc., 1994).

122 Elaine Scarry, *The Body in Pain: The Making and Unmaking of the World* (New York and Oxford: Oxford University Press, 1986).

123 See my *Mourning Sex: Performing Public Memories* (New York and London: Routledge, 1997) for a fuller discussion of the implications of this for those of us who still believe language can describe pain and must be employed to keep alive ethical and affective responses to it.

124 For a fuller discussion see my 'Joyce Kozloff's Crimes of Passion', *Artforum* (May 1990) 173–77.

125 See the exhibition catalogue *Cecilia Edefalk* (Bern: Kunsthalle; Stockholm: Moderna Museet, 1999).

126 Parveen Adams has written the best account I've read of the risks and rewards of Della Grace's photography. See 'The Three (Dis)Graces' and 'The Bald Truth', both in her *The Emptiness of the Image: Psychoanalysis and Sexual Differences* (London and New York: Routledge, 1996 132–40, 141–59.

127 'On Being a Jenny Saville Painting', from the exhibition catalogue *Jenny Saville: Terrains* (New York: Gagosian Gallery, 1999) 24.

128 Johanna Burton, 'The Primal Seen: Jenny Saville and the Matrix of Materiality', unpublished paper.

129 Linda Nochlin, 'Courbet's *l'origine du monde*: The Origin without an Original', *October*, 37 (Summer 1986) 77–86.

WORK-S

MAGDALENA ABAKANOWICZ
MARINA ABRAMOVIC & ULAY
EIJA-LIISA AHTILA
CHANTAL AKERMAN
LAURIE ANDERSON
ELEANOR ANTIN
JANINE ANTONI
IDA APPLEBROOG
ALICE AYCOCK
ALEX BAG
JUDY BAMBER
JUDITH BARRY
UTE META BAUER
VANESSA BEECROFT
LYNDA BENGLIS
SADIE BENNING
DARA BIRNBAUM
LEE BONTECOU
PAULINE BOTY
LOUISE BOURGEOIS
SONIA BOYCE
GENEVIÈVE CADIEUX
SOPHIE CALLE
HELEN CHADWICK
SARAH CHARLESWORTH
JUDY CHICAGO
ABIGAIL CHILD
LYGIA CLARK
BETSY DAMON
LINDA DEMENT
MARLENE DUMAS
JEANNE DUNNING
CHERYL DUNYE

MARY BETH EDELSON
NICOLE EISENMAN
DIAMELA ELTIT
CATHERINE ELWES
TRACEY EMIN
VALIE EXPORT
KAREN FINLEY
ROSE FINN-KELCEY
ANDREA FRASER
SUSAN FRAZIER, VICKIE
HODGETTS & ROBIN WELTSCH
COCO FUSCO
ANYA GALLACCIO
ROSE GARRARD
NAN GOLDIN
ILONA GRANET
RENÉE GREEN
GUERRILLA GIRLS
LUCY GUNNING
ANN HAMILTON
BARBARA HAMMER
HARMONY HAMMOND
MARGARET HARRISON
MONA HATOUM
LYNN HERSHMAN
EVA HESSE
SUSAN HILLER
LUBAINA HIMID
CHRISTINE & IRENE
HOHENBÜCHLER
JENNY HOLZER
REBECCA HORN
KAY HUNT

JOAN JONAS
TINA KEANE
MARY KELLY
KAREN KNORR
ALISON KNOWLES
SILVIA KOLBOWSKI
JOYCE KOZLOFF
BARBARA KRUGER
SHIGEKO KUBOTA
YAYOI KUSAMA
LESLIE LABOWITZ
SUZANNE LACY
KETTY LA ROCCA
BRENDA LAUREL
LOUISE LAWLER
ZOE LEONARD
SHERRIE LEVINE
MAYA LIN
YVE LOMAX
SARAH LUCAS
ANA MENDIETA
ANNETTE MESSAGER
KATE MILLETT
TRINH T. MINH-HA
MARY MISS
LINDA MONTANO
LAURA MULVEY & PETER
WOLLEN
ALICE NEEL
SHIRIN NESHAT
YOKO ONO
CATHERINE OPIE
ORLAN

THÉRÈSE OULTON
GINA PANE
HOWARDENA PINDELL
ADRIAN PIPER
RONA PONDICK
YVONNE RAINER
AIMEE RANKIN
PAULA REGO
ELAINE REICHEK
CATHERINE RICHARDS
SU RICHARDSON
PIPILOTTI RIST
ULRIKE ROSENBACH
MARTHA ROSLER
BETYE SAAR
NIKI DE SAINT-PHALLE
DORIS SALCEDO
JENNY SAVILLE
MIRIAM SCHAPIRO
CAROLEE SCHNEEMANN
MIRA SCHOR
COLLIER SCHORR
JOAN SEMMEL
CINDY SHERMAN
KATHARINA SIEVERDING
SHAHZIA SIKANDER
LAURIE SIMMONS
LORNA SIMPSON
MONICA SJÖÖ
SYLVIA SLEIGH
JAUNE QUICK-TO-SEE SMITH
KIKI SMITH
JO SPENCE

NANCY SPERO
ANNIE SPRINKLE
JANA STERBAK
RACHEL STRICKLAND
MITRA TABRIZIAN
ROSEMARIE TROCKEL
COSEY FANNI TUTTI & GENESIS
P. ORRIDGE
MIERLE LADERMAN UKELES
VERUSCHKA (VERA LEHNDORFF
& HOLGER TRULZSCH)
VNS MATRIX
KARA WALKER
KATE WALKER
GILLIAN WEARING
CARRIE MAE WEEMS
RACHEL WHITEREAD
FAITH WILDING
HANNAH WILKE
SUE WILLIAMS
MARTHA WILSON
FRANCESCA WOODMAN
MARIE YATES

TOO MUCH

Although largely unrecognized, women artists played a significant role in the new art forms that emerged in the early 1960s. Happenings, Fluxus and performance sought a discursive, interactive relationship between artist and spectator; new conceptual frameworks emerged, informed by gender awareness. Critic and curator Lucy R. Lippard identified an emerging style infused with bodily connotations, in the work of Eva Hesse among others, that she termed 'Eccentric Abstraction'. Women artists began to intervene directly in male-defined social and political spheres, articulating frustration at the injustices of domination. As avant-garde performance artist Carolee Schneemann wrote: 'Our best development grows from works which initially strike us as "too much" … Because my sex and work were harmoniously experienced I could have the audacity, or courage, to show the body as a source of varying emotive power.'

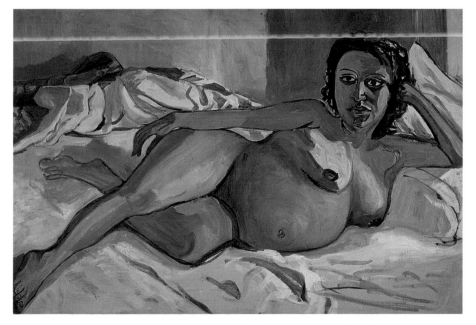

Alice NEEL
Pregnant Maria
1964
Oil on canvas
81.5 × 119.5 cm [32 × 47 in]

Pregnant Maria is one of several portraits Neel produced of pregnant women she knew in New York. Neel's painting draws attention towards unresolved tensions in her subject matter through the creation of a disjuncture in viewers' expectations: the subject is framed within a set of references which are unfamiliar in this context. Here the portrayal of pregnancy is formally and stylistically conflated with the confrontational re-working of an erotic pose frequently found in mass media photography and which can be traced back through the history of Western painting to models such as the female nudes of Titian and Goya.

Born in 1900, Alice Neel had made accomplished figurative work since the 1930s but it was not until ten years after this painting was completed that she had her first museum retrospective at the age of seventy-four.

Lee BONTECOU
Untitled
1961
Welded steel, canvas, wire
204 × 226 × 88 cm [80.25 × 89 × 34.75 in]
Collection, The Museum of Modern Art, New York

Bontecou's sculptural constructions, exhibited from 1960 onwards, were influential precedents for the development of what critic Lucy R. Lippard would later refer to as 'Eccentric Abstraction'. Made of worn-out conveyer belts, aeroplane parts and saws, encased in wire frameworks supporting stretched canvas fragments in sombre shades of rust and grey, Bontecou's reliefs combined seduction and repulsion. Projecting uncomfortably into the viewer's space, the surfaces are punctured with holes, some of which are seductive, suggesting what feminist artists such as Judy Chicago would later describe as 'central core' imagery. Others are barred from view with jagged teeth, suggesting *vagina dentata*. Despite these overtly vaginal allusions and the prominent use of stitching, Bontecou's constructions were described by the majority of contemporary male critics as icons of industrialism, mechanical power, thrust and propulsion.

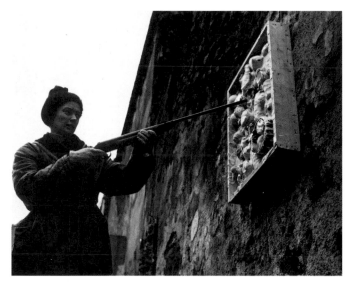

Niki de SAINT-PHALLE
Tir à Volonté (Fire at Will)
1961
Paris

Tir à Volonté (*Fire at Will*) was a series of works de Saint-Phalle made in the early 1960s. She attached bags of liquid pigment onto white relief surfaces. These burst when they were fired at with a .22 calibre rifle by herself or others (including artists Jasper Johns and Robert Rauschenberg). The works were first exhibited at Galerie J, Paris, in 1961.

'The smoke gave the impression of war. The painting was the victim. Who was the painting? Daddy? All men? Small men? Tall men? Big men? Fat men? Men? My brother John? Or was the painting me? … The new bloodbath of red, yellow and blue splattered over the pure white relief metamorphosed the painting into a tabernacle for death and resurrection. I was shooting at myself, society with its injustices. I was shooting at my own violence and the violence of the times. By shooting at my own violence, I no longer had to carry it inside of me like a burden.'
– Niki de Saint-Phalle, Artist's statement, 1961

Nancy SPERO
Female Bomb
1966
Gouache and ink on paper
86.5 × 68.5 cm [34 × 27 in]

Enraged by the Vietnam war, Spero made a series of ink and gouache drawings between 1966 and 1969 which attempted to express war's obscenity. Drawings such as *Female Bomb* and *Sperm Bomb* (made in the same year) highlighted the sexual and scatological metaphors behind the language of modern warfare. In all of these works the machines of war are personified, gendered and sexualized.

'I thought the terminology and slogans like "pacification" were really an obscene use of language. They would firebomb whole villages and then the peasants would be relocated into refugee camps. This was called "Pacification and Re-education". So In [another painting in the series, *S.U.P.E.R.P.A.C.I.F.I.C.A.T.I.O.N.* (1968)] the helicopter has breasts hanging down and people are hanging on with their teeth … '

Despite the strongly gendered nature of Spero's protest, not until the early 1970s did she identify her work explicitly with feminism.
– Nancy Spero, 'Jo Anna Isaak in conversation with Nancy Spero', 1996

left

Pauline BOTY

It's a Man's World I

1963

Oil on canvas, collage

122 × 91 cm [48 × 34 in]

bottom left

Pauline BOTY

It's a Man's World II

1963-65

Oil on canvas

122 × 122 cm [48 × 48 in]

Between 1961 and her premature death at the age of twenty-eight in 1966, Boty constructed an alternative narrative within the male-dominated British Pop art scene. Her works address issues of identification and pleasure which would occupy feminists in the following decades. The first of these two paintings, which constitute a diptych, is composed of figures – from Lenin to Einstein to Elvis – and artefacts drawn from spheres symbolically associated with male power: aviation; classical and neoclassical sculpture and architecture; sport; pop music; literature; politics; science. In these images derived from either high art or mass media photography Jackie Kennedy is the only female presence, the 'exceptional female', portrayed turning to her husband at the fateful Dallas motorcade. These assembled icons of patriarchal culture are juxtaposed with the second painting that presents images which could signify liberated female eroticism. However, their similarity to photos from men's pornographic magazines, their vertical, 'phallic' compositional arrangement, and their superimposition onto an eighteenth-century landscape park, seem to confirm that the women's bodies are regulated by the normative culture of masculine privilege and authority represented in the first painting. The 'permissiveness' of the swinging 1960s scene, in which Boty was a fashionable figure, offered the promise that bodily pleasure could be liberating. These paintings are a critical portrayal of the spaces of male power which continued to ensure that this promise was denied.

Niki de SAINT-PHALLE (with Jean TINGUELY and Per-Olof ULTVEDT)
Hon
1966
Wood, papier mâché, paint, found and fabricated objects
600 × 2350 × 1000 cm [236 × 925 × 394 in]

Hon, meaning 'She' in Swedish, was constructed as a temporary monument at the Moderna Museet, Stockholm, 1966, in collaboration with Jean Tinguely and Per-Olof Ultvedt. Visitors entered the gigantic, vividly multicoloured female figure through the space between her legs, finding themselves inside a warm, dark 'body' that contained among other features a bar, a love nest, a planetarium, a gallery of 'suspect' artworks, a cinema and an aquarium. *Hon*, which evolved from the artist's earlier small-scale figurines called *Nanas*, playfully paid homage to ancient and modern mythical archetypes of woman as nurturer, while simultaneously demythologizing notions of the female body as a place of dark, unknowable mysteries.

Paula REGO
The Punishment Room
1969
Acrylic and mixed media on canvas
120 × 120 cm [47.5 × 47.5 in]

The Punishment Room traces memories of Rego's Catholic childhood in Portugal. Fragmented, brightly coloured images suggesting innocent girlish pleasures are juxtaposed with large, foreboding male figures. This early work by the British-based figurative painter was influenced by *art brut*. Using quick drying, vividly coloured acrylics, the work is executed in a style reminiscent of childrens' doodling and comic-book illustration. Rego viewed the constraints of the fine art tradition as a kind of 'punishment room'. Her discovery from 1959 onwards of the work of Dubuffet and his contemporaries freed her from these strictures, enabling her to challenge the taboos associated with non 'high art' material and representation.

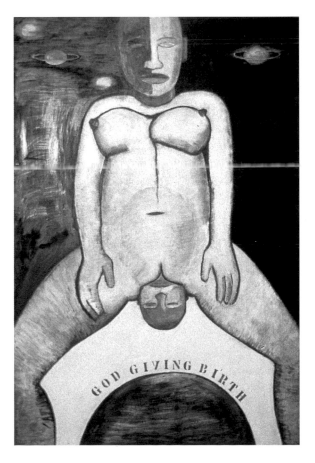

Monica SJÖÖ
God Giving Birth
1968
Oil on hardboard
183 × 122 cm [72 × 48 in]
Collection, Museum Anna Nordlander, Skelleftea, Sweden

A self-taught artist and activist in the British Women's Liberation Movement, Swedish-born Sjöö rejected abstraction for figuration after the experience of giving birth to her first child. She researched matriarchal cultures and ancient womancentred religions founded upon worship of goddess figures and mysteries based on the lunar cycles. Paintings such as *God Giving Birth* were intended as empowering images for women, which challenged the oppressively patriarchal nature of Christian and secular Western iconography. In 1973 the work was shown in London in the group exhibition organized by Sjöö, Ann Berg, Beverley Skinner and Liz Moore, ''Five Women Artists: Images of Womanpower'. It aroused such controversy that public complaints led to a police report being sent to the Director of Public Prosecutions; Sjöö was threatened with legal action on charges of blasphemy and obscenity.

Judy CHICAGO
Pasadena Lifesavers, Yellow No. 4
1969-70
Acrylic lacquer on acrylic sheet,
Plexiglas
152.5 × 152.5 cm [60 × 60 in]

'*Pasadena Lifesavers* ... embodied all of the work I had been doing in the past year, reflecting the range of my own sexuality and identity, as symbolized through form and colour, albeit in a neutralized format. There were fifteen paintings, sprayed on the back of clear acrylic sheets, then framed with a sheet of white Plexiglas behind the clear sheet. The series consisted of five images, painted in three different colour series ... I had internalized parts of society's dictum that women should not be aggressive, and when I expressed that aspect of myself through forms that were quite assertive, I became frightened and thought there was "something wrong with my paintings" ... As I recovered from my feelings of shame for having revealed something that was so different from the prevailing concepts of "femininity", I gradually accepted the paintings, and in doing so, also accepted myself more fully ... '
– Judy Chicago, *Through the Flower: My Struggles as a Woman Artist*, 1975

Miriam SCHAPIRO
Sixteen Windows
1965
Acrylic on canvas
183 × 203 cm [72 × 80 in]

Sixteen Windows is a transitional work that led Schapiro towards feminism. In the late 1950s she began her career as a painter of hard-edge, geometric compositions which referenced architectural forms. In the mid 1960s Schapiro began to recognize that although these compositions reflected a specific 'masculine' tradition, they were also strongly connected with women's experience of domestic architectural environments. In 1967 Schapiro took up a teaching post at the University of California, San Diego, encountering Judy Chicago, with whom she would initiate the Feminist Art Program at California Institute of the Arts in 1971. *Womanhouse* (Institute of the Arts, Valencia, California, 1972), initiated by Schapiro and Chicago in collaboration with other artists, was a house transformed into a series of installations and sites for shared experiences and exchanges. *Dollhouse* (1972), a miniature installation, further explored domestic architectural space as a site of political transformation.

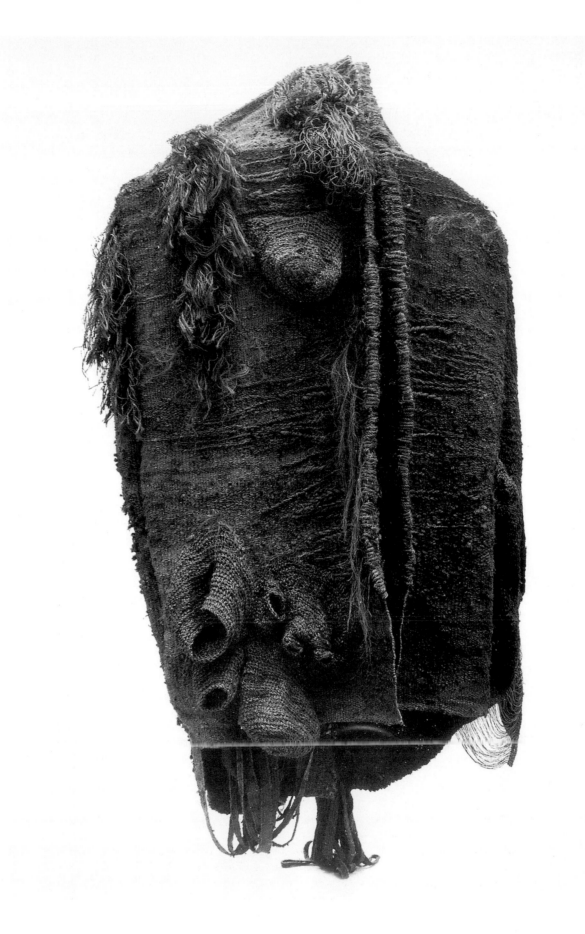

Magdalena ABAKANOWICZ
Black Garment
1969
Sisal
300 × 180 × 60 cm [118 × 71
× 23.5 in]
Collection, Stedelijk Museum,
Amsterdam

Born in Poland in 1930, Abakanowicz
began working as an artist in Warsaw
in the late 1950s. In the aftermath of
Poland's wartime devastation and
transformation, she decided that her
own art had to represent a total break
with the recent past. This included
abandoning the materials from which
this recent past was fabricated.
Abakanowicz thereby attempted to
re-connect human experience with
conditions that existed before the
alienation and brutality of the industrial
age. By the mid 1960s, she had begun
to work exclusively with natural fibres,
such as sisal. She began to make woven
room-sized structures which a Polish
critic in 1965 referred to as *Abakans*, a
name the artist adopted for these works
from then onwards. In contrast to the
often industrially fabricated and
immediately manifest works of
Minimalism, the *Abakans* revealed
themselves slowly, inviting touch and
exploration, presenting visual and tactile
contrasts to be reconciled in the mind of
the viewer. 'The fibre which I use in my
works derives from plants and is similar
to that from which we ourselves are
composed ... Our heart is surrounded by
the coronary plexus, the most vital of
threads ... Handling fibre we handle
mystery. A dry leaf has a network
reminiscent of a mummy ... When the
biology of our body breaks down, the
skin has to be cut so as to give access to
the inside. Later it has to be sewn on like
fabric. Fabric is our covering and our
attire. Made with our hands, it is a record
of our thoughts.'
— Magdalena Abakanowicz quoted by
Barbara Rose, *Magdalena Abakanowicz*,
1994

Eva HESSE

Contingent

1969

Cheesecloth, latex, fibreglass

8 units, dimensions variable

Collection, National Gallery of Australia, Canberra

Contingent comprises eight sheets of rubberized cheesecloth and fibreglass which vary in proportion and texture. These undulating, light-catching surfaces are hung from threads attached to hooks in the ceiling and reach down to the floor. Markedly different yet still related to the grids and rectangles of Minimalism, such works set up a form of interference, highlighting both the formalism of Minimal art's ordering structures and its arbitrary, obsessive undercurrents. *Contingent* avoids the evocation of specific bodily connotations, yet as critic Lucy R. Lippard observed, Hesse's works convey a sense of identification between the maker's or viewer's body and abstract or figurative forms.

Louise <u>BOURGEOIS</u>
Femme Couteau
1969-70
Pink marble
9 × 67 × 12.5 cm [3.5 × 26 × 5 in]

In the late 1960s Bourgeois moved away from predominantly vertical, totemic figures in wood, patinated bronze or plaster, to the horizontal. Using new materials such as marble to create smooth, sensuous forms reminiscent of Surrealist objects, she explored formal and symbolic relationships of tension and mutability between the poles of 'masculine' and 'feminine' imagery.

Louise <u>BOURGEOIS</u>
Cumul I
1969
White marble
57 × 127 × 122 cm [22.5 × 50 × 48 in]
Collection, Centre Georges Pompidou, Paris

During a flight over the Sahara desert Bourgeois had seen small dwellings clustered around the scarce sources of water. This experience is one of the sources of imagery for the *Cumul* series. These works combine the suggestion of water-bearing cumulus clouds, in their overall white, nebulous forms, with emerging protrusions which suggest simultaneously phallus and breast associations.

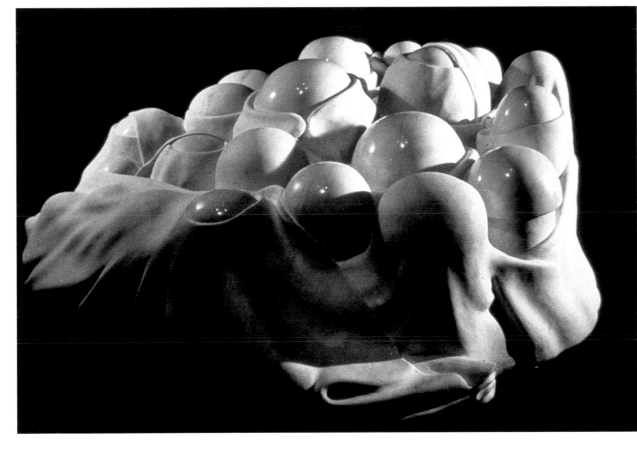

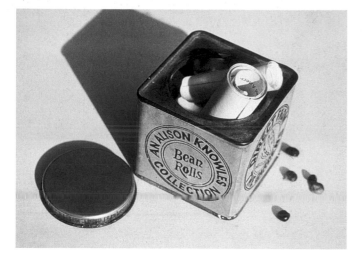

Alison KNOWLES
Bean Rolls: A Canned Book
1963
Metal can, beans, paper rolls, text
Dimensions variable

'Using the Alison Knowles *Bean Rolls* and six to eight performers, unroll the rolls over the audience and start reading aloud. Have the audience join in. A single performer goes among the other performers with scissors, cutting out large sections of the rolls. This performer determines the length of the performance.'
– Alison Knowles, 'Simultaneous Bean Reading', 1964

 Alison Knowles was closely involved in the Fluxus movement in New York from its inception, introducing a female perspective into the movement's aims of blurring of the boundaries between art and everyday action.

'Alison Knowles is quite aware at this point that only a woman would have made a public salad in 1962, and that only a woman would be so identified with another food – beans, of all kinds, which have figured in so much of her work … [George] Brecht and Robert Watts … had organized a Fluxus-type event called the Yam Festival … I only remember being served a salad, the product of a performance called *Proposition*, with its instruction "Make a salad", by Alison Knowles … On stage she had huge quantities of salad materials, which she mixed in a big pickle barrel and served on paper plates … Knowles has also made a number of word scores involving shoes … a tall woman with outsized feet [she] says her obsession with shoes dated from a remark from a shoe salesman when she was fifteen. He said, "After size nine, a woman buying shoes in our society can't afford to be fussy."'
– Jill Johnston,' Flux Acts', *Art in America*, 1994

Yoko ONO
Cut Piece
1964
Yamaichi Concert Hall, Kyoto

In this performance Ono sat on the stage and invited the audience to approach her and cut away her clothing, so that it gradually fell away from her body. Challenging the neutrality of the relationship between viewer and art object, Ono presented a situation in which the viewer was implicated in the potentially aggressive act of unveiling the female body, which had served historically as one such 'neutral' and anonymous subject for art. Emphasizing the reciprocal way in which viewers and subjects become objects for each other, *Cut Piece* also demonstrated how viewing without responsibility has the potential to harm or even destroy the object of perception.

'People went on cutting the parts they do not like of me. Finally there was only the stone remained of me that was in me but they were still not satisfied and wanted to know what it's like in the stone.'
– Yoko Ono, Artist's statement, 1971

Cut Piece was also performed at the 'Destruction in Art' Symposium at the Institute of Contemporary Arts, London, in 1966

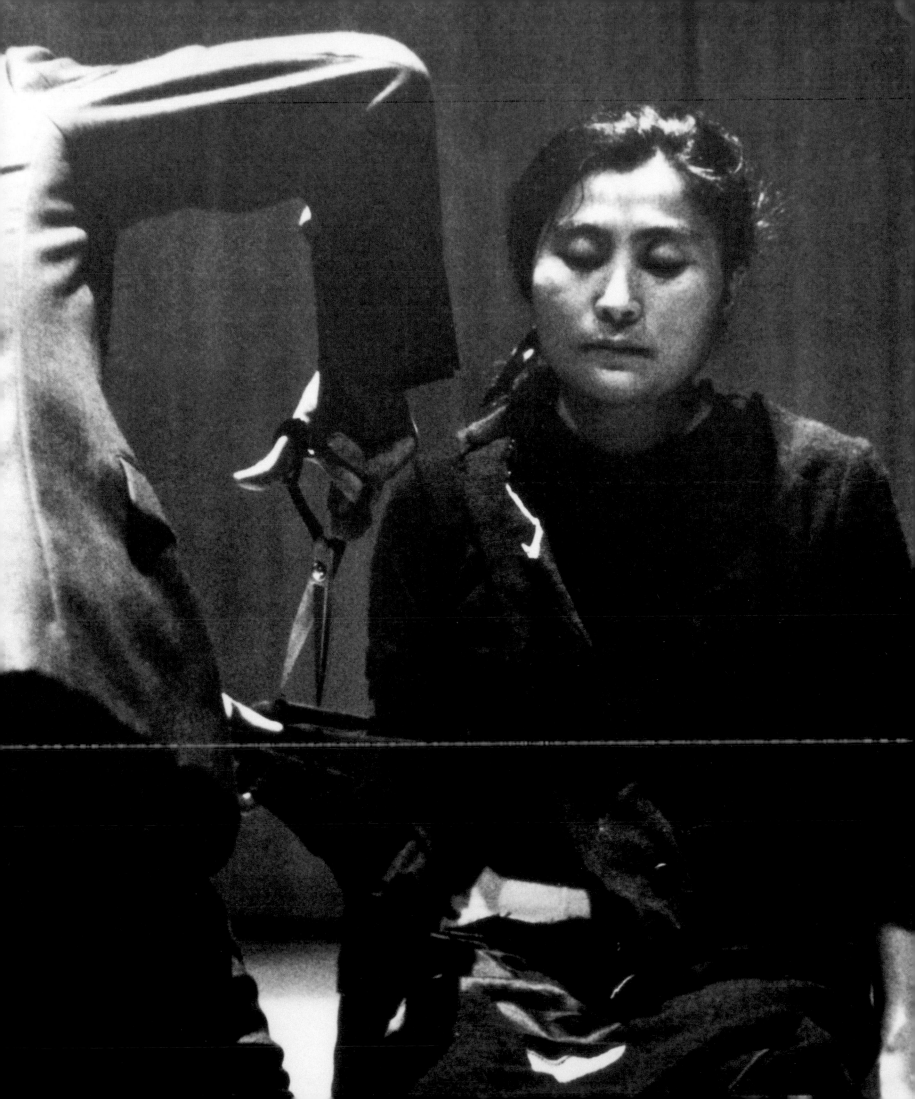

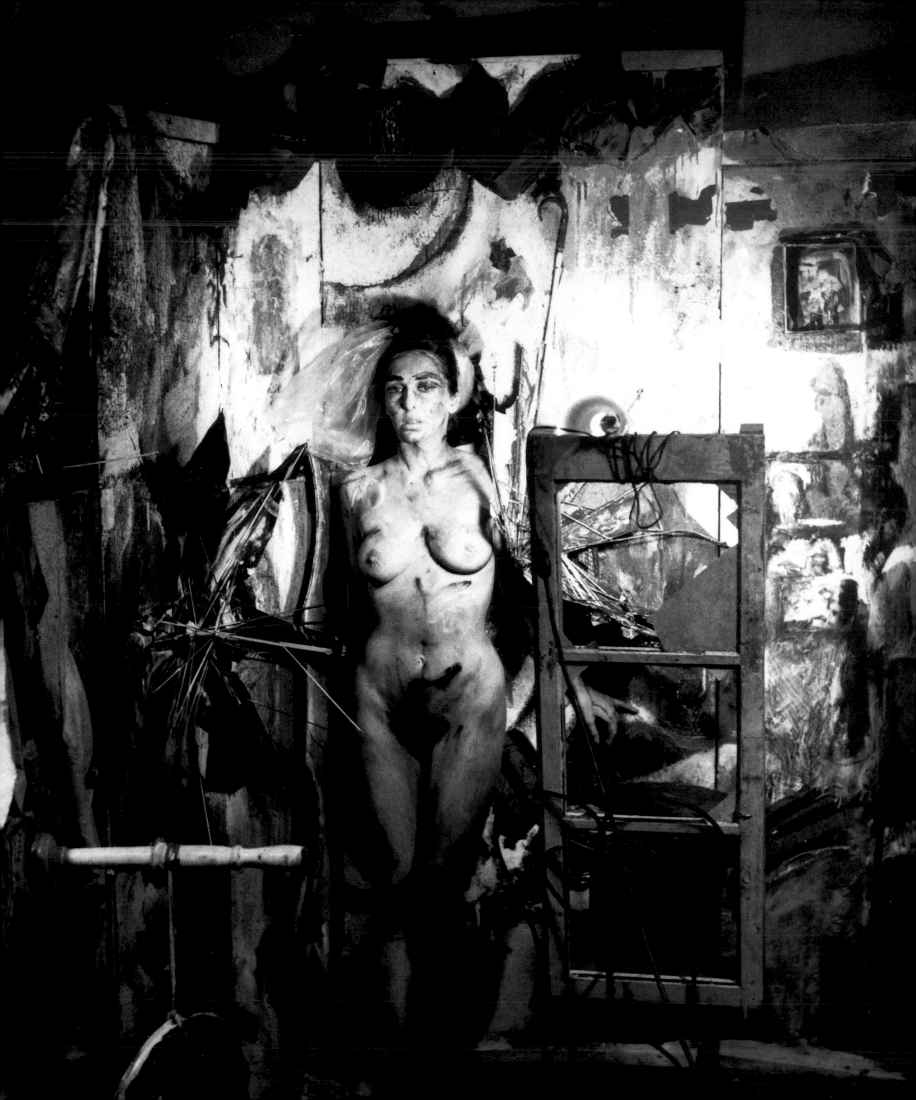

Carolee <u>SCHNEEMANN</u>
Eye Body: 36 Transformative Actions
1963
New York

'In 1962 I began a loft environment built of large panels interlocked by rhythmic
colour units, broken mirrors and glass, lights, moving umbrellas and motorized parts.
I worked with my whole body – the scale of the panels incorporating my own physical
scale. I then decided I wanted my actual body to be combined with the work as an
integral material ... '
Schneemann's self-transformations within this environment were recorded by her
friend, the Icelandic artist Erró.
'Covered in paint, grease, chalk, ropes, plastic, I establish my body as visual territory.
Not only am I an image-maker, but I explore the image values of flesh as material
I choose to work with. The body may remain erotic, sexual, desired, desiring, but it is
as well votive: marked, written over in a text of stroke and gesture discovered by my
female creative will. I write "my female creative will" because for years my most
audacious works were viewed as if someone else inhabiting me had created them –
they were considered "masculine" when seen as aggressive, bold. As if I were
inhabited by a stray male principle; which would be an interesting possibility – except
in the early 1960s this notion was used to blot out, denigrate, deflect the coherence,
necessity and personal integrity of what I made and how it was made.'
– Carolee Schneemann, *More Than Meat Joy*, 1979

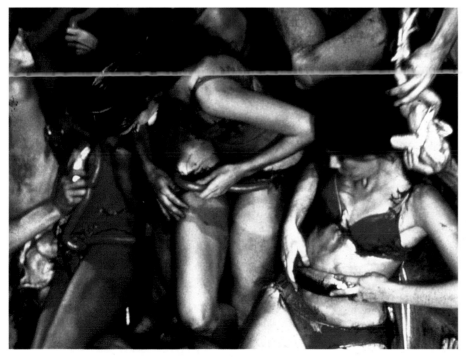

Carolee <u>SCHNEEMANN</u>
Meat Joy
1964
Paris

'*Meat Joy* has the character of an erotic rite: excessive, indulgent, a celebration of
flesh as material: raw fish, chickens, sausages, wet paint, transparent plastic, rope,
brushes, paper scrap. Its propulsion is toward the ecstatic – shifting and turning
between tenderness, wildness, precision, abandon: qualities which could at any
moment be sensual, comic, joyous, repellent. Physical equivalences are enacted as
a psychic and imagistic stream in which the layered elements mesh and gain intensity
by the energy complement of the audience.'
– Carolee Schneemann, *More Than Meat Joy*, 1979
Meat Joy was an orgiastic Happening in which male and female performers grappled
with one another and a variety of fleshy, messy materials in close proximity to the
audience. It was first performed in Paris in an event called 'Expression' organized by
the artist and critic Jean-Jacques Lebel and subsequently presented in London and
New York. The Happening was a series of improvised gestures and relationships
which had been loosely planned and rehearsed. The participants were expected to
develop these ideas during the performance. Schneemann composed a soundtrack
of Paris street sounds – traffic noise and the cries of food vendors – superimposed on
Motown tunes. Light and sound technicians were also expected to improvise to a large
extent, following the energy shifts of the performers and the audience.

Valie EXPORT (with Peter WEIBEL)
Tapp und Tastkino (Touch Cinema)
1968
Vienna

In 1968, Export collaborated with Actionist Peter Weibel on a series of guerrilla street actions. *Tapp und Tastkino (Touch Cinema)* documents Export's street appearance wearing a miniature stage set constructed around her naked but concealed breasts. Using a megaphone, Weibel encouraged members of the public to step up, reach through the stage curtain and touch her breasts.

'In that I, in the language of film, allowed my "body screen", my chest, to be touched by everybody, I broke through the confines of socially legitimate social communication. My chest was withdrawn from the "society of spectacle" which had drawn the woman into "objectification" with it. Moreover, the breast is no longer the property of one single man; rather, the woman attempts through the free availability of her body to determine her identity independently: the first step from object to subject.'
– Valie Export quoted in Peter Nesweda, 'In Her Own Image: Valie Export, Artist and Feminist', *Arts Magazine*, 1991

Yvonne RAINER
Trio A
1966
Portland Center for the Visual Arts, 1973

Rainer's most celebrated piece of choreography, *Trio A* was first performed in 1966 as part of a larger work entitled *The Mind Is a Muscle, Part 1*, a collaboration with other experimental dancers and choreographers such as Steve Paxton. The first version was performed at Judson Church in Greenwich Village, the New York theatre space central to the development of new practices in 'movement theatre', where artists such as Carolee Schneemann and Robert Morris also performed. In *Trio A*, Rainer designed a series of movements which were not based on formally delineated phrases and which disrupted the rhythms between climax and rest. Conceived with the intention that it could be performed by someone with no previous dance training, the piece extended the boundaries of previous improvised dance derived from ballet, and focused on everyday movements, often related to the performance of tasks. The piece also attempted to undermine what Rainer perceived as the polarized narcissism and voyeurism central to the spectacle of dance: 'the "problem" of performance was dealt with by never permitting the performers to confront the audience. Either the gaze was averted or the head was engaged in movement.'
– Yvonne Rainer, 'The Mind Is a Muscle', 1999

Shigeko <u>KUBOTA</u>
Vagina Painting
1965
'Perpetual Fluxfest', New York

At the 'Perpetual Fluxfest', a Fluxus movement public festival in New York in 1965,
Kubota made an 'action' painting, disliked at the time by many of her male fellow
artists, which referred to and subverted Jackson Pollock's method of making drip
paintings on the floor of his studio. Kubota laid a large sheet of paper on the floor
and proceeded to paint red strokes on it with a brush attached to the crotch of her
underwear. This created a deliberately 'feminine' process of gestural painting, flowing
from the creative core of the female body, in contrast to the 'ejaculation' of thrown,
dripped and scattered paint. Kubota was also parodying Yves Klein's use of naked
women as 'human paintbrushes' in his Happenings of the late 1950s and early 1960s.
Using her vagina as a source of inscription, Kubota questioned the Western cultural
designation of female genitalia, interpreted by Freud as a site of 'lack' (of the phallus),
and the notion that this 'lack' denies access to valid expression through language,
visual signs and gestures.

Yayoi <u>KUSAMA</u>
Kusama's Peep Show or Endless Love Show
1966
Mirrors, coloured lights
210 × 240 × 205 cm [83 × 94.5 × 81 in]
Installation, Castellane Gallery, New York

This and other installation environments Kusama created from 1963 onwards combined her obsessive drive to gain control over her hallucinations of infinitely repeating patterns with an astute critical awareness of developments in current art movements. This work in particular represented a new departure; accompanied by a pop music soundtrack, it fused the aesthetics of Pop, experimental and kinetic art with the gaudy flashing lights and mirrors of a peep show or disco floor. The work was also participatory. Invited to peer through a peep hole on the outside of the plain hexagonal box structure, suddenly the viewer would be immersed within a startling, incandescent environment, seemingly repeated into infinity, thus sharing in the artist's own visionary perception. From this date onwards Kusama began to organize participatory performance events. Often involving naked body painting sessions, these actions included protests against the war in Vietnam and in favour of freedom of bodily and sexual expression. An art practice that had originally arisen for personal therapeutic reasons was transformed by the artist into public, politicized gestures of revolution.

Lygia <u>CLARK</u>
Estruturas Vivas (Living
Structures)
1969
Paris

A web of elastic bands was connected at its ends to one of the feet of four people lying down, and to the hands of four people standing. The disposition of the people in space followed the design of the web. The ordering of the group's movements formed a structure experienced through its component gestures. In the 1960s Clark, a leading member of the Brazilian Neo-Concrete movement, began to explore the possibilities of art that was invitational and participatory. In 1966 she abandoned metal constructivist forms and began to use both natural and domestic 'relational objects', in works that invited 'sensorial' experiences of relation to the world through the body. From 1969 to 1976 Clark lived and taught in Paris, conducting experiments in gestural communication with groups of up to sixty students. On her return to Rio de Janeiro in 1976, precipitated by illness, she evolved a form of therapy for individuals based on her experimental art practice which continued until her death in 1988.

PERSONALIZING THE POLITICAL

By the early 1970s feminism had engendered a recognized art movement. Throughout Europe and the United States feminists came together to organize women-only exhibitions and formed groups dedicated to consciousness-raising, activism and research. The first Women's Liberation Movement group exhibition was held in London; The Ad Hoc Women Artists' Committee was established in New York; Judy Chicago led women-only studio classes at Fresno State University and with Miriam Schapiro instigated the Feminist Art Program at the California Institute for the Arts; Faith Ringgold and Michele Wallace initiated the activist group Women, Students and Artists for Black Art Liberation. Womanhouse, a collective project that emerged from the Feminist Art Program, became a catalyst for the creation of radical, women-only communities where personal histories could be shared and social change engendered. Private, everyday actions and objects, including artists' own bodies, became both the subject and often the medium itself of women's art. Artists depicted men in poses stereotyped as 'feminine', or traced suppressed elements in culture through investigation of matriarchal archetypes, the unconscious and the prelingual.

Margaret HARRISON
The Little Woman at Home
1971
Graphite and watercolour on paper
63.5 × 52 cm [25 × 20.5 in]

Harrison participated in the first Women's Liberation Movement group exhibition at the Woodstock Gallery, London, in 1971. In the same year her show of drawings at Motif Editions Gallery was London's first overtly feminist solo exhibition. In these works, stereotypical imagery of women was depicted with ironic humour, and sometimes transposed onto male subjects. The exhibition was closed by police after only one day due to complaints about defamatory material, in particular a depiction of *Playboy* magazine's founder and editor, Hugh Heffner, as a male 'bunny girl', complete with a 'bunny penis'. The title *The Little Woman at Home* highlights lack of support in the art world for artists such as Harrison, whose work engaged directly with social issues. These satirical drawings freed her from the constraints of prevalent styles which were deemed suitable for feminist subject matter. Harrison viewed the growing feminist hostility to painting as a new form of conservatism, denying the possibility of subject matter opening up form.

Joan <u>SEMMEL</u>
Intimacy Autonomy
1974
Oil on canvas
127 × 249 cm [50 × 98 in]

'A few years ago, several of us got together to "split" a model, only in this case, there were two models, a man and a woman who were involved with each other, so they posed like lovers. That got me into dealing with the subject in an open way. Then other things began to enter, including my identification with feminism. Women have never allowed themselves to admit their sexual fantasies. They have been encouraged to create themselves in terms of male fantasy. I wanted to make imagery that would respond to female feelings. My paintings deal with communication, how a hand touches a body, rather than male or female domination. Women are conditioned to play a masochistic role. But I want to show sensuality with the power factor eliminated. The images are handled in an objective, cool way, with non-realistic space, with a sense of being removed from the world. But there is feeling in the gestures, passion in the colour. Ultimately, the play and relationship of colour is what my painting is about. I'm using sex to hang my art on.'
– Joan Semmel, 'Sex to Hang Art On', 1974

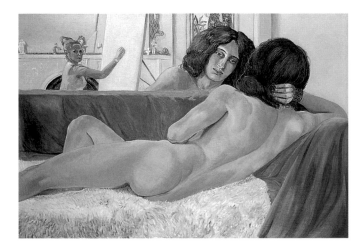

Sylvia <u>SLEIGH</u>
Philip Golub Reclining
1971
Oil on canvas
107 × 152.5 cm [42 × 60 in]

In this and other paintings of the same period Sleigh attempted to reverse the historical pictorial hierarchy of male artist and female model in Western art. In doing so she drew attention to some of the problems involved in this reversal. The subject's langorous pose, long hair, fine features and apparent narcissism appear conventionally 'feminine': like the female subject of the traditional male gaze, he appears to present himself as an object of vision. However, Sleigh introduces a deliberate awkwardness into the style and composition of the work, highlighting the forced, uncomfortable nature of a relationship that is still in transition.

Nancy SPERO

Codex Artaud I (detail)

1971

Typescript, gouache and collage on paper

56 × 218 cm [22 × 86 in]

At the end of the 1960s Spero painted a series of gouaches dedicated to the French writer associated with Surrealism, Antonin Artaud. In the *Codex Artaud* series that followed these paintings, Spero worked with collage on non-uniform panels and friezes, using whatever kind of paper was immediately available. This marked a further departure in her work from the heroic, monumental associations of scale and material that prevailed in US art at the time. Typescript sections of texts by or referring to Artaud were placed in relation to images of fragmented human and animal figures, words and letter forms from different cultures. The work explores the extremes and limitations of language, alongside the dissolving and re-combining of cultural and corporeal connections. Artaud's mental disturbance, and his incarceration in a mental institution, were closely linked with his attempts to be liberated from both linguistic and bodily constraints, which he saw as intimately connected. His writing has been discussed by theorist Julia Kristeva in relation to feminist discourse, as expressing the pain and rage of those who are marginalized, outside of the dominant forms of language. Amidst the ambiguous fusion of representational symbols in *Codex Artaud*, women's tongues appear to swell into phallic forms, evoking the patriarchal basis of the symbolic order of language, and the continuing alterity of women's voices.

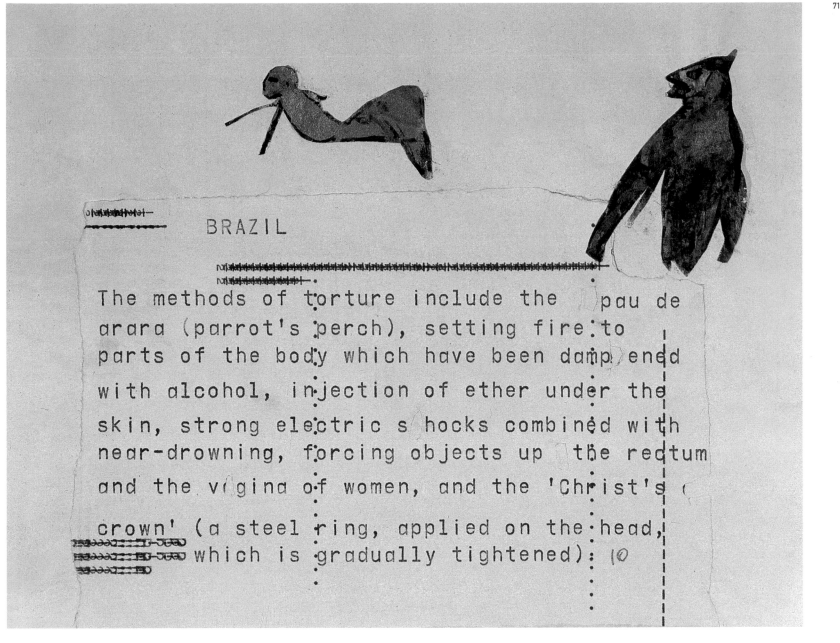

BRAZIL

The methods of torture include the pau de arara (parrot's perch), setting fire to parts of the body which have been dampened with alcohol, injection of ether under the skin, strong electric shocks combined with near-drowning, forcing objects up the rectum and the vagina of women, and the 'Christ's crown' (a steel ring, applied on the head, which is gradually tightened). ⑩

Nancy SPERO
Torture of Women (detail, panel 7)
1976
Typescript, gouache, handprinting and collage on paper
14 panels, 51 × 3810 cm [20 × 1500 in] overall
Collection, National Gallery of Art, Ottawa

'In 1972 I had had enough of Artaud. I thought there is real pain and torture going on … His pain is real, but it is the expression of an internal state … I decided to address the issues I was directly involved in – women's issues. I wanted to investigate the more palpable realities of torture and pain.'
– Nancy Spero, Artist's statement, 1996

Torture of Women, which occupied Spero for the next three years, was her first explicitly feminist work and followed her active involvement in groups such as WAR (Women Artists in Revolution) and the founding of AIR (Artists-in-Residence), the first women's gallery in New York, in 1972. Handprinted enlarged text fragments as well as typewritten reports from Amnesty International on the torture of women in totalitarian regimes were collaged alongside imaginary and mythological figures, which Spero had begun to handprint from 1974. Images based on ancient Egyptian goddess figures, among other sources, were juxtaposed with those of contemporary women freedom fighters and anonymous victims of violence.

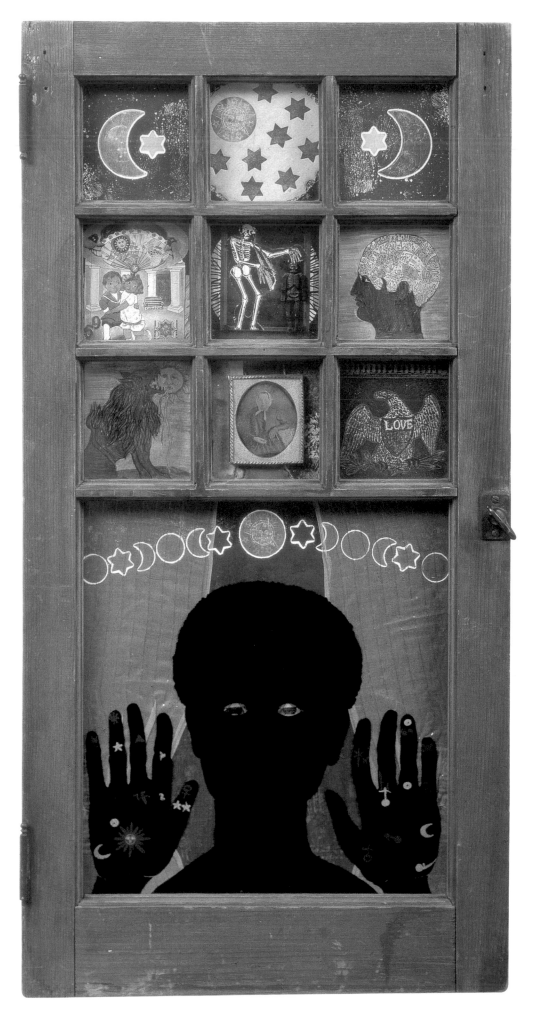

Betye SAAR
Black Girl's Window
1969
Found objects, wood, paint
91 × 46 × 4 cm [36 × 18 × 1.5 in]

'I knew it was autobiographical …
there's a black figure pressing its face
against the glass, like a shadow. And two
hands that represent my own fate. On the
top are nine little boxes in rows of three
marked by the crescent, the star and
the sun. But look what's at the centre,
a skeleton. Death is in the centre.
Everything revolves around death. In the
bottom is a tintype of a woman. It's no
one I know, just something I found. But
she's white. My mother's mother was
white, Irish, and very beautiful. I have a
photograph of her in a hat covered with
roses. And there's the same mix on my
father's side. I feel that duality, the black
and the white.'
– Betye Saar, Artist's statement, 1984

Saar first explored autobiography in
Black Girl's Window. In this work Saar
adds a further dimension to her previous
use of assemblage; it becomes a ritual
process. Symbols derived from occult
sources suggest that the trapped figure
needs to connect with the spiritual in
order to escape from her confines.

Saar began making assemblage
works in the late 1960s. She used
assemblage not only because it
challenged fine art categories in its use
of found and recycled materials but
because it enabled her to work with
concentrated layers of symbolism.

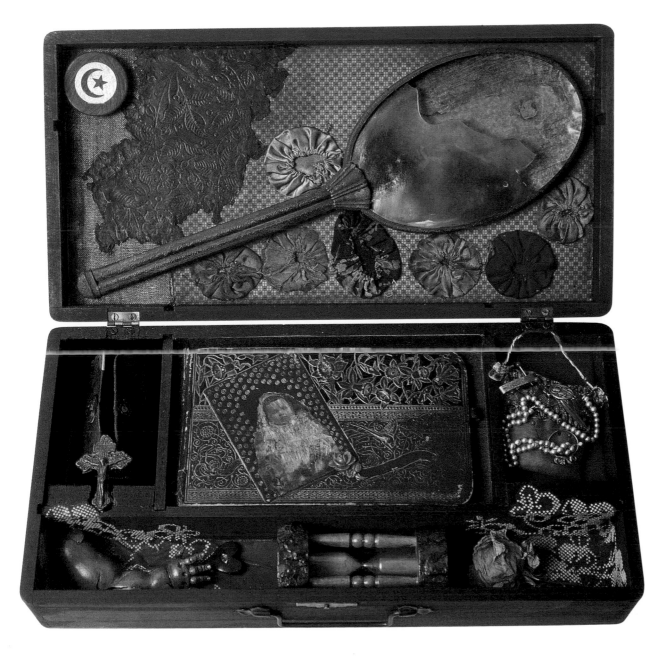

Betye SAAR
Record for Hattie
1974
Found objects, wood, paint
34 × 55.5 × 5 cm [13.5 × 22
× 2 in]

Record for Hattie was made as a
memorial to Saar's aunt; assembling
her personal posessions, the work
evokes reveries and reflections upon
her womanhood. Saar began
incorporating her assemblage works in
boxes in the 1970s, influenced in part by
Joseph Cornell, whose work she had
first encountered in Pasadena in 1968.
Modernist movements such as
Surrealism, which forms the
background to Cornell's work, were
strongly influenced by African art and
aesthetics, but mainly in terms of their
European notion of 'the primitive' as an
anti-rational, reverse mirror of Western
values. The objects collected together
in Saar's works, while familiar, also
appear enigmatic and suggestive of
ritual and spirituality. However, rather
than exoticizing cultural artefacts,
Saar presents them, from her African-
American perspective, as a repository
of memories, evidence of the collective
social and spiritual values of people of
African descent.

left, Joyce <u>KOZLOFF</u>
Zenmour
1975
Acrylic on canvas
198 × 122 cm [78 × 48 in]

In the early 1970s Kozloff, along with Miriam Schapiro and students at California Institute for the Arts, began researching vernacular traditions of art making by women across a wide range of cultures, as appropriate forms to adopt in the creation of new feminist art. Collectively, this tendency became known as the Pattern and Decoration Movement. Its first exhibition, 'Ten Approaches to the Decorative', was held in New York in 1976. The artists' formalized use of patterns derived from ceramic, weaving and other traditional arts and crafts critiqued the 'purity' of geometric abstraction, and the pejorative, often gender-based use of the term 'decorative'. Kozloff researched and travelled extensively to locate the source material for her paintings, such as *Zenmour*, that shift the specific historical and cultural meanings of the original forms through re-situating them as painting in a contemporary context. In many of Kozloff's works, two different decorative systems are set in opposition; the superimposition of colours and patterns leads to shifts in the sense of pictorial space. Her work is both celebratory and refutational:
'*Negating the Negative*

anti-pure, anti-purist, anti-puritanical, anti-minimalist, anti-post-minimalist, anti-reductivist, anti-formalist … anti-universal, anti-internationalist, anti-imperialist, anti-bauhausist, anti-dominant, anti-authoritarian … anti-logic, anti-conceptual, anti-male-dominated, anti-virile, anti-tough, anti-cool, anti-cruel … anti-controlled, anti-controlling, anti-arrogant, anti-sublime, anti-grandiose, anti-pedantic, anti-patriarchal, anti-heroic, anti-genius, anti-master
On Affirmation

fussy, funny, funky, perverse, mannerist, tribal, rococo, tactile, self-referring, sumptuous, sensuous, salacious, eclectic, exotic, messy, monstrous, complex, ornamented … '
– Joyce Kozloff, 'Negating the Negative', 1976

opposite, Miriam <u>SCHAPIRO</u>
Connection
1976
Collage, acrylic on canvas
183 × 183 cm [72 × 72 in]

Schapiro combined acrylic painting with patchwork-like fabric collage to construct large-scale works such as *Connection*. She and her fellow collaborators, who included students at California Institute of the Arts, defined these as *femmage*:
'We feel that several criteria determine whether a work can be called *femmage*. Not all of them appear in a single object. However, the presence of at least half of them should allow the work to be appreciated as *femmage*. 1. It is a work by a woman. 2. The activities of saving and collecting are important ingredients. 3. Scraps are essential to the process and are recycled in the work. 4. The theme has a woman-life context. 5. The work has elements of covert imagery. 6. The theme of the work addresses itself to an audience of intimates. 7. It celebrates a private or a public event. 8. A diarist's point of view is reflected in the work. 9. There is drawing and/or handwriting sewn in the work. 10. It contains silhouetted images which are fixed on other material. 11. Recognizable images appear in narrative sequence. 12. Abstract forms create a pattern. 13. The work contains photographs or other printed matter. 14. The work has a functional as well as an aesthetic life.

'These criteria are based on visual observation of many works made by women in the past … this art has been excluded from the mainstream, but why is that so? What is mainstream? How may such an ommission be corrected? … the culture of women will remain unrecognized until women themselves regard their own past with fresh insight. To correct this situation, must we try to insert women's traditional art into the mainstream? How will the authorities be convinced that what they consider low art is worth representing in history? The answer does not lie in mainstream art at all, but in sharing women's information with women.'
– Melissa Meyer and Miriam Schapiro, '*femmage*', 1978

Louise BOURGEOIS
The Destruction of the Father
1974
Latex
238 × 364 × 249 cm [94 × 143.5 × 98 in]

This work was first exhibited as part of the installation 'Le repas du soir' at 112
Greene Street Gallery, New York, in 1974. In a dramatically lit space, it formed part
of a larger, cave-like environment. Bourgeois recounts the childhood fantasy that
generated *The Destruction of the Father*:

'At the dinner table my father would go on and on, showing off, aggrandizing himself.
And the more he showed off, the smaller we felt. Suddenly there was a terrific
tension, and we grabbed him – my brother, my sister, my mother – the three of us
grabbed him and pulled him on to the table and pulled his legs and arms apart ...
And we were so successful in beating him up that we ate him up.'
– Louise Bourgeois, *Destruction of the Father/ Reconstruction of the Father: Writings
and Interviews 1923–1997*, 1998

The basis of this work is a 'table' which is encrusted and overhung with sprouting,
ambiguous bodily derived forms, suggestive of a nurturing motherhood that
overwhelms the patriarchal place of the father. Among the sources of imagery the
work recalls are ancient Greek statues of Artemis, whose rituals involved the
castration of bulls and the sacrifice of males; these have clusters of similar rounded
forms protruding from their torsos, which could represent castrated testicles as
much as breast forms.

Alice AYCOCK
A Simple Network of Underground Wells and Tunnels
1975
Earth, concrete, timber
Wall, 30 × 900 × 1500 cm [12 × 354 × 590 in]
Underground excavation, 600 × 1200 cm [236 × 472.5 in]
Merriewold West, Far Hills, New Jersey

A series of six concrete block wells, connected by tunnels, was built in an excavated area. Three of the wells could be entered and three functioned as vertical 'relieving' wells, which were closed and completely surrounded with earth. The open-entry wells were indicated above ground by wooden covers. Inside the wells were ladders to enable participants to climb down and crawl through tunnels which connected the open wells to each other. The dark underground tunnels were designed to produce unease and disorientation, heightening psychic awareness of the body's relationship to this spatial environment. Aycock's use of the maze form drew experimentally upon cultural associations of female identity with the earth and natural cycles. She referred to her archaeological-architectural structures as 'psycho-architecture'. In conceiving this work Aycock drew on experiences from her past, combining architectural history with personal memories and dreams.

Mary MISS
Perimeters/Pavilions/Decoys
1977-78
Wood, steel, earth
Tallest tower, 5.5 m [18 ft]
Underground excavation, 12 × 12 m [40 × 40 ft]
Pit opening, 5 × 5 m [16 × 16 ft]

Three tower-like structures, two earth mounds and an underground courtyard were built on a 10 hectare (4 acre) site. The work must be walked through in order to be experienced in its entirety; there are changes of scale in the towers and innaccessible spaces in the underground structure. Boundaries and perceptions of distance are brought into question, as are the limits of illusion and reality. The viewer is aware of both the passage of time and of the changing relationships of the body in space. 'You feel the work is disappearing before your eyes or that, while experiencing it, you are passing through a mirror into another reality ... Despite her good craftsmanship and her love of materials, she denies you the possibility of being seduced by their surface appearances. (All of her outdoor pieces have succumbed to the elements or have been destroyed, except the wood-lattice in an open air pit piece she did at Oberlin which has been remade in metal.) Her attitude is reticent and respectful towards her materials, in the manner of Japanese temple architecture and symbolic garden landscaping ... '
– April Kingsley, 'Six Women at Work in the Landscape', 1978

Susan HILLER

Sisters of Menon

1972–79

Blue pencil, typewriting, gouache, labels on paper

8 panels, 193 × 183 cm [76 × 72 in] overall

top, installation of panels

bottom, detail of typescript panel

'I had been working on a project called *Draw Together*, a group investigation into "the origins of images and ideas". One evening … I picked up a pencil and began to make random marks on a blank sheet of drawing paper. At first the marks formed what looked like childish letters I could not decipher. Then coherent words began to appear. The pencil seemed to have a mind of its own and wrote page after page of text in an unfamiliar style … Here my spontaneous scribbling ended up as writing. In later examples, writing dissolved into marks that look like crypto-linguistic, calligraphic signs … Perhaps the last word [one] in the *Sisters of Menon* scripts provides a clue, for the ancient Greeks (I'm told) had only one term for writing and drawing.'
– Susan Hiller, *Sisters of Menon*, 1983

'… the *Sisters of Menon* script reformulates the encounter between the Sphinx and Oedipus. The Sisters text revolves around a new perspective on the question, Who am I? The Sisters ask, "Who is this one?" and they answer themselves, "I am this one. You are this one. Menon is this one. We are this one." It's a new starting point. Identity is a collaboration, the self is multiple. "I" am a location, a focus.'
– Susan Hiller, 'Looking at New Work: an interview with Rozsika Parker', 1983

Fragments (detail)
1977-78
Potsherds, gouache drawings,
charts, texts
Dimensions variable

A hundred small broken pieces of Pueblo pottery were placed on 100 sheets of sketchbook paper laid on the floor in a grid formation. Each sheet also contained a gouache painting of a pottery fragment, different from the actual one resting on the paper. There were further fragments, in archaeological specimen bags, on the walls as well as a photograph and texts.

Inspired by women pioneers in the field, Hiller had studied and taught anthropology in the mid 1960s. However, she became disillusioned, aware that passionate involvement with the values of peoples encountered had been replaced by theoretically detached appropriation of cultural data for its use value. After fieldwork in Central America she left the US in 1970 and settled in Britain. Determined to find a way of becoming a full participant in shared cultural experience, she became an artist. *Fragments* juxtaposed indigenous (Pueblo) systems of taxonomy with those of anthropologists. The work included statements by Pueblo artists emphasizing that their design ideas were simultaneously traditional (based on fragments from the past) and innovative, original (inspired, for example, by dreams). Their practice was thus located as an art form rather than relegated to 'craft'. Texts shown alongside the shards juxtaposed typescripts from fieldwork by archaeologists and anthropologists such as Ruth Bunzel, one of the pioneers Hiller admired, with handwritten records of statements by the Pueblo women. Visual representations and diagrams by the artist suggested parallels between the activities of the field worker and the artist. Hiller's material was not appropriated; its parallel existence was maintained as an acknowledgment of the culture that had affected her subjectively in forming the work.

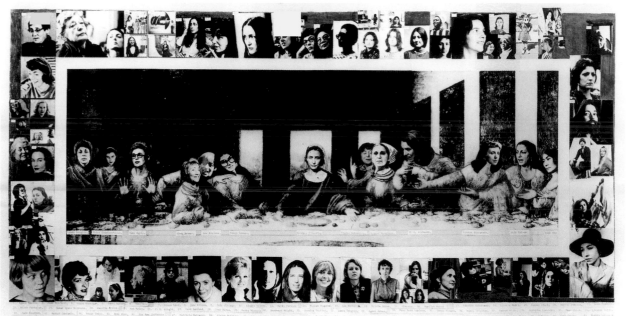

SOME LIVING AMERICAN **WOMEN** ARTISTS

Mary Beth <u>EDELSON</u>
Some Living American Women
Artists/Last Supper
1972
Offset poster
66 × 132 cm [26 × 52 in]

Edelson's collage depicts over eighty living women artists. Those seated at the table include Georgia O'Keeffe (centre), Lee Krasner, Helen Frankenthaler, Lynda Benglis and Yoko Ono. Produced as a poster, the work 'was widely reproduced in early feminist publications … Organized religion's penchant for cutting women out of positions of authority is challenged in this poster, as well as the widespread assumption that women do not have access to the sacred. But here we are instated in this famous religious icon for all the world to see.'
– Mary Beth Edelson, Artist's statement, 2000

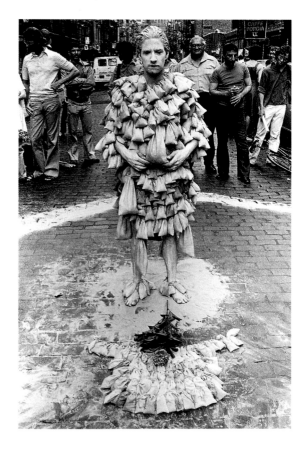

Betsy <u>DAMON</u>
7,000 Year-old Woman
1977
Prince Street, New York

'She found me in Los Angeles in Spring 1975. I began imagining myself covered with small bags filled with flour. For the next two years I constantly saw the image with one change. She became a clown and I decided to paint my face and body white. Only after completing the first Sacred Grove did I identify her as a 7,000 year-old woman. While I was more and more in awe of her and did not know much about her, naming her was the first step towards performing her.'

This piece was performed on two occasions, first in an intimate gallery space, and secondly, in collaboration with artist filmmaker Su Friedrich, in the broader public arena of a New York street. Damon recalls the first performance:

'Hanging from and covering my body were 420 small bags filled with 60 lbs of flour that I had coloured a full range of reds from dark earth red to pink and yellow. To begin the piece I squatted in the centre of the gallery while another woman drew a spiral out from me which connected to a large circle delineated by women who created a space with sonic meditation. Very slowly I stood and walked the spiral, puncturing and cutting the bags with a pair of scissors … By the end of the performance the bags on my body were transformed into a floor sculpture. I invited the audience to take the bags home and perform their own rites … During the performance I was a bird; a clown; a bagged woman; an ancient fertility goddess; heavy-light; a striptease artist; sensuous and beautiful. After the performance I was certain that at some time in history women were so connected to their strength that the ideas of mother, wife, lesbian, witch, as we know them, did not exist.'
– Betsy Damon, Artist's statement, 1977

Mary Beth <u>EDELSON</u>
Goddess Head
1975
Photo collage
Approx. 20 × 25 cm [8 × 10 in]

Exploring mythical connections of the feminine with the ocean's maternal source
of life, Edelson collaged a fossilized spiral shell in the place of her head, creating
an enigmatic 'goddess' figure. Thus transformed, the artist presents an image of the
modern female body connected with ancient and monolithic sources of energy. In her
collages of the 1970s Edelson looked to the symbols and myths of women's 'lost'
history in order to recuperate a sense of female heritage and to bind contemporary
woman to a collective feminine community.

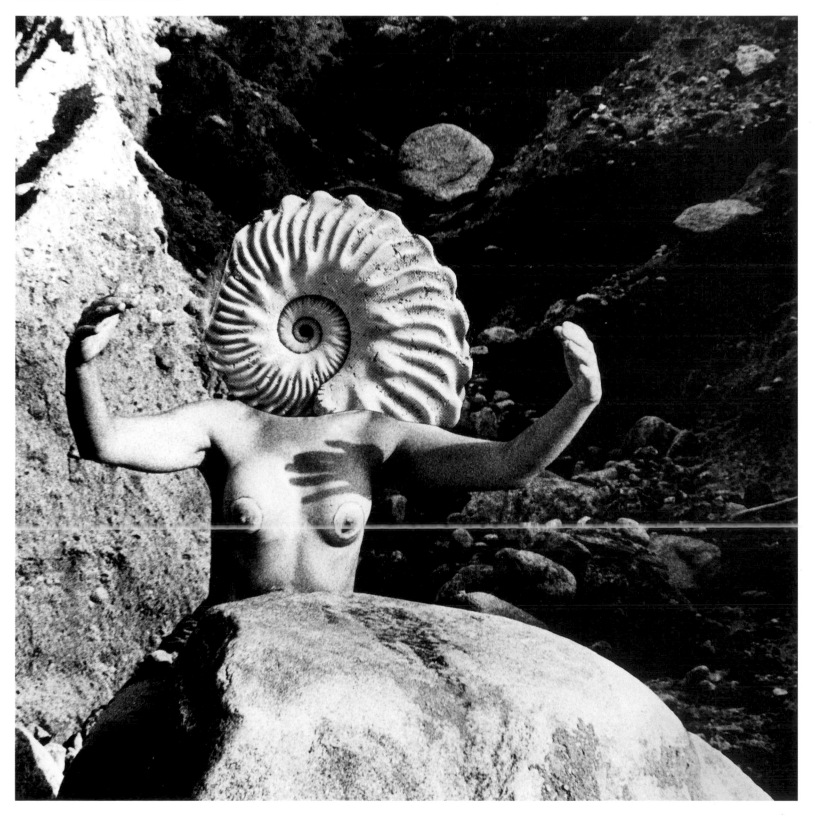

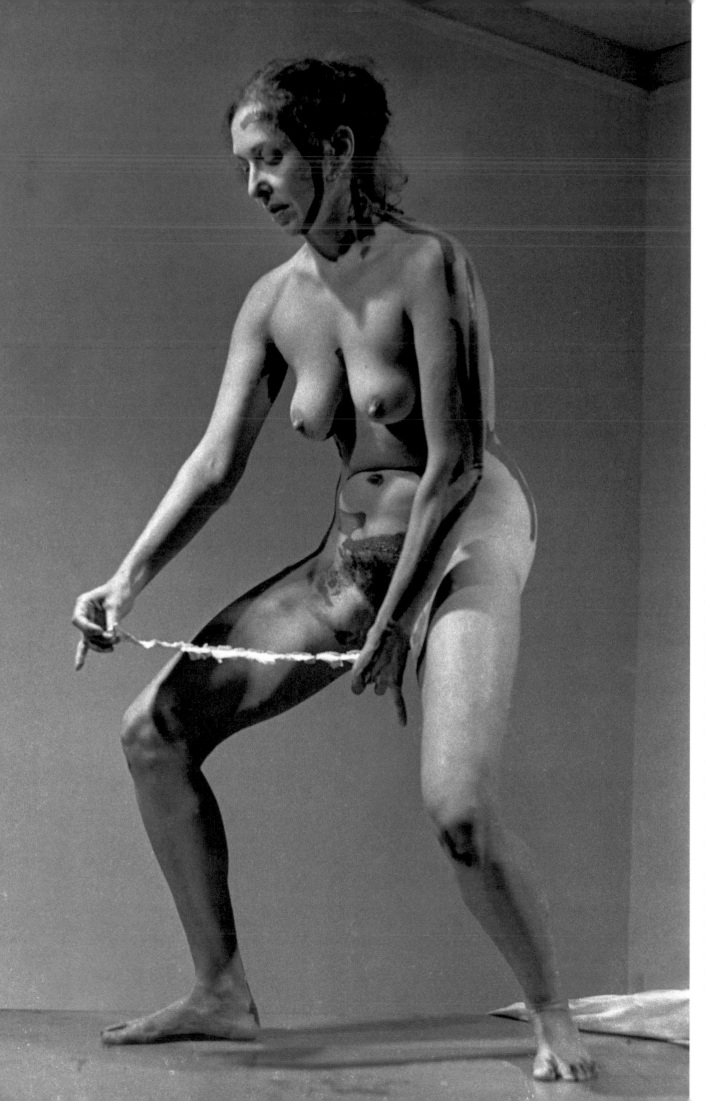

Carolee **SCHNEEMANN**
Interior Scroll
1975
East Hampton, Long Island

Wearing only a sheet, Schneemann told her audience she would read from her book, *Cézanne, She Was a Great Painter*. She then unwrapped the covering sheet and painted large strokes of mud on the contours of her body and face. She climbed onto a long table and read the text while assuming a series of life-model poses, balancing the book in one hand. Dropping the book, she slowly extracted a scroll from her vagina and read the inscriptions on it, which were taken from feminist texts she had written for a previous work. One of these, originally written for her film *Kitch's Last Meal* (1973–77), describes her encounter with a male structuralist filmmaker who complains that her work is full of 'personal clutter … persistence of feelings … diaristic indulgence' and so on:

'He said you can do as I do
take one clear process
follow its strictest
implications intellectually
establish a system of
permutations establish
their visual set …
he protested
you are unable to appreciate
the system of the grid
the numerical rational
procedures –
the Pythagorean cues …
he said we can be friends
equally though we are not artists
equally I said we cannot
be friends equally and we
cannot be artists equally …

'he told me he had lived with
a "sculptress" I asked does
that make me a "film-makeress"?

'Oh No he said we think of you
as a dancer'

First performed for an exhibition of paintings and series of performance works for a largely female audience, entitled 'Women Here and Now', *Interior Scroll* resulted from Schneemann's research into 'vulvic space' and its connection with serpent forms as Goddess attributes in ancient cults.

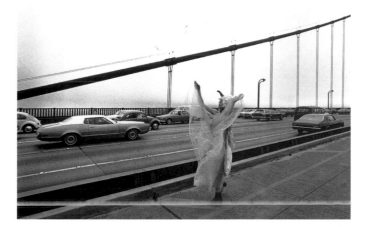

Linda <u>MONTANO</u>

Chicken Dance

1972

Golden Gate Bridge, San Francisco

In 1969, while a graduate student at the University of Wisconsin, Montano became frustrated with conventional art practice. She decided to blur the boundaries between art and everyday life in order to explore unconscious subject matter, fears, fantasies and healing processes. She experimented with different personae, the first being Chicken Woman, an alter ego that enabled her to experience a range of identities including that of 'nun, saint, martyr, plaster statue, angel, absurd snow white dream character'. For the next seven years Chicken Woman presided over various art events, was spied sitting on sidewalks in New York or performing the Chicken Dance on San Francisco's Golden Gate Bridge, as an act of healing for past suicides. From the mid 1970s onwards Montano developed other personae including Dr Jane Gooding, neurosurgeon and shaman; Sister Rose Augustine; Kay Rogers, Blues singer; and Hilda Mahler, Olympic swimmer and karate black belt.

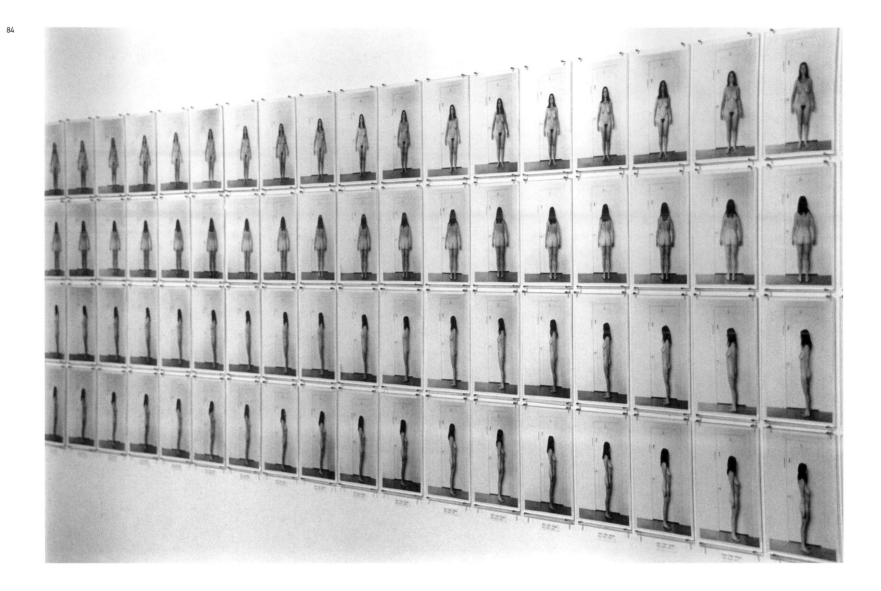

Lynda BENGLIS
Bounce I
1969
Poured pigmented latex
Dimensions variable

Bounce I was a hybrid of painting, sculpture and performance, and one of the first instances when Benglis explicitly commented on the gendered aspects of gestural forms. She dripped fluorescently pigmented liquid latex rubber in 'formless' configurations onto the floor of the Bykert Gallery, New York. The piece critiqued formalist art criticism's classification of the gestural actions of male Abstract Expressionist painters as 'masterly'. Although these artists had been a major influence on her own earlier work, Benglis was concerned to open up questions about designations of the 'feminine' through a continual questioning of expressive forms and the deployment of new or unorthodox materials.

Eleanor ANTIN
Carving: A Traditional Sculpture
1973
Black and white photographs, text
144 photographs, 18 × 12.5 cm [7 × 5 in] each
Collection, Art Institute of Chicago

'This work was carved during the period between 15 July 1972 and 21 August 1972. The material (the artist's body) was photographed every morning in four positions – front, back, right and left profile – to depict the process of "carving" down during a strict dieting regimen.' Parodying the method of traditional Greek sculpture in which the sculptor worked his way round a figure, repeatedly carving a thin layer from all sides in order to 'keep the whole in view', Antin presented her body as the object of her own sculpting activity, through a process that, unlike carving, worked from the inside out. Like the Greek sculptor she could choose when to stop. 'When the image was finally refined to the point of aesthetic satisfaction the work was completed.' There was a proviso that the final result would be determined by '(1) the ideal image towards which the artist aspires, and (2) the limitations of the material'. Antin concludes with a paraphrase of a quote from Michelangelo, 'not even the greatest sculptor can make anything that isn't already inside the marble', and ironically points to the primacy of the material internal to her 'sculpted' body, which is precisely what enables her to control that body.
– all quotes from Eleanor Antin, Artist's writings, 1973

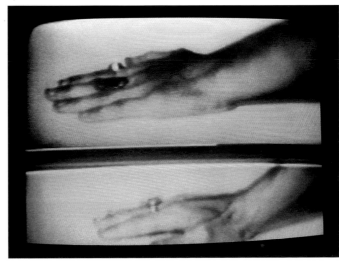

Joan JONAS
Vertical Roll
1972
Video
19 mins., black and white, sound

Influenced by the movement theatre of the Judson Dance Group, Jonas mixed sound, movement and image, seeking to break down boundaries between traditional artforms and the new media of video and performance art. This unedited video tape utilizes one of the primary technical features of video, the vertical roll across the screen that results from two out-of-sync frequencies: the frequency signal sent to the monitor and the signal by which it is interpreted. When both signals are the same, the image is stable. In the first sequence Jonas bangs a spoon against a mirror, creating the impression of a relationship between the sound and the image disturbance. She is then seen jumping up and down, sometimes in sync with the vertical roll as it hits the bottom of the monitor, sometimes appearing to jump over the roll. Her hands then appear, making similar movements; the vertical roll creates the illusion that they are clapping. In the final image Jonas' head fills the frame; the vertical roll appears to push her head out of the picture.

Faith <u>WILDING</u>

Waiting

1971

Womanhouse, Los Angeles, 1972

Wilding performed *Waiting* as part of the group consciousness-raising activities of the Womanhouse project in Los Angeles. Sitting passively with her hands in her lap she rocked back and forth as she listed the endless waiting of a woman's life. 'Waiting … waiting … waiting/Waiting for someone to come in/Waiting for someone to pick me up/Waiting for someone to hold me/Waiting for someone to feed me/Waiting for someone to change my diaper … Waiting/… Waiting to be a big girl/ … Waiting to wear a bra/Waiting to menstruate/Waiting to read forbidden books/ … /Waiting to have a boyfriend/Waiting to go to a party, to be asked to dance, to dance close/Waiting to be beautiful/Waiting for the secret/Waiting for life to begin … Waiting …

' … Waiting to be somebody/ … Waiting for my pimples to go away/Waiting to wear lipstick, to wear high heels and stockings/Waiting to get dressed up, to shave my legs/Waiting to be pretty … Waiting …/Waiting for him to notice me, to call me/Waiting for him to ask me out … /Waiting for him to fall in love with me …

'Waiting to get married/ … Waiting for my wedding night/… Waiting for him to come home, to fill my time … /Waiting for my baby to come/Waiting for my belly to swell/Waiting for my breasts to fill with milk/Waiting to feel my baby move/Waiting for my legs to stop swelling/Waiting for the first contractions/Waiting for the contractions to end/Waiting for the head to emerge/Waiting for the first scream, the afterbirth/ … Waiting for my baby to suck my milk/Waiting for my baby to stop crying …

Waiting for him to tell me something interesting, to ask me how I feel/Waiting for him to stop being crabby, to reach for my hand, to kiss me good morning/Waiting for fulfilment …

'Waiting for my body to break down, to get ugly/Waiting for my flesh to sag/ … Waiting for a visit from my children, for letters/Waiting for my friends to die … /Waiting for the pain to go away/Waiting for the struggle to end … /Waiting … '

– Faith Wilding, *Waiting*, 1971

Susan <u>FRAZIER</u>, Vickie <u>HODGETTS</u> and Robin <u>WELTSCH</u>

Nurturant Kitchen

1972

Found and fabricated objects, paint

Dimensions variable

Womanhouse, Los Angeles

'Out of our consciousness-raising techniques came the motif for the kitchen. As we expressed our real underlying feelings about the room, it became obvious that the kitchen was a battleground where women fought with their mothers for their appropriate state of comfort and love. It was an arena where ostensibly the horn of plenty overflowed, but where in actuality the mother was acting out her bitterness over being imprisoned in a situation from which she could not bring herself to escape and from which society would not encourage such an escape. Three women collaborated on the kitchen. They painted everything a store-bought pink – refrigerator, stove, canned goods, toaster, sink, walls, floor, ceiling. Drawers were papered with collages of far away places. On the ceiling and walls were attached fried eggs, which transformed themselves into breasts as they travelled down the walls. Five moulds were made from clay showing this transformation, and they were created in a spongy material and painted realistically. The reality of the woman's condition that was epitomized by this kitchen, coupled with a consistently high level of quality art making, made the experience of walking into our nurturing centre breathtaking … '

– Miriam Schapiro, 'The Education of Women as Artists: Project Womanhouse', 1973

Nurturant Kitchen was one of the site-specific collaborations created over a six-week period at Womanhouse (Valencia, California, 1972), initiated by Judy Chicago and Miriam Schapiro with fellow artists and students at the California Institute for the Arts. In an abandoned residential building on the outskirts of Los Angeles, seventeen room installations were created; regular debates and consciousness-raising sessions were held, which led to performances that articulated female experience.

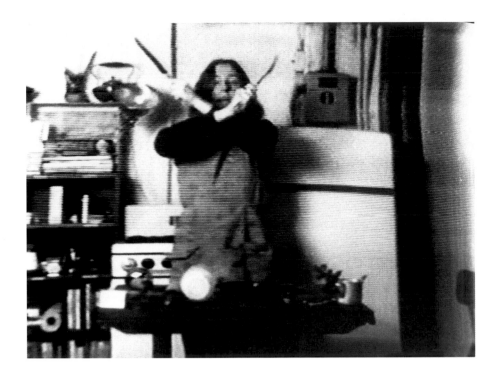

Martha <u>ROSLER</u>
Semiotics of the Kitchen
1975
Video
6 mins., black and white, sound

Rosler stands, as in a TV cookery lesson, in front of a kitchen table piled with various cooking utensils. She recites the alphabet, holding up an item to the camera to illustrate each letter, so that A stands for apron, B for bowl, C for chopper and so on. However Rosler's gastronomic lexicon becomes muffled as she aggressively brandishes each object. She swishes and stabs the air with a kitchen knife, or stirs and then suddenly aims a throw at an imaginary victim with the soup ladle. Repressed rage at domestic servitude simmers and overflows the containing signifiers of language. From the outset, Rosler's practice has been equally engaged with both art and theory. This is one of the earliest video works which evidences her commitment to the idea that the purpose of theory (in this case the prevailing structuralism of the 1970s) is not merely to transform theory but also to transform the inequity of social and political conditions.

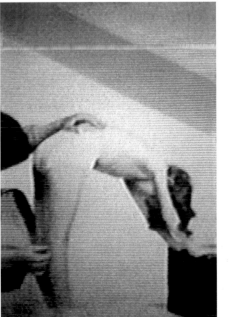

Martha <u>ROSLER</u>
Vital Statistics of a Citizen, Simply Obtained
1977
Video
40 mins., colour, sound

Rosler is seen, clothed and unclothed, being systematically measured by two male 'researchers' who record her measurements on a chart and compare them with a set of 'normal' measurements. Rosler's acting out of this submissive status is contrasted with her directorial, voice-over statements:

'Her mind learns to think of her body as something different from her "self" … I needn't remind you about scrutiny, about the scientific study of human beings. Visions of the self, about the excruciating look at the self from the outside as if it were a thing divorced from the inner self. How one learns to manufacture oneself as a product. How one learns to see oneself as a being in a state of culture as opposed to a being in a state of nature. How to measure oneself by the degree of artifice: the re-manufacture of the look of the external self to simulate the idealized version of the natural. How anxiety is built into these looks. How ambiguity, ambivalence, uncertainty are meant to accompany every attempt to see ourselves, to see herself as others see her. This is a work about how to think about yourself … '
– Martha Rosler, *Vital Statistics of a Citizen, Simply Obtained*, 1977

Laura <u>MULVEY</u>, Peter <u>WOLLEN</u>
Riddles of the Sphinx
1976
95 mins., colour, sound

Mulvey's film theory and practice arose from participation in the London Women's Film Group, set up in 1971, which linked Marxist and structuralist theory with Freudian theories of the unconscious to analyse the production of woman as a sign within the patriarchal order. This collaboration with Wollen retells the Oedipus myth from the perspective of the Sphinx – the silent, half-female creature situated outside the city gates. The central section of the film is composed of thirteen slow 360 degree pans. The riddles become contemporary dilemmas confronted by a young mother whose feminist consciousness gradually comes into voice: 'Question after question arose, revolving in her mind without coming to any conclusion. They led both out into society and back into her own memory. Future and past seemed locked together. She felt a gathering of strength but no certainty of success.'
– Laura Mulvey, Peter Wollen, *Riddles of the Sphinx*, script, 1976

 Mulvey and Wollen were closely associated with Mary Kelly during this period; their films resemble Kelly's structural schema for sections of her work *Post-Partum Document* (1973–79). Images from Kelly's work were incorporated within *Riddles of the Sphinx*.

Chantal <u>AKERMAN</u>
Jeanne Dielman, 23 Quai du commerce, 1080 Bruxelles
1975
210 mins., colour, sound

Three days in the life of a widowed Belgian mother are documented with great precision, in a film of over three hours duration in its original version. Much of the action is filmed in real time. Jeanne Dielman's rigid household routines include visits from different male clients each day whose fees for her sexual services support herself and her son. Maintaining a relentlessly even distance from the action throughout, the film refuses to set up privileged points of view on the action by close-ups, cut ins and other narrative techniques of classic cinema. The camera position corresponds to Akerman's own height, constructing a 'woman's eye' view. These cinematic elements establish the order of Dielman's household tasks, which exert control over her life. The smallest digressions from this ordered routine assume enormous proportions but are also perceived as no more or less important than her final 'slip', the murder of her third client. As in structural film, to which Akerman's 'hyperrealist' work is related, the viewer is forced to keep a distance, taking an active part in deciphering both narrative and image.

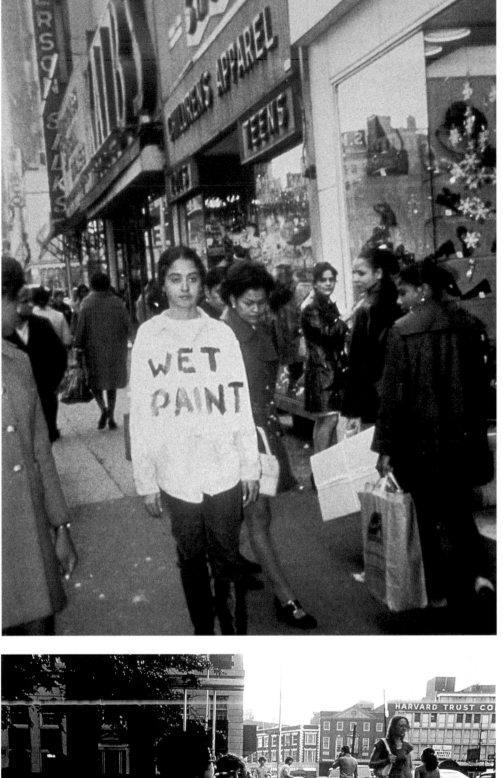

bottom
Adrian <u>PIPER</u>
The Mythic Being: Cruising White
Women
1975
Cambridge, Massachusetts

Piper's performances, which took place
in the street, on the subway, in museums,
bookshops and other public places,
demonstrate a desire to question and
disrupt general social attitudes towards
difference, and how this is read through
a person's appearance and gestures.
In her *Catalysis* series her presence, or
'quirky personal activities', were genuinely
disruptive. For example, she would
appear on the subway in stinking clothes
during rush hour or with balloons attached
to her ears, nose, hair and teeth. She
would go shopping in a smart department
store in clothing with sticky paint letters
reading 'WET PAINT' or to a library
carrying a concealed tape recording
of loud belches. In this way she forced
a direct confrontation with the public.
In the *Mythic Being* series Piper
disguised herself as an androgynous,
racially indeterminate young man,
wearing a black t-shirt, flared jeans, big
sunglasses, an afro wig and Zapata-style
moustache. The *Mythic Being* series also
included drawings, photographs and
collages that developed in conjunction
with the performances.

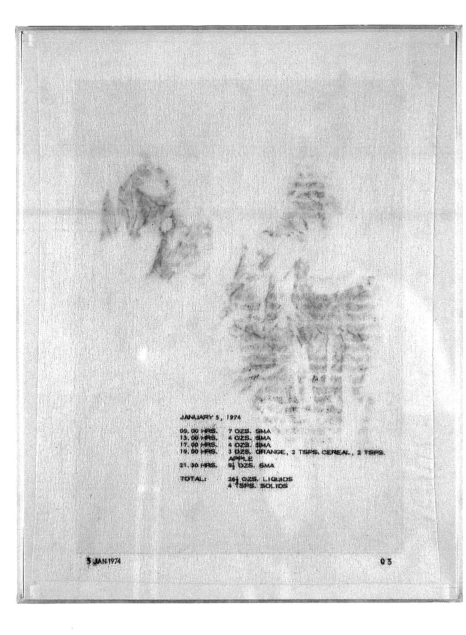

left

Mary <u>KELLY</u>

Post-Partum Document: Documentation I, Analysed Faecal Stains and Feeding Charts (prototype)

1974

Perspex units, white card, diaper lining, plastic sheeting, paper, ink

1 of 7 units, 28 × 35.5 cm [11 × 14 in] each

Collection, E.A. Generali Foundation, Vienna

opposite

Mary <u>KELLY</u>

Post-Partum Document: Documentation VI, Pre-writing Alphabet, Exergue and Diary (detail)

1978

Perspex units, white card, resin, slate

1 of 15 units, 20 × 25.5 cm [8 × 10 in] each

Collection, Arts Council of England

In 1973 *Post-Partum Document* 'was conceived as an ongoing process of analysis and visualization of the mother/child relationship. It was born as an installation in six consecutive sections, comprising in all 135 small units. It grew up as an exhibition, adapted to a variety of genres (some realizing my desire for it to be what I wanted it to be, others resisting, transgressing) and finally reproduced itself in the form of a book.'

– Mary Kelly, 'Preface', *Post-Partum Document*, 1983

The project analysed the artist's lived experience of motherhood; it inserted the voice of feminine subjectivity into the language of Conceptual art, while also explicitly refuting naturalization of the discourse of women's practice. Furthermore her investigation led Kelly to depart from psychoanalytic orthodoxy to posit a concept of maternal fetishism. Kelly suggests that if a baby fulfils in fantasy the plenitude denied by 'lack' of the phallus (according to Freudian Oedipal theory), the growing distance and thus 'loss' of the maturing child represents a castration threat, in response to which the mother's memorabilia – shoes, locks of hair, photographs – both commemorate the loss and defend against it. Kelly represents the 'transitional objects' of the mother as well as the child, not as surrogates but as emblems of desire, drawing attention to the fetishistic nature of representation itself.

(age 3.6) e IS FOR ELEPHANT. He calls it the "curvy one" and pronounces it–"eeh". He often forgets it and sometimes writes it upside-down, "ə". When he sees an e, a present or a breast, he says, "What's that?" Something at once lost, forgotten, remembered and hoped for. "ə" as in "me." E IS FOR ALLIGATORS ENTERTAINING ELEPHANTS. E IS FOR AN EAGLE ON AN ELEPHANT IN AN EGG AND SPOON RACE. GOOD NIGHT EDWARD ELMER ELEPHANT. GOOD NIGHT LITTLE E.

February 22, 1977: I noticed the general conditions more than the children this time, like the rubbish outside the building and the dust inside. When I washed the cups the rag looked so grey I couldn't bring myself to use it. But I suppose they do the best they can, it isn't their own space, its only rented during the day from a Boys club. There's no playground and the children have to stay indoors. All but about 20 mins of the 2 hrs. is 'unstructured' and seems to get out of hand, I'm afraid they'll get hurt. I can't stand the bad grammar after about an hour of it - I can't believe I could be so uptight and pretentious. I feel inadequate myself because I cant offer Kelly more. I wish he could go to a good school, but it's hopeless in this area. I went to the Social Services Dept. and self-righteously demanded the names and addresses of proper nursery schools. They just smiled and refused, saying it would be of no use since all of them had at least a 2 yr. waiting list.

3.603e

Mierle Laderman UKELES
Hartford Wash: Washing, Tracks, Maintenance: Outside
1973
Hartford, Connecticut

In a series of performances between 1973 and 1976, Ukeles carried out 'maintenance' activities in public spaces, during public hours, cleaning streets and museum floors as well as performing all the duties of the guards in a museum. Her maintenance actions provoked the viewer to question the importance of such actions as cultural activities, and to celebrate the people who traditionally carry them out.

'I am an artist. I am a woman. I am a wife.

'I am a mother. (Random order)

'I do a hell of a lot of washing, cleaning, cooking, renewing, supporting, preserving, etc. Also, (up to now separately) I "do" art.

'Now, I will simply do these maintenance everyday things, and flush them up to consciousness, exhibit them, as Art. I will live in the museum as I customarily do at home with my husband and my baby, for the duration of the exhibition (Right? or if you don't want me around at night I would come in every day), and do all these things as public Art activities: I will sweep and wax the floors, dust everything, wash the walls (i.e., "floor paintings, dust works, soap-sculpture, wall-paintings"), cook, invite people to eat, make agglomerations and dispositions of all functional refuse.

'The exhibition area might look "empty" of art, but it will be maintained in full public view.

'MY WORKING WILL BE THE WORK … '

– Mierle Laderman Ukeles, *II. The Maintenance Art Exhibition: 'Care'. A. Part One: Personal*, from *Manifesto for Maintenance Art, 1969. Proposal for an Exhibition: 'Care'.*, 1969

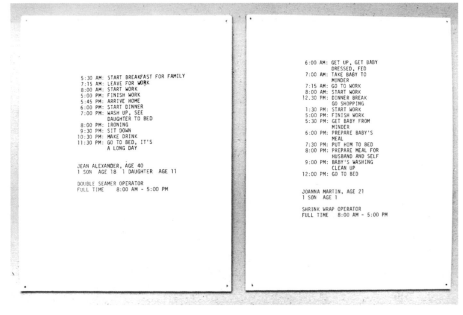

Margaret HARRISON, Kay HUNT, Mary KELLY
Women & Work: A Document on the Division of Labour in Industry
1973-75
Black and white photographs, charts, tables, photocopied documents,
film loops, audiotapes
Dimensions variable
South London Art Gallery, London, 1975

Between 1970 and 1975, two collective projects in London examined women's working conditions in unprecedented ways. The Berwick Street Film Collective made the documentary *Nightcleaners* (1970–75), which focused on the complexities and minute details of its subjects' real-time experience. *Women & Work* was a documentary installation on the implementation of the Equal Pay Act in a metal box factory. In 1972 the Collective, which included Mary Kelly, came to a meeting during 'Strike', an exhibition about a strike by women workers, by the artist Conrad Atkinson, with whom Harrison worked, held at the Institute of Contemporary Arts, London. Harrison and Kelly discussed working on a project together, which became *Women & Work* when they were joined by artist and activist Kay Hunt, who initiated the project at a South London factory similar to one where her female relatives had worked. Like Atkinson's work the project was rooted in working-class experience and used all available forms of information and display to convey the interwoven complexities and iniquities of the system. However, it built on this work by foregrounding the role of gender in working-class situations. The project questioned the authoritative position of the artist outside the field of investigation and highlighted the necessity of allowing space for incorporating subjective material from the participants. The female workers not only discussed their factory work and conditions but their unpaid labour in the home and their feelings about their roles. This reinforced a perception that the division of labour was psychologically and gender based as well as socially determined by the capitalist class system. Harrison went on to develop these investigations in important subsequent projects such as the controversial work *Rape* (1977) and *Homeworkers* (1978) on the conditions of mainly women with young children who do piece work at home, working longer hours than full-time office or factory workers, but earning less than a quarter of an average weekly salary. Kay Hunt went on to make pacifist work based on extensive research into the conditions of women who worked in munitions factories during World War II.

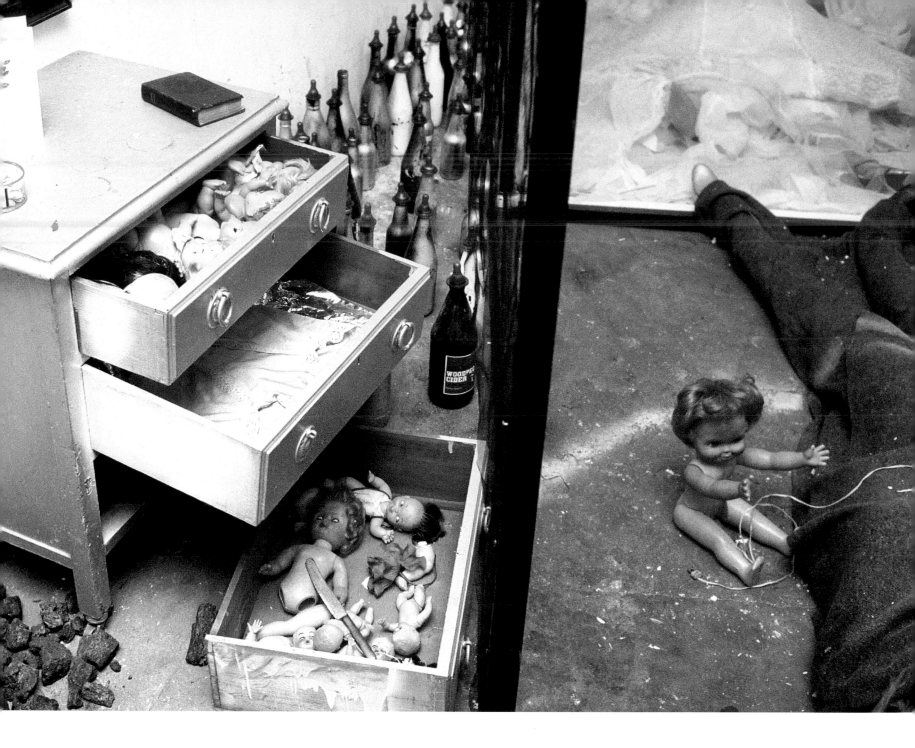

Kate WALKER
Death of the Housewife (detail)
1974
Found objects, assemblage
Dimensions variable
Women's Centre, Radnor Terrace, London

Inspired by the Womanhouse project in California, Walker set up Woman's Place in the South London Women's Centre, a dilapidated house in Radnor Terrace, south east London. Six women – Phil Goodall, Patricia (Chick) Hull, Catherine Nicholson, Su Richardson, Monica Ross and Suzy Varty – took part in constructing different environments in each room. Walker's installation occupied three rooms and was themed around domesticity, marriage and death. Walker and others worked with discarded everyday objects out of economic as well as emotional necessity; it was also a means of creating art quickly within the limited amount of time available to them outside domestic obligations.

Tina **KEANE**
Collapsed Dream
1974
Mirrorboard, bamboo, string
274.5 × 213.5 × 122 cm [108 × 84 × 48 in]
Women's Workshop/Artists Union exhibition, Arts Meeting Place, London
'image/dream/illusion
image/language/illumine …
The mirrorboard the illusion of water,
the bamboo poles elegance,
the string a tangled web'
— Tina Keane, Artist's statement, 1974
The Women's Workshop collective was formed in 1972, as a support structure to counteract women artists' isolation. Its exhibitions were non-selective, in counter-distinction to the male-dominated art world's hierarchies and in recognition of the fact that unless they joined together to take over a space, women practitioners of many different aesthetic and political perspectives were all equally marginalized.

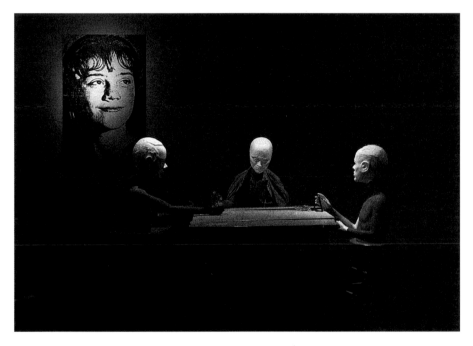

Kate **MILLETT**
The Trial of Sylvia Likens (detail)
1965-78
Found objects, wood, paint, photocopies, tape recordings
Dimensions variable
'On October twenty-sixth, 1965, in Indianapolis, Indiana, the starved body of a sixteen-year-old girl named Sylvia Likens was found in a back bedroom of Gertrude Baniszewski's house on New York Street, the corpse covered with bruises and with the words 'I am a prostitute and proud of it' carved upon the abdomen. Sylvia's parents had boarded her and her younger sister, Jenny Likens, with Gertrude in July. The beatings and abuse Sylvia suffered over the summer had increased so, by September, that the last weeks of her life were spent as a captive in the basement of the house … '
— Kate Millett, *The Trial of Sylvia Likens*, 1978
Best known as a writer, Millett also produced sculpture over a fifteen year period. Utilizing a New York basement space for the work's first presentation in 1978, Millett attempted to create a visual metaphor for the various types of imprisonment the tragedy represented. Tableaux recreating the events were juxtaposed with large photocopied images, detailed written documentation and tape-recorded readings by the artist, creating a nauseatingly claustrophobic, oppressive environment.

Su **RICHARDSON**
Burnt Breakfast, from Feministo
1975-77
Crocheted wool
ø approx. 23 cm [9 in]
Burnt Breakfast was made for 'Feministo: Portrait of the Artist as a Housewife', a project set up in 1975 by Sally Gollop, Kate Walker and others in response to domestic isolation and exclusion from the art system. Women ranging in age from nineteen to sixty years old participated in the project which involved exchanging small artworks through the mail. These were shown in an exhibition of the same name at the Institute of Contemporary Arts, London, in 1977. The pieces were exhibited within a series of tableaux based on domestic environments. Three hundred works were included in the exhibition, which toured regional cities in Britain as well as Germany and Austria. Among the many women who participated in this project, Birmingham-based Phil Goodall emerged as a central figure. In 1977 she devised, with Tricia Davis, the multimedia collaborative project 'Mother's Pride: Mother's Ruin.'

Laurie <u>ANDERSON</u>
Fully Automated Nikon
(Object/Objection/Objectivity)
(detail)
1973
Black and white photographs, text
Dimensions variable

'I decided to shoot pictures of men who made comments to me on the street. I had always hated this invasion of my privacy and now I had the means of my revenge. As I walked along Houston Street with my fully automated Nikon, I felt armed, ready. I passed a man who muttered 'Wanna fuck?' This was standard technique: the female passes and the male strikes at the last possible moment forcing the woman to backtrack if she should dare to object. I wheeled around, furious. 'Did you say that?' He looked around surprised, then defiant. 'Yeah, so what the fuck if I did?' I raised my Nikon, took aim, began to focus. His eyes darted back and forth, an undercover cop? CLICK.'
– Laurie Anderson, Artist's statement, 1994

Suzanne <u>LACY</u>
Rape Is
1972
Artist's Book

This book work was made by Lacy as a project of the Women's Design Program, set up by Sheila Levrant de Breitteville in 1971 as an extension of the Feminist Art Program at California Institute of the Arts. The book describes a range of behaviours which constitute rape, in a neutral, non judgemental form. The reader is required to 'violate' the book's red seal in order to open it. Each section opens with the statement 'Rape Is', on the left. On the right are descriptions of situations in which women find themselves on a regular basis, ranging from psychological to emotional and physical harassment:
'Rape Is/When your boyfriend hears your best friend was raped and he asks, "What was she wearing?"'

Valie <u>EXPORT</u>
Genital Panic
1969
Munich

In 1969, dressed in a black shirt, jeans with the crotch removed, and with a machine gun slung over her shoulder, Export entered a sex cinema in Munich. Addressing the audience, she announced that real female genitals were available and they could do whatever they wished.

'I moved down each row slowly, facing people. I did not move in an erotic way. I walked down each row, the gun I carried pointed at the heads of the people in the row behind. I was afraid and had no idea what people would do. As I moved from row to row, each row of people silently got up and left the theatre. Out of film context, it was a totally different way for them to connect with the particular erotic symbol.'
– Valie Export, 'Interview with Ruth Askey', 1981

Judy <u>CHICAGO</u>
Red Flag
1971
Photo lithograph
51 × 61 cm [20 × 24 in]

'"Offensiveness" played a potent part in destroying femininity and female beauty … for Judy Chicago, in her notorious *Red Flag*, a photo lithograph of herself from the waist down pulling out a bloody tampon. [Germaine] Greer suggested that to overcome disgust for one's menstrual blood, a woman should taste it. In order to overturn femininity, feminist artists necessarily flouted good taste and feminine respectability by pointedly showing women's desire for sexual and cultural power, manifested … by breaking the taboo of ladylike purity. *Red Flag* takes a female bodily process out of obscurity; it is interesting to note that some viewers saw the tampon as an image of castration, which shows how much the eye has been socially and culturally educated to *not* see the reality of women's bodies.'
– Joanna Frueh, 'The Body Through Women's Eyes', 1994

Ana <u>MENDIETA</u>
Rape Scene
1973
Moffit Street, Iowa City, Iowa

Mendieta performed several actions around the subject of rape following an incident on the Iowa University campus where a fellow student had been raped and murdered. In one version of this work she invited friends and fellow students to visit her at her own apartment in Moffit Street, Iowa City. Finding the apartment door slightly open, the visitors entered a darkened room in which a single light illuminated the artist stripped from the waist down, smeared with blood and stretched over and bound to the table. Broken plates and blood lay on the floor beside her. Mendieta later recalled in an interview how the incident had moved and frightened her.

Mendieta also performed this piece outside, away from the domestic environment, in 'untamed' nature. Her violated female body, half hidden by leaves and twigs, was linked more to primal forces in this location, but the emotional impact was just as powerful. Her direct identification with a specific victim meant that she could not be seen as an anonymous object in a theatrical tableau. Her performances presented the specificity of rape, through which she hoped to break the code of silence that renders it anonymous and general, denying the particular and the personal.

Ana <u>MENDIETA</u>
Untitled (Snow Silueta)
1977
Iowa

Mendieta's earth actions stage a death or a dissolution that implicates a rebirth through reintegration with the maternal body of the earth.
'My art is grounded in the belief in one Universal Energy which runs through everything from insect to man, from man to spectre, from spectre to plant, from plant to galaxy.

'My works are the irrigation veins of the Universal fluid. Through them ascend the ancestral sap, the original beliefs, the primordial accumulations, the unconscious thoughts that animate the world.

'There is no original past to redeem; there is the void, the orphanhood, the unbaptized earth of the beginning, the time that from within the earth looks upon us. There is above all the search for origin.'
— Ana Mendieta, Artist's statement, 1988

Marina <u>ABRAMOVIC</u>
Rhythm 0
1974
Studio Morra, Naples

In an evening performance exploring the dynamics of passive aggression, Abramovic
stood by a table and offered herself to spectators, who could do what they liked with
a range of objects and her body. A text on the wall read, 'There are seventy-two objects
on the table that can be used on me as desired. I am the object.' The objects included a
gun, a bullet, a saw, an axe, a fork, a comb, a whip, lipstick, a bottle of perfume, paint,
knives, matches, a feather, a rose, a candle, water, chains, nails, needles, scissors,
honey, grapes, plasters, sulphur and olive oil. By the end of the performance all her
clothes had been sliced off her body with razor blades, she had been cut, painted,
cleaned, decorated, crowned with thorns and had had the loaded gun pressed against
her head. After six hours the performance was halted by concerned spectators.
Abramovic described this piece as the conclusion of her research on the body.

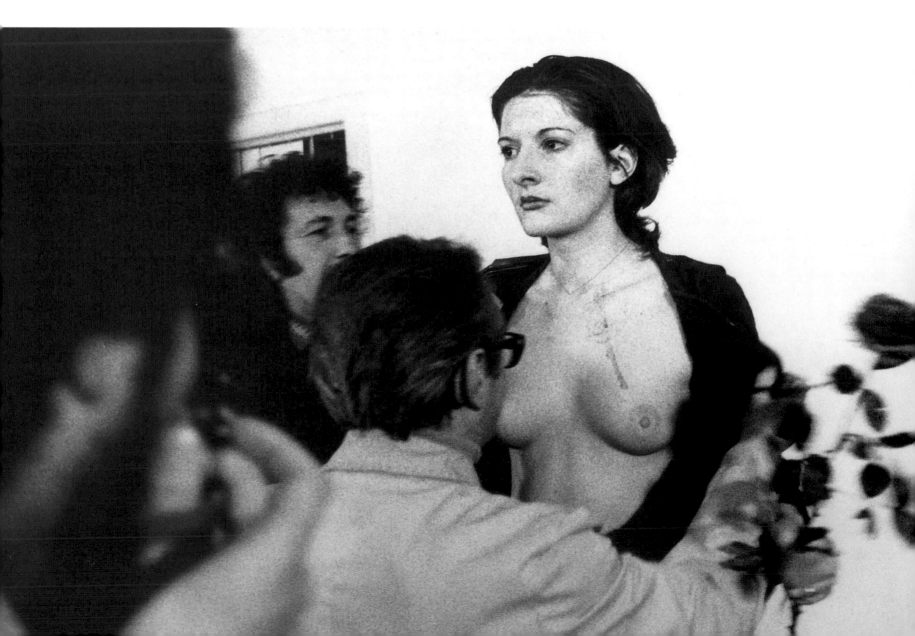

Gina PANE
Autoportrait(s)
1973
Galerie Stadler, Paris

During the first part of this action the artist lay suspended like an inert object above burning candles for half an hour. In the second part she stood facing a wall onto which slides of women painting their fingernails were projected. With her back to the audience, Pane made small incisions in the skin around her own fingernails with a razor blade. Photographic documentation of the work was later exhibited within a photomontage. Between 1968 and 1978 Pane placed her own body at the centre of her art practice, often creating self-inflicted wounds in front of an audience who became direct participants in the ethical and existential issues raised by the work. 'With these actions, I wanted to indicate radically the "sign" of the body, and the wound was the real sign of "this" body, of "this" flesh. It was impossible for me to reconstruct an image of the body without the flesh being present, without it being placed frontally, without veils and mediations.' To Pane, the body was 'the irreducible core of the human being, its most fragile part. This is how it has always been, under all social systems, at any moment in history. And the wound is the memory of the body; it memorializes its fragility, its pain, thus its "real" existence … '
– Gina Pane, 'Interview with Ezio Quarantelli', 1988

Ulrike ROSENBACH
Don't Believe I Am an Amazon
1975
Kunstmuseum, Dusseldorf

Rosenbach covered a target with a large black and white reproduction of Shephan Lochner's Renaissance painting *Madonna of the Rose Bower* (c. 1435–40), at which she shot fifteen arrows. From a square hole cut into the centre of the target, a video camera recorded Rosenbach shooting the arrows. The performance subsequently appeared as a video in which the recording made by the camera in the target was superimposed on the image of the Madonna, thus reversing the direction of the shooting arrows so that the artist's own face is superimposed on the Madonna's face as she shoots. The artist thus appears as both victim and torturer, which would seem to point to the multiple nature of feminine roles within society.

Lynda BENGLIS
Untitled
1974
Colour photograph
26.5 × 26.5 cm [10.5 × 10.5 in]

For her exhibition invitations Benglis used photographs of herself staged in various gender roles, ranging from 'macho male' to 'submissive female'. This image was published in the advertisement placed in *Artforum* shown above. It was initally intended to be one of the magazine's artist projects. The image should have appeared as a centrefold artist's statement, but this was not permitted by the magazine. Benglis declined the magazine's offer to reproduce the image provided it was accompanied by an article on her work. Instead she paid for advertising space under her gallery's name, claiming that 'placing the gallery's name on the work strengthened the statement, thereby mocking the commercial aspect of the ad, the art-star system and the way artists use themselves, their persona, to sell the work. It was mocking sexuality, masochism and feminism.'

– Lynda Benglis quoted by Susan Keane, 'Dual Natures', 1991

Lynda BENGLIS (with Marilyn LENKOWSKY)
Female Sensibility
1973
Video
13 mins., colour, sound

Titled after the question often repeated by feminists at the time as to whether there was such a thing as 'female sensibility', this video features Benglis and Marilyn Lenkowsky slowly caressing and kissing each other. The colour is exaggerated to highlight the blue-green lipstick on Benglis and the red-black on Lenkowsky. Radio talk shows and musical refrains play in the background, including 'When a man needs a woman … ' *Female Sensibility* is one of several videos made by Benglis in which the viewer's voyeuristic position is playfully subverted.

Cosey Fanni <u>TUTTI</u>
Untitled (detail)
1976
Black and white photograph exhibited as part of magazine page
'Prostitution', Institute of Contemporary Arts, London

Tutti worked for two years on the 'Prostitution' project devised by COUM Transmissions, of which she and Genesis P. Orridge were founder members. Tutti had approached producers of sex magazines and films, presenting herself as a model, without discussing her own project with the makers. The resulting material, such as the photograph reproduced here, was shown as part of 'Prostitution' at the Institute of Contemporary Arts, London, in 1976. The colour and black and white photographs of Tutti posing alone, or with other women and men, for the sex industry were intended to be hung on the gallery walls in their original magazine format. Due to censorship restrictions imposed on the exhibition organizers these images were only allowed to be viewed one at a time, in a print rack. The project also involved performance and discussion events on issues of sex and prostitution, inviting women who worked in the sex industry, artists and members of the public to enter into dialogue. Materials exhibited included the artist's used tampons. Together with the incorporation of used diapers by Mary Kelly in *Post-Partum Document*, the preceding exhibition in the same space, this perceived transgression of aesthetic boundaries aroused hysterical reactions from the British media and art establishment, unable to address the political implications of the work.

As part of a description of the project which Tutti published in the ICA bulletin, she reflected on the complex politics and psychology of production and consumption that her investigation had revealed: 'The people who produce it think that they are "using" the public. The producers are using the public, but in a way they either do not know or never think or admit that they know. It is basically all a means by which they can explore their own sexual fantasies, "using" the models, and presuming the models don't have the intelligence to see what they are doing. I project myself into the role of "model" knowing fully what is happening and what to expect. The only thing that invisibly sets me apart is my perception of things. As yet I have met no one who has seen the commercial sex world as I have, or who would care to admit it. They seem so busy keeping their games to their related roles that they are blind to the truly strange, complicated, ironic situation they are in.

'My projects are presented unaltered in a very clinical way, as any other COUM project would be. The only difference is that my projects involve the very emotional ritual of making love. To make an action I must feel that the action is me and no one else, not a projected character for people's entertainment.'
– Cosey Fanni Tutti, Artist's statement, 1976

Barbara <u>HAMMER</u>
Multiple Orgasm
1976
16mm film
6.5 mins., colour, silent

The image of a cave's interior is superimposed upon the artist's filmic view of herself during masturbation. 'Woman, with her two genital lips, is already two according to [Luce] Irigaray; two who stimulate and embrace continually and who are not divisible into ones. This idea, so poetically expressed, reinforced my desire to express myself in multiple images either through superimpositions, bi-packing of two or more images in the optical printer, or passing the film through the printer various times.'
– Barbara Hammer, Artist's statement, 1990

Hammer's experimental film juxtaposes images that refuse easy assimilation, inviting viewers actively to confront their emotional reactions. An eco-feminist, Hammer draws connections between natural phenomena and female sexuality.

Ketty LA ROCCA
La Vittoria di Samotracia (The Victory of Samothrace)
1974
Photograph, ink on paper
25.5 × 78.5 cm [10 × 31 in]

La Vittoria di Samotracia uses a sequential format and a graphic inscription of the word 'you' overlaid on a reproduction of a work of art. Using this found imagery from printed media as its visual source, the work progressively dissolves the original referent of the image so that it is transformed into a form that suggests the pre-symbolic. La Rocca's collages of newspaper images and words emerged in the 1960s from the context of the visual poetry and performance work of the avant-garde in Florence. In these works she subtly undermined the subliminal messages within advertising and investigated processes of translation and transcription. Her work of the 1970s evolved from a series of photographic images of hands, which explored the relationship between language and the body. Writing, reduced to the word 'you', overlays these images, questioning the distinctions between author and viewer, self and other. The use of graphic outlines first appeared in the third version of her key work *Le mia parole e tu? (My Words and You?)*. Images of hands which make gestures like sign language are arranged in a sequence: first a photograph, then its outlines appearing as written lines of text, then a graphic diagram of the photograph. In the first panel La Rocca conceals her face with her hand, suggesting the invisibility of the self and of the female artist.

Rebecca HORN
Einhorn (Unicorn)
1970-72
Fabric and wood
Dimensions variable

A semi-naked performer wandered through a field of wheat and a forest, wrapped in an armature of bandages, connected together to form a body support for a wooden pole balanced on the head, evoking the horn of the unicorn, a medieval symbol of purity. The performance was documented in the eponymous film of 1970, and again in the film *Performances 11* (1973). In Horn's early works performers wear strange prostheses and garments, experiencing the state of constriction as a precondition for a new experience of the self.

'When I saw her first on the street, walking by – (me, dreaming my own "unicornian" dreams) – her strange rhythm, one step in front of the next …

'All was like an echo-shock of my own imagination. Her movements, a flexibility: (knowing how to use the legs entirely), but the rest of her: frozen in ice, from head to hips, and back again …

'Next weeks finding right proportions, body weights and object heights, distances and balances …

'The performance took place in early morning – still damp, intensely bright – the sun more challenging than any audience …

'Her consciousness electrically impassioned; nothing could stop her trancelike journey … '
– Rebecca Horn, *Einhorn (Unicorn)*, 1971

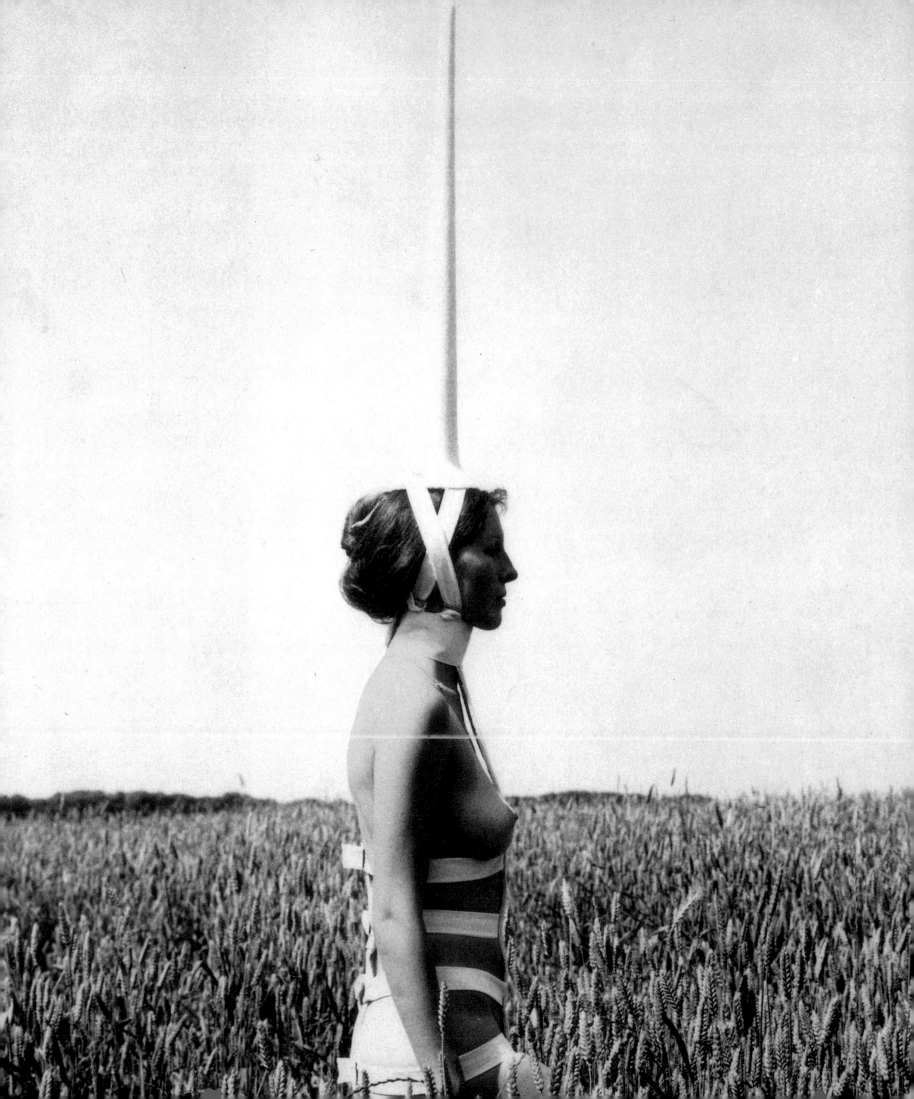

Martha WILSON
Breast Forms Permutated
1972
Black and white photograph
71 × 81 cm [28 × 32 in]

This image is accompanied by the following text inscribed underneath in pencil:
'Beginning with the flat-chested example in the upper left-hand corner, breast
forms can occur as either conical (down), spherical (diagonal), or pendulous (across).
The intermediate forms (small-conical, small-pendulous, conical-full, pendulous-full)
complete the diagram. Theoretically, the "perfect set" is located in the centre.'

Wilson's work of this period sets up a critical counterpoint between the idealized
systems, permutations and grids of 1970s Minimal and Conceptual art, as well as
commercial design and advertising, and the infinite variance and integrity of individual
women's bodies.

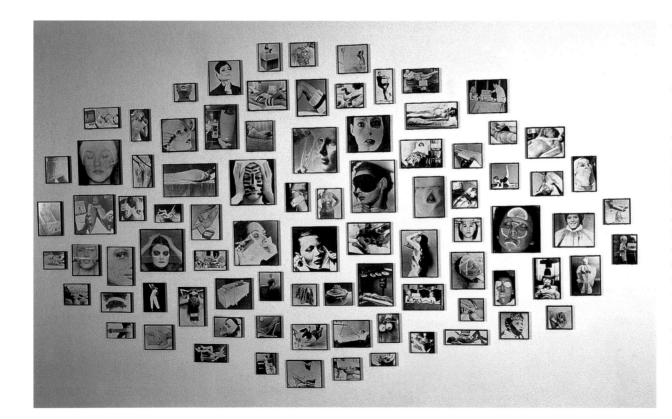

Annette MESSAGER
Les tortures volontaires
(Voluntary Tortures)
1972
86 gelatin silver prints, 1 album
Dimensions variable

In this installation, presented in various
combinations in different locations,
Messager exhibited a selection of
photographs derived from images
produced by the beauty industry to
promote its products and services.
Although the work draws attention to the
implicit violence evoked in imaging and
conforming with stereotypes of beauty,
the message of these fragmentary
images is ambiguous: some of the
'tortures' involve cosmetic surgery,
but most are depictions of mundane
cosmetic treatments and procedures,
which appear both banal and absurd in
Messager's recontextualization.

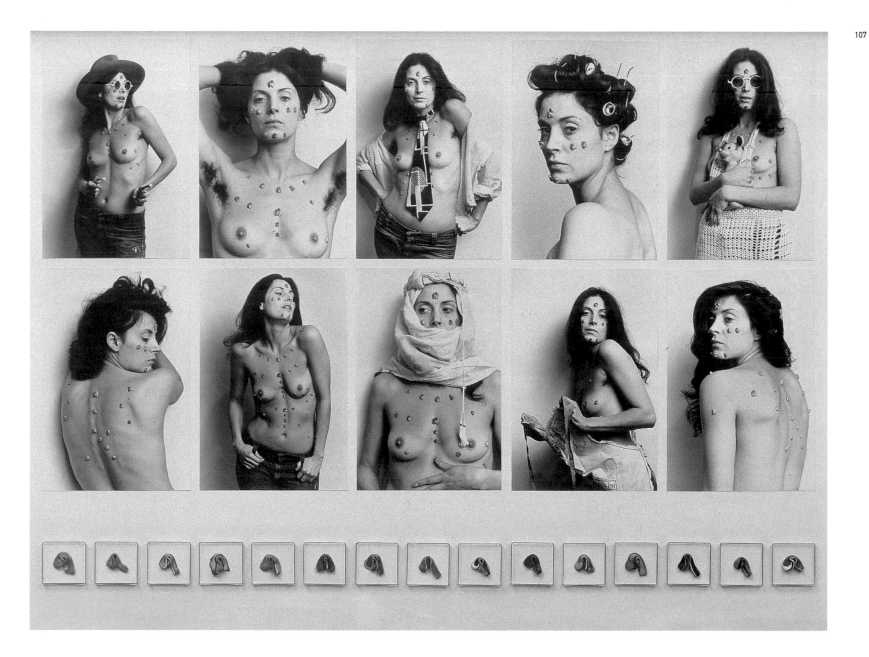

Hannah WILKE

S.O.S. Starification Object Series

1974-79

28 black and white photographs

15 × 10 cm [6 × 4 in] each

This photographic series arose from live performances where Wilke, topless,
flirted with her audience as they chewed pieces of gum, which she then collected
and arranged on the surface of her skin. These were modelled into labial shapes,
derived from her exploration of vulvar sculptural forms from the late 1950s onwards.
Marking her body as 'feminine' they also suggested historical scars.

'To also remember that as a Jew, during the war, I would have been branded and
buried had I not been born in America. Starification-Scarification … Jew, Black,
Christian, Muslim … Labelling people instead of listening to them … Judging
according to primitive prejudices. Marxism and Art. Fascistic feelings, internal
wounds, made from external situations.'

– Hannah Wilke, Artist's statement, 1977

'Visual prejudice has caused world wars, mutilation, hostility and alienation generated
by fear of "the other". Self-hatred is an economic necessity, a capitalistic, totalitarian,
religious invention used to control the masses through the denial of the importance
of a body language … The pride, power and pleasure of one's own sexual being
threatens cultural achievement, unless it can be made into a commodity that has
economic and social utility.'

– Hannah Wilke, Artist's statement, 1980

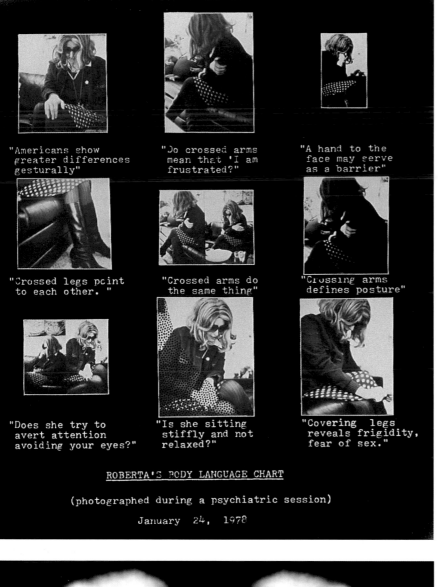

Lynn HERSHMAN
Roberta's Body Language Chart
1976
Gelatin silver print
86 × 76 cm [34 × 30 in]

'In 1975 Hershman began to construct an identity, "Roberta Breitmore", which she refers to as "a portrait of alienation and loneliness". She considers this a transmutation, calling Roberta "an alchemical portrait" …

'Hershman activated "Breitmore" in a number of cities and has advertised for roommates and dates. She has written: "Roberta is being documented by audiotapes, film and photographs. Her progression is being recorded in the form of three viewpoints, that of a pyschoanalyst, a journalist and herself. When Roberta becomes 'real' enough, it is likely she will commit suicide."

'For a show at the University of California, San Diego, Hershman checked into a hotel downtown, far from the rich community housing the gallery, where she showed records of "Roberta": stolen images of herself with her "contacts", a psychiatric work-up, a vita. She showed holograms of herself making up as Breitmore and photos of her face marked with names of the make-up used.'
– Martha Rosler, 'The Private and the Public: Feminist Art in California', 1977

Katharina SIEVERDING
Transformer 1 A/B
1973
Digital analogue, acrylic, Perspex
2 parts, 190 × 125 cm [75 × 49 in] each

This series of works included images of performance artists Jürgen Klauke and Urs Lüthi with Sieverding, placed alongside those of androgynous rock musicians David Bowie, Brian Eno and Lou Reed. Sieverding also created photographic montages with her partner Klaus Mettig, in which their male and female faces became almost indistinguishable. Blurred boundaries and arbitrary distinctions emphasize lack of difference between self and other. For Sieverding 'the conquest of another gender takes place in oneself'. While many women artists working with images of identity were concerned with emphasizing their difference from the masculine, Sieverding explored the zones of similarity as a way to communicate 'roles, repressions … and self-extension' common to the psychology of both genders.
– all quotes from Lucy R. Lippard, 'The Pains and Pleasures of Rebirth', 1976

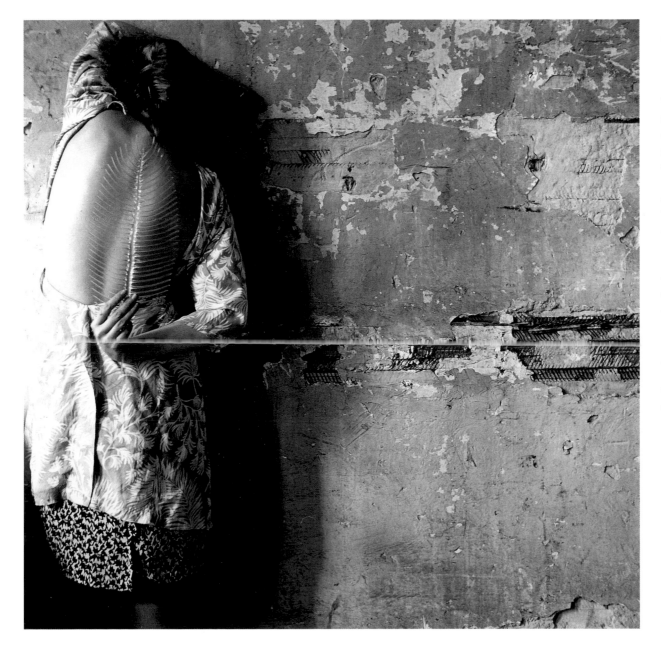

Francesca <u>WOODMAN</u>
Untitled (New York)
1979
Black and white photograph
20 × 25.5 cm [8 × 10 in]

This series of works shows the artist posed in various relationships with details of interiors; in this image the patterns on her clothing and the form of the fish bone set up a series of mediations between the artist's body and the features of the wall behind. This series of images relates to an earlier series Woodman made in 1975–76 at Providence, Rhode Island, in which her body is not distinguished from its background, as it is in later works, but seems to disappear into the fabric of a dilapidated house. Frequently blurred by movement, her body merges into the building's fragmenting structure. Abandoning overt objecthood to present herself as an 'in-between' presence, Woodman at once repels and invites the voyeurism conventionally invoked by depictions of the female body.

DIFFERENCES

In the late 1970s psychoanalytical concepts of sexual difference became influential in feminist circles. Informed by the work of post-Freudian theorists, most notably Jacques Lacan, feminist artists examined the construction of difference in visual representation. 'Difference: On Representation and Sexuality' (New Museum of Contemporary Art, New York, 1984) presented both female and male artists from the United States and Britain whose work specifically addressed the intersection of gender, cultural identity and representation. Visual artists began to focus on issues of spectatorship and voyeurism in relation to the 'Other'. Performance and installation works increasingly articulated feminist perspectives of difference across a wide range of political issues. Appropriation was explored by artists who sought no longer to make 'positive images of women' but to work critically with the existing order, exposing latent cultural meanings as well as the paternal authority inherent in notions of artistic originality.

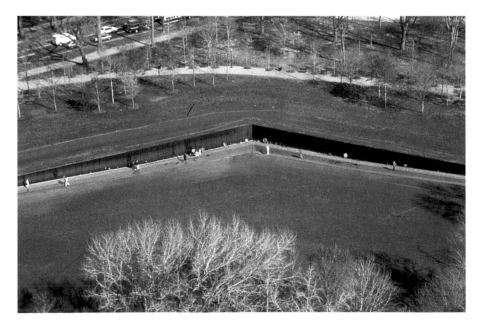

Maya LIN
Vietnam Veterans Memorial
1982
Black granite
1. 150 m [493 ft]

Lin designed a memorial which departs radically from historical notions of the monumental. In contrast to the vertical obelisk of the nearby Washington Memorial, Lin's monument is a horizontal black granite wall that descends 10 feet (3 metres) below grade level at its vertex. The wall is inscribed with the names of the more than 58,000 United States citizens recorded killed or untraced during the Vietnam war. Viewers are reflected in the surface as they read the names. The wall reaches its deepest point at the date at which the highest casualties were recorded; its incision then decreases up to the date of the US withdrawal.

'The Vietnam Veterans Memorial is not an object inserted into the earth but a work formed from the act of cutting open the earth and polishing the earth's surface – dematerializing the stone to pure surface, creating an interface between the world of the light and the quieter world beyond the names. I saw it as part of the earth – like a geode.'
– Maya Lin, Artist's statement, 1995

Judy <u>CHICAGO</u>
The Dinner Party
1974-79
Wood, ceramic, fabric, needlework, metal, paint
1463 × 1280 × 91.5 cm [576 × 504 × 36 in]

Over a hundred women collaborated on this monumental project. Thirty-nine place
settings, each commemorating a female historical or mythological figure, are placed
around an equilateral triangle formed from three tables. Each of the thirty-nine
women is represented on a hand-painted plate by an abstract form based on 'central
core' vulvic imagery; an embroidery and a chalice. On the base tiles are inscribed
a further 999 names. The work's chronological sequence traces the social origins and
decline of matriarchy, its replacement by patriarchy, the institutionalization of male
oppression and women's response to it. The work toured internationally and attracted
among the largest crowds ever to view a museum exhibit.

opposite

Harmony HAMMOND
Kudzu
1981
Cloth, wire, wood, celastic, acrylic, glitter, rhoplex, gesso, wax, charcoal powder
228.5 × 228.5 × 106.5 cm [90 × 90 × 42 in]
Collection, Wadsworth Atheneum, Hartford, Connecticut

'When I was driving into North Carolina in the early 1980s as a visiting artist, I saw this huge vine that seemed to grow everywhere, engulfing houses and whole stands of trees on the hillside. When I asked what it was called, I was told "Kudzu". "Kudzu" was brought into the south east over a century ago to control soil erosion but because it grows so quickly is now out of control. It seemed like the perfect metaphor for racism, homophobia and xenophobia, or people's fears of that which is "different".'
– Harmony Hammond, Artist's statement, 2000

Hammond's work often combines painting and sculpture in an attempt to acknowledge and develop the political dimensions of abstraction. Her identitification with lesbianism, and the possibility of articulating this through abstract works, emerged during her participation in the AIR (Artists-in-Residence) gallery project in New York in the early 1970s. The in-between, transitional state of Hammond's objects and narrative-like juxtapositions suggests metaphors for change. Hammond's work shows us a different view of the agricultural landscape, a terrain marked not by beauty but by hardship and struggle, exploitation and grief.

Harmony HAMMOND
Kudzu

Jaune Quick-to-See SMITH
Site: Canyon de Chelly
c. 1985
Oil on canvas
142 × 107 cm [56 × 42 in]

Smith's consistent point of reference is her childhood experience on the lands of the Salish and Kootenai peoples of Montana, followed by a long period of formal European-American education. Among the most noted Native American artists, curators and environmental activists of her generation, Smith was initially discouraged from pursuing art because she was a woman. Forging alliances with the women's movement in the 1970s, she developed a feminist approach to the incorporation of materials, patterns and techniques traditionally associated with women's labour. In paintings and collages she combines these with references to the Modernist abstraction of artists such as de Kooning and Rauschenberg, to create an intercultural dialogue. In 1985 she curated, with Harmony Hammond, 'Women of Sweetgrass, Cedar and Sage', an exhibition of paintings, drawings and objects made by Native American women, at the American Indian Community House, New York. 'Like New York artists incorporating and reacting to western art history, we respond to our visual history while crossing into new territories. But in this case we are bridging two cultures and two histories of art forms.' Smith's later work, particularly her use of collage, is not without humour in its critique of the Western canon: 'Humour has been a panacea for what ails. The women tend to express their humour in a more subtle way than the men … Humour is considered to have a role alongside the art forms, the landscape, storytelling and religion. Humour is a mainstay of Indian life.'
– all quotes from Jaune Quick-to-See Smith, 'Women of Sweetgrass, Cedar and Sage', 1985

Untitled (Film Still) No. 3
1977
Black and white photograph
20.5 × 25.5 or 76 × 101.5 cm [8 × 10 or 30 × 40 in]

In 1973, while still at college, Sherman had produced a series of photographs in which she altered her face with make-up and hats, taking on different personae (*Untitled A–E*). This fascination with self-transformation led her to dress up in different costumes when attending gallery openings and events in her home town of Buffalo, New York State. When she moved to New York City she began a series of photographs documenting her role-playing in the series *Film Stills*, in which she posed as a variety of familiar but unidentifiable film heroines. Sherman leaves the viewer free to construct a narrative for each character, thus implicating the spectator in the voyeuristic nature of these images. At the same time, by offering so many different characters within the series, Sherman undermines any attempt to fix identities.

In many images Sherman appears as a seductress, caught in a moment of pensive contemplation, looking in the mirror, lying on her bed – traditionally 'feminine' reflective activities. Speaking of these images Sherman said, 'to pick a character like that was about my own ambivalence about sexuality – growing up with the women role-models that I had, and a lot of them in films, that were like that character, and yet you were supposed to be a good girl'.
– Cindy Sherman, 'Interview with George Howell', 1995

Cindy SHERMAN
Untitled No. 87
1981
Colour photograph
61 × 122 cm [24 × 48 in]

Following her untitled black and white film stills in the early 1980s, Sherman made a group of horizontal colour images. These less obviously stereotypical images of women in unidentifiable spaces were often photographed from above. The horizontality of these photographs, the facial expressions of the women, the viewing position and dramatic lighting used, were interpreted in different ways. Film theorist Laura Mulvey saw these images as a further development of mechanisms of masquerade. In her 1993 essay 'Cindy Sherman: Untitled', art historian Rosalind Krauss discussed these works in terms of the new signifiers developed in them (backscreen projection, colour and point of view) rather than in terms of character and role. She writes of both high art's and the mass media's insistent use of the vertical and suggests Sherman's transition from the vertical to the horizontal in these photographs indicates her interest in desublimation. This is further developed in the intense lighting contrast that complicates the relationship between the three- dimensional form of the figure and the background.

Sherrie LEVINE

Untitled (After Walker Evans No. 3, 1936)
1981
Gelatin silver print
25.5 × 20.5 cm [10 × 8 in]
Collection, Metropolitan Museum of Art, New York

In presenting an identical photograph of the famous original, Sherrie Levine appropriates, literally takes, Walker Evans' image of an impoverished woman during the 1930s depression. The images by male photographers and artists which Levine appropriates invariably have as their subjects images of the 'Other' – women, nature, the poor. Levine's action not only highlights the paternal authority invested in the original image but reveals how the original in turn represents an act of appropriation in relation to its subjects.

Karen KNORR

Connoisseurs (detail)
1986
Colour photograph, brass plaque
103 × 103 cm [40.5 × 40.5 in]

A brass plaque placed beneath this image when it is exhibited, states 'The Genius of the Place'. Knorr often produces her work in series, specifically to contest the value system signified by the single work. The sequences of images in a series, each with a caption-like text either printed onto the photographic paper as an integral part of the work or on a separate plaque beneath, can be read as fragmented narratives with no fixed beginning or closure. Knorr's works from this period, which include 'gentlemen's clubs' among their subjects, appropriate the high society genres of group portraiture and photography of interiors, transforming the material into what the artist describes as non-portraiture – a commentary on the social mores of privileged patriarchal groups.

Living Room Corner, Arranged by Mr and Mrs Burton Tremaine, New York
City
1984
Cibachrome
71 × 99 cm [28 × 39 in]

The artworks in this photograph are presented as two objects among other decorative
commodities within the domestic environment of the collectors' home. Lawler's
photographs showing artworks as they are privately, commercially or institutionally
displayed draw attention to the conditions surrounding the reading of art; they
investigate the social role of placement or position in the production of meaning.
Lawler's focus suggests that meaning derives not from the internal order of an
artwork but from its context. It is variable rather than fixed and depends on its cultural
and historical surroundings.

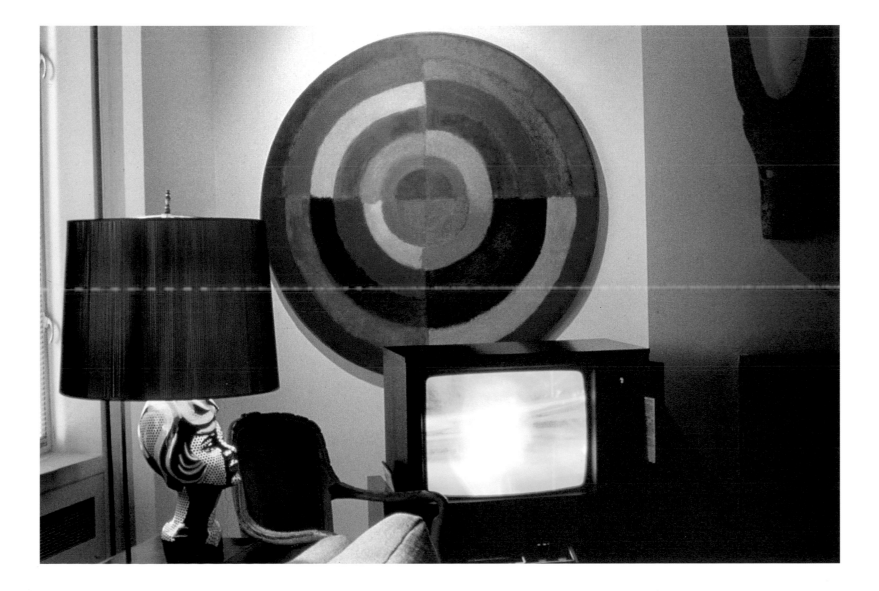

Living Room Corner, Arranged by Mr and Mrs Burton Tremaine, New York
City

Marie YATES
Image-Woman-Text (detail)
1980
Colour photographs, photocopies, text
2 panels, 107.5 × 107.5 cm [48 × 48 in] each

Two composite panels display photographs of women's faces. In the first panel the photographs exist as photocopies which have been overpainted in a gestural style. In the second panel the same photographs are reproduced with a high gloss finish. Texts are either overprinted onto the image or appear on the white paper backing of corners of the photographs which are folded over. Interrupting the images the texts reproduce unanchored statements from various non-specific perspectives alternating between first, second and third person voices: 'In a dream'; 'I thought something was wrong'; 'The sight made her gloomy'. The images appear de-individualized, reduced to anonymous formats and styles of representation. In the process of attempting to decipher the work the viewer encounters ways in which the imaging of women is connected to the projection of fantasies.

Silvia KOLBOWSKI
Model Pleasure I, Reposition
1984
Cibachrome
41 × 51 cm [16 × 20 in]

The *Model Pleasure* series, begun in 1982, consists of ten works, each composed of a grouping of images taken from fashion and advertising plates which are rephotographed and reassembled. In reframing these images and drawing attention to their construction, Kolbowski accentuates the double meanings which the advertising industry employs in its uses of images of women. Her work seeks to understand how idealized images are projected in the context of consumerist industries, exploring the masculine attempt to fix woman within a system of spectacle, as object of the controlling gaze. *Model Pleasure I* (1982), which includes four spotlit found photographs, is rephotographed and reduced in size within the frame of the resulting work, *Model Pleasure I, Reposition*. Here the 'void' surrounding the image inset within it is itself subjected to scrutiny. It disrupts the conventional trajectory of vision associated with male positions of control over visual spectacle.

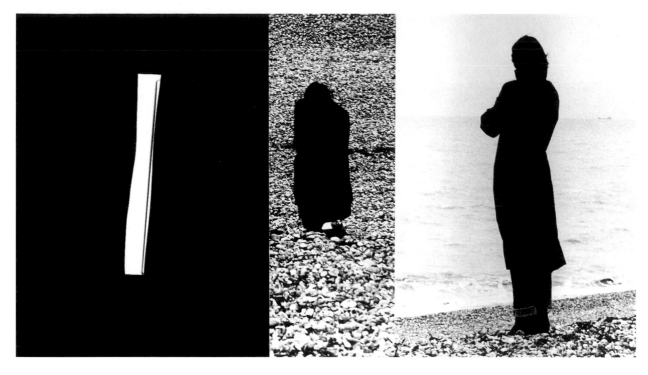

Open Rings and Partial Lines
(detail)
1983–84
15 black and white and colour
photographs
58.5 × 81 cm [23 × 32 in] each

This photographic series is suggestive
of filmic narrative; however, the
fragmentary sequence of the images
renders such a reading elusive.

'I have attempted to bring into play the
basic assumptions of the classical model
of communication, i.e. subject/object,
sender/message/receiver. In short, to
open up these communications and not
to take them for granted. So … in the
work I have attempted to produce an
assemblage where a "middle" or "third"
term neither unifies nor fragments
nor divides.'
– Yve Lomax, Artist's statement, 1983

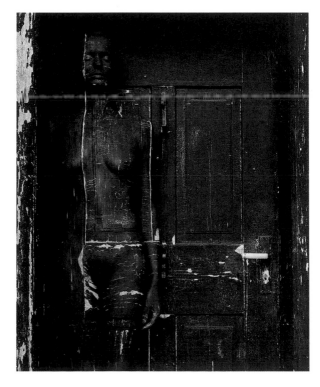

VERUSCHKA (Vera Lehndorff
& Holger Trulzsch)
Black door to the garden, Peterskirchen
1975
Dye transfer on paper
30.6 × 29.6 cm [12 × 11.75 in]

A celebrated fashion model of the 1960s, Veruschka (Vera Lehndorff) began to make
artworks in the 1970s. In collaboration with the photographer Holger Trulzsch, she
staged her body, camouflaged with water-based theatrical paint, to effect its partial
or complete merger with urban or natural environments. This reversal of the conven-
tional codes of representation dominant in nude photography allowed Veruschka
to transform and control her relation to the camera as a naked female subject.
' … There is something far more aesthetically engaging and philosophically astute
than a thing's appearance, and that is a thing's disappearance … In Zen meditation
the meditator is absorbed into the perceived object, becoming 'the same thing'.
The goal of the images … is the merger of the body with the found environment,
but the body never disappears completely. The extent of its absorption into the
background is the psychic charge of the image.'
– Gary Indiana, 'Ex-Model Found in Wall', 1985

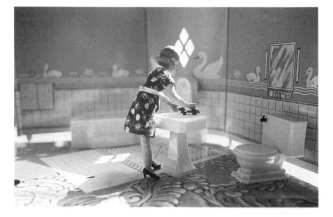

Laurie SIMMONS
First Bathroom (Woman Standing)
1978
Colour photograph
15 × 23 cm [6 × 9 in]

A number of artists have used staged photographs to create fantastic or surreal environments. Simmons' scenarios, although seductive and humorously kitsch, ultimately focus on the banality and constriction of women's everyday lived experience. The tiny 1950s style plastic women concentrate on domestic tasks or occasionally go on outings; whatever they are doing, they appear to be 'programmed', their dream house environments becoming prisons of depersonalization.

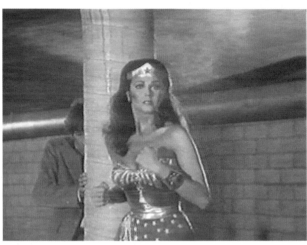

Dara BIRNBAUM
Technology/Transformation: Wonder Woman
1978-79
Video
6 mins., colour, sound

Footage from the 1970s TV series *Wonder Woman*, in which an ordinary woman is transformed into a superhero, is spliced together so that the heroine is repetitively spinning, running and fighting. The repetition of these special effects is juxtaposed with the original soundtrack, which has been subjected to the same formal procedures as the images. The second part of the video includes the lyrics of the pop song 'Wonder Woman', reproduced in white letters on a blue background, drawing attention to its sexist and politically reactionary ideology. Through a complex series of manipulations Birnbaum's work draws attention to and transforms the ideological messages which underlie technologically mediated mass cultural forms.

Laurie ANDERSON
United States
1979-83
Multimedia performance and recording

Anderson's seven-hour opus is divided into four sections – *Transportation*, *Politics*, *Money*, *Love*. Broadening her focus from the personal, autobiographical tone of her earlier solo performances, *United States* is a multimedia examination of the social codes, linguistic and sign systems by which information is transmitted and received in urban society, and of their ideological implications. Fast-changing projections of a wide range of urban imagery create a sense of geographical and temporal dislocation, compounded further by Anderson's multivocal narratives and her fusion of human and synthetic, technocratic messages and sounds. Further undermining the stability of her identity as performer through parody and quotation, Anderson assumes an almost shamanistic role, both orchestrating and mediating the messages of a technocratic society.

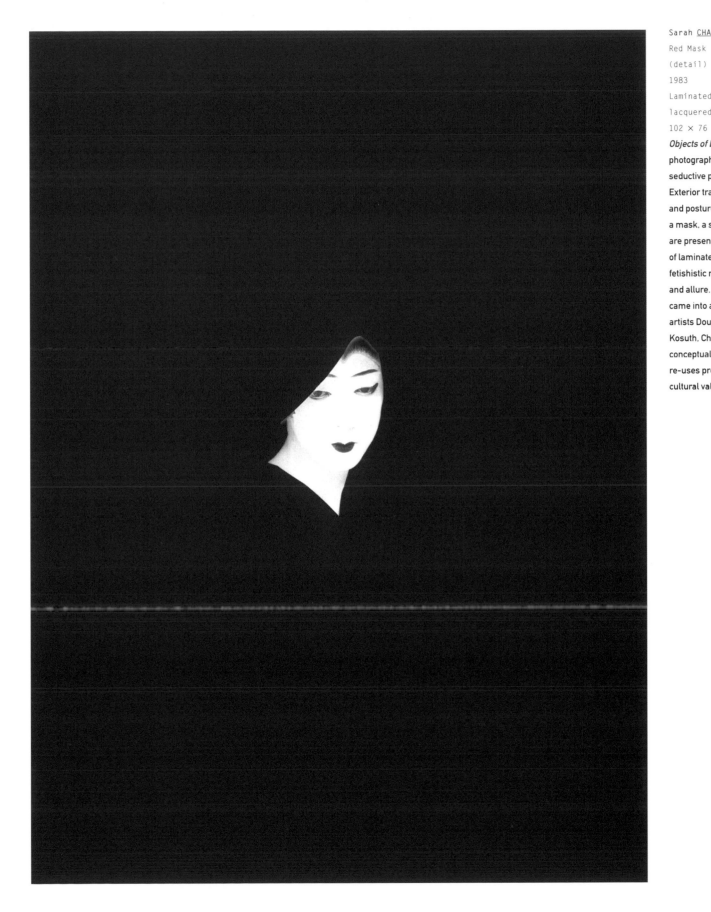

Sarah <u>CHARLESWORTH</u>
Red Mask (from Objects of Desire)
(detail)
1983
Laminated cibachrome print,
lacquered wood frame
102 × 76 cm [40 × 30 in]
Objects of Desire is a series of
photographs which examine the
seductive powers of photography.
Exterior trappings of identity, the forms
and postures of seduction – a scarf,
a mask, a shock of blonde hair –
are presented within the high sheen
of laminated surfaces, emphasizing the
fetishistic nature of their significance
and allure. Since the late 1960s when she
came into association with Conceptual
artists Douglas Huebler and Joseph
Kosuth, Charlesworth has made
conceptual photographic work which
re-uses pre-existing imagery to explore
cultural values.

Jenny HOLZER
Truisms
1977-82
Spectacolor sign
Project, 'Messages to the Public', Times Square, New York, 1982

Holzer began to make *Truisms* after she moved from Rhode Island to Manhattan
in 1977 to join the Whitney Museum of American Art's Independent Study Program.
Adapting the language-based practice of her male Conceptual art predecessors for
an interventionist, more directly politicized use, Holzer extensively researched social
statements such as truisms from a wide range of sources. She adapted this material
to construct texts that mimic the authoritative voices of capitalism and mass culture.
By making the statements gender neutral, and presenting them as if they were
familiar and accepted, Holzer highlighted the subliminal influences of social
conditioning on the unconscious. Originally printed in black type on white paper and
pasted, anonymously, onto walls around Manhattan, the *Truisms*, and other related
series, were later presented in a range of media which included printed T-shirts,
billboards and electronic signs.

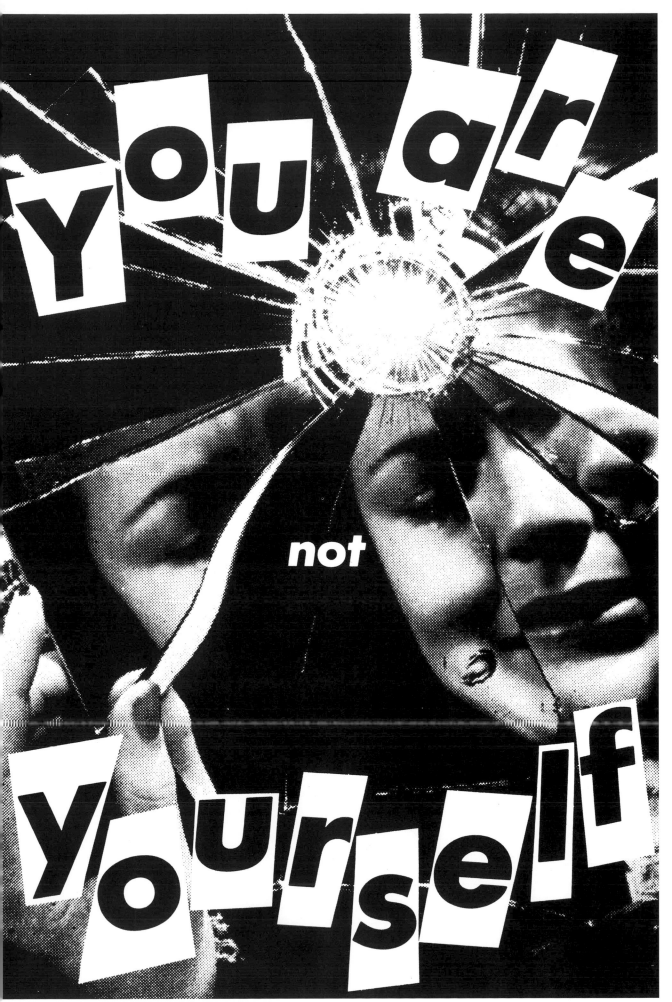

Barbara <u>KRUGER</u>
Untitled (You are not yourself)
1982
Black and white photograph
183 × 122 cm [72 × 48 in]

Barbara Kruger's work of the early 1980s registers her generation's turn away from the immediately preceding strategies of feminism. Female solidarity had been explored and celebrated but it was now perceived that there had been a failure to challenge the fundamental ideological structures from which discrimination emanates. In 1982, alongside making her work, Kruger began to write criticism which addressed latent ideologies in cinema, a prevailing subject of feminist theory in which gender and sexuality came increasingly to be perceived as constructions produced through the signs of representation. Kruger, who had formerly worked as a commercial graphic artist, directed her focus to the media's strategies of producing normalized subjects, who conform to its ideological, social and economic orders. Like Holzer, she observed that coercion was effected through the way we receive verbal or visual messages, as we consume the codes circulated by anonymous sources of power. Kruger sought to intercept this process and reverse its logic. When she deploys the personal pronouns 'I', 'me', 'we' and 'you', known in linguistics as 'shifters', instead of being invested with the coercive authority of advertising, they begin to reveal ways in which the place of the viewer in language is indefinite, refusing alignment with gender. Rather than 'masculine' or 'feminine' positions, there emerges an interplay between 'active' and 'passive' relations.

Heart-shaped Bruise, New York City, 1980 (from The Ballad of Sexual
Dependency)
1980
Colour photograph
Dimensions variable

Since the early 1970s Nan Goldin has documented every aspect of the lives of herself
and her intimate friends. '*The Ballad of Sexual Dependency* is the diary I let people
read ... There is a popular notion that the photographer is by nature a voyeur, the last
one invited to the party. But I'm not crashing; this is my party. This is my family, my
history ... I don't ever want to be susceptible to anyone else's version of my history.'
– Nan Goldin, *The Ballad of Sexual Dependency*, 1986

The work was first shown at the Mudd Club, New York, in 1979, as a slide show
accompanied by recordings of contemporary rhythm and blues and rock ballads.
An ongoing project, it has been shown in many venues and formats around the world,
ranging from nightclubs to art centres. In 1986 one definitive selection of images
from the series was published in a book of the same title. Goldin's own experiences,
transformations and relationships are seen as interdependent with those of the
friends who shape her sense of a recreated family and whose trust establishes
the basis of her representational frame.

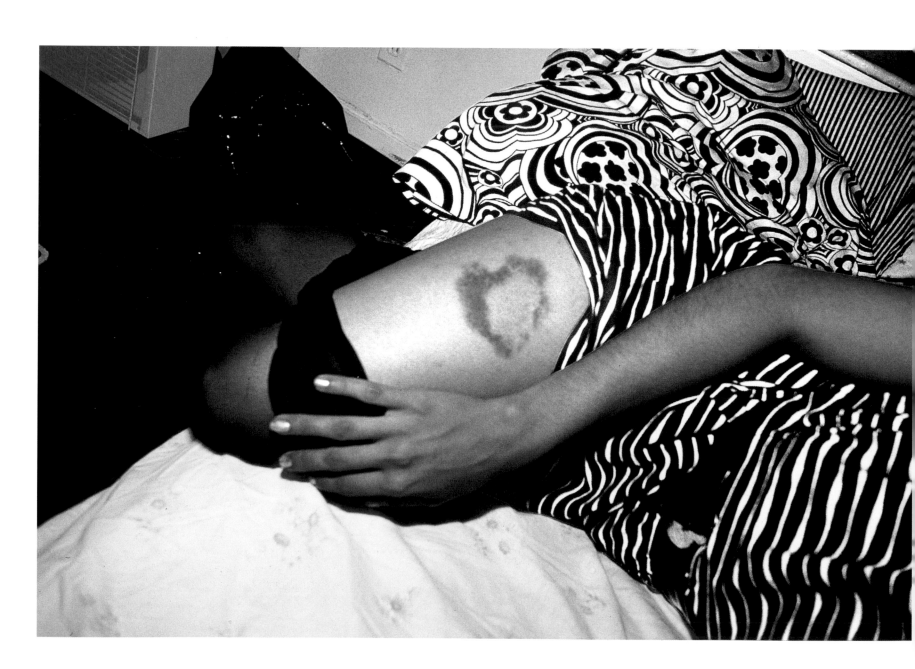

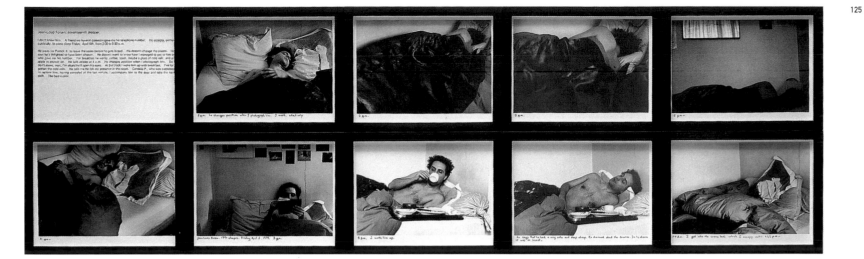

Sophie CALLE

The Sleepers (Jean-Loup Forain) (detail)

1979

Black and white photographs, text

Dimensions variable

When Calle returned to her home city of Paris after a period of seven years travelling, she felt compelled to begin a series of projects to reacquaint herself with the city, its people and herself. At this stage, she did not view her activities as art which could be exhibited, but as private social experiments which were of personal significance. She entered a series of real life roles, including that of a striptease artist, which she fulfilled for a limited time and documented. In this work she invited strangers to come into her apartment and sleep in her bed when she was not using it. She documented their presence there, and her conversations with them, as they explained why they had responded to the invitation and described their lives and their patterns of work and rest.

Sophie CALLE

Suite vénitienne

1980

Black and white photographs, text

Dimensions variable

Suite vénitienne documents Calle's journey to Venice in pursuit of a man whom she had seen briefly at a party in Paris. He did not know that he was being followed. She located the hotel in Venice where he was staying and photographed her subject at every opportunity, recording the places he visited and what he himself photographed. Over a two-week period, disguised by a blonde wig, Calle learned his plans by questioning people in the shops and bars he had visited. He eventually discovered that he was being followed and confronted her. She took a different train from him back to Paris in order to wait for his arrival and take her last picture. The photographs are presented in sequence with a text below describing the course of events. In 1988 the French theorist Jean Baudrillard wrote an essay describing this project in terms of a reciprocal loss of will on the part of both the pursued and the pursuer. This was published alongside the artist's work in a book of the same title.

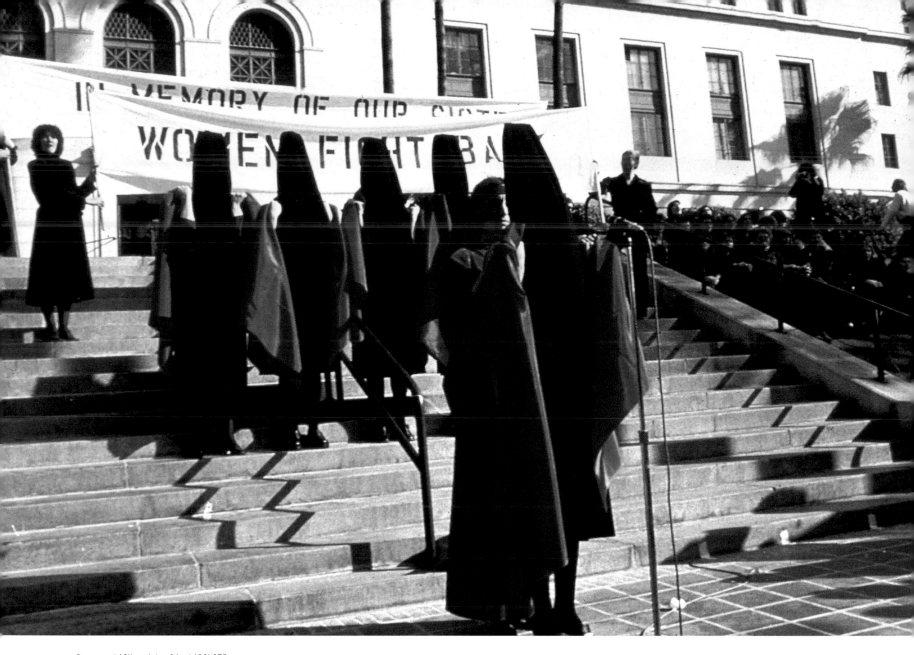

Suzanne LACY and Leslie LABOWITZ

In Mourning and in Rage

1977

Performance

Los Angeles City Hall

This action, Lacy's first collaboration with Labowitz, formed a powerful and succesful protest against the local media's sensationalized coverage of a series of rape-related murders of women in Los Angeles. Media reports had exploited women's fears and vulnerability for commercial gain, offering no access to support lines, participatory debate, or other means of empowerment. The artists and their collaborators co-ordinated the support of local council officials and others in their actions, which effected a swift turnaround in the attitudes of the newspaper journalists and TV broadcasters. For *In Mourning and in Rage*, both a memorial and a public address, black garments worn by the women participants symbolized mourning; the costumes created an artificial sense of height, transforming the women into seven-foot high, powerful presences; red shawls evoked both pain and anger. This action was one of the major events in a city-wide Los Angeles project centred on abuse of women, *Three Weeks in May*, organized by Ariadne: A Social Network. Founded by Lacy and Labowitz, Ariadne evolved into a nationwide organization for women.

Hannah <u>WILKE</u>

What Does This Represent? What Do You Represent? (Reinhardt)

1978-84

Black and white photograph

152.5 × 101.5 cm [60 × 40 in]

In 1945 the New York school painter Ad Reinhardt drew a cartoon of a man pointing to an abstract painting, jeering, 'What does this represent?' Below, the painting reconfigures itself into an angry face, sprouting legs and a pointing arm, shouting at the bewildered man, 'What do you represent?' In Hannah Wilke's work the artist, naked except for make-up and stiletto heels, wearing an ambiguously victimized and defiant expression, sits with legs spread so that her genitals are placed at the centre of the image. Reinhardt's text is printed over the area of the floor, on which are scattered 'boy's toys', including model pistols and machine guns. The piece redirects Reinhardt's ironic word play specifically towards the balance of power in gender representation. This work is part of Wilke's *So Help Me Hannah* series of self-portrait performances, recorded on video between 1979 and 1985. Each image is overprinted with quotations from male artists and philosophers.

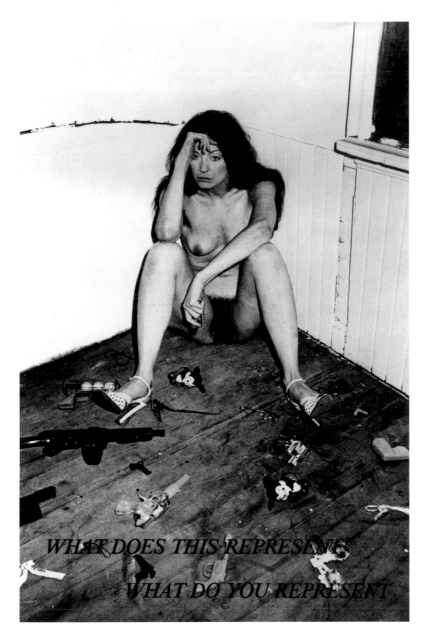

WHAT DOES THIS REPRESENT

WHAT DO YOU REPRESENT

Marina <u>ABRAMOVIC</u> and <u>ULAY</u>

Relation in Time

1977

Studio G7, Bologna

Marina Abramovic and Ulay sat for sixteen hours, back to back, tied together by their hair, without any movement, isolated from the audience. When this time had elapsed, viewers could enter. The artists held their pose for a further hour. The gaze of the artists outwards rather than towards each other rendered both vulnerable to the audience's direct gaze. However, direct engagement by the audience was denied by inviting them to enter the room towards the end of the performance, leading to a sense of intrusion. The physical and emotional bond between the artists forged by the action heightened both their mutual closeness and their distance from the audience. When Abramovic and Ulay began to collaborate in 1976 they spoke of themselves collectively as an androgynous being. The series of relation works they performed in the mid 1970s moved between socially defined poles of masculinity and femininity, engaging spectators in their own exploration of the boundaries of relationship.

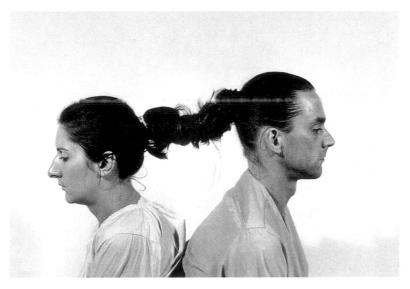

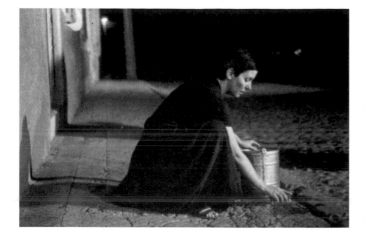

Diamela ELTIT
Maipu
1980
Santiago, Chile

Eltit inflicted cuts and burns on her arms and legs before going to a brothel where she read aloud part of a novel she had written. She then washed the pavement in front of the brothel. 'The self-mortification of her body testifies to a refusal to accept the model of beauty which makes a fetish of the woman … In all of Eltit's work the woman is mainly portrayed in situations which locate her on the edge of the social system, or on the verge of always being excluded from its symbolic contract. These situations exacerbate her sense of alienation in a world ruled by masculine representations; borderline situations where she has to make the most of her relationship to language and its codes of representation and reality.'
– Nelly Richard, 'The Rhetoric of the Body', 1986

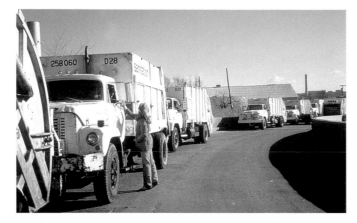

Mierle Laderman UKELES
Touch Sanitation
1979-80
New York

This project was begun on 24 July 1979 and continued until 26 June 1980, the time it took Ukeles to travel with and work alongside every single one of New York's 8,500 sanitation workers. The project required her to shake hands with every one of these workers in order to represent a 'healing vision' and 'share' in the housekeeping of the city, a 'maintenance ritual act celebrating daily survival'. Ukeles drew attention to the maintenance activities of daily life, those chores that women regularly assume and without which society would fall apart. She sought to highlight the fact that the enacting of these chores is generally taken for granted, and those who maintain our cities receive no acclaim.

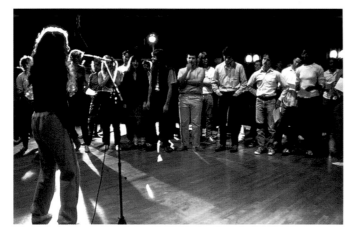

Adrian PIPER
Funk Lessons
1982-84
University of California at Berkeley

Piper enacted a series of collaborative performances with both large and small audiences. Funk has its origins in African tribal music and dance, where the concern is with participation as a collectively shared experience of pleasure and unity. Piper began by introducing some of the basic dance movements to the white participants, discussing their cultural and historical meanings and their roles within black culture. The participants would then rehearse, internalize and improvise on these movements. Piper concentrated on the structural features, major themes and subject matter that define funk music and its relation to disco, rap, rock, punk and new wave. Her performances attempted to overcome cultural and racial barriers and divisions between high and low culture in order to politically activate these spaces.

Howardena PINDELL
Free, White and 21
1980
Video
12 mins., colour, sound

This piece is a video self-portrait that recounts several of Pindell's experiences as an African-American woman growing up in the United States. It recounts her childhood experience of being cared for by a white babysitter; her experiences in kindergarten; as a student in high school; in university; receiving a job rejection; and finally being treated badly at a wedding, as the only black woman present. During these accounts a white woman interjects with: "you don't exist until we validate you"; "and you know, if you don't want to do what we tell you to do then we will find other tokens"; and finally: "and you really must be paranoid. I have never had experiences like that. But, of course, I am free, white and twenty-one" The work directly criticizes white feminists and the racism prevalent within the art world. Pindell worked with the Heresies collective and other feminist groups. This video was first shown in the exhibition 'Dialectics of Isolation: An Exhibition of Third World Women Artists in the United States' in September 1980 at AIR Gallery, New York, curated by the artist Ana Mendieta.

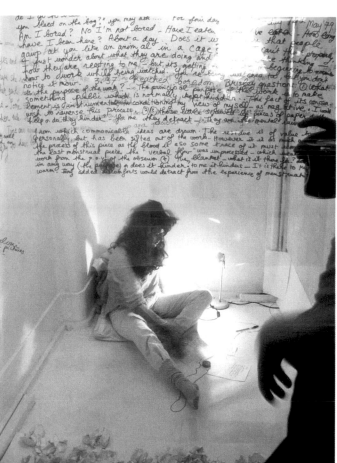

Rose FINN-KELCEY

Mind the Gap

1980

'About Time: Video, Performance and Installation by 21 Women Artists',
Institute of Contemporary Arts, London, and Franklin Furnace, New York

'Two parallel running tracks were marked out on the floor, heading in opposite directions, each into a dead end. Facing each other across the tracks were a large block of ice and a treadmill/moving carpet … A small flickering tongue of electric light on a stand, a Marconi radio facing a microphone, rows of chairs for the audience, these completed the scene. We took our seats and were soon enveloped in the sound of numbing musical platitudes, supermarket muzak, absurdly contrasting with the formal beauty of the installation … Rose's recorded voice periodically overlaid the music. Each insertion described a working idea, generally discarded, occasionally carried out. "The steam from six kettles against the energy produced by her running on the treadmill. Could she outlast the evaporating water?" … Was the artist ever going to appear? Her recorded voice had claimed that she would not … As I was concluding that she would not appear, Rose emerged from the darkness … She was carrying two weightlifter's dumb bells linked by a fine wire. With great care, she hung them over the block of ice and left them to rotate gently … A man's voice on the tape read a passage from Mary Kelly's Frankenstein in which the inventor faces his own creation. Here we can identify the artist exhausted as her creation comes to life and she can see that it has inherited all the imperfections of its creator's intentions. The treadmill at last came into lumbering life. Rose climbed onto the machine … she broke into a slow jog … Rose became a ghostly figure, headless and handless, as the ultra-violet light picked out only her clothes. The white figure then disappeared. The tape ended with the shattering sound of an earth rift and the all clear siren …

'I sense the danger of continually focusing on the hardships and contradictions facing the woman artist, but in this image of the runner, Rose Finn-Kelcey has been able to produce a positive, powerful work which sacrifices nothing to truth but, in the use of ambiguity, irony and sharp observation, has been able to transcend what can so easily become a self-defeating pessimism.'

– Catherine Elwes, 'Rose Finn-Kelcey, Mind the Gap', 1980

Catherine ELWES

Menstruation

1979

A three-day performance at the Slade School of Art, London, to coincide with the duration of a menstrual period, this work was also presented in 1980 in the 'About Time' exhibition at the Institute of Contemporary Arts, London. Dressed in white, against which the menstrual blood was visible, Elwes inhabited a glass-fronted white box-like room. She was asked questions by the audience to which she responded by writing on the walls and the glass. The work was intended to reconstitute menstruation as a metaphorical framework by giving it the authority of cultural form and placing it within an art context.

'My work currently involves my presence as a live element interacting with pre-recorded dialogues or monologues. I try to set up a network of shifting identities that draw the viewer/listener in at various levels. In this way I allow her/him a freedom within the work to make a series of identifications or deductions that enable her/him to complete the "story". Time past, present and future is the medium through which memories, fantasies and projections emerge as a sequence of fluctuating images. The work reflects the social and psychological position I share with many women of my generation. I inherited a set of values that were challenged in the 1970s by a growing awareness of the women's movement. I saw the possibility of freeing myself from an old order that restricted my development as an individual and as an artist … I base my work on a continued analysis of that past in order to build an understanding of present conflicts as a bridge to a possible future.'

– Catherine Elwes, 'Each Fine Strand', 1980

Rose <u>GARRARD</u>
Beyond Still Life
1980
'About Time: Video, Performance and Installation by 21 Women Artists',
Institute of Contemporary Arts, London, and Franklin Furnace, New York

From a revisited childhood incident Garrard developed a performance exploring relationships between representation and female subjectivity within a perspective of layered time. Seeing her older brother kill a sparrow had overwhelmed her capacity to express her feelings, afraid that her expression of outrage would be perceived as weakness. She had quietly retrieved the dead bird and placed it next to a book and vase she was painting at the time, in an attempt to create a 'still life'. In Garrard's performance, a book recreating this scene lay open at the myth of Pandora, from which extracts were read by a recorded male voice. 'Recalling this small but traumatic event to which I remained a passive observer, led me to examine my detached "still life" roles – the artist as observer, the passivity of the female model – and the role of active performer seen usually as a scene of masculine power ... the prejudiced roles of these familiar stereotypes are questioned as the artist alternates between being performer, subject and spectator in relation to the objects.'
– Rose Garrard, Artist's statement, 1980

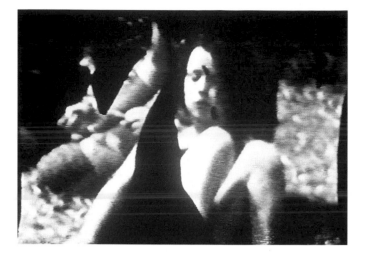

Tina KEANE
In Our Hands, Greenham
1984
12 video monitors, coloured spotlights, scaffolding
Dimensions variable

Set within a blockade-like structure, twelve video monitors show women peace campaigners at Greenham Common, England, a major site of United States nuclear missile installations during the 1980s. The women join hands around the base's perimeter fence, into which they weave strands of wool, decorating it with family photographs and personal memorabilia. These images are juxtaposed with film of a spider spinning its web; the imagery is framed by the outline of a woman's hands. 'The symbol most closely associated with the women's peace movement is the weaving of webs. Each link in a web is fragile, but woven together creates a strong and coherent whole.'
– Alice Cook, Gwyn Kirk, *Greenham Common Everywhere*, 1984

Margaret HARRISON
Common Land/Greenham (detail)
1989
Installation of found objects, painting, wire fence
Dimensions variable

Harrison's installation, exhibited in Britain and the United States, connected the political issues and symbolism of the women's peace movement with debates about feminist painting and the representation of landscape. Since 1981, when the peace camp was first established at Greenham Common, the women had been charged with trespass. In their defence they argued their historic rights to occupy common land. At Greenham, issues of power, property, ecology and gender converged. Harrison's installation recreated the women's action of festooning perimeter fences with clothes and other symbolic objects and included quotations from both protestors and their military adversaries. The landscape paintings incorporated in the work challenged the ahistoricism of romanticism, portraying landscape as a genre of historical and political transformation.

Mona HATOUM
Under Siege
1982
Aspex Gallery, Plymouth

In this performance the naked artist struggled to remain standing in a transparent plastic cubicle filled with wet clay, repeatedly slipping and falling. Three different soundtracks of revolutionary songs, news reports and statements in English, French and Arabic created a sound collage that filled the space. This work functioned as a statement about the persistent struggle endured by marginalized groups in a state of constant seige, an experience Hatoum had encountered as a Palestinian woman in European society, unable to return to Beirut because of the war. One week after this performance Lebanon was invaded and Beirut was under siege.

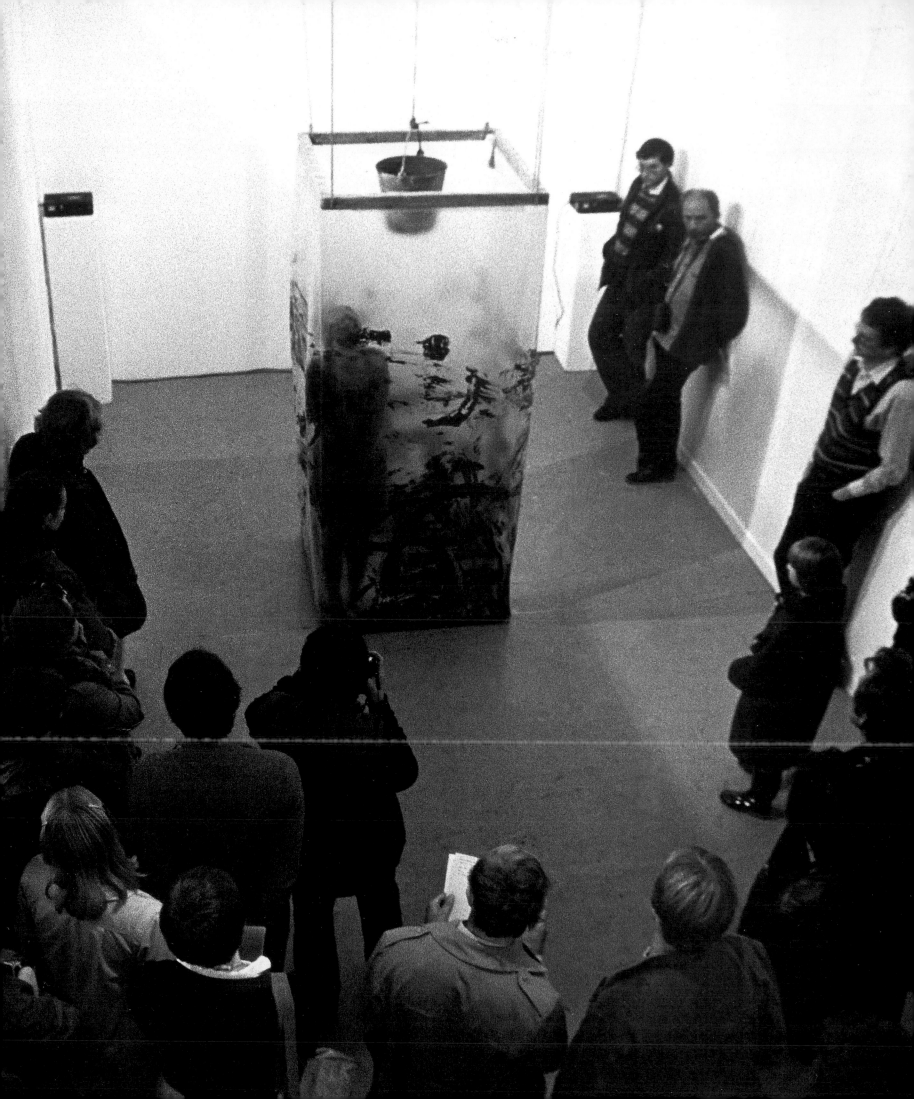

IDENTITY CRISES

A number of feminist artists had become internationally successful by the close of the 1980s. Theoretically engaged work was widely debated in art journals such as *Artforum* and *October*. Artists explored the subversive possibilities of female spectatorship. A new generation of African-American and black British feminist artists explored the intersection of racial and sexual identities and the legacies of colonialism, and drew attention towards the dominance of white women within feminism. Female performance artists questioned distinctions between art, popular culture and lived experience, and explored bodily taboos. These artists were especially vulnerable in the United States 'culture wars' of the late 1980s. Conservative politicians attacked public arts funding for work which gave voice to the 'transgressive' expression of communities marginalized through gender, racial and sexual exclusion. Graphic activists responded, addressing the political dimensions of rape, abortion, AIDS, and the continuing marginalization of women in the art world's institutions.

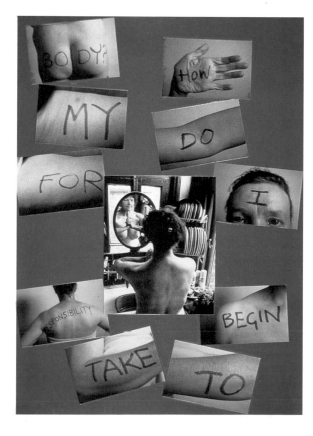

Jo SPENCE
How Do I Begin to Take Responsibility for My Body?
1985
Colour photomontage
70 × 50 cm [27.5 × 19.5 in]

In 1979 Spence was diagnosed with breast cancer. Rejecting conventional treatment, she explored holistic therapy, and the personal and feminist political dimensions of living with cancer. Spence used the term 'photo-therapy' to define her collaboration with the photographer Rosy Martin. In this image, the central photograph by Maggie Murray of Spence performing breast-strengthening exercises before a mirror is surrounded by 'images of my fragmented body which had been written on and staged for the camera in a photo therapy session with Rosy Martin. My aim is to try and form a bridge between work done on health struggles, usually dealt with through documentary photography, and work done on body as image. An understanding of how these spheres relate seems to me essential to being healthy and well balanced.' – Jo Spence, *Putting Myself in the Picture: A Political and Photographic Autobiography*, 1985

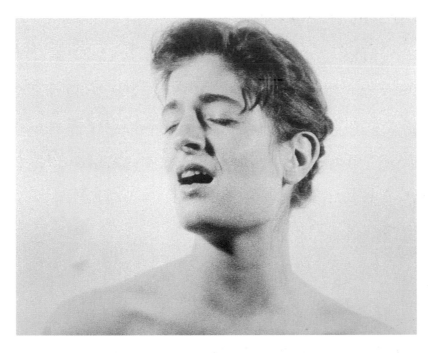

Hear Me with Your Eyes
1989
Black and white resin coated
prints and chromogenic print
mounted on wood screen
Triptych, 249 × 310 cm [98 × 122
in] each

Cadieux's huge photographic panels
portraying close-up images of the
human face or body evoke conflicting
emotions in tension – fear and euphoria,
desire and repression, articulation and
silence. They raise questions about the
relationships between the body, desire
and gesture in the face of contemporary
crises of subjectivity. Their large-scale
format imposes a claustrophobic
response, refusing the viewer the
reassurance of distance. At the same
time, however, they also suggest an
oceanic sense of emotional and
expressive release. One of the work's
relationships to other media is the use
of the visual lexicon and limitations of
cinematic frames for the representation
of pain or desire. Cadieux addresses the
idea of the sublime, freezing moments
that seem to have the potential to disrupt
or transcend the limits of signification.

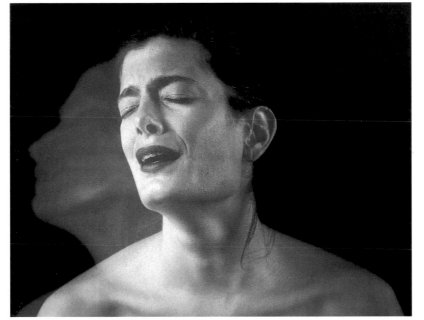

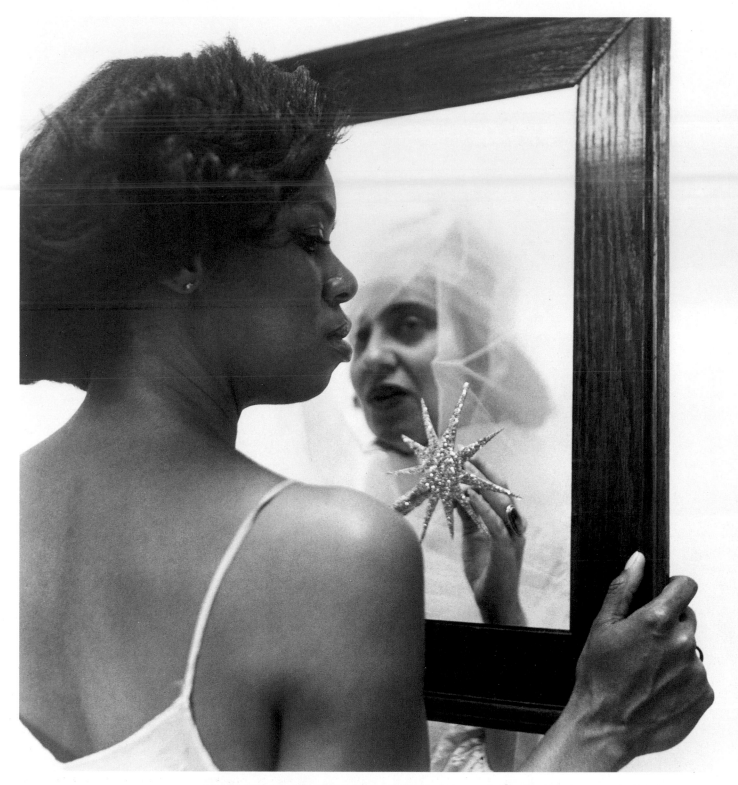

LOOKING INTO THE MIRROR, THE BLACK WOMAN ASKED, "MIRROR, MIRROR ON THE WALL, WHO'S THE FINEST OF THEM ALL?" THE MIRROR SAYS, "SNOW WHITE, YOU BLACK BITCH, AND DON'T YOU FORGET IT!!!"

Carrie Mae <u>WEEMS</u>
Mirror, Mirror
1987-88
Gelatin silver print
51 × 41 cm [20 × 16 in]

Weems has worked since the mid 1980s with visual and verbal narratives that
address African-American experience of racial and gender stereotyping and
oppression. She offers possible strategies for black women's self-recovery, through
the engagement of various levels of reading of African-American cultural forms such
as folklore, as well as representations from white culture. Weems combines and
subverts the cultural expectations of viewers approaching the work from various
perspectives, using tableaux, narratives, ironic and sardonically humourous images
and texts. Prejudice based on skin colour is addressed directly in *Mirror, Mirror*,
part of the *Ain't Jokin* series. The work ironically rebounds upon and thus renders
impotent the genre of the racist joke. At the same time, *Mirror, Mirror* communicates
dilemmas of identification for both black and white women who encounter the work,
inviting each to question the notions of beauty in which they situate themselves.

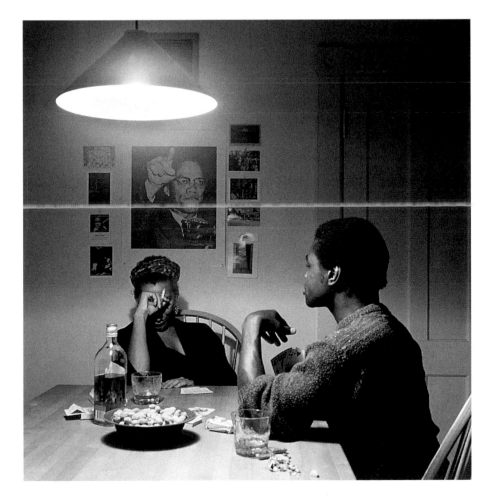

Carrie Mae <u>WEEMS</u>
Untitled (Kitchen Table Series) (detail)
1990
Gelatin silver print
68.5 × 68.5 cm [27 × 27 in] each

In this series of photographs Weems stages a domestic scene in which gestures
and everyday objects convey unspoken messages about African-American identities
and their representation, using herself as one of the subjects in the images.
'When I was constructing the *Kitchen Table* series, Laura Mulvey's article "Visual
and Other Pleasures" came out, and everybody and their mama was using it, talking
about the politics of the gaze, and I kept thinking about the gaps in her text … All the
pieces in the *Kitchen Table* series highlight "the Gaze" … using that as the beginning
and the turning point … to start creating a space in which black women are looking
back … and challenging all those assumptions about the gaze, and also questioning
who is in fact looking. How much are white women looking? How much are black
men looking?

'The work is very class based. It is working-class based; I think that reality shapes
the pictures – the way the images are constructed. I'm very interested in ideas about
blues and jazz, that expressive musical culture. That's where I function … But how
do you again use that, how do you … begin to construct a visual world that this music
is played in, that's generated by the culture that the music creates. So in doing the
Kitchen Table piece, it was always about how you construct it. How do you make
a blues piece? What does that look like?'
– Carrie Mae Weems, quoted in bell hooks, *Art On My Mind: Visual Politics*, 1995

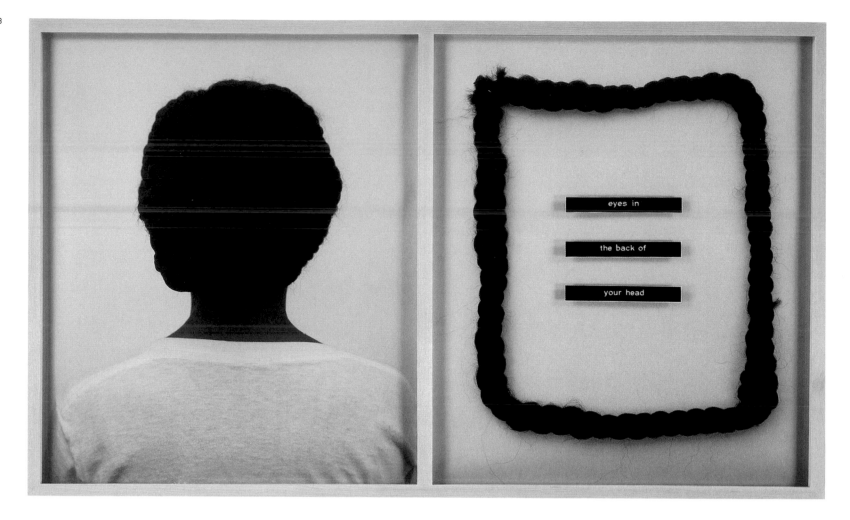

eyes in

the back of

your head

Dear Friend,
 I am black.
 I am sure you did not realize this when you made/laughed at/agreed with that racist remark. In the past, I have attempted to alert white people to my racial identity in advance. Unfortunately, this invariably causes them to react to me as pushy, manipulative, or socially inappropriate. Therefore, my policy is to assume that white people do not make these remarks, even when they believe there are no black people present, and to distribute this card when they do.
 I regret any discomfort my presence is causing you, just as I am sure you regret the discomfort your racism is causing me.
 Sincerely yours,
 Adrian Margaret Smith Piper

Adrian PIPER
My Calling Card 1
1986-90
Guerrilla performance with calling card
Card, 5 × 9 cm [2 × 3.5 in]

Piper frequently found herself at a dinner or cocktail party where the guests were almost exclusively white. The guests, not aware of Piper's African-American identity (she is of mixed race parentage), would freely engage in racist conversation. As one of a range of options Piper established to deal with such situations, she presented this 'calling card' to each person who had acted in this way. Piper describes this and other similar actions as reactive guerrilla performances.

Lorna SIMPSON
Back
1991
2 colour Polaroids, 3 plastic plaques
63.5 × 105.5 cm [25 × 41.5 in]

This is one of a series in which Simpson has assembled fragmented Polaroid images
of a female model whom she has regularly collaborated with; at other times, in a work
such as *Guarded Conditions* (1989) Simpson has used images of her own body. In both
cases, the body is fragmented and viewed from behind. The back of the model's head
is sensed as being in a state of guardedness towards possible hostility she can
anticipate as a result of the combination of her gender and the colour of her skin.
In this image the complex historical and symbolic associations of African-American
hairstyles are also brought into play. The message of the text and the formal treatment
of the image reinforce a sense of vulnerability. The fragmentation and serialization
of bodily images disrupts and denies the body's wholeness and individuality.
In attempting to read the work the viewer is provoked into confronting recent
histories of Western appropriation and consumption of the black female body.

Mitra TABRIZIAN (with Andy Golding)
The Blues (detail)
1986-87
Colour photographs, text
3 triptychs, 130 × 180 cm [51 × 71 in] each

This series of three triptych works uses as a unifying motif the African-American
musical form of the blues, which offers an attempt to achieve meaning in a situation
fraught with contradictions. The blue colour is also an integral part of the *mise en
scène* of crime films, and the photographs use the codes of film posters to present
untold stories, critical moments in black subjects' confrontations with the status of
whiteness. No matter what position he is placed in, under police interrogation, in
prison, in a low-paid job, the black male subject of the work questions the centrality
of white male identity. The work begins with a confrontation between men, derived
from the artist's reading of Frantz Fanon's study of the traumatic effects of
colonialism, *Black Skin White Masks* (1952). It ends with the encounter between
a black man and a black woman, as Tabrizian extends and reinterprets Fanon's
political analysis of binary oppositions and constructions of difference, addressing
their wider implications for relations between women and men.

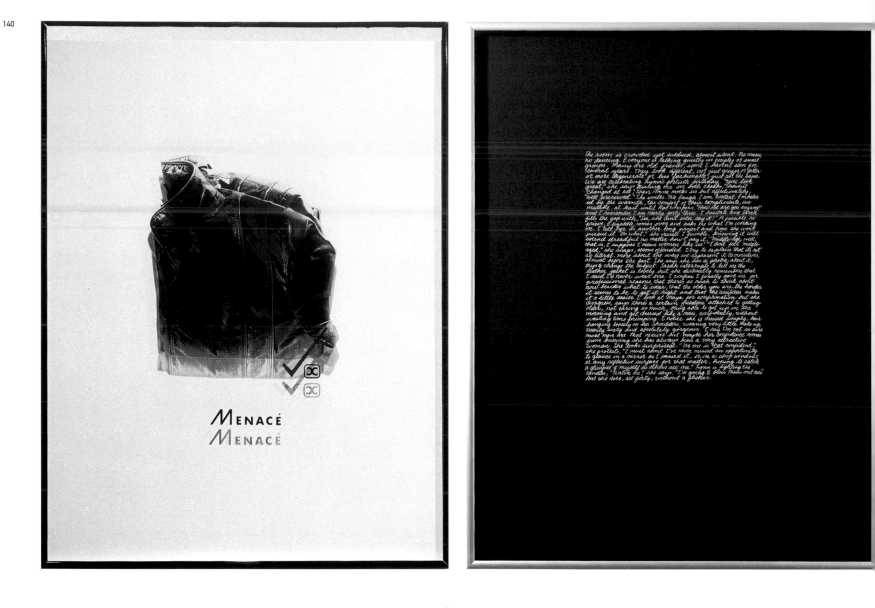

Mary KELLY

Interim Part I: Corpus (detail)

1984-85

Laminated photo positive, silkscreen, acrylic on Plexiglas

2 of 30 panels, 122.5 × 90 cm [48 × 35.5 in] each

Corpus is a component of the Interim project, an installation comprising thirty panels
of silkscreened and laminated photographs on Plexiglas. It invokes the body (corpus)
through photographs of folded, twisted and knotted articles of clothing placed along-
side panels of hand-written first-person accounts of the experiences of ageing. These
images take the place of imagery of women's faces or bodies (which was considered
by Kelly at that time to be problematic) in order to explore the notion of femininity and
the social order that names and describes it. Kelly's work makes reference to the
photographic records of 'female hysteria' made by the nineteenth-century French
neurologist J.-M. Charcot. The clothing is arranged in similar exaggerated poses
to those of the women in his photographs and labelled with the terminology he gave
to the so-called 'passionate attitudes' which accompanied hysterical attacks. Interim
challenges the notion of the condition of 'femininity' as biological and re-situates
it within the order of discourse and language, as a cultural construct.

Rosemarie <u>TROCKEL</u>

Untitled

1985

Wool

2 panels, 40 × 50 cm [16 × 19.5 in] each

Trockel's knitted works of the 1980s can be seen as comments on female art production as well as on Pop and Minimal art. They also question the function and meaning of symbols. The artist talks explicitly of the 'depreciation' she intends to inflict upon the visual elements she has selected, which lose their ideological significance as they become 'purified' into a geometrical motif. Trockel focuses on what has been 'removed' from the realm of art by reintroducing a discussion of the categories of creativity; in so doing she aims at positing a re-definition of historical, feminine creativity. Decorative motifs, presented as autonomous and formal, occupy a realm of ambiguity between figuration and abstraction, shedding their original meaning and assuming a new, uncertain identity.

Rosemarie TROCKEL
Untitled
1985
Wool
2 panels, 40 × 50 cm [16 × 19.5 in] each

Helen CHADWICK
Of Mutability
1986
left
Carcass
Organic and vegetable matter, glass
228.5 × 61 × 61 cm [90 × 24 × 24 in]
below and opposite
Oval Court
Colour photocopies, wood, paint, mirrors
Dimensions variable
'Helen Chadwick: Of Mutability', Institute of Contemporary Arts, London
Collection, Victoria & Albert Museum, London

For the installation *Of Mutability*, Chadwick made photocopied images from her body alongside images of dead and decaying flora and fauna, presenting them in a raised, pool-like, cyclical installation. The body's poses mimic famous displays of the female subject, such as Bernini's *Ecstasy of Saint Theresa*. Five golden spheres were placed on top of the pool. On the surrounding walls were *trompe l'oeil* colonades on paper scrolls and vanitas mirrors depicting the artist's face. Presenting her own body in poses of allegorical excess, Chadwick invited the viewer to interpret it metaphorically. The sadomasochistic qualities of the iconography – the noose around her neck, the hood over her head, the axe in her groin – are a reminder of the destructiveness inherent in consumption. Through the plurality of her image – her body appears twelve times – the artist herself disappears into the impersonal realm of the flesh and the senses. *Carcass* was installed in the space adjoining *Oval Court*. It comprised a glass container in which remnants of material used to make the cornucopia images for *Oval Court* were packed, together with household refuse, and left to decay. This was intended as a *memento mori* of the work's construction. 'The boundaries have dissolved, between self and other, the living and the corpse. This is the threshold of representation … '
– Helen Chadwick, *Enfleshings*, 1989

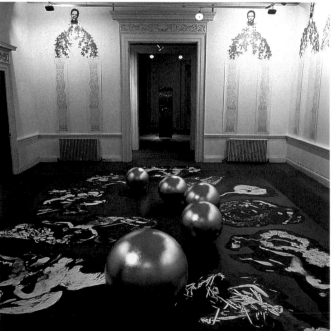

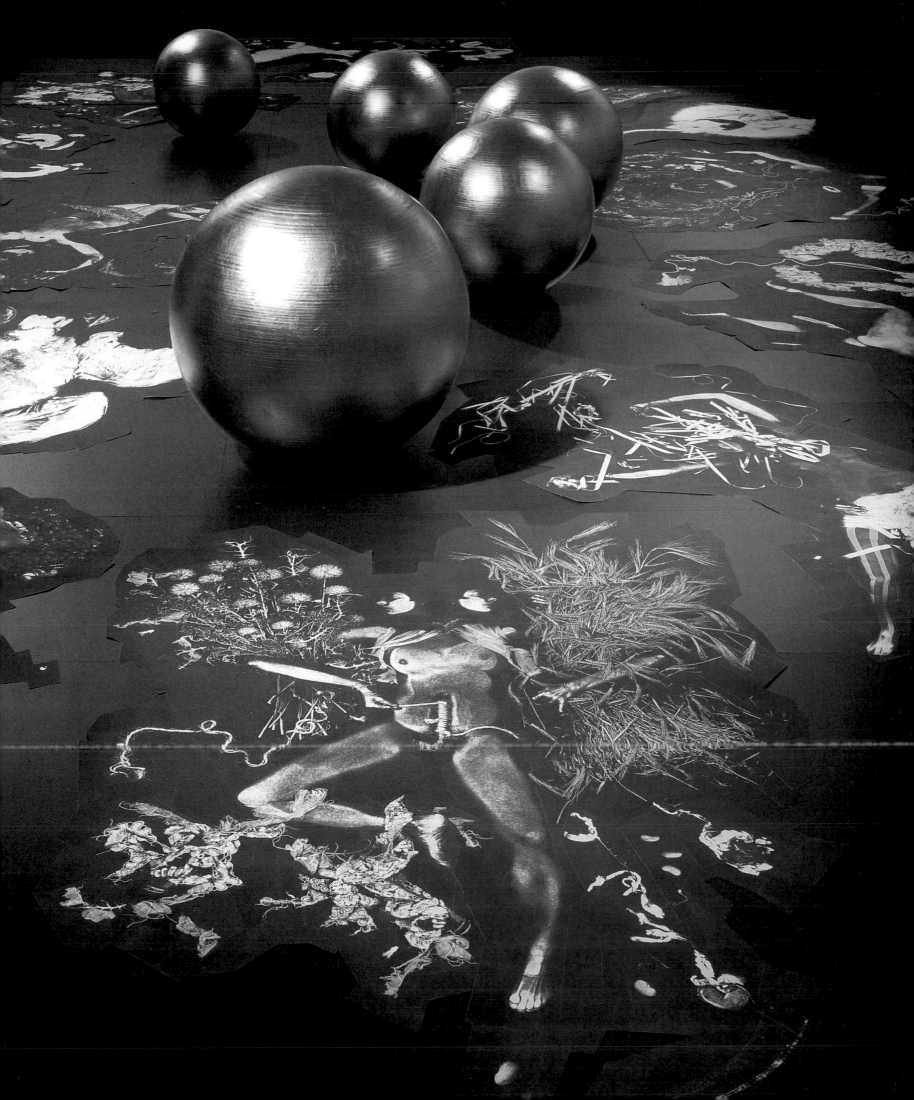

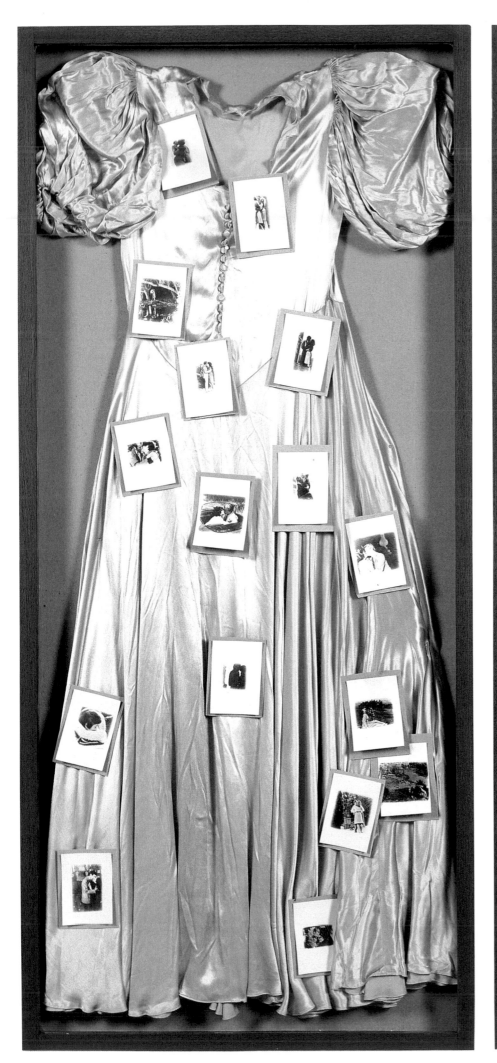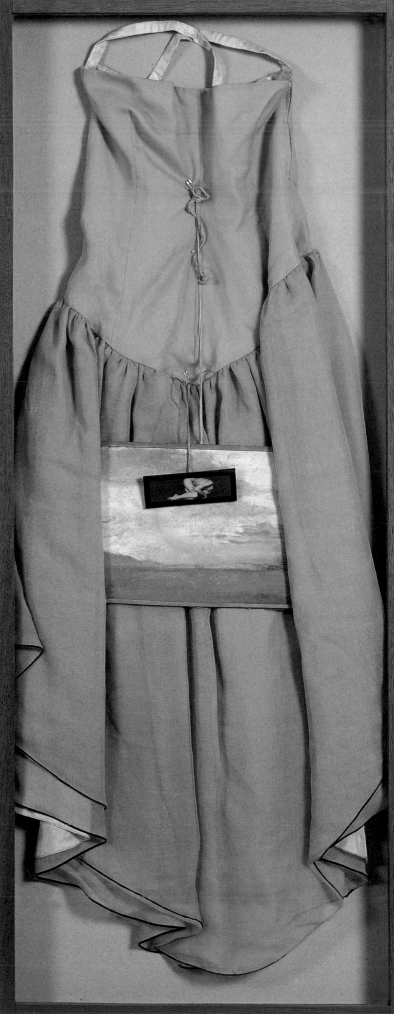

Annette MESSAGER
Histoire des robes (Story of
Dresses)
1990
Dresses, pastel drawing, black
and white photographs, string,
pins, wood, glass
376 × 353 × 18 cm [148 × 139
× 7 in]

Encased in shallow glass vitrines,
small paintings, framed photographs
and texts are attached to dresses in
a manner reminiscent of religious
shrines. In this work Messager has
refined her longstanding investigation
of the subjugation of the female body to
the point at which images of the body are
no longer directly conspicuous but are
replaced by the metaphorical presence
of clothing, which she here views as a
'second skin', embodying all the secrets
and hopes of everyday existence.

Jana STERBAK
Remote Control
1989
Steel frame, electronic controls
h. 127 cm [50 in]
Collection, Museu d'Art Contemporàni, Barcelona

Sterbak created two, larger than human scale, mechanized structures based on
the historical form of the crinoline dress. Once lowered into one of the crinolines,
the performer, who is suspended above the ground, can mobilize herself using
a radio-operated remote control mechanism, enabling her to glide around the room.
However, even though the remote control is in the performer's hands, her movements
are determined by those of the mechanical apparatus. The work interactively critiques
the complex, culturally inscribed performance of 'femininity'.

Lubaina HIMID
We Will Be
1983
Wood, paint, drawing pins, wool, collage, silver paper
183 × 91.5 cm [72 × 36 in]

British artist Himid was born in 1954 on the African island of Zanzibar, then still
a British colony, now part of the independent republic of Tanzania. Himid's work
excavates repressed and forgotten histories of the experiences and culture of people
of African descent. She brings these histories into contemporary contexts where
white social and historical hierarchies are questioned and challenged. Her figures
often evoke the Nubian physiognomies and cultural forms of the Egyptians whose
civilization was absorbed into classical Greek culture – an African influence that
was gradually denied and written out of European history from the early period
of the European slave trade until the late twentieth century. Important to her work
is painting's intersection with decoration and adornment in the everyday life of
cultures which have been marginalized. Himid also draws on the tradition of history
painting, depicting moments where black women are visible in history and are active
in determining its course.

Mona HATOUM
Measures of Distance
1988
Video
15 mins., colour, sound

Arabic script, taken from letters Hatoum's mother wrote to her in London from Beirut, rolls over the screen like a veil, covering the still photographs of her naked mother in the shower. The images were taken by Hatoum on a visit to her home in Beirut. Her voice-over translates the text which speaks of her mother's sorrow at the distance which separates her from her daughter. The complexity of the piece is an interplay of the closeness and distance which political circumstances have forced upon this close bond between mother and daughter, the centrality of language, and their trespass on patriarchal law ('don't mention a thing about it to your father'). These issues of identity and alienation recur throughout Hatoum's work as an exiled woman living in London.

Susan HILLER
Belshazzar's Feast
1983-84
Video installation
Collection, Tate Gallery, London
Campfire version, Institute of Contemporary Arts, London, 1986

Hiller's investigation of the 'unconscious' aspects of her society's culture extended in the 1980s to video installation.

'Nowadays we watch television, fall asleep, and dream in front of the set as people used to do by their firesides. In this video piece I'm considering the TV set as a substitute for the ancient hearth and the TV screen as a potential vehicle of reverie replacing the flames. Some modern television reveries are collective. Some are experienced as intrusions, disturbances, messages, even warnings, just as in an old tale like *Belshazzar's Feast*, which tells how a society's transgression of divine law was punished, advance warning of this came in the form of mysterious signs appearing on the wall. My version quotes newspaper reports of "ghost" images appearing on televisions, reports that invariably locate the source of such images outside the subjects who experience them. These projections thus become 'transmissions', messages that might appear on TV in your own living rooms.'
– Susan Hiller, Artist's statement, 1985

Aimee RANKIN
Ecstasy Series
1987
Wood, digital media, mirrors, lighting, sound
Dimensions variable

A series of coloured wall-mounted boxes have peepholes, deliberately made small so that it is difficult to see inside. Peering in, the viewer can make out a dazzling, rectangular space which is filled with lights – the optical illusion of an 'infinity tunnel' created using mirrors. This seemingly infinite, receding space is also conceived as symbolizing the 'bed' at the centre of an imaginary 'bedroom'. The work 'reveals the underside of an extremely complex technological system, in the seething impulses of entropy always gnawing at the edges of this order ... I was working with the issue of seduction, which in visual terms is the play with what is not revealed ... I wanted that frustration to reveal something about the workings of desire.'
– Aimee Rankin, Artist's statement, 1987

Judith BARRY
Echo (detail)
1986
Mixed media video installation
Dimensions variable

In this installation a free-hanging double-sided screen reflects images that are interrupted by the spectators' silhouettes as they pass between screen and projector. On either side of the screen, two alternating projections containing two film-loop inserts reproduce an endless cycle of multiple scenes, repeating, yet never the same, one side depicting 'nature' and the other side an evening view of the 1937 World's Fair globe and AT & T's 'Chippendale' building. The piece reinterprets the entropy of the mythical figures Echo and Narcissus, in terms of the seductive and destructive power of spectacle generated by corporate technology. Barry's installations examine the impact of information and computer media on the design and use of public space and address the paradox of technological systems which both aid and inform while exercising powers of surveillance and control.

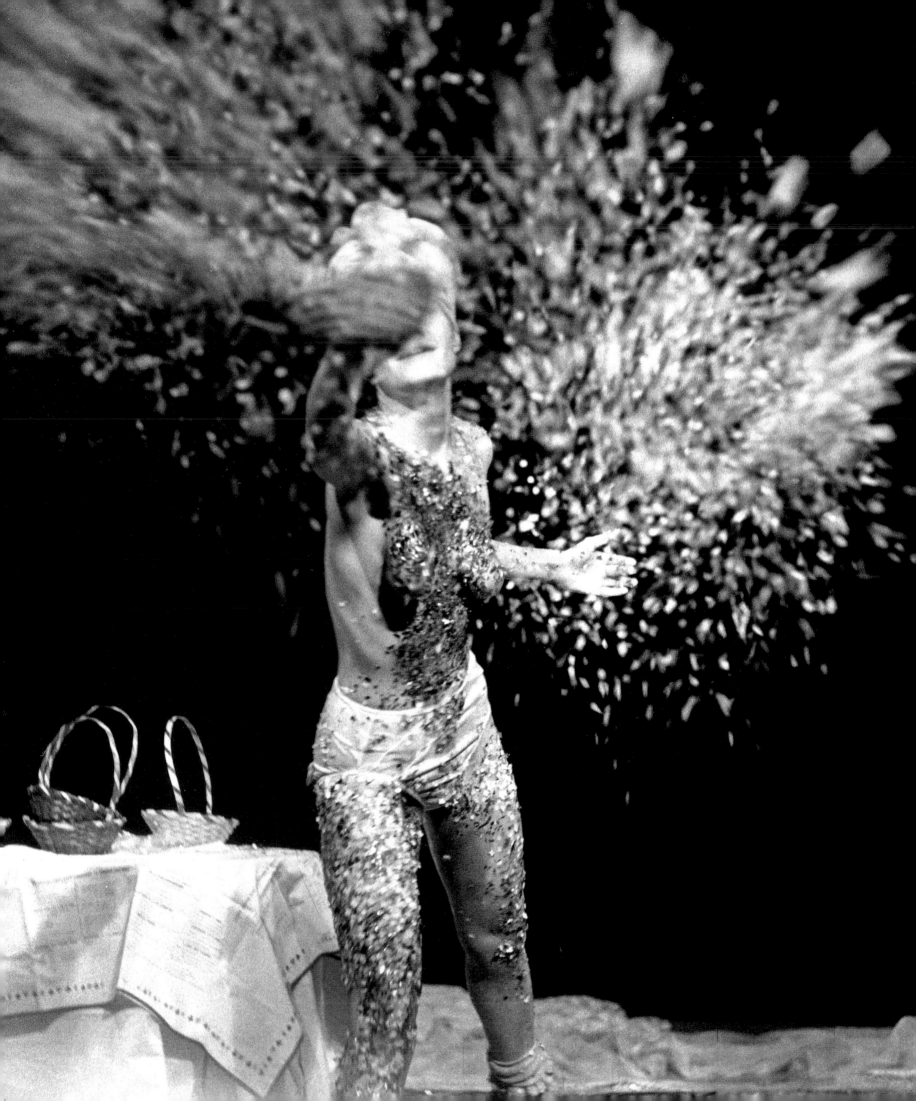

Karen <u>FINLEY</u>
The Constant State of Desire
1906
The Kitchen, New York

In 1985 Finley toured the US with the solo performance *I'm An Ass Man*, which dealt with the themes of sexual abuse and misogynist attitudes which affect the lives of women from infancy until death. In December 1986, The Kitchen performance space in New York hosted Finley's next major work, *The Constant State of Desire*, which dealt with the desire to control others. It received much critical acclaim and toured throughout the US and Europe. Finley has made performances using her body as a visual field on which fear, desire and violence are projected in order to challenge prevailing attitudes towards women, sex and art. More recently her work has questioned notions of censorship and the rights of artists to speak out about issues of abuse and the commodification of desire in Western capitalist societies.

Annie <u>SPRINKLE</u>
Post-Porn Modernist Show
1992
New York

Self-styled 'feminist porn activist', Sprinkle makes performances informed by her work in the sex industry, where she transformed herself from a sex object into a figure empowered by her sexuality. In this performance she narrated and demonstrated her career achievements. After douching she inserted a speculum and invited the audience to see her cervix, inverting the power relations between subject and object.

Cindy <u>SHERMAN</u>
Untitled No. 222
1990
Colour photograph
152.5 × 112 cm [60 × 44 in]

Sherman's series of thirty-five *History Portraits* (1989–90) arose from a commission where she collaborated with the Limoges factory in France to produce porcelain from original eighteenth-century moulds, decorated with images of the artist dressed in period costumes. The following year Sherman produced a series of photographs based on characters from the French Revolution for the bicentennial in Paris, and these were followed by further works which, with the exception of several based on actual paintings, depict types from the genre. 'The pictures, with their almost sculptural but artificial "deep space", propose subjects that point to the fact that we are never coherent in ourselves but always take meaning from the others whose significance we in turn project. (A dynamic, not incidentally, that could be said to describe the hidden mechanics of art history as a discipline.)'
– Amelia Jones, *Cindy Sherman*, 1997

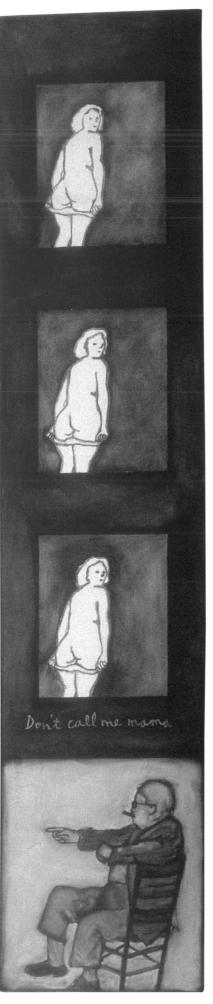

far left
Ida <u>APPLEBROOG</u>
Untitled
1986
Oil on canvas
112 × 41 cm [44 × 16 in]
left
Ida <u>APPLEBROOG</u>
Don't Call Me Mama
1987
Oil on canvas
112 × 41 cm [44 × 16 in]

Applebroog's multi-partite paintings of the 1980s focus on apparently trivial scenes and actions, often using cartoon-like repetition to present sequences that suggest fragmented stories. In the mid 1970s Applebroog made a transition from abstract sculpture to figurative painting and book works as a result of her encounter with feminism. She made small books which presented disjunctive narratives and questioned ideologies of representation, mailing these to friends and figures in the art world. These were followed by her sequential paintings which address feminist issues of victimization and marginalization with a fine balance of empathy and irony. In deciphering and interpreting these works, the viewer is invited to engage an active ethical response.

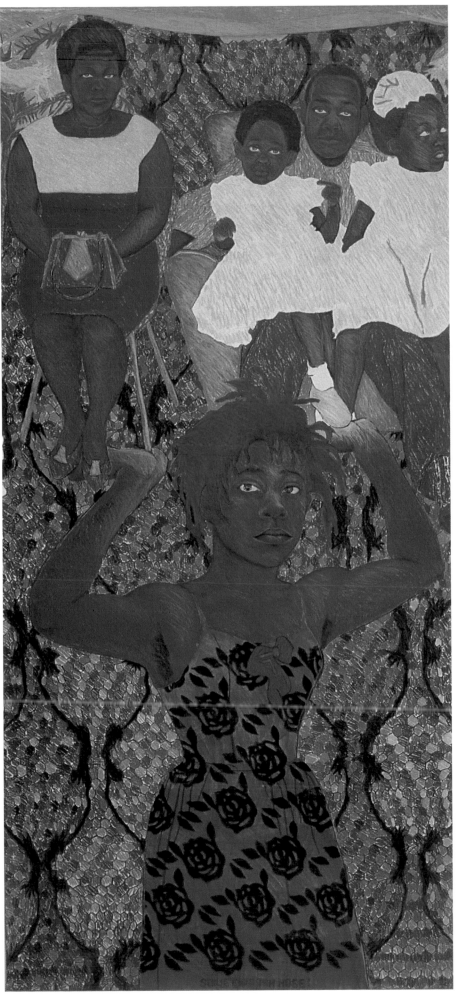

Sonia **BOYCE**
She Ain't Holding Them Up,
She's Holding On
1986
Acrylic on canvas
227 × 113 cm [89.5 × 44.5 in]
Collection, Middlesbrough Museum
and Art Gallery, England

The title reinforces the problematic
position of the woman in the bottom
half of the painting. She is identified
with a sense of Englishness by the rose
patterns that adorn her dress, while
above and around her other, richer
patterns proliferate. These reflect both
the influence of her mother's West
Indian sense of decoration, and Boyce's
contention at the time that her work,
despite resembling painting, was
drawing, a means of expression which
should be appreciated on its own merits.
'In one sense I am celebrating the
strength of black women; however
I try not to glorify that strength because
I'm constantly reminded of why black
women have to be strong. As we know
there is a barrage of institutionalized
representations of black people.
There are enough insulting and negative
images. The question becomes then,
how does one confront these distortions
and initiate change? ... When you
start to discuss the issues that affect
a community, transposing positives
for negatives is insufficient in dealing
with the complexities of human
experiences ... '
– Sonia Boyce, 'In Conversation with
John Roberts', 1987

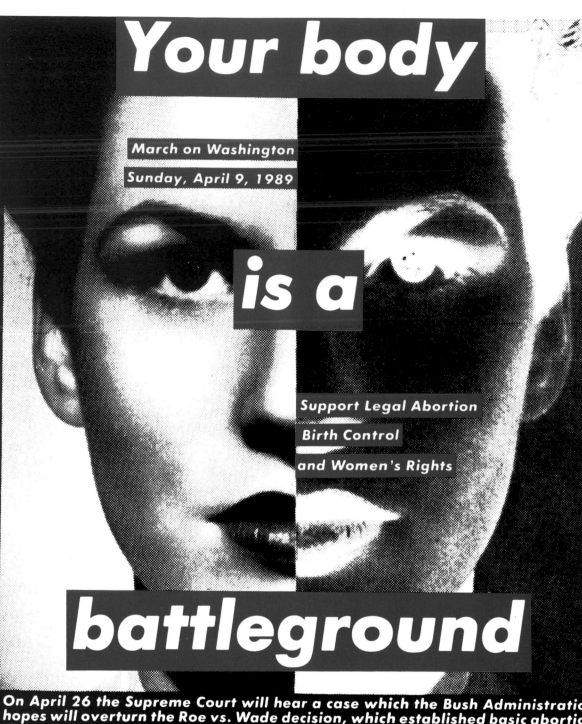

Barbara KRUGER
Untitled (Your body is a battleground)
1989
Photographic silkscreen on vinyl
61 × 61 cm [112 × 112 in]

In the embattled late 1980s, during the censorious 'culture wars' in the US provoked by right-wing politicians in alliance with religious fundamentalists; the worsening AIDS crisis; and retrogressive legislation on women's rights, Kruger showed her solidarity with a number of graphic activist groups, such as Gran Fury, by producing posters and other artefacts for direct action use. This work was used as the rallying poster for the 1989 pro-choice march on Washington and was subsequently adapted for the promotion of women's rights in other countries.

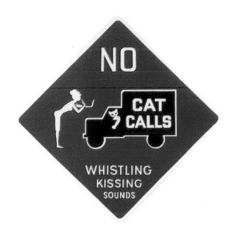

Ilona GRANET
No Cat Calls
1985-88
Silkscreen on metal
61 × 61 cm [24 × 24 in]

From 1985 to 1988 New York art activist Ilona Granet created and erected street signs in lower Manhattan, New York. Collectively she titled them the *Emily Post* series, named after a well known United States authority on etiquette. The signs were a protest against male street behaviour towards women, such as cat-calls, whistles and suggestive comments, and made their point with humour. Many of them were reworkings of standardized images taken from sign-painters' dictionaries. The signs were displayed in the street as 'regulations' for etiquette, suggesting that sexual harassment is as dangerous as the traffic accidents that their sign prototypes were designed to prevent.

GUERRILLA GIRLS
Do women have to be naked to get into the Met. Museum?
1989
Poster

The Guerrilla Girls, an anonymous group of women artists who have staged protests against institutionalized sexism and racism, were most active in the late 1980s and early 1990s. Their campaigns used posters, cards, flyers and other graphic material to present revealing statistics and uncompromising political messages. For public appearances members have protected their anonymity with gorilla masks, assuming the names of women artists in history such as Georgia O'Keeffe. Originally intended for a billboard, this poster was rejected by the Public Art fund in New York and was subsequently self-funded and displayed on the buses and streets of New York.

Trinh T. <u>MINH-HA</u>
Surname Viet, Given Name Nam
1989
16mm film
108 mins., colour, sound

This formally complex film explores the historical and cultural experience of Vietnamese women in traditional and post-war societies of North and South Vietnam and in the United States, and the ways in which they intersect.
'It is illusory to think that women can remain outside of the patriarchal system of language. The question is … how to engage poetic language without simply turning it into an aestheticized, subjectivist product … Language is at the same time a site for empowerment and a site for enslavement. And it is particularly enslaving when its workings remain invisible. How one brings that out in a film is precisely what I have tried to do in *Surname Viet, Given Name Nam* … what is important is not only what the women say but what site of language they occupy (or do not occupy) in their struggle.'
– Trinh T. Minh-ha, 'Speaking Nearby', 1994

Yvonne <u>RAINER</u>
The Man Who Envied Women
1985
16mm film
125 mins., colour, sound

In *The Man Who Envied Women* Rainer takes the critical work of feminist filmmaker and theorist Laura Mulvey to its logical conclusion. Mulvey's analysis demonstrated that the male gaze is an integral part of cinematic structure, inscribed by everything from camera position to narrative form. Rainer decided to test what happens when the usual object of the male gaze, the heroine, is denied a visual presence within the film. This strategy was prefigured in Rainer's earlier choreographic work: one of the important innovations of *Trio A* was the refusal of the female dancer to engage with the gaze of the viewer throughout the performance. In *The Man Who Envied Women* the protagonist, played by the dancer and choreographer Trisha Brown, never appears in view throughout the film's duration. Further problematizing the way that audiences would identify and engage visually with the narrative, Rainer's two male protagonists play the same role, so that they become interchangeable. The film employs a wide array of spatial arrangements as an integral part of its narrative method, as Rainer investigates the cinematic devices that keep characters inside and spectators outside of the frame.

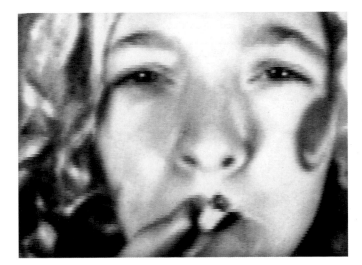

Abigail CHILD
Mayhem
1987
16mm film
20 mins., colour and black and white, sound

Perils, *Mayhem* and *Mercy* belong to the series *Is This What You Were Born For?* (1986–89) in which Child investigates power and gender relations through a homage to past cinematic genres such as *film noir*. Through rapid collages of image fragments from early cinema, Child assembles experimental narratives, drawing attention to the minutiae of conventional techniques of cinema such as gesture and camera frame, which establish not only narrative continuity and pace, but the construction of gender and sexual identities. Child destabilizes these artifices, focusing on moments of rupture and excess where subliminal apprehensions of alternative readings become apparent.

Cheryl DUNYE
Janine
1990
Video
9 mins., black and white, sound

Janine was the first of Dunye's video works to gain international acclaim. Her work uncovers the hidden histories of black lesbian identities, and works towards cinematic representations of black women that refute racial, gender and sexual stereotypes. Dunye creates a new level of subjectivity through her self-referential role as both director and actor in her works, as well as the often humorous blurring of distinctions between fiction and documentary. These find their most ambitious expression in her first feature film, *The Watermelon Woman* (1996), a mock-documentary centred on an aspiring filmmaker, played by Dunye, obsessed with a 1930s African-American actress whom she suspects was the lover of a white female director. The controversial cultural historian Camille Paglia appears as herself within the film's narrative, giving voice to critical analysis within the fictional frame.

Sadie BENNING
It Wasn't Love
1992
Video
20 mins., black and white, sound

Benning began at fifteen to weave her diary entries into experimental narratives. The videos were usually made in the confines of her own bedroom and suggest the intimacy of a confessional. In this work, she sits perched before the camera, disclosing intimate details about falling in love, feeling as if she is a freak, quitting school, discovering she is a lesbian. Her early works were made using a hand-held Fisher-Price PXL2000 'Pixelvision' video camera, designed for use by children but soon adopted by experimental filmmakers for its low-resolution pixelated effects. Benning experimented from the outset with masks and drawings in relation to her personae. In a later work such as *The Judy Spots* (1998), broadcast on MTV, the angst she explores is portrayed by a papier mâché doll .

CORPOREALITY

The 1990s saw a renewed interest in the gendered body as an artistic source – no longer as the fetishized object of the male gaze but as something to be explored in all of its diversity. The 1990s body was infused with consciousness of polymorphous perversity and cyborg futures. Many women artists returned to the traditional media of painting and sculpture, in contrast to the predominance of photography and language-based work of the previous decade. Feminists working with new technologies often introduced a visceral component. There was a return to objects, rather than words; 'lightness' instead of the weight of theory. This is seen in a number of artists' embrace of humour, sentimentality and the naive. Others appropriated macho attitudes and nonchalant poses. The generation profiled in several exhibitions of the mid 1990s coincidentally titled 'Bad Girls' also depicted the abject body, a concern that was central to the work of established women artists who explored ageing, illness and loss. Other female artists explored neglected and in-between spaces and ephemeral materials, and critiqued the institutional exclusion of women.

Andrea FRASER
Welcome to the Wadsworth: A Museum Tour
1991
Wadsworth Atheneum, Hartford, Connecticut
In a series of works of the late 1980s and early 1990s Fraser invented an alter ego based on one of the 'docents' who, usually on a voluntary basis, conduct guided tours of museums. At the commencement of each tour, provided for visitors who were usually unaware of her subversive position, Fraser would mirror the conventional speech of the docent, only gradually introducing a series of strategic departures from the normal narrative as the tour progressed. Unexpectedly referring, for example, to directional signs, the gift shop or the security system and describing them as if they were works of art on exhibit, she gradually and subtly introduced political and feminist critique of the institution, speaking from an indeterminate position, between institutional insider and the 'ideal visitor' from whom the ranks of many museum volunteers are drawn.

Ute Meta <u>BAUER</u> (with Tine Geissler and Sandra Hastenleufel)
Informations Dienst (Information Service)
1992-95
Archival documentation, filing and presentational materials
Dimensions variable

This archive documenting artworks by contemporary women artists was first exhibited in 1992 at Martin Schmitz Galerie in Kassel, concurrently with Documenta IX, in protest at Documenta's under-representation of women. The archive was subsequently exhibited at other locations where the institutionalized absence of women was noted. In each case the hosts of the archive agreed to a basic set of formal presentation conditions established by the organizers. Each new site had the opportunity to recontextualize the exhibition of the archive through varying curatorial decisions.

Renée <u>GREEN</u>
Import/Export Funk Office
1992
Installation with audio, video and reading materials
Dimensions variable
Collection, The Museum of Contemporary Art, Los Angeles

Green's installation juxtaposes materials which range across the histories of African-American and white American and European literature and film. In such a context a 1930s film of 'exploration' that describes a journey into 'deepest, darkest Africa' becomes a tool in its own deconstruction. Placed alongside the works of writers such as Hawthorne and Melville are key African-American texts such as Harriet Jacobs' autobiographical *Incidents in the Life of a Slave Girl*, as well as a 'lexicon of funk'. Presenting as simultaneous these diverse accounts of history, culture and community, the archive enables visitors to reconstruct culturally diverse readings within an institutional space. Green's work addresses the diasporic histories of African-American experience, often in relation to indexes, genealogies and taxonomies. Her work highlights and questions received ideas about unitary black identities and communities and traces alternative readings of history.

Thérèse OULTON
Correspondence I
1990
Oil on canvas
233.5 × 213.5 cm [92 × 84 in]

In Oulton's paintings the problematic historical relationship of women's art with the 'old masters' is addressed, not through appropriation or irony, but through gestures of refusal. Conventional ways of interpreting and appreciating painterly technique are refused through a subversive use of high art conventions. Chiaroscuro is employed, for example, to imply modelling, yet no discernable object of representation can be observed to justify the use of this technique. Gestural marks and techniques are denuded of their habitual representational meanings, yet their affective associations are retained. Oulton seeks thus to transform the 'debased' inherited language of painting from within, so that the possibility of renewal might emerge organically through her engagement with the medium.

Mira SCHOR
Area of Denial (detail)
1991
Oil on linen
16 panels, 40.5 × 51 cm [16 × 20 in] each

This series of sixteen paintings refers to a military term used in the Gulf war to describe a type of bomb designed to explode above ground and 'deny' oxygen to enemy soldiers below. Schor often works with fragments of language that are charged with the political resonances of current events. A complex relationship is set up between the source of the phrase and the political dimensions of the act of painting, in which the military terminology of the modernist avant-garde is one point of reference. Through a re-exploration of the possibilities of relationship between figure and ground, Schor refutes those postmodernist critics who have proclaimed the death of painting. 'In French, *terrains vagues* describes undeveloped patches of ground abutting urban areas, grey, weedy lots at the edge of the architectural construct of the city. *Terrains vagues*, spaces of waves, the sea of liquidity, where the eye flows idly and unconstructed, uninstructed. These spaces are vague, not vacant (*terrains vides*). In such interstices painting lives, allowing entry at just these points of "imperfection", of neglect between figure/ground. Between figure/ground there is imperfection, there is air, not the overdetermined structure of perspectival space or the rigid dichotomy of positive and negative space, not the vacuumed vacant space of painting's end … '
– Mira Schor, 'Figure/Ground', 1997

Marlene <u>DUMAS</u>

Porno Blues

1993

Ink wash, watercolour on paper

6 drawings, 30.5 × 22.5 cm

[12 × 9 in] each

In two series of drawings both made in 1993, *Porno Blues* and *Porno as Collage*, Dumas used pages from sex magazines as her source material, investigating the interplay between pornography's photographic revelations and the veilings and concealments of art, which are widely held to be the distinguishing features of eroticism. Marlene Dumas has been placed in the tradition of Expressionism and compared with Edvard Munch and Emil Nolde. Due to her ironic view of painting's production and reception she has also been considered a neo-conceptualist. A further dimension in her work of the 1990s has been a distinctive exploration of eroticism. Although Dumas' imagery of predominantly female subjects is often derived from mass media photographic sources, she is not interested in strategies of refusal, or the construction of 'anti-images' as a way of subverting stereotypical representations. Rather, through exploring the sensuous properties of her medium, she aims to expand the possibilities in painting for representation of the workings of desire.

Nicole <u>EISENMAN</u>
The Minotaur Hunt (detail)
1992
Acrylic mural, no longer extant
3 × 4.5 m [10 × 15 ft]
Trial Balloon Gallery, New York

Eisenman's radical re-evaluation of historical and contemporary mythologies led her to make a series of works in the early 1990s which featured plural manifestations of the legendary Minotaur. Several of these took the form of large scale temporary murals in a mock history painting style. One version was exhibited at Trial Balloon Gallery, New York, in 1992; another was shown at the 'Bad Girls' exhibition (Institute of Contemporary Arts, London, 1993–94).

'A tribe of strapping amazons hunt minotaurs.

'In Picasso's private mythology, these women, Olga, Dora, Françoise, are muses. Refashioned, these muses become the huntresses, symbols of strength and vengeance.

'The tribunal of women gives way to the central conflict. The bound minotaur is stabbed. The bounty of this hunt is the blood of the beast that Paloma [Picasso] has introduced onto the world market this fall: the cologne for men *Minotaur*. The story is of Paloma's endangered integrity, self defence through aggressive capitalism and patricide by cannibalism.

'The murals to me always seem unfinished, sections are incomplete. The life of the mural is short – like that of a drunken teenager smashing his car into an oncoming train; there is no chance of failure, to die with potential, to live in memory, heroic.'
– Nicole Eisenman, Artist's statement, 1993

Sue <u>WILLIAMS</u>
A Funny Thing Happened
1992
Acrylic on canvas
122 × 107 cm [48 × 42 in]

Sue Williams' graffiti-like series of paintings refer in unexpectedly disturbing ways to the kind of humour addressed, for example, by the artist Richard Prince in his series of paintings and collages based on jokes. Williams goes a stage further than the ironic ambiguity of Prince's appropriations, of which she is critical. Not only do the dilemmas she presents appear to be as unresolved as the paintings themselves, but there appears to be no escape from the tortuous emotions they evoke.

'Do victims feel the kick as pain or pleasure? "Fuck off." When the object of my love and affection gives me the boot as hard as he can it hurts quite a bit. Also, a deep feeling of humiliation and rejection (harder please). Yet there is something horny about the feeling: dear old Dad. Of course I go back for more (home). This is a riot for everyone with their shit together. Well no alternatives came to mind at the time. What can I say? And all these bruises about the face and misshapen lip touching the nose (a turn-off) so everyone knows what you've been up to. Oh, the embarrassment, the shameful feeling of worminess. "Look, an untogether woman" Even from Dad! "How could she let that happen?" No gun. "How could she do that to herself?" How did I kick myself in the head? I am a worm, hear me whimper mumble mumble. Fuck you all. Fifteen years of therapy, groups, twelve-step-programmes. I'll never do it again. Then I am attacked and raped by a total stranger (I swear! O can't he see that I am centred and working on boundary issues? That I have my shit together: Hell – I OWN my OWN SHIT. What gives? Why wasn't I training in combat? Should I go outside again? Well, no alternatives came to mind at the time.'
– Sue Williams, Artist's statement, 1993

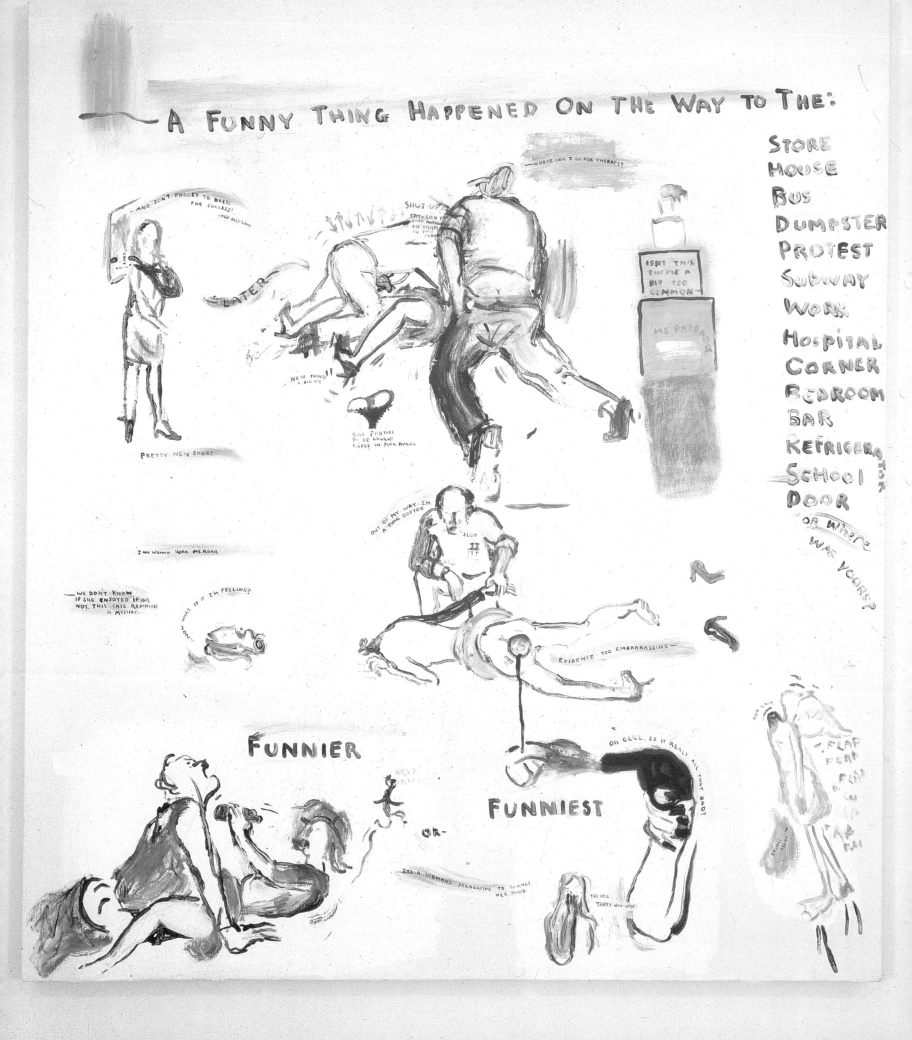

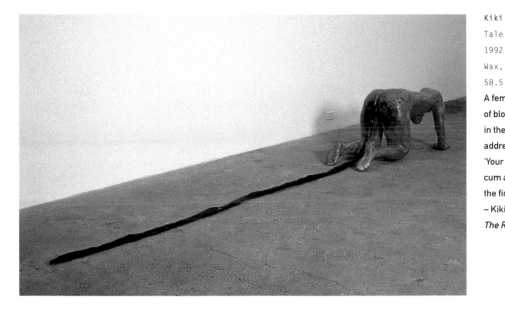

Kiki SMITH
Tale
1992
Wax, pigment, papier mâché
58.5 × 58.5 × 406 cm [23 × 23 × 160 in]

A female figure crawls abjectly along the floor, trailing an indeterminate stream of blood or excrement. In her sculptures Smith works through problems that persist in the representation of the female body figuratively as a universal referent. *Tale* addresses the dilemma of being unable to control readings of the female body. 'Your hair holds on you, the shit and the pee and the chafed skin, the milk and the cum and the placenta, you can feel your hair in the second person not feeling it in the first. Tender threads. Haunting ways to remain staining.'
– Kiki Smith, quoted by Jo Anna Isaak, *Feminism and Contemporary Art: The Revolutionary Power of Women's Laughter*, 1996

Helen CHADWICK (with David Notarius)
Piss Flowers (detail)
1991-92
Bronze, cellulose, enamel
Dimensions variable
Collection, Banff Centre for the Arts, Canada

During a four-week residency at the Banff Centre for the Arts in Canada, Chadwick, together with her partner David Notarius, created a series of sculptures cast from the shapes which emerged as they urinated into deep snow. The indented shapes which formed as the snow was displaced were immediately filled with plaster, then cast in bronze and covered in enamel paint. When transformed from negative to positive forms in space, the artist's female urine pattern resembled a phallic stem and her male partner's resembled the petals of an open flower, reversing the symbolism conventionally associated with their gendered creative positions.

Janine ANTONI
Gnaw (detail)
1992
600 lbs (270 kg) of chocolate gnawed by the artist
54 × 54 × 54 cm [21 × 21 × 21 in]

Over several weeks, Antoni performed the action of repeatedly biting into two large cubes, one consisting of lard, the other of chocolate. The mouthfuls of the two substances which she spat out were collected and fashioned into commodities such as lipstick and chocolate sweets. These were exhibited in glass cases alongside photographic documentation of the gnawed cubes. Drawing attention to feminist associations of the comforting and aphrodisiac properties of chocolate and the abject quality of lard, this work also engaged with Antoni's ongoing art historical critique. The minimalist cube was devoured and its substance converted, in an oral-sadistic gesture which was both destructive and imbued with pathos, into products stereotypically associated with femininity.

For some commentators, who had been engaged in psychoanalytically based feminism during the previous decades, this work signified a regression in women's art practice from the linguistic to the oral, the theoretical to the pre-verbal. Others welcomed Gnaw and other key works by Antoni, such as Loving Care (1993), for their articulation of women artists' ambivalent relationship to patriarchal art history.

Rona PONDICK
Treats
1992
Plastic and rubber
300 parts, approx. 5 × 5 × 5 cm [2 × 2 × 2 in] each

Like Antoni's Gnaw, Pondick's installations of the early 1990s also evoked infantile oral-sadistic fantasies. Works such as Mouth (1992–93) and Treats are composed of teeming, randomly strewn balls which resemble disembodied, greedy, savage mouths with rows of grinning, bared teeth, or devouring breast-like forms. Rather than marking a regression from more theoretical, discursive practice, Pondick's works, as well as Antoni's, were widely discussed by some feminists as opening up a space for the articulation of an assertive female subjectivity.

Anya GALLACCIO
Prestige
1990
24 kettles, air compression·unit
Dimensions variable

This installation in the central chimney of the defunct Wapping pumping station, London, consisted of twenty-four kettles linked to an air compressor so that their whistles could be heard continuously. The viewer's encounter was channelled through the sound, audible for some distance around the building, before the installation was seen. Through being massed together, domestic kettles 'take over' the monumental space of male industrial power with their different reverberation of sound. Gallaccio's installation works respond to the charged identity of their sites through the placement within them of ephemeral and transient materials and phenomena, such as flowers, chocolate, salt or ice.

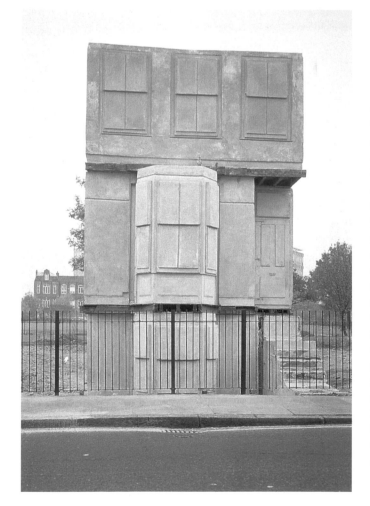

Rachel WHITEREAD
House
1993
Concrete
h. approx. 7.5 m [25 ft]

In 1993 Whiteread completed a cast in concrete of a nineteenth-century house in the East End of London. Bordering a park, it was the last in its row to be evacuated prior to its intended demolition. Via the public arts organization Artangel, permission was secured from local authorities to make the work, which involved infilling the interior space of the entire structure, then carefully demolishing its shell so that the concrete cast of negative space remained as a monument to the house's existence and the life which it had sustained. The work, which was temporary, provoked strong but unresolved responses across all constituencies. 'House was both a closed architectural form and an open memorial; at one and the same time hermetic and implacable, but also able to absorb into its body all those individual thoughts, feelings and memories projected onto it.'
– James Lingwood, Rachel Whiteread: House, 1995

Doris SALCEDO
Unland: the orphan's tunic
1997
Wood, cloth, hair
80 × 245 × 98 cm [31.5 × 96.5 × 38.5 in]

As the viewer approaches an old, worn table, spliced together from two broken sections, a white sheen is perceived to be a fine covering of silk. At the join of the two parts, human hair is also seen to be woven into the table's surface. In Unland, a series of three works made between 1995 and 1998, Salcedo referred in her titles to writing by the exiled German Jewish poet Paul Celan (1920–70). A survivor of the Holocaust, Celan reflected in his poetry a despair in the possibility of recovering coherent meaning and of overcoming loss. In his fragmented verse the negative prefix 'un' appears frequently, as do references to blindness and constraints against sight. Salcedo's sculptures using found women's shoes, clothing and domestic furniture are similarly fragmented, dislocated objects that evoke the personal tragedies of loss in her native Colombia, provoking meditation on their universal significance.

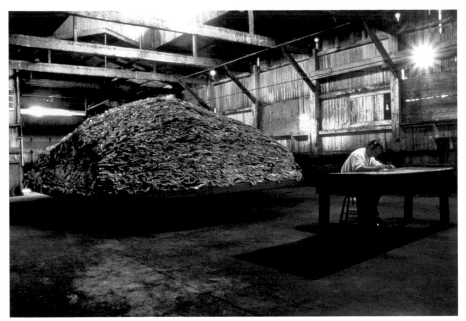

Ann HAMILTON
indigo blue
1991
Site specific installation and performance, Spoleto Festival,
Charleston, South Carolina

'Located in an old garage in Charleston, South Carolina ... this piece was informed by the experience of living for six weeks in Charleston and more than a year of readings in American labour history. In the centre, a steel platform was piled with 14,000 lbs of company-owned recycled work clothing ... Obscured by the pile from the front, at the back of the space a figure sat erasing slim blue books, seated at a table borrowed from the central market that once housed one of Charleston's pre-Civil War slave markets. With a Pink Pearl eraser and saliva, the books were erased back to front, with the eraser waste left to accumulate over the duration of the piece. Although the space was entered at ground level, a window in the small upstairs office of the garage gave another view of the pile and of the activity at the table. One wall of the office was hung with udder-sized net bags of soya beans, which sprouted and later rotted in the leakage of summer rains. With the humid weather, the space was filled with the musty smell of the damp clothes and the organic decomposition of the soya beans.'
– Ann Hamilton, Artist's statement, 1991

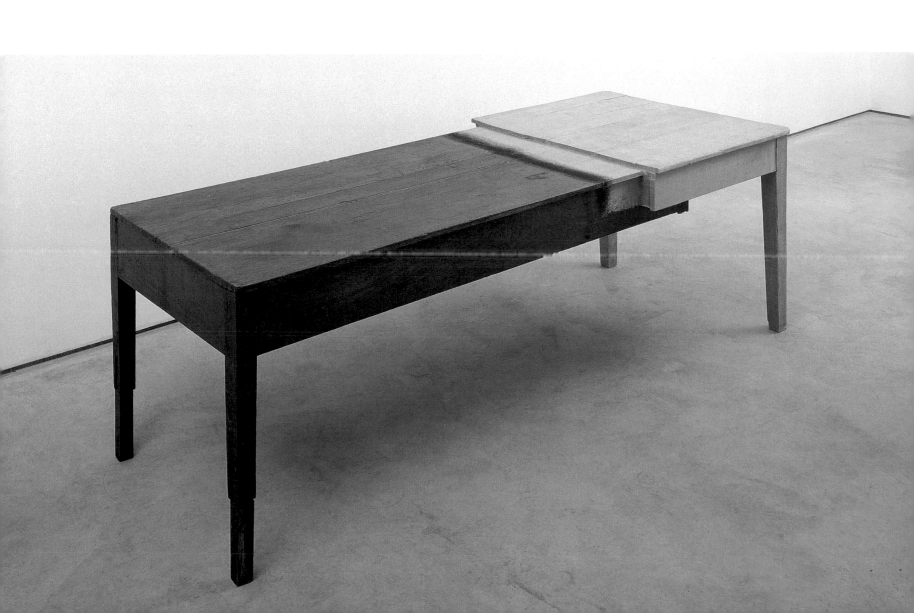

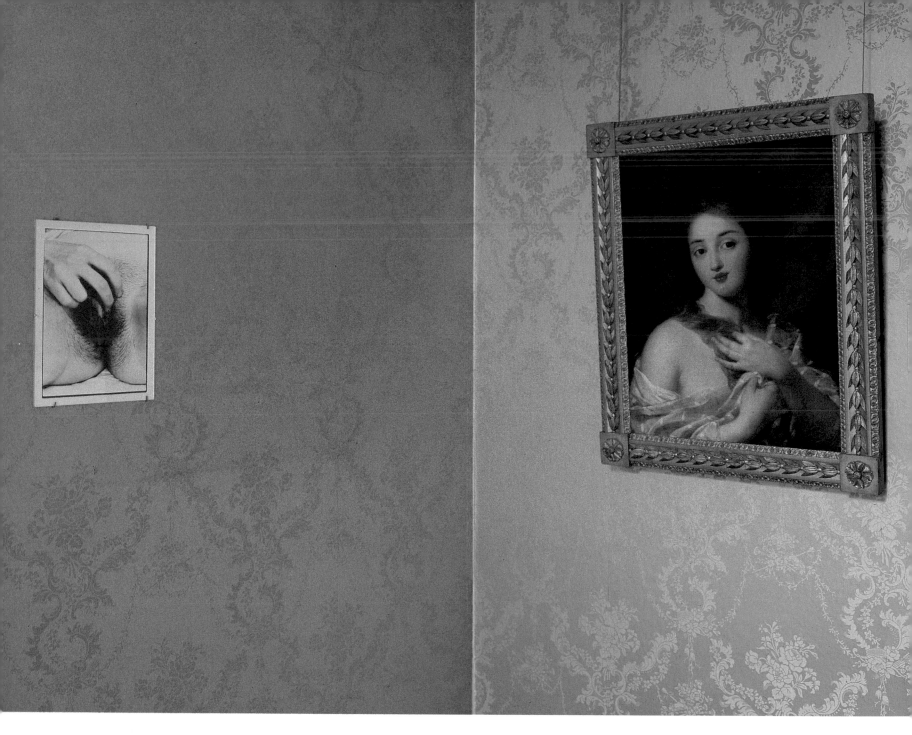

Zoe LEONARD
Untitled
1992
Black and white photographs
19 photographs, dimensions variable
Neue Galerie, Documenta IX, Kassel, Germany

In the Neue Galerie, a public collection of historical German art, Leonard made a site-specific intervention in one entire wing, a suite of seven rooms. The first and last rooms were left unchanged. The five rooms in between were each altered in the following way: eighteenth- and nineteenth-century portraits of men and landscape paintings were removed while paintings in which women were the primary subject remained. Nineteen black and white close-up photographs of women's genital area were inserted in the space left by the removed paintings.

'Documenta IX in 1992 was a break for me. I was finally able to inject funny, sexy, powerful images directly into a stymied and claustrophobic atmosphere.'
– Zoe Leonard, *Art in America*, 1994

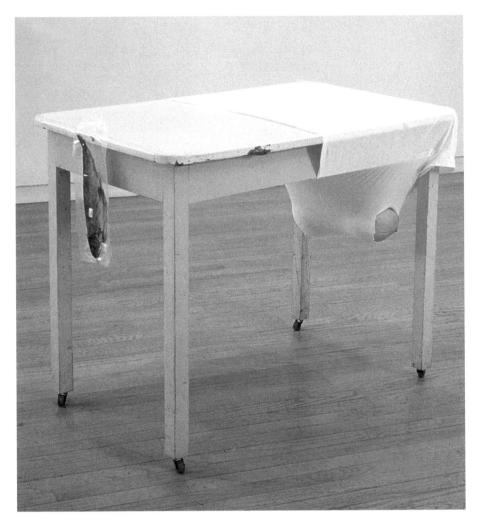

Sarah LUCAS
Bitch
1995
Table, melons, T-shirt, vacuum-packed smoked fish
approx. 80 × 100 × 50 cm [31.5 × 39.5 × 19.5 in]

A T-shirt hanging over the end of an old kitchen table is pulled out of shape by two large melons protruding underneath. At the other end a smoked fish in a bag makes its presence known. The allusion to a sexist, derogatory portrayal of a woman on all fours is evident. However, far from being one-liners, Lucas' sculptures, assemblages and collages continue to resonate after the initial affect of their Rabelaisian wit has subsided. The work invites and sustains a range of unresolved, intersecting responses from both women and men, opening up the body as a site of discussion, rather than adopting a clearly delineated oppositional stance.

Judy BAMBER
My Little Fly, My Little Butterfly
1992
Wood, found objects, paint
2 parts, 24 × 19 cm [9.5 × 7.5 in] each

Two small hyperrealist paintings of female genitals are hung at the eye level of a woman of average height. One image is covered with flies, the other with butterflies, fixed to the surface with pins. The first image both repels the male gaze and underlines feelings of abjection confronted by women impelled, through conformity to social norms, to suppress the visceral presence of their bodies. The second image transforms the scene through symbolic associations of butterflies with metamorphosis, beauty and freedom. Bamber's work engages with pornographic codes of representation, reversing and transforming their fetishization of the feminine subject.

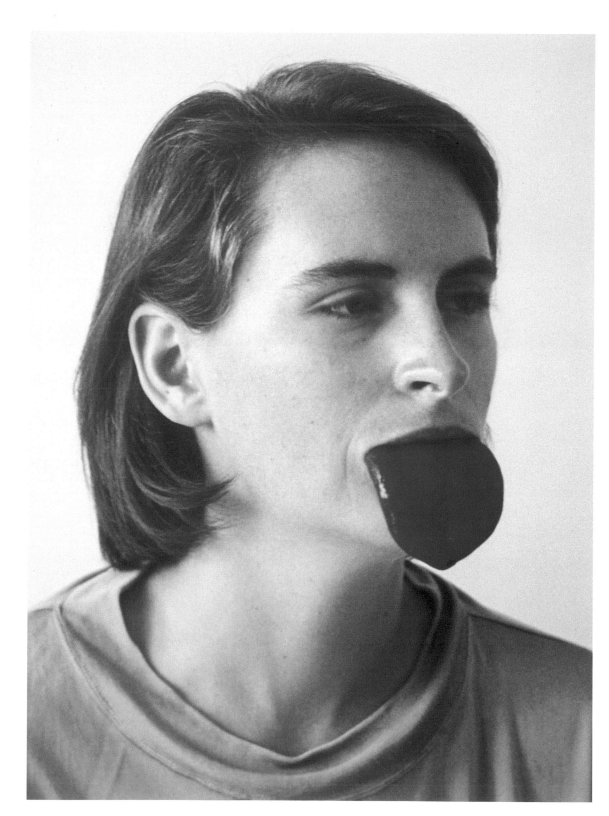

Jeanne <u>DUNNING</u>
Untitled with Tongue
1990
Cibachrome and frame
57 × 46 cm [22.5 × 18 in]

In 1990 Dunning continued her
investigation of female portraiture begun
in 1988 when she had made a series of
portraits of women in which the addition
of facial hair disrupted viewers' expec-
tations. The 1990 series was made up
of three images: a woman with an
'unshaven', soiled appearance; a woman
with a mysterious bulge in her cheek;
a woman displaying a disturbingly
oversized, bright red tongue. These
images were exhibited alongside other
photographs of ambiguous close-up
subjects, suggestive of body parts or of
fruit and vegetable matter. Dunning uses
traditional strategies of photography
such as still life and portraiture,
disrupting them so that they mutate,
unsettling the authority of the tradition.
The viewer is unable to grasp the
'correct' meaning, due to the addition
of unexpected details. Simultaneously
seductive and repellent, the works
engage with the viewer's desire to gain
access to the subject through symboli-
zation. The failure to do so which they
provoke forces a realization of the
violence implicit in this process.

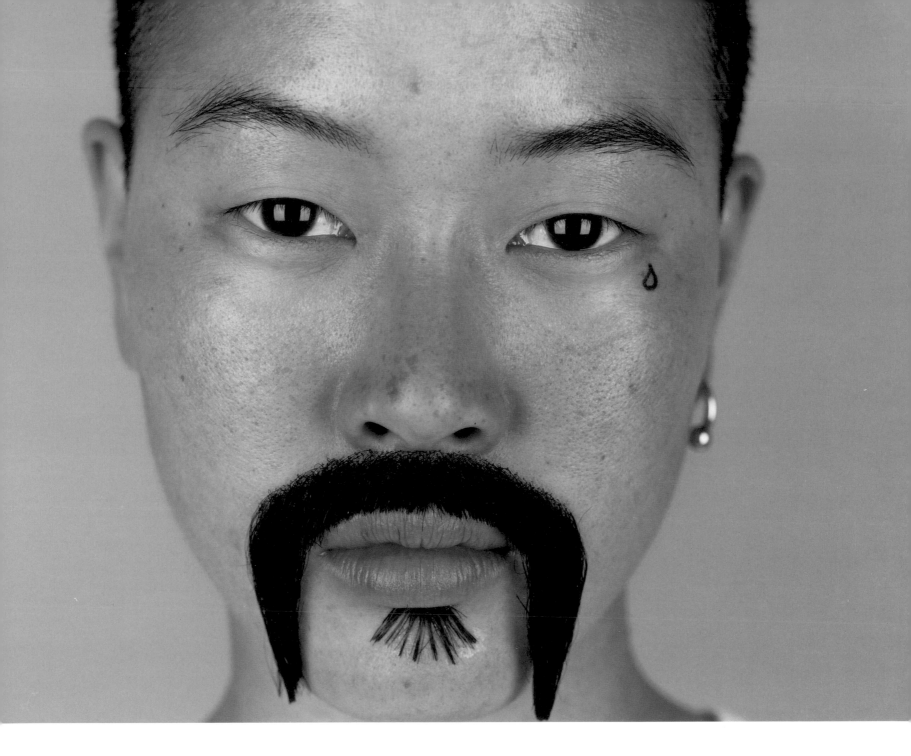

Catherine OPIE
Chicken (from Being and Having)
1991
Chromogenic print
43 × 56 cm [17 × 22 in]

'Opie created a set of framed portraits of mustachioed or bearded faces … In each shot, the camera moves up close to the model's face … The close-up articulates what feels like an intimacy between the model and the artist, an intimacy, moreover, not available to the viewer. The person looking at the photograph is positioned simultaneously as voyeur, as mirror image and as participant, but ultimately it is the spectator who feels caught between looks, between being and having.

'Very often the camera comes close enough to the model's face to reveal the theatricality of the facial hair; in other portraits the facial hair appears to be real, and this sets up a visual trap in which the viewer might attempt to determine whether she or he is looking at a male or female face. This is a trap because Opie's images are often quite beyond the boundaries of gender … '
– Judith Halberstam, *Female Masculinity*, 1998

VNS MATRIX
All New Gen
1992
Wall-mounted and back-lit digital images, online video game
Dimensions variable

All New Gen is an interactive work created by a group of artists based in Adelaide, Australia, which humorously mimics a 'boy's own' adventure world of computer games in order to hijack cowboy toys and re-map cyberspace. The work comprises a series of back-lit, wall-mounted computerized images, large laminated hoardings and an online computer game. Through this the 'spectator' can follow the adventures of All New Gen, an anarcho-cyber terrorist, agent of the new world disorder, who with her band of renegade DNA sluts Patina de Panties, Dentata and the Princess of Slime (fem-warriors), refuse to take any prisoners in their wars against Big Daddy Mainframe. The game offers the player the option of unscrewing a chrome penis and turning it into a portable phone. The DNA sluts seductively suggest through the headphones that the player should visit the three-dimensional Alpha Bar and the Bonding Booth, in which various bisexual punishment rituals are played out on video.

Brenda LAUREL, Rachel STRICKLAND
Placeholder
1993
Interactive video game

Laurel and Strickland disrupt the masculine world of video game production to create virtual reality simulations in which body boundaries become ambiguous. *Placeholder* creates an interactive environment centred on three locales: a group of vertical rock formations known as 'hoodoos', a natural cave and a mountain waterfall. The simulated environments are then animated and the user can interact by choosing one of four game-playing identities: spider, crow, snake or fish. A goddess figure also appears, making suggestions or commands. The piece can accommodate two users, who can interact simultaneously to create their own narratives.

Linda DEMENT
Cyberflesh Girlmonster
1995
Interactive video animation

The user of this interactive computer work can click onto abject, monstrous, biomorphic-appearing, visceral forms or onto disembodied grinning mouths or seductive lips. When thus activated these whisper 'press here' and 'touch me', or another monstrous shape may appear, or a digital video, a story or medical information about the state described in the story may appear. There is no menu system or clear, controllable interface, so that the player engages in the game in a relatively blind state. The hybrid imagery and speech is derived from selected body parts and statements recorded and scanned by over thirty women volunteers during the Artists' Week of the Adelaide Festival, Australia, in 1994. Conglomerate bodies were made from the information donated. The work is a macabre, comic representation of monstrous femininity from a feminist perspective that encompasses revenge, desire and violence.

Catherine <u>RICHARDS</u>
The Virtual Body
1993
Electronics, computer, wood, glass, mirror, brass, liquid crystal
Mylar, monitor, transparencies
122 × 61 × 61 cm [48 × 24 × 24 in]
Installation in Rococo room, Antwerp 93 Festival

A wooden cabinet stood in the centre of a Rococo room in Antwerp. As spectators entered they could see a miniature glass room on top of the cabinet. Through its semi-transparent and illuminated walls the image of the room it was situated in could be dimly perceived. Peering through a brass peephole in the ceiling of the miniature room, spectators momentarily saw a reflected image of the Rococo room's ceiling, but just as it appeared it was replaced by an image of the floor, which in turn was overtaken by the ceiling as the space in the miniature room destabilized. At one side of the cabinet was a space through which the viewer could place a hand. This triggered a third state: the glass walls became opaque and the viewer could see the floor image scrolling beneath his or her hand, gradually creating an illusion of motion as the hand appeared to be travelling infinitely further away from the body. The installation reinterpreted notions of space in Baroque and Rococo architecture and painting, in the context of the digital age. In this scenario the sense of the body as a unitary whole dissolved to the point where it could no longer be distinguished from the surrounding digital information environment.

ORLAN
Omnipresence
1993
Sandra Gering Gallery, New York

Orlan's work of the 1990s has continued her longstanding concern with historical stereotypes of female beauty, through plastic surgery operations upon her own face. At each operation, one of the artist's features is transformed to resemble that of a famous art historical precedent, for example, Leonardo da Vinci's Mona Lisa. Cumulatively, these transformations form a composite 'ideal' physiognomy combining features from many works of art. *Omnipresence*, Orlan's seventh 'performance-operation', was broadcast live by satellite from New York to fifteen sites worldwide, including the Centre Georges Pompidou, Paris. Spectators around the world could ask the artist questions both before and during parts of the operation, performed by a feminist surgeon. Elaborately staging the event with drapery and costumes created by fashion designers, Orlan transformed the operating theatre (set up inside a New York gallery) into her studio, while her operation provided the material for the production of film, video, photographs and objects to be exhibited later. Over the forty-day period directly after the operation, Orlan juxtaposed photographs of her bruised, healing face with computer-morphed images of goddesses from Greek mythology. This emphasized the physical deformity and pain she was undergoing in order to attain a culturally idealized beauty.

Hannah WILKE (with Donald Goddard)
Intra-Venus Series II (details)
1993
Chromogenic supergloss photographs
121 × 182 cm [48 × 72 in] each

Wilke made *Intra-Venus* while she was dying of lymphoma. A series of life-sized colour photographs of her swollen and bruised body displays the deforming effects of cancer treatment. Self-portrait watercolours, medical object-sculptures and collages made with the hair she lost during chemotherapy are also part of the work. Prior to *Intra-Venus* Wilke had been known (and often criticized by other feminists) for work using her own glamorous, model-like face and body as a central element in her performance works. Transformed by her illness, Wilke continued to make work using her body, no longer young and beautiful, no longer conforming to an idealized feminine image. *Intra-Venus* was exhibited posthumously at the Ronald Feldman Gallery, New York, in 1994.

opposite
Tracey EMIN
Why I Never Became a Dancer
1995
Video
6 mins., 30 secs., colour, sound

Emin recounts a talent contest for dancing when she was heckled by boys in the audience. The camera retraces the scenes of her youth in Margate.

' I'd slept with quite a few of them ... I was fourteen and they were between nineteen and twenty-four. You could say that they should have known better than to sleep with a fourteen-year-old girl ... They shouldn't have publicly humiliated me. But this story is very edited. Even when I walked down the High Street they used to shout "Slag!" or "Slut!" I never did anything wrong to them; all I did was have sex with them ... '
– Tracey Emin, 'The Story of I: Interview with Stuart Morgan', 1997

Emin's recollections of the past, often anguished, scenes of her life, function as an exorcism of the emotional trauma. In this respect her work reactivates a function of art that had been present in early feminist art activities such as the consciousness-raising groups of Womanhouse (Valencia, California, 1972), and had continued in live art practice, but had been largely excluded from the arena of visual art until the 1990s. Emin's sharing of her personal experiences is the conceptual material of her work, which she expresses through a variety of forms, from performance and video to installations such as a tent embroidered with the names of all the people she has shared a bed with, *Everyone I Have Ever Slept With 1963–1995* (1995).

Alex BAG
Untitled (Fall 95)
1995
Video
28 mins., colour, sound

In *Untitled (Fall 95)* Bag appears in the persona of an art student who goes through a variety of transformations, delivering often hilarious monologues accompanying the various phases her assumed identities pass through. Bag's works use low-tech, vox-pop style video and an array of self-mutations to redirect television's ubiquitous presence, turning it into a tool that can be 'curated' by individuals for their own needs and pleasures rather than those of the broadcasting corporations. Blending street awareness with social experimentation, Bag creates a chameleon presence, mixing and matching, slipping and sliding between TV culture and personal agendas.

Collier SCHORR
Bundeswehr
1998
C-print
30 × 40 cm [12 × 16 in]

During the 1990s, Schorr, a New York-based artist, frequently used Germany as a location for studying the intersection of personal, group and national identities. In images of young models, often posed in military uniforms, that are at first glance reminiscent of recent German photography by artists such as Thomas Ruff and Candida Hofer, Schorr observes the existential isolation of her subjects. Gesture, pose, attitude, the ways that movement is performed for the moment of the photograph, are key to Schorr's investigation of the ideological play between binary oppositions of identity: '*Bundeswehr* ... is about skirting heroism. The subject strikes a pose to suggest the starry high associated with fictional soldiers. The text skirts the model's chest, highlighting the possibility of breasts ... '
– Collier Schorr, Artist's statement, 2000

Lucy <u>GUNNING</u>
Climbing around My Room
1993
Video
7 mins., 30 secs., colour, sound

A video camera trails the movements of the protagonist as, with the quiet concentration of a rock climber, she uses every available surface except the floor (door knob, clothes hook, window ledge, bookshelf …) to edge her way around the perimeter of a room. Barefoot, clad in a red dress, she demonstrates great skill in preventing her climb from lapsing into the 'unladylike'. Like the subjects in Gunning's other works, whether mimicking horse sounds (*The Horse Impressionists*, 1994) or performing inaudibly (*Opera Singer*, 1996), this woman has a complex relationship with 'normal' language and expression. Gunning's subjects seem aware that they could be accused of not complying with the composure expected of womanhood, that various forms of assertive action are still classed as bordering on hysteria when performed by women. At the same time, their resolute performance alters and modifies that perception.

FEMMES DE SIÈCLE

The work of many women artists at the end of the 1990s showed evidence of millennial reflection, exploring collective memories, associations and traumas to re-open questions of history and the memorial. Pushing the limits and definitions of gender, some artists have explored gender identification in states of transition. Others have, sometimes controversially, reappropriated stereotypical imagery to address social and historical issues. In contrast to these challenging strategies, a number of artists have pursued the unsensational re-evaluation of the everyday, addressing banal situations, liminal spaces and chance encounters.

Coco FUSCO
Better Yet When Dead
1997
YYZ Artspace, Toronto;
International Arts Festival
of Medellín, Colombia

'Despite … an exceptional array of cults dedicated to virgins and female saints, Latin America is still a terrain where women do not exercise control over their own bodies … Latin women gain power over the collective cultural investment in their bodies when they die spectacular deaths, particularly if they die young. I sought to perform this ultimate expression of female will by feigning death – as other women.' Seeking to 'activate the psychodynamics of cross-cultural attraction', a central concern of her work, Fusco performed this action for several hours a day over several days, first in Canada, then in Colombia. Among the artists who inspired the work, referred to in accompanying texts, were Frida Kahlo, Ana Mendieta and performer Evita Perón.
– all quotes from Coco Fusco, 'Better Yet When Dead', 2000

Christine and Irene HOHENBÜCHLER
Zwei Rechts, Zwei Links Stricken
(To Knit 2, Purl 2)
1994
Cotton rope
Dimensions variable
Kunstverein, Munich, 1996

Born and based in Vienna, the Hohenbüchlers focus in much of their work on the traditionally 'female' skills of sewing, knitting and weaving – the only area of accomplishment which Freud notoriously allowed as women's original contribution to Western civilization. The Hohenbüchlers extend their own sibling collaboration to include the participation of groups with learning difficulties or from psychiatric and penal institutions, whose texts and artefacts are often interwoven with those of the artists. Rather than functioning as therapists, the Hohenbüchlers describe their strategy in terms of multiple authorship. Offering a collaborative framework, they hope to challenge viewers' expectations of work which blurs the boundaries between art and handicraft and which gives voice to those excluded by social institutionalization.

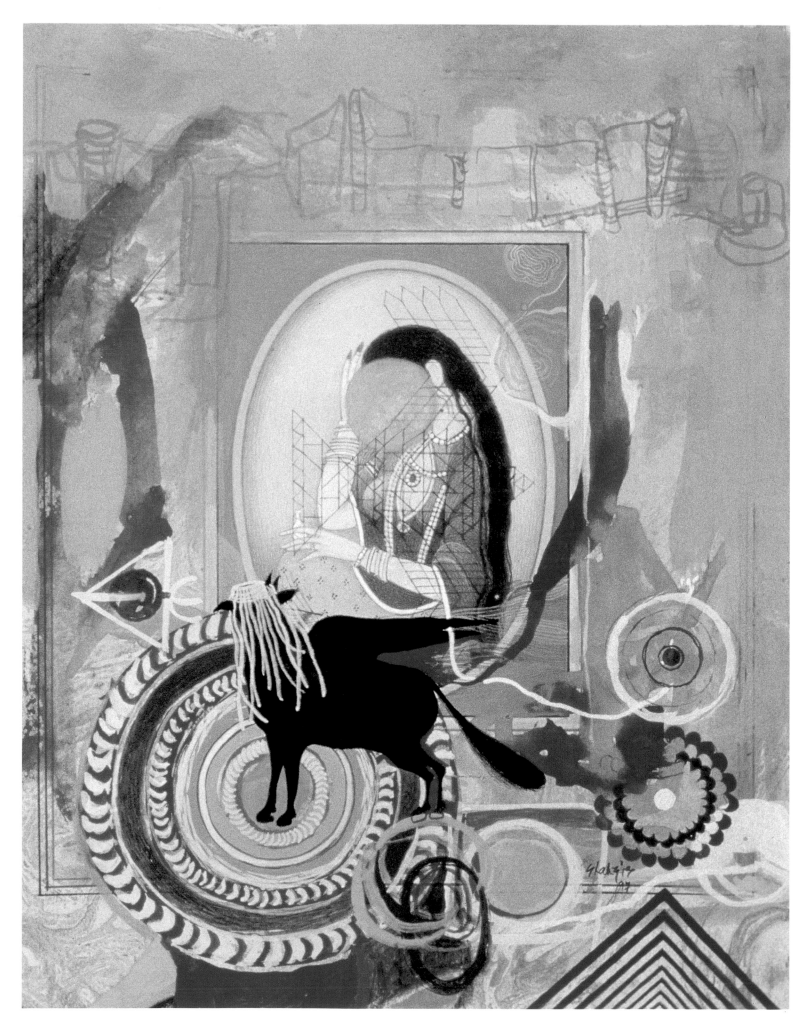

Shahzia <u>SIKANDER</u>
Ready to Leave
1994-97
Vegetable colour, dry pigment,
watercolour, tea on hand-prepared
'wasli' paper
25 × 19 cm [10 × 7.5 in]

Sikander studied traditional Mughal styles of miniature painting in Lahore, Pakistan. She applies these techniques in her small-scale works. Although some of her work directly represents contemporary political figures and issues, more often she creates a fantasy world, where traditional religious and allegorical imagery provides a starting point for modern, hybrid figures and scenes. Small, floating female figures are encircled by loops and cascades of white ribbons. A recurring principal figure often wears a white veil and has ribbons instead of feet. Often she is depicted with multiple arms brandishing a range of weapons. She is conceived as a symbol of female empowerment, rather than aggression, and floats to show that she is not grounded in anything other than herself. The figure is unnamed and changes form and meaning at will, a characteristic which the artist, raised as a Muslim and now resident in the US, adapts from the openness of Hindu mythology and applies to the diversity of her own shifting sense of identity.

Kara <u>WALKER</u>
Camptown Ladies
1998
Cut paper and adhesive on wall
274 × 2042 cm [108 × 804 in]
overall

Walker uses black-paper silhouette cut-outs to construct imagery that mingles 'the most deeply disturbed fantasies of Southern whites with the hitherto unimaginable visions of a contemporary young African-American woman … these scenes, at first glance the offspring of countless moonlight-and-magnolias illustrations, invariably turned out on closer inspection to involve blatantly coarse seductions or horrifically perverse scenarios.'
– Jerry Cullum, 'Landscape, Borders and Boundaries', 1995

The work sparked controversy, going beyond a clearly positioned critique of historically racist imagery to explore a seductive fascination with repressed and forbidden layers of interpretation.

Elaine <u>REICHEK</u>
Sampler (World Wide Web)
1998
Embroidery on linen
28.5 × 36 cm [11 × 14 in]

Reichek has focused on needlework sampler traditions to explore developments in artistic and cultural history through the perspective of a historically devalued craft medium. Re-presenting diverse material, from works by male artists, authors and filmmakers to those of Jenny Holzer and Barbara Kruger, Reichek links these and even the World Wide Web with an alternative history of fabrication and conceptualization.

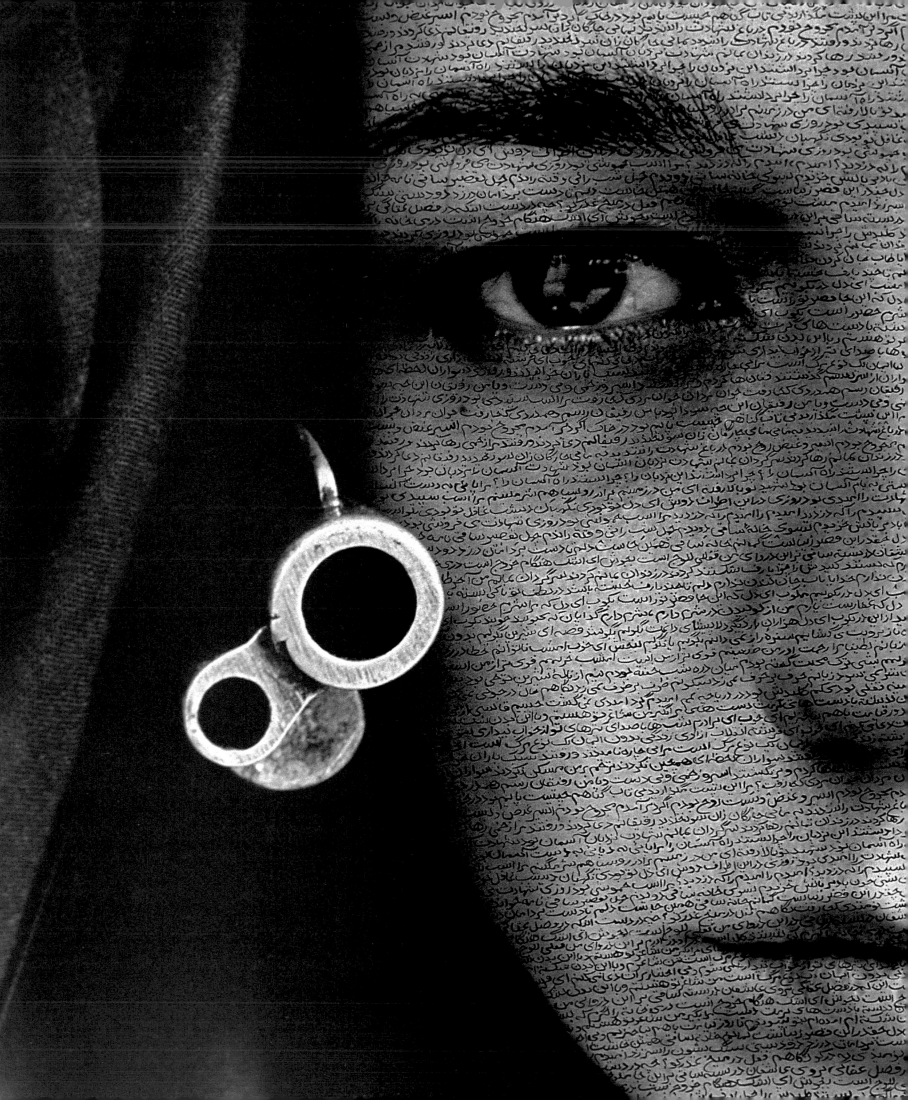

Shirin NESHAT
Speechless
1996
Black and white photograph
101.5 × 152.5 cm [40 × 60 in]

Neshat's photograph shows an Islamic woman wearing a veil (*chador*) which is lifted to reveal her face. What at first glance might be fleetingly misread as an earring is seen to be the foreshortened barrel of a gun pointing towards the viewer; it is disconnected yet embedded in the image of the female subject. The image is overlaid with Arabic text. To the non Arabic-literate viewer the text remains a mute, decorative form whose meaning is inaccessible. This double effect of inscription and concealment is echoed by the black *chador*, which for a Western audience is a symbol of oppression and suffering, while in the Islamic world the *chador* makes female entrance into the public sphere possible through its obliteration of the private, individual realm of the visible female body. The gun embodies similar double-edged interpretations. Neshat constructs images of Iranian identity that challenge assumptions about the meaning and status of visual representation associated with the Islamic world. For those who understand the texts, these also maintain positions of ambiguity and struggle. They are authored by Iranian women, some of whom, like the feminist Forough Farokhzad, complain of being trapped in Iranian culture; others, such as the poet Tahereh Saffarzadeh, express passion for the Islamic revolution and the liberation of the *chador*.

overleaf
Jenny HOLZER (with Tibor Kalman)
Lustmord
1993-94
Photographs of handwriting in ink on skin
32 × 22 cm [12.5 × 8.5 in] each

The English equivalent of the German word 'lustmord' is 'rape-slaying'. This was the title of several works Holzer made in the aftermath of war in the former Yugoslavia. The project was first presented in *Südeutsches Zeitung Magazin* in Germany. Texts were written on the skin of women volunteers, and presented as cropped photographs on the magazine pages. There is no way of knowing whether the skin surfaces belong to a victim, perpetrator or observer. The texts similarly alternate between the three viewpoints. The magazine cover reproduced one of the texts in red ink mixed with blood provided by women involved in the project. The writing on the skin opens up the incongruity between the rape as a traumatic act and its symbolic inscription. The inscriptions remain detached from the body; they are messages that can never convey the trauma of the act itself.

I TRY TO
EXCITE MYSELF
SO I
STAY CRAZY

I WANT TO
FUCK HER
WHERE SHE
HAS TOO
MUCH HAIR

I WANT TO BRUSH
HER HAIR BUT
THE SMELL OF HER
MAKES ME CROSS
THE ROOM. I HELD
MY BREATH AS
LONG AS I COULD.
I KNOW I DISAPPOINT HER

MY BREASTS
ARE SO
SWOLLEN
THAT I
BITE THEM

I KNOW WHO
YOU ARE AND
IT DOES ME
NO GOOD
AT ALL

SHE ACTS
LIKE AN ANIMAL
LEFT FOR COOKING

SHE FELL ON THE FLOOR
IN MY ROOM.
SHE TRIED TO BE
CLEAN WHEN SHE DIED
BUT SHE WAS NOT.
I SEE HER TRAIL

SHE HAS NO
TASTE LEFT
TO HER AND
THIS MAKES IT
EASIER FOR ME

SHE STARTED RUNNING
WHEN EVERYTHING
BEGAN POURING FROM
HER BECAUSE
SHE DID NOT WANT
TO BE SEEN.

THE BIRD TURNS
ITS HEAD AND
LOOKS WITH
ONE EYE WHEN
YOU ENTER

THE COLOR OF
HER WHERE SHE
IS INSIDE OUT
IS ENOUGH TO
MAKE ME
KILL HER

WITH YOU
INSIDE ME
COMES THE
KNOWLEDGE OF
MY DEATH

YOU CONFUSE ME
WITH SOMETHING
THAT IS IN YOU
I WILL NOT
PREDICT HOW
YOU WANT TO
USE ME

YOU HAVE SKIN
IN YOUR MOUTH
YOU LICK ME
STUPIDLY

HER GORE IS IN
A BALL OF CLEANING
RAGS. I CARRY OUT THE
DAMPNESS LEFT FROM
MY MOTHER. I RETURN
TO HIDE HER JEWELRY

THE BLACK SPECKS
INSIDE MY EYES
FLOAT ON HER BODY
I WATCH THEM WHILE
I THINK ABOUT HER

YOUR AWFUL
LANGUAGE
IS IN
THE AIR
BY MY HEAD

I TAKE HER
FACE WITH ITS
FINE HAIRS.
I POSITION
HER MOUTH

Susan HILLER
From the Freud Museum
1991-97
Vitrine installation, 50 archival boxes individually titled and dated,
containing artefacts, notes, images, 1 video programme on lcd monitor
Boxes 25.5 × 33.5 × 6.5 cm [10 × 13 × 2.5 in] each
Collection, Tate Gallery, London

This installation's title refers to Sigmund Freud's last home, now the London Freud
Museum, where this work was first installed near to Freud's own remarkable collection
of antiquities and ethnographic objects. The title is also intended to suggest that we all
inhabit particular historically formed archives, which, in the case of Western Europeans,
might well be named 'the Freud museum'. The key to the work is the explicit evocation of
memory and its corollary, forgetting – waters from the streams of Lethe and Mnemosyne
have a central place in Hiller's suggestive collection of relics, samples, fragments and
rubbish. The process of interpreting the contents of each box in relation to its title and
its accompanying text, diagram or picture provides space where viewers can experience
their own roles as active participants – collaborators, interpreters, analysts or detectives.

Mona HATOUM
Present Tense
1996
Soap and glass beads
4.5 × 299 × 241 cm [2 × 118 × 95 in]

In 1996 Hatoum, whose Palestinian parents came from Haifa but had not been able
to return there since 1948, visited Jerusalem for the first time. *Present Tense* is one
of a series of installations and small works she made during her month there. 'On my
first day in Jerusalem I came across a map divided into a lot of little areas circled in
red, like little islands with no continuity or connection between them. It was the map
showing the territorial divisions arrived at under the Oslo Agreement, and it
represented the first phase of returning land to the Palestinian authorities. But really
it was a map about dividing and controlling the area.' A week later, Hatoum decided
to make a work with the pure olive oil soap made traditionally by hand in factories in
a Palestinian area; a transient substance which she also became aware of as a shared
symbol of continuity and resistance. She decided at that point to draw the outline of the
map on the surface of the soap, at first using nails but rejecting their aggressive form,
using instead glass beads pressed into the soap's surface. Responses to the work
revealed the very different backgrounds of the two cultures trying to co-exist. While
some Israeli visitors to the exhibition saw the soap as referring to the atrocities of the
concentration camps – a reference not intended by the artist – Palestinian visitors
immediately recognized the smell and associations of the soap. One visitor asked,
'Did you draw the map on soap because when it dissolves we won't have any of these
stupid borders?'
– all quotes from Mona Hatoum, *Mona Hatoum*, 1997

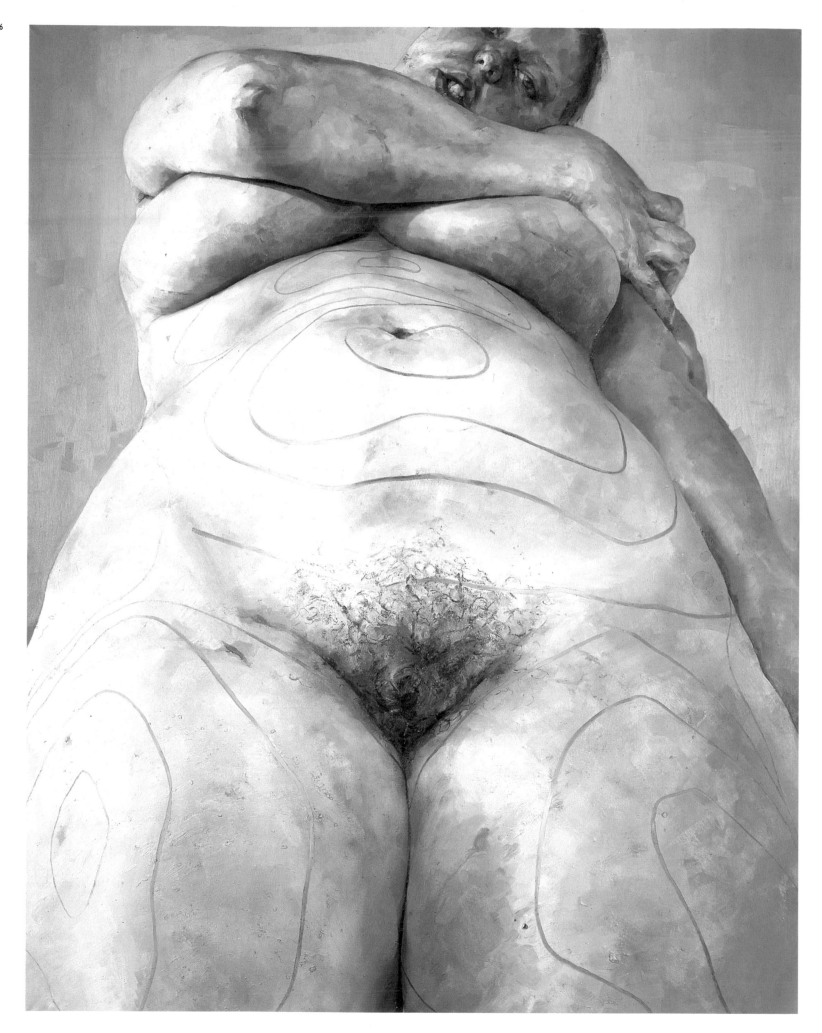

Jenny SAVILLE
Plan
1993
Oil on canvas
274.5 × 213.5 cm [108 × 84 in]

In this painting Saville combines the image of a female subject's body with the suggestion of landscape. The lines painted on the body's surface resemble contour markings on maps, while also suggesting areas of the body's topography indicated for liposuction, the surgical removal of unwanted fat. In this mapping of the body as an area of problematic terrain a relationship is set up between perceptions of the natural and the planned. The question of who is exercising control over this 'plan' remains troubling and implicates the viewer of the image.

Saville originally began making her large-scale paintings of female nudes by using photographs of parts of her own body to explore the role of model and artist at the same time. Both seductive and disturbing, Saville's images present the female nude pushing out towards the viewer, rather than being safely contained within a frame.

Vanessa BEECROFT
vb.dw.337.c
1994
Graphite and watercolour on paper
26 × 18 cm [11.5 × 8 in]

This is one of a series of works, originally conceived as part of a diary-like document chronicling a subject's struggle with anorexia nervosa. It takes the form of small pencil and watercolour sketches on paper. These are often fragmented and sometimes brightly coloured or covered in black marks. Beecroft's drawings are integrally related to her live performance and video works with young female participants. These explore the contrast between the individuality of the models and the stereotypes from the world of fashion and the media which they are required to mimic during the performances.

Eija-Liisa AHTILA
If 6 Was 9
1995
Split-screen video installation, colour, sound, each tape 10 mins.

The dialogues of three different groups of teenagers are projected simultaneously across a three-part split screen. They speak in Finnish with English subtitles. The dialogues are fictitious but are based on the Finnish artist's conversational research with teenagers on their attitudes towards sex and womanhood. What results is an indefinite combination of private memories, real and fictive events. Ahtila experiments with narrative techniques and temporal perspective to subvert traditional feature and TV film techniques in favour of mulilayered narratives with many possible readings. The form and context of the work are similarly intentionally adaptable, so that most of the artist's works can be presented in varied exhibition contexts, as cinema screenings or as TV broadcasts.

Gillian WEARING
Take Your Top Off (detail)
1993
3 C-type prints mounted on aluminium
73.5 × 99.5 cm [29 × 39 in] each

'I phoned people without meeting them first, and then went to their places and got into bed. I wouldn't go through a rehearsal beforehand. I just wanted to know what would happen, so it was all done on the same day ... When I first showed it I didn't tell anyone that the people in the work were transsexuals ... I didn't want to make that point ... I wanted them just to be seen as people who looked like women.'
– Gillian Wearing, 'In conversation with Donna De Salvo', 1999

The artist sits in bed alongside her subjects, three people at different stages of transsexual transformation. With her own top off, she appears as a friendly participant yet strangely over-involved, occupying a troubling, ambiguous position. Often placing herself in vulnerable, unpredictable situations with strangers, Wearing acts out and implicitly questions notions of the artist as social anthropologist.

Pipilotti RIST
Sip My Ocean
1996
Video projection
3.5 mins., colour
Collections, Louisiana Museum of Modern Art, Humblebaek, Denmark; Museum of Contemporary Art, Chicago; Solomon R. Guggenheim Museum, New York

Continuously projected as two mirrored video images in the corner of a room, *Sip My Ocean* evokes a dream-like world of the unconscious. Images composed almost entirely of underwater scenes present kaleidoscopic impressions that become related, through the accompanying vocal soundtrack, to the experience of falling in love and surviving it. Rist sings a version of Chris Isaac's song 'Wicked Game', moving from the whispered adolescent longing of 'I never thought I'd fall in love with someone like you', to the emotional devastation of the adult recognition 'I never thought I'd lose someone like you'. The mirroring effect of the projection suggests the dualities at play in emotional desire. The seductiveness of desire and fulfilment is counterposed by suggestions of perilous undercurrents when everyday objects of domestic security – a toaster, a plate, a cup – are seen floating like abandoned toys to the bottom of the sea.

APPEN-
DICES

ARTISTS' BIOGRAPHIES

Magdalena **ABAKANOWICZ** [b. 1930, Falenty, Poland] lives in Warsaw. A pioneer of fibre art, in the late 1960s she developed the monumental textile sculptures named *Abakans*. From the mid 1970s medical and anthropological studies led to clay cast and textile forms based on fragmented human figures, such as *Backs* (1981). She was included in three Venice Biennales (1968; 1980; 1995).

Marina **ABRAMOVIC** [b. 1946, Belgrade] lives in Paris and Amsterdam. She began using her body in performance in 1972, exploring pain and physical resistance. From 1976-88 she collaborated with East German artist Uwe Laysiepen (Ulay) making works which tested bodily relationships. She was included in Documenta 6, Kassel (1977). Solo shows include 'The Artist is Present', Museum of Modern Art, New York (2010)

Eija-Liisa **AHTILA** [b. 1959, Hämeenlinna, Finland] lives in Helsinki. Her film and video works hover between reportage, soap opera and fantasy genres, performed by actors in Finnish with English subtitles and shown in various formats, from installation to screenings, to broadcasts. She was included in the XLVIII Venice Biennale (1999). Solo shows include Museum Fridericianum, Kassel, Germany (1998).

Chantal **AKERMAN** [b.1950, Brussels] lives in Paris. An independent filmmaker, from 1971 onwards Akerman developed structural film into her unique cinematic form, often described as 'hyperrealist', which traces the complexities of relationships through observation of everyday actions from a non-privileged viewpoint. A retrospective show of her work was held at the Walker Art Center, Minneapolis, in 1995.

Laurie **ANDERSON** [b. 1947, Chicago] lives in New York. Her solo musical performances using electronically adapted instruments developed by the end of the 1970s into spectacular multimedia events which explored issues of the gendered and classed subject in technological, urban culture. Her writings and performance documentation, *Stories from the Nerve Bible*, were published in 1994.

Eleanor **ANTIN** [b. 1935, New York] lives in California. In her photographically

documented actions she often presents self-portraits as symbols for explorations of the self and of notions of female identity. She was included in the São Paulo Biennale (1975). A major retrospective was held at the Los Angeles County Museum of Art (1999).

Janine **ANTONI** [b. 1964, Freeport, Bahamas] lives in New York. Antoni uses her own corporeality in relation to traditional media in order to intervene in and disrupt male-centred art historical forms. She was included in the XLV Venice Biennale (1993). Solo shows include 'Slumber', Anthony d'Offay Gallery, London (1994) and 'Swoon', Whitney Museum of American Art, New York (1998).

Ida **APPLEBROOG** [b.1929, New York] lives in New York. A painter and book artist, Applebroog questions received notions of the feminine, addressing issues such as male aggression towards women. Her imagery refers both to popular culture and Modernism. She was included in the Whitney Biennial, Whitney Museum of American Art, New York (1993). Solo shows include the Irish Museum of Modern Art, Dublin (1993).

Alice **AYCOCK** [b. 1946, Harrisburg, Pennsylvania] lives in New York. She is best known for her large scale, semi-architectural projects which address the interaction between structure, site, materials and viewers' responses. She was included in Documentas 6 and 8, Kassel (1977; 1987) and three Venice Biennales (1978; 1980; 1982). A retrospective of her work, 'Complex Visions', was presented at Storm King Art Center, Mountainville, New York (1990).

Alex **BAG** [b. 1969, New York] lives in New York. A video artist, she acts out personae who comment on struggles towards self-definition and the superficiality of pop culture. She was included in 'Young and Restless', The Museum of Modern Art, New York (1997). Solo shows include Le Magasin, Grenoble (1996).

Judy **BAMBER** [b. 1961, Detroit] lives in New York. Her work in photography and mixed media explores the feminist political dimensions of seduction and abjection. She was included in 'Sexual Politics: Judy Chicago's *Dinner Party* in Feminist Art', UCLA/Armand Hammer Museum

of Art, Los Angeles (1996). Solo shows include Richard Telles Fine Art, Los Angeles (1992; 1994; 1996).

Judith **BARRY** [b. 1954, Columbus, Ohio] lives in New York. A video and new media installation artist, and a writer on art and technology, she has focused, from a feminist perspective, on the political power structures underlying technologies of representation. She was included in the Whitney Biennial, Whitney Museum of American Art (1987) and 'On taking a normal situation … , Museum van Hedendaagse Kunst, Antwerp (1993). Solo shows include 'Public Fantasy', Institute of Contemporary Arts, London (1991).

Ute Meta **BAUER** is Dean of the School of Fine Art at the Royal College of Art, London. As a curator she addresses political aspects of documentation, highlighting exclusion. In 1996 Bauer co-curated, with Fareed Armaly, a section of the exhibition 'NowHere', Louisiana Museum, Humlebaek, Denmark.

Vanessa **BEECROFT** [b. 1969, Genoa] lives in New York. Beecroft explores stereotypes in biographical works and in performances, videos and photographs with participants. She was included in 'Aperto Italia '95', Trevi Flash Art Museum, Trevi (1995). Solo shows include Galerie Analix B & L Polla, Geneva (1995; 1996).

Lynda **BENGLIS** [b. 1941, Lake Charles, Louisiana] lives in New York. Her 'formless' sculptural works, photographs and video works explore gendered power relationships. She was included in 'Contemporary Women: Consciousness and Content', Brooklyn Museum, New York (1977). Solo shows include Cheim & Read Gallery, New York (1998).

Sadie **BENNING** [b. 1973, Madison, Wisconsin] lives in New York. Her video works subvert the predominantly heterosexual codes and critical framework of avant-garde film. She was included in the Whitney Biennial, Whitney Museum of American Art, New York (1993; 2000).

Dara **BIRNBAUM** [b. 1946, New York] lives in New York. Her video works recontextual-ize imagery derived from media sources to

underline its ideological effects. She was included in Documentas 7 and IX, Kassel, Germany (1982; 1992). Retrospectives include Kunsthalle, Vienna (1994).

Lee **BONTECOU** [b. 1931, Providence, Rhode Island] lives in East Hampton, New York First shown in the early 1960s, her reliefs used worn-out conveyor belts, aeroplane parts and saws in compositions which dispelled equations of the feminine with softness and passivity. She was included in 'The Art of Assemblage', The Museum of Modern Art, New York (1961). Retrospectives include the Museum of Contemporary Art, Chicago (1972).

Pauline **BOTY** [b. 1938, London; d. 1966, London] was the only woman painter associated with the British Pop art movement in the 1960s. Her approach to imagery from popular culture is significant for introducing a female perspective into the Pop lexicon. She was included in 'New Art 62', Festival of Labour, London (1962) and the BBC film *Pop Goes the Easel* (1962).

Louise **BOURGEOIS** [b. 1911, Paris; d. 2010, New York] lived in New York. She was one of the twentieth century's most acclaimed sculptors, whose work existentially addresses corporeal existence. Retrospectives include The Museum of Modern Art, New York (1982), and touring, The Frankfurter Kunstverein, Frankfurt am Main (1989), and touring, and Solomon R. Guggenheim Museum, New York (2008).

Sonia **BOYCE** [b. 1962, London] lives in London. Her media include drawing, sculpture, photography and installation. Her work explores desire and identity. She was included in 'Five Black Women', Africa Centre, London (1983), and the Havana Biennale, Cuba (1989). Solo shows include Whitechapel Art Gallery, London (1988).

Geneviève **CADIEUX** [b. 1955, Montreal] lives in Montreal. Her work in both photography and video installation develops theories of film and visual representation into complex investigations of psychological and corporeal states. Retrospectives include the Montreal Museum of Fine Arts (2000).

Sophie **CALLE** [b.1953, Paris] lives in Paris. A photographer and installation

artist, she documents life situations that evidence desire and loss. She was included in the Whitney Biennial, Whitney Museum of American Art, New York (1993). Solo shows include the Museum Boijmans Van Beuningen, Rotterdam (1994).

Helen **CHADWICK** [b. 1953, Croydon, England; d. 1996, London] was a British sculptor, photographer and installation artist whose works investigate female identity in art history and contemporary culture. Important solo shows include 'Of Mutability', Institute of Contemporary Arts, London (1986) and the Museum of Modern Art, Tel Aviv (1997).

Sarah **CHARLESWORTH** [b.1947, East Orange, New Jersey] lives in New York. Her photographic work addresses photography's role in signifying identities and desires. She was included in 'The Art of Memory', New Museum of Contemporary Art, New York (1985). Solo shows include Tyler Gallery, Temple University, Philadelphia (1988).

Judy **CHICAGO** [b. 1939, Chicago] lives in New Mexico. A key figure in US feminist art, she is renowned for her collaborative sculpture *The Dinner Party* (1974-79). She was included in 'Sexual Politics: Judy Chicago's *Dinner Party* in Feminist Art History', UCLA/Armand Hammer Museum of Art, Los Angeles (1996). Solo shows include 'Trials and Tributes', Florida State University Museum of Fine Arts, Tallahassee (1999).

Abigail **CHILD** [b. 1948, San Francisco] lives in New York. A film and video maker and writer, she employs film techniques to reconfigure narrative and representational codes of gender and identity. She was included in the Whitney Biennial (1989; 1997) Whitney Museum of American Art, New York.

Lygia **CLARK** [b. 1920, Belo Horizonte, Brazil; d. 1988, Rio de Janeiro] lived in Rio de Janeiro. From the late 1960s her work was centred on phenomenological perceptions of space, time and relationship, informed by her practice as a psychotherapist. Retrospectives include the São Paulo Biennale (1994) and Fundació Antoni Tàpies, Barcelona (1997).

Betsy **DAMON** [b. 1940] lives in St. Paul, Minnesota. An eco-feminist interdisciplinary artist, she performed works such as *7,000 Year-old Woman* in US and European cities between 1976-82. After 1990 water became the focus of her work.

Her large scale environmental projects include a six-acre Living Water Garden in Chengdu, China.

Linda **DEMENT** [b. 1959, Australia] lives in Sydney. Working with virtual reality technology she has produced CD-ROM works that explore possibilities of inserting visceral bodily traces into the disembodied arena of virtual simulations.

Marlene **DUMAS** [b. 1953, Cape Town] lives in Amsterdam. Her figurative drawings and paintings are executed in an expressionist style which combines a conceptual approach with sensuous qualities conveying an ambiguous eroticism. She was included in Documentas 7 and IX, Kassel, Germany (1982; 1992). Solo shows include a retrospective at the Museum van Hedendaagse Kunst, Antwerp (1999).

Jeanne **DUNNING** [b. 1960, Granby, Connecticut] lives in Chicago. Her photographic, sculptural and video work explores our relationship to our own physicality through unfamiliar images. She was included in 'Feminin-Masculin', Centre Georges Pompidou, Paris (1995). Solo shows include the Hirshhorn Museum and Sculpture Garden, Washington, D.C. (1994).

Cheryl **DUNYE** [b. 1966, Liberia] lives in Philadelphia. A video and filmmaker and curator, Dunye often assumes the performer's as well as director's role to address, with ironic humour, the complexities and dilemmas of African-American lesbian identity in films such as *The Watermelon Woman* (1997). She was included in 'NowHere', Louisiana Museum, Humlebaek, Denmark (1996).

Mary Beth **EDELSON** [b. 1933, East Chicago, Indiana] lives in New York. In performances and photographs of the 1970s she evoked ancient goddess mythology as a means of empowerment. In the 1990s she has investigated social aggression. She was included in 'International Feministische Kunst', Stichting de Appel, Amsterdam (1979). Solo shows include Nicole Klagsbrun Gallery, New York (1993).

Nicole **EISENMAN** [b.1965, Verdun, France] lives in New York. Her murals, paintings and installations playfully critique patriarchal culture from a lesbian perspective. She was included in 'From the Corner of the Eye', Stedelijk Museum, Amsterdam (1998). Solo shows include Rice

University Art Gallery, Houston, Texas (1998).

Diamela **ELTIT** [b. 1949, Santiago de Chile] lives in Santiago, Chile. Primarily a poet, she collaborated with Raúl Zurita during the dictatorship in a group called Colectivo de Acciones de Arte, making protest actions. Self-inflicted wounds symbolize the communal body of suffering, connecting her female body with the socially outcast.

Catherine **ELWES** [b. 1952, St. Maixent, France] lives in London. In the late 1970s she made performances, moving to video from 1981 onwards. She was co-organizer of 'Women's Images of Men' and 'About Time', Institute of Contemporary Arts, London (1980). She has written extensively on time-based and women's art for catalogues and journals, and contributed to the books *Women's Images of Men* (1985) and *Diverse Practices: A Critical Reader on British Video Art* (1996).

Tracey **EMIN** [b. 1963, London] lives in London. Her work centres on communication of personal experiences through actions and installations. She was included in 'Life's a Bitch', Stichting De Appel, Amsterdam (1998). Solo shows include 'I Need Art Like I Need God', South London Gallery, London (1997).

Valie **EXPORT** [b. 1940, Linz] lives in Vienna and Cologne. She is a Professor at the Kunsthochschule für Medien, Cologne. Her 1960s street actions and later video works have investigated the body as a bearer of meaning and communication. She was included in Documenta 6, Kassel, Germany (1977). Solo shows include 'Psycho-Prognose', Neuer Aachener Kunstverein, Aachen, Germany (1998).

Karen **FINLEY** [b. 1956, Chicago] lives in New York. Her performances address dilemmas such as domestic abuse, rape, social intolerance and AIDS. She was included in 'Uncommon Sense', Museum of Contemporary Art, Los Angeles (1997). Key performances include *The Constant State of Desire*, The Kitchen, New York (1986).

Rose **FINN-KELCEY** [b. 1945, Northampton, England] lives in London. Her work encompasses sculpture, installation, performance, film and video, and has addressed themes ranging from militarism to ephemerality. She was included in

Documenta IX, Kassel, Germany (1992). Solo shows include 'Bureau de Change', Matt's Gallery, London (1988).

Andrea **FRASER** [b. 1965, Billings, Montana] lives in New York. Working mainly with performance, she makes interventions into art institutions, uncovering the signs and systems used to legitimate the values and desires that operate within them. Solo shows include The Philadelphia Museum of Art, Philadelphia (1989).

Coco **FUSCO** [b. 1960, New York] lives in Los Angeles. An interdisciplinary artist and writer, she has made performance projects, lectured and curated events internationally, examining cultural relations between North and South America. She is the author of *English Is Broken Here: Notes on Cultural Fusion in the Americas* (1994).

Anya **GALLACCIO** [b. 1963, Glasgow, Scotland] lives in London. An installation artist, she uses ephemeral materials to explore transience in relation to specific sites. She was included in 'Freeze', Surrey Docks (1988). Solo shows include Delfina Studios, London (1998).

Rose **GARRARD** [b. 1946, Bewdley, England] lives in Malvern. Her installations and performances make a feminist critique of western art history. A retrospective, 'Archiving My Own History', was presented at Cornerhouse, Manchester (1994), and touring.

Nan **GOLDIN** [b. 1953, Washington] lives in New York. Since the early 1970s, Goldin has created a photographic diary of the lives and experiences of herself and her intimate friends from the alternative scenes of New York, Paris, Berlin and other cities. A retrospective, 'I'll Be Your Mirror', was presented at the Whitney Museum of American Art, New York (1996).

Ilona **GRANET** [b. 1948, Brooklyn, New York] lives in New York. Since the early 1970s, she has made performances, installations, mixed media, graphic and book works which engage with issues such as violence against women, using unconventional wit to convey their messages. She was included in the 'Manifesto Show', New York (1980) and 'The Revolutionary Power of Women's Laughter', Max Protetch Gallery, New York (1983).

Renée **GREEN** [b. 1959, Cleveland, Ohio] lives in New York. Working primarily in installation, she addresses intersections of black and white representations of diasporan cultural identity. She was included in 'Mirage: Enigmas of Race, Difference and Desire, Institute of Contemporary Arts, London (1995). Solo shows include 'World Tour', The Museum of Contemporary Art, Los Angeles (1993).

GUERRILLA GIRLS [New York] were most active from the mid 1980s to the mid 1990s, using graphics campaigns to reveal deep-seated patriarchal prejudice in public and private art institutions. In public, members wore gorilla masks to maintain anonymity, assuming the names of female artist predecessors such as Lee Krasner. Campaigns of the 1990s have addressed wider issues of social injustice.

Lucy **GUNNING** [b. 1964, Newcastle, England] lives in London. In video works Gunning orchestrates her subjects, mostly women, to perform activities in exaggerated circumstances, exploring the compulsive nature of everyday actions. She was included in 'Behind Closed Doors: Video in Interior Spaces', Museum of Contemporary Art, Chicago (1996). Solo shows include City Racing, London (1996).

Ann **HAMILTON** [b.1956, Lima, Ohio] lives in Columbus, Ohio. In her site-specific installation works Hamilton highlights intangible traces of existence in time and place, exploring political, democratic and poetic dimensions of physical spaces and materials. Shows include 'The Body and the Object: Ann Hamilton 1984-1996', Wexner Center for the Arts, Columbus, Ohio (1996) and the XLVIII Venice Biennale (1999).

Barbara **HAMMER** [b. 1939, Hollywood, California]. An experimental filmmaker engaged with feminist and lesbian issues, she is internationally known for influential works such as her documentary trilogy on lesbian and gay histories, *Nitrate Kisses* (1992), *Tender Fictions* (1995) and *History Lessons* (2000).

Harmony **HAMMOND** [b. 1944, Chicago] lives in Galisto, New Mexico. An artist, critic and curator, she co-founded AIR, New York's first women-only gallery, and organized one of the first lesbian group exhibitions (112 Green Street, New York, 1978). She was co-founder of the journal *Heresies* (1976). She was included in 'Soft

as Art', New York Cultural Center, New York (1973). Solo shows include Center for Contemporary Art, Santa Fe, New Mexico (1992). She is the author of *Lesbian Art in America: A Contemporary History* (2000).

Margaret **HARRISON** [b. 1940, Wakefield, Yorkshire] lives in Manchester and San Francisco. She is Visiting Professor at the University of California at Davis. Working in painting, drawing and mixed media installation, she is a key artist and activist of the British feminist movement. She was included in the first Women's Liberation Exhibition, Woodstock Gallery, London (1971) and 'Lives', Hayward Gallery, London (1977). Solo shows include the New Museum of Contemporary Art, New York (1989) and Intersection for the Arts, San Francisco (2001).

Mona **HATOUM** [b. 1952, Beirut, Lebanon] lives in London. Her work in performance, video, installation and sculpture addresses issues of culture and identity. She was included in 'Foreign Body', Museum für Gegenwartskunst, Basel (1996). Solo shows include the New Museum of Contemporary Art, New York (1998).

Lynn **HERSHMAN** [b. 1941, Cleveland, Ohio] now Hershman Leeson, lives in San Francisco. Her media includes photography, film, video and computer-based installations. In 1979 she pioneered the first artist's CD-ROM. She was the first woman to receive a retrospective at the San Francisco International Film Festival (1995).

Eva **HESSE** [b. 1936, Hamburg; d. 1970, New York] lived in New York. Her sculptures evidenced their handmade origin and relation to the body, implicitly questioning the male-dominated Minimalist idiom of grids, industrial materials and serial repetition. She was included in 'Eccentric Abstraction', Fischbach Gallery, New York (1966). Retrospectives include the Solomon R. Guggenheim Museum, New York (1972).

Susan **HILLER** [b. 1940, Tallahassee, Florida] lives in London. An artist, writer and curator, she has worked in media including painting, sculpture, video, photography, installation and artist's books. She investigates cultural phenomena and their undercurrents in projects that are often participatory. Retrospectives include the

Serpentine Gallery, London (1976) and Tate Liverpool (1996).

Lubaina **HIMID** [b. 1954, Zanzibar, Tanzania] lives in Preston, Lancashire. In her paintings, collages and assemblages she excavates traces of black women's histories hidden beneath the official histories of colonialism. She was included in 'Five Black Women', Africa Centre, London (1983) and 'The Other Story', Hayward Gallery, London (1989). Solo shows include Tate Gallery, St Ives (2000).

Christine and Irene **HOHENBÜCHLER** [b. 1964, Vienna] live in Vienna. Twins, they have exhibited together since 1988, collaborating with institutionalized groups such as psychiatric patients and prisoners. They provide frameworks for collaborators rather than acting as therapists, using 'feminine' media such as weaving. They were included in 'NowHere', Louisiana Museum, Humlebaek, Denmark (1996). Solo shows include De Vleeshal, Middelburg, The Netherlands (1994).

Jenny **HOLZER** [b. 1950, Gallipolis, Ohio] lives in Hoosick, New York. Her work is language-based, subtly inverting the messages of mass culture. Since 1977 she has distributed messages via media ranging from printed ephemera to electronic sign boards. Retrospectives include the Solomon R. Guggenheim Museum, New York (1989).

Rebecca **HORN** [b. 1944, Michelstadt, Germany] has lived in Berlin, Hamburg and New York. Her early works used the body as a vehicle for sculptural extensions presented in ritualized performances documented on film. Later she developed large scale installation works. She was included in Documenta 8 (1987). Solo shows include the Solomon R. Guggenheim Museum, New York (1993).

Kay **HUNT** [b. 1933, London] now Kay Fido Hunt, lives in London. Since the late 1960s she has made documentary work which reflects personal experience and community history. Since 1975 she has researched women's labour history for anti-war projects. She was included in the John Moores Exhibition, Walker Art Gallery, Liverpool (1962). Solo shows include Courtauld Institute, London (1973).

Joan **JONAS** [b. 1936, New York] lives in New York. Working in live art, video and installation, she uses video in

environments which enable audiences to view different aspects of a work simultaneously. She was included in Documenta 5, Kassel (1972). Retrospectives include the Stedelijk Museum, Amsterdam (1994).

Tina **KEANE** [b. 1949, England] lives in London. Working in video, film and installation, she explores issues of personal and collective identity and political freedom. She was included in 'Signs of the Times', Centre d'Art Contemporain, Noisel-Paris (1993). Solo shows include 'Caution - X-Ray', Museum of Installation, London (1994).

Mary **KELLY** [b. 1941, Fort Dodge, Iowa] lives in Los Angeles. Kelly's installations and theoretical texts are informed by her feminist interpretation of psychoanalytic theory. She was included in 'Difference: On Representation and Sexuality', New Museum of Contemporary Art, New York (1984). Solo shows include 'Post-Partum Document', Institute of Contemporary Arts, London (1976). *Imaging Desire*, her collected writings, was published in 1996.

Karen **KNORR** [b. 1954, Frankfurt am Main, Germany] lives in London. Working predominantly in photography, sometimes in collaboration with other artists such as Olivier Richon, she has investigated and critiqued the institutionalized spaces of privileged patriarchal elites. She was included in 'Beyond the Purloined Image', Riverside Studios, London (1983), the Fifth Sydney Biennale (1985) and 'Other Than Itself', Cambridge Darkroom, Cambridge, England (1989).

Alison **KNOWLES** [b. 1933, New York] lives in New York. An artist, composer and poet, she began her involvement in Fluxus in 1962. Retrospectives include 'Twenty Years of Performance Art: Dick Higgins and Alison Knowles', University of Massachusetts Gallery, Amherst (1980) and 'Indigo Island', State Gallery, Sarbrüken (1997).

Silvia **KOLBOWSKI** [b. 1953, Buenos Aires] lives in New York. An artist and former co-editor of the journal *October* (1993-2000), in her mixed media projects she investigates themes such as art's societal status. Her projects include *an inadequate history of conceptual art* (1999).

Joyce **KOZLOFF** [b. 1942, Somerville, New Jersey] lives in New York. Originally a

'hard edge' abstract painter, in the 1970s she began to incorporate female traditions of 'pattern and decoration' from traditional cultures. Her later ceramic tile public commissions include San Francisco Airport. She was included in 'Patterning', Palais des Beaux Arts, Brussels (1979). Solo shows include University of New Mexico, Albuquerque (1978).

Barbara **KRUGER** [b. 1945, New Jersey] lives in New York. Using photomontage and graphics Kruger recontextualizes fragments of images from media sources with texts that subvert the manipulations of corporate capitalist culture. A major retrospective was presented at The Museum of Contemporary Art, Los Angeles, and Whitney Museum of American Art (2000).

Shigeko **KUBOTA** [b. 1937, Niigata, Japan] lives in New York. Originally involved in Fluxus, she makes innovative video installations. Much of her work re-examines the legacies of Modernism's 'father' figures such as Marcel Duchamp, from a feminist perspective. She was included in Documenta 7, Kassel (1977). Solo shows include the National Museum of Art, Osaka (1992).

Yayoi **KUSAMA** [b.1929, Matsumoto, Japan] lives in Tokyo. All her works share a common vocabulary of dense, repetitive patterns shaped in cell-like clusters or aggregations of phallic forms, which she uses to explore notions of sexuality, self-image and infinity. Solo shows include the Castellane Gallery, New York (1964), the XLV Venice Biennale (1993) and 'Love Forever: Yayoi Kusama 1958-68', Los Angeles County Museum of Art (1998-99) and touring.

Leslie **LABOWITZ** [b.1946, Uniontown, Pennsylvania] lives in California. A conceptual and performance artist, she has collaborated with Suzanne Lacy and other feminists as Ariadne: A Social Network, a nationwide women's organization which staged pioneering events such as the first Women Take Back the Night march (San Francisco, 1978).

Suzanne **LACY** [b.1945, Wasco, California] lives in Oakland, California. A conceptual and performance artist, she has organized large scale participatory actions on urban social issues. She participated in Womanhouse, Valencia, California (1972). Key projects have been *In Mourning and in Rage* (Los Angeles, 1977) in collaboration with Leslie Labowitz, and *The Crystal Quilt* (Minneapolis, 1987). Her survey of new genre public art, *Mapping the Terrain*, was published in 1995.

Ketty **LA ROCCA** [b. 1938, La Spezia, Italy; d. 1976, Florence] lived in Florence. Her conceptually-based work recorded progressions of subjective awareness and decipherability, through performance, photographs, collage and drawing. She was included in 'Per una Poesia Totale', Studio Artivisive, Rome (1969). Retrospectives include the XXXVIII Venice Biennale (1978).

Brenda **LAUREL** lives in Santa Cruz. A designer, researcher and writer, she has undertaken a series of projects investigating virtual reality and digital technological environments. Her work focuses on interactive narrative, human computer interaction and cultural aspects of technology. She is editor of *The Art of Human-Computer Interface Design* (1990) and author of *Computers as Theatre* (1991).

Louise **LAWLER** [b. 1947, Bronxville, New York] lives in New York. She photographs or recreates arrangements of works of art in private or public collections. Her work provokes consideration of the social and political dimensions of the display and reception of works of art. She was included in 'The Art of Memory/The Loss of History', New Museum of Contemporary Art, New York (1985). Shows include The Museum of Modern Art, New York (1987) and the Kunstverein, Munich (1995).

Zoe **LEONARD** [b. 1961, Liberty, New York] lives in New York. She has worked in photography, site specific installation, performance, film and video. She uncovers the viscerality and ethical dilemmas which underlie that which is excluded and repressed as being impure or 'dirty', unfit for the gaze. She was included in 'In a Different Light', University Art Museum, Berkeley, California (1996). Solo shows include Centre National de la Photographie, Paris (1999).

Sherrie **LEVINE** [b. 1947, Hazleton, Pennsylvania] lives in New York. She reproduces and re-appropriates art objects by established figures included in the historical canons of art and photography. Her works question the exclusivity of Modernist aesthetics, drawing attention to contextual frames of reference. She was included in 'Difference: On Sexuality and Representation', New Museum of Contemporary Art, New York (1984). Solo shows include The Museum of Contemporary Art, Los Angeles (1995).

Maya **LIN** [b. 1959, Athens, Ohio] lives in New York. A sculptor, she produces site-specific public projects, informed by her architectural training. Her contemplative environments use natural and recycled materials, harmonizing with rather than disrupting their sites. Solo shows include 'Public/Private', Wexner Center for the Arts, Columbus, Ohio (1993) and 'Maya Lin: Topologies', Southeastern Center for Contemporary Art, Winston-Salem, North Carolina (1998-99), and touring.

Yve **LOMAX** [b. 1952, Dorset] lives in London. A photographer and theorist, Lomax investigates the implications of theories of, for example, cinematic narrative, on photographic representation. She was included in 'Three Perspectives on Photography', Hayward Gallery, London (1979), and 'Difference: On Representation and Sexuality', New Museum of Contemporary Art, New York (1984). Solo shows include The Photographer's Gallery, London (1989).

Sarah **LUCAS** [b. 1962, London] lives in London. Her work includes photography, installation, assemblage, collage and video. Using visual puns and double-take strategies, she confronts social issues such as sexism and addiction, allowing wit and ambiguity to shift closed perspectives into new registers. She was included in 'Freeze', PLA Building, Surrey Docks, London (1988). Solo shows include Museum Boijmans Van Beuningen, Rotterdam (1996).

Ana **MENDIETA** [b. 1948, Havana; d. 1985, New York] lived in Iowa and New York. Her work was informed by her youthful exile from her home and culture. She recorded private rituals of reconnection with the earth by carving, sculpting, immersing and burning her silhouette into natural settings. She was a founder member of AIR, the first all-women's gallery in New York, where she exhibited and curated shows of work by other artists. She was included in 'Inside the Visible', Whitechapel Art Gallery, London (1998). Retrospectives include the New Museum of Contemporary Art, New York (1987).

Annette **MESSAGER** [b. 1943, Berck, France] lives in Paris. She works with photography, assemblage and installation.

In the mid 1970s her own body was her principal medium. Later installation works explore hidden, often painful facets of women's daily existence, evoking both sadomasochism and humour. She was included in 'Photography as Art', Institute of Contemporary Arts, London (1979). Solo shows include P.S. 1, Long Island City, New York (1981).

Kate **MILLETT** [b. 1934, St. Paul, Minnesota] lives in New York. She is a writer, artist and activist known internationally for her book *Sexual Politics* (1970) and her autobiography *Flying* (1974). A touring retrospective of her sculptures was presented by the University of Baltimore in 1993.

Trinh T. **MINH-HA** [b. 1952, Hanoi] is Professor of Women's Studies and Film at the University of California, Berkeley. An experimental filmmaker, writer and composer, she is renowned for films such as *Surname Viet Given Name Nam* (1989), which address feminist postcolonial issues. Key books include *Woman, Native, Other: Writing Postcoloniality and Feminism* (1989), and *When the Moon Waxes Red: Representation, Gender and Cultural Politics* (1991).

Mary **MISS** [b. 1944, New York] lives in New York. She is a sculptor, filmmaker and environmental artist. Since the 1970s she has played a leading part in redefining public sculpture and the possibilities for sculpture sited in the landscape. She was included in 'Sitings', La Jolla Museum of Contemporary Art, California (1986). Solo shows include 'Mary Miss: Photo Drawings', Des Moines Art Center, Des Moines, Iowa (1996).

Linda **MONTANO** [b. 1942, Kingston, New York] lives in Kingston, New York. Her performance works and life activities often require her self-transformation through various assumed personae, involving endurance, meditation, ritual and healing acts towards others. She began art-life counselling in 1980 and in 1984 began *Seven Years of Living Art*, a personal experiment based on rituals related to the chakras. In the 1990s she has performed in healing institutions such as the Ananda Ashram in Monroe, New York.

Laura **MULVEY** [b. 1941] lives in London. She is an experimental filmmaker and theorist. *Riddles of the Sphinx*

(with Peter Wollen, 1976) used cinematic devices to shift narrative perspective to the mother in the Oedipal triangle, investigating the repression of women's discourse in patriarchy. Her key essay, 'Visual and Narrative Pleasure' (1973) describes how the representation of woman is structured by the Hollywood cinematic apparatus of the male gaze. She is the author of *Visual and Other Pleasures* (1989).

Alice **NEEL** [b. 1900, Merion Square, Pennsylvnia; d. 1984, New York] lived in New York. A distinguished figurative painter, she worked for prominent US organizations such as the Works Progress Administration but received little critical recognition until her first retrospective at the Whitney Museum of American Art, New York (1974).

Shirin **NESHAT** [b. 1957, Qazvin, Iran] lives in New York. Her photographs inscribed with Arabic text explore the contradictory roles of women in Muslim society. Neshat has also made video works such as *Rapture* (1998), included in the XLVIII Venice Biennale (1999). Solo exhibitions of her work include the Serpentine Gallery, London (2000).

Yoko **ONO** [b. 1933, Tokyo] lives in New York. Ono composed experimental music and made conceptual installations and performances in Tokyo in the 1950s. By the early 1960s she had settled in the US, becoming associated with Fluxus. She expanded her work to include experimental film. She was included in 'Japanese Art After 1945: Scream Against the Sky', Yokohama Museum of Art, Japan (1994), and touring. 'Yes', a major retrospective, was held at the Japan Society Gallery, New York (2000).

Catherine **OPIE** [b. 1961, Sandusky, Ohio] lives in Los Angeles. Working primarily in photography, she is concerned with the representation of urban context and the individual portrait, often working in collaboration with subjects who are exploring diverse gender identities. She was included in 'Femininmasculin', Centre Georges Pompidou, Paris (1995) and 'Rrose is a Rrose is a Rrose: Gender Performance in Photography', Solomon R. Guggenheim Museum, New York (1997).

ORLAN [b. 1947, St. Etienne, France] lives in Paris. In the 1970s she staged *tablaux vivants* parodying historical portrayals of women. Since the 1990s, she has become the site of an ongoing project of self-transformation through plastic surgery. Her work questions the search for perfection embodied in idealizations. Performances include *The Reincarnation of Saint Orlan*, 'Edge 90', Newcastle (1990). Solo shows include 'This is My Body…This is My Software', Cornerhouse, Manchester (1996), and touring.

Thérèse **OULTON** [b. 1953, Shrewsbury, England] lives in London. A painter, she reorients painterly conventions of mark-making to evoke traces of the feminine. Her heavily impastoed surfaces reclaim the landscape genre in art history in terms of women's cultural traditions. She was included in 'Landscape, Memory, Desire', Serpentine Gallery, London (1984). Solo shows include the Museum of Modern Art, Oxford (1985).

Gina **PANE** [b. 1936, Biarritz, France; d. 1990, Paris] lived in Paris. Working with her body, she began making actions in nature before shifting her focus more exclusively to actions on her body. She presented performances at the Galerie Stadler, Paris, in the 1970s. She was included in Documenta 6, Kassel (1977). Solo shows include 'La Pêche Endeuillée', Galleria Diagramma, Milan (1975), and 'Partitions: Opera Multimedia 1984-85', Padiglione d'Arte Contemporanea, Milan (1986).

Howardena **PINDELL** [b. 1943, Philadelphia] lives in New York, where she was Associate Curator at The Museum of Modern Art, 1967-79. Her painting and mixed media work have drawn attention towards African-American women's oppression by white patriarchal society. She was included in 'Race and Representation', Hunter College Art Gallery, New York (1987). A touring retrospective was organized by Exhibits USA, Kansas City (1993).

Adrian **PIPER** [b. 1948, New York] lives in New York and Wellesley, Massachusetts. An artist and philosopher, her media include performance, drawings, texts, video and installation. From 1970 onwards she abandoned pure conceptualism for interventionist works dealing with political issues of racial, gender and class identity. She was included in 'Contested Histories', Carpenter Center, Harvard University (1998). Retrospectives include the New Museum of Contemporary Art, New York (2000).

Rona **PONDICK** [b. 1952, Brooklyn, New York] lives in New York. In her sculptures Pondick integrates forms reminiscent of body parts with others that suggest inanimate forms such as shoes. Her work evokes oral and sadistic drives, exploring possibilities of assertive female forms. She was included in 'Corporal Politics', MIT List Visual Arts Center, Cambridge, Massachusetts (1992). Solo shows include The Israel Museum, Jerusalem (1992).

Yvonne **RAINER** [b. 1934, San Francisco] lives in New York. In the 1960s she was a leading performer and choreographer of the Judson Dance Group in New York. In 1971 she moved from dance to filmmaking, using experimental cinema aesthetics to address issues of sexual difference. Performances include *Trio A* (1966) and *Continuous Project Altered Daily*, Whitney Museum of American Art, New York (1970). Films include *Film About A Woman Who …* (1974) and *The Man Who Envied Women* (1985).

Aimee **RANKIN** now Aimee Morgana [b. 1958, Chicago] lives in New York. A video and installation artist and critic, she investigates the complexities produced by advanced technological forms of media, experimentally constructing new relationships between digital media and the workings of perceptual and unconscious faculties. She was included in 'Voyeurism', Whitney Museum of American Art, New York (1987). Solo shows include American Fine Arts, New York (1991).

Paula **REGO** [b. 1935, Lisbon] lives in London. A figurative painter, she draws on influences from the folklore of her Catholic childhood, and her perceptions of male dominance and oppression in both public and domestic spheres. She was included in the São Paulo Biennale (1976; 1985). Solo shows include a retrospective at the Fundaçio Calouste Gulbenkian, Lisbon, the Casa de Serralves, Oporto, the Serpentine Gallery, London (1988), and Tate Liverpool (2007).

Elaine **REICHEK** [b. 1943, New York] lives in New York. She uses sewing, weaving and embroidery as a means of continuing the traditions of women's craftwork within art discourse to critique its hierarchical distinctions and values. She was included in 'Division of Labour: Women's Work in Contemporary Art', Bronx Museum of the Arts, New York (1995). Solo shows include 'Native Intelligence', Grey Art Gallery, New York University, and touring (1992), and 'Projects 67', The Museum of Modern Art, New York (1999).

Catherine **RICHARDS** lives in Ottawa, Canada. Her work explores the spectator's role in virtual reality technologies. She created *Spectral Bodies* (1991) with the first virtual reality system in Canada at the Computer Science Department, University of Alberta, and the Banff Centre for the Arts. She was included in 'The Body Obsolete', Gemeentemuseum, Arnhem, The Netherlands (1995). Solo shows include the Ottawa Art Gallery (2000).

Su **RICHARDSON** [b. 1947, South Shields, England] lives in Birmingham. An artist and designer, she has worked and exhibited in both fields as well as engaging in teaching and consultancy for arts projects. She was a principal organizer of 'Feministo: Portrait of the Artist as a Housewife', Institute of Contemporary Arts, London (1977), and touring.

Pipilotti **RIST** [b. 1962, Schweizer Rheintal, Switzerland] lives in Zurich. She works with video, film and video installation, using popular culture sources and her own body in witty, sophisticated explorations of contemporary female identity. Her work was included in the XLVII and XLVIII Venice Biennales (1997; 1999). Solo shows include 'Himalaya Pipilotti Rist, 50kg', Kunsthalle, Zurich, Musée d'Art Moderne de la Ville de Paris (1999), and the Hayward Gallery, London (2011).

Ulrike **ROSENBACH** [b. 1943, Bad Saizdetfurth, Germany] lives in Cologne. She began making video and live performances dealing mainly with feminist subjects in the early 1970s. She was included in Documentas 6 and 8 (1975 and 1987). Solo shows include 'Last Call for Engel', Kunstmuseum, Heidenheim (1996), and touring.

Martha **ROSLER** [b. 1943, Brooklyn, New York] lives in Brooklyn. An artist and writer, Rosler works in photography, video, performance and installation. A pioneer of politicized video, her work offers a feminist critical analysis of society, politics and the media. She was included in 'Difference: On Representation and Sexuality', New Museum of Contemporary

Art, New York (1984). A major retrospective was presented at the Ikon Gallery, Birmingham (2000), and 'London Garage Sale' was held at the Institute of Contemporary Arts, London (2005).

Betye **SAAR** [b. 1926, Los Angeles] lives in Los Angeles. Much of Saar's work comprises assemblages using found objects that have a personal, ritualistic resonance, addressing race, class, ancestral memory and power. She was included in 'Black Artist Invitational', Los Angeles County Museum of Art, Los Angeles (1972) and 'Ritual and Myth', Studio Museum in Harlem, New York (1982). Solo shows include the Whitney Museum of American Art, New York (1975).

Niki de **SAINT-PHALLE** [b. 1930, Neuilly-sur-Seine; d. 2002, San Diego, California] lived in New York and Paris. In the early 1960s she explored the creative freedom of destruction in works made by firing with a gun at painting/assemblages. Her small decorated female figures (*Nanas*) led to large sculptural projects such as the huge walk-in environment *Hon* (Moderna Museet, Stockholm, 1966). She was included in 'Zero et Paris 1960, et aujourd'hui', Musée d'Art Moderne et d'Art Contemporain de la Ville de Nice (1998). Solo shows include Centre Georges Pompidou, Paris (1980), and a retrospective at Tate Liverpool (2008).

Doris **SALCEDO** [b. 1958, Bogotá, Colombia] lives in Bogotá. She is a sculptor who transforms domestic furniture or clothing into poetic and philosophical meditations on loss, trauma, recovery and healing. She was included in the XLV Venice Biennale (1993) and the Carnegie International (1995). Solo shows include the New Museum of Contemporary Art, New York and SITE, Santa Fe (1998), and San Francisco Museum of Modern Art (1999 and 2005).

Jenny **SAVILLE** [b. 1970, Cambridge] lives in Oxford. Her paintings depict the female body in monumental scale as a feminist response to objectifications of female flesh in art history. In the late 1990s she made photographs in collaboration with Glen Luchford. She was included in 'Contemporary '90', Royal College of Art, London (1990). Solo shows include 'Territories', Gagosian Gallery, New York (1999), and Museo d'Arte Contemporanea, Rome.

Miriam **SCHAPIRO** [b.1923, Toronto, Canada] lives in New York. A painter, she incorporates traditional women's arts and crafts in her works in an act of revaluation and linkage with female traditions, for which she coined the term *femmage*. A leading figure in the women's art movement of the 1970s, she co-founded the Feminist Art Program at California Institute of the Arts with Judy Chicago. She was included in 'Toward a New Abstraction', The Jewish Museum, New York (1963). A retrospective was held at the College of Wooster Art Museum, Ohio (1980), and touring.

Carolee **SCHNEEMANN** [b. 1939, Fox Chase, Pennsylvania] lives in New Paltz, New York. A germinal figure in 1960s performance and body art, in her works she centred on her own body and her position as female subject and object. Retrospectives include 'Carolee Schneemann: Up to and Including Her Limits', New Museum of Contemporary Art, New York (1998). Her books include *The Body Politics of Carolee Schneemann* (2000).

Mira **SCHOR** [b. 1950, New York] lives in New York. She is a painter and theorist of painting. She was a participant in the Womanhouse project of the Feminist Art Program at California Institute of the Arts (1972). Her paintings combine seductively crafted surfaces with textual inscription, exploring areas of denial in public and private domains. She is co-editor of *M/E/A/N/I/N/G*, a journal of contemporary art, and author of *Wet: On Painting, Feminism and Art Culture* (1997).

Joan **SEMMEL** [b. 1932, New York] lives in New York. A figurative painter, since 1970 she has explored the possibilities of constructing female perspectives to replace the viewpoint of the male gaze. Group exhibitions include Matthew Marks Gallery, New York (1999), curated by artist Robert Gober. Solo shows include 141 Prince Street Gallery, New York (1973) and Jersey City Museum, Jersey City, New Jersey (2000).

Cindy **SHERMAN** [b. 1954, New Jersey] lives in New York. With her *Untitled (Film Still)* series (1977-80), shown at The Kitchen (1978) and Metro Pictures (1979), both in New York, she established an *oeuvre* built on photographing herself in diverse guises and settings to portray aspects of the image of woman in

contemporary culture. She was included in 'Four Artists', Artists' Space, New York (1978). Retrospectives include the Whitney Museum of American Art, New York (1998), and touring, and the Museum of Modern Art, New York (2012).

Katharina **SIEVERDING** [b. 1944, Prague] has lived in Dusseldorf, Hamburg and Berlin. Her early photographic work features large-scale, close-up self-portraits with many variations. In the mid 1970s she began making monumental photographic tableaux which combine image and text and refer to political events. She was included in 'Transformer: Aspekte der Travestie', Kunsthalle, Lucerne (1973). Solo shows include the Stedelijk Van Abbemuseum, Eindhoven (1979).

Shahzia **SIKANDER** [b. 1969, Lahore, Pakistan] lives in Houston, Texas, and New York. Her study of traditional Asian miniature painting techniques is employed to invent a new hybrid symbolism that allows female assertiveness to be represented in a traditional frame. She was included in 'Global Visions', Deste Foundation for Contemporary Art, Athens (1998). Solo shows include the Hirshhorn Museum and Sculpture Garden, Washington, D.C. (1999).

Laurie **SIMMONS** [b.1949, Long Island, New York] lives in New York. She is best known for her staged photographic tableaux in which tiny plastic female figures are posed in everyday activities. She was included in 'Image Scavengers', Institute of Contemporary Art, University of Pennsylvania, Philadelphia (1982). Solo shows include Tyler School of Art, Temple University, Philadelphia (1985).

Lorna **SIMPSON** [b. 1960] lives in New York. She is a leading African-American practitioner in the use of photography and text to explore issues of cultural identity. Focusing on the intersection of racial, sexual and gender stereotypes, she turns her subjects' backs to the camera, dislocating conventional relationships between the viewer and the viewed. She was included in 'The Body', New Museum of Contemporary Art, New York (1986) and the XLIV Venice Biennale (1990). Retrospectives include the Whitney Museum of American Art (2007).

Monica **SJÖÖ** [b. 1938, Härnösand, Sweden; d. 2005, Bristol] lived in Bristol. A painter and writer, she used matriarchal symbolism throughout her work. A principal

organizer of the first Women's Liberation Movement group exhibition (London, 1971), she is best known for *God Giving Birth* (1969), which depicts God as a woman in childbirth. She was included in 'Five Women Artists: Images of Womanpower', Swiss Cottage Library, London (1973). Solo shows include Casa de Colores, Brownsville, Texas (1999), and touring.

Sylvia **SLEIGH** [b. 1935, Llandudno; d. 2010, New York] lived in New York. She was a painter, producing predominantly portraits. Her paintings of the 1970s were informed by feminist theories of representation; portraits of male subjects investigated ways of suggesting the eroticism of the male body for the female viewer. Solo shows include 'Sylvia Sleigh: Invitation to a Voyage and Other Works', Wisconsin Art Museum, Milwaukee (1990), and touring.

Jaune Quick-to-See **SMITH** [b. 1940, St. Ignatius, Montana] lives in New Mexico. She works in paint, collage and mixed media, combining figuration and abstraction to address themes such as environmental destruction, oppression of Native American cultures, and American cultural mythology. She was included in 'The New Feminism', Ohio State University, Columbus, Ohio (1983). Solo shows include Bernice Steinbaum Gallery, New York (1992).

Kiki **SMITH** [b. 1954, Nuremberg, Germany] lives in New York. She is a sculptor and mixed media installation artist. In the late 1980s and 1990s she created full scale female figures which investigate dilemmas of representing female embodiment. She was included in 'Feminin-Masculin: le sex de l'art', Centre Georges Pompidou, Paris (1995). Solo shows include The Museum of Contemporary Art, Los Angeles (1995).

Jo **SPENCE** [b. 1934, London; d. 1992] lived in London. She used photography to explore issues raised by feminism. With Terry Dennett she founded the Photography Workshop (1974) and *Camerawork* journal. The diagnosis in 1982 of breast cancer led to her therapeutic photo series, in collaboration with Rosy Martin, and book, *Putting Myself in the Picture: A Political, Personal and Photographic Autobiography* (1986).

Nancy **SPERO** [b. 1926, Cleveland, Ohio; d. 2009, New York] lived in New York. In her

work she questions the way images of the female body have been used by a male dominated culture by juxtaposing and rearranging existing images of women from diverse historical sources, evolving new symbolic associations and messages. Spero became a member of WAR (Women Artists in Revolution) in 1969 and was a founder member of AIR (Artists-in-Residence), the first all-women artists' gallery in New York. A major retrospective was presented at the Ikon Gallery, Birmingham (1998).

Jana **STERBAK** [b. 1955, Prague] lives in Montreal and Paris. Her media include sculpture, photography, video and installation. She addresses struggles to establish individual freedom from social constraints, focusing on the body as site and metaphor. She was included in 'NowHere', Louisiana Museum, Humlebaek, Denmark (1996). A retrospective was presented at the Musée d'Art Moderne de Saint-Etienne (1995), and touring.

Rachel **STRICKLAND** is a member of the research staff at Interval Research Corporation in Palo Alto, California. Her work with digital technologies focuses on the cinematic dimensions of architectural space. Her 'Portable Portraits' are a video work in progress, exploring participants' designs for miniature environments which they are enabled to carry around with them.

Mitra **TABRIZIAN** [b.1952, Iran] is Professor of Photography at the University of Westminster. She is a photographer and theorist whose work explores issues of race, sex and class from a feminist perspective. She was included in 'Beyond the Purloined Image', Riverside Studios, London (1983) and 'The Body Politic', Photographer's Gallery, London (1987). Solo shows include Cornerhouse, Manchester (1988).

Rosemarie **TROCKEL** [b. 1952, Schwerte, Germany] lives in Cologne. Her media include drawing, sculpture, works in wool, video and installation. Her work places art historical formalism in relation to notions of the feminine and domestic. Solo shows include Galerie Monika Spruth, Cologne (1983), a retrospective at the Institute of Contemporary Art, Boston (1991-92), and touring, and 'Rosemarie Trockel: Bodies of Work 1986-1998', Hamburger Kunsthalle (1999), and touring.

Cosey Fanni **TUTTI** [b. 1951, Hull, England] lives in Norfolk. Her improvised actions and collaborative projects investigate life experiences and the fragile boundaries between artist, work and audience. With Genesis P. Orridge she co-founded the group COUM which performed actions, exhibited and produced films, 1969-79. She was included in 'Prostitution', Institute of Contemporary Arts, London (1976) and 'Out of Actions: Between Performance and the Object, 1949 to 1979', The Museum of Contemporary Art, Los Angeles (1999).

Mierle Laderman **UKELES** [b. 1939, Denver, Colorado] collides opposing Western cultural systems - free raw creation and its maintenance - revealing surprising rigidities and flexibilities in the search for expanded limits. Her key works include *Touch Sanitation* (1978-84), a citywide action in collaboration with 8,500 sanitation workers and solo exhibition at Ronald Feldman Fine Arts, New York. She was the recipient of a Percent for Art Commission as 'Artist of the Fresh Kills Landfill', New York, from 1990 onwards. Solo shows include 'Unburning Freedom Hall', The Museum of Contemporary Art, Los Angeles (1997).

VERUSCHKA [Vera Lehndorff, b. 1939, Kalingrad, Russsia] studied art in Hamburg and then Florence in the early 1960s, where she was asked to model at the Palazzo Pitti collections. She became one of the most celebrated fashion models of the period, photographed by Irving Penn and Diana Vreeland. In the early 1970s she retired from modelling and collaborated with the photographer Holger Trulsch to make works in which she 'worked against' her modelling career by making her body merge with its background and 'disappear'.

VNS MATRIX [formed 1991, Australia] is a group of four Australian women artists: Francesca da Rimini, Josephine Starrs, Julianne Pierce, and Virgina Barratt, whose mission is to remap cyberspace by subverting gender stereotypes and introducing polymorphously perverse sexuality into digital games and virtual reality environments.

Kara **WALKER** [b. 1969, Stockton, California] lives in Providence, Rhode Island. From her initial studies in painting, her practice has evolved into making large wall-mounted installations of small silhouettes made from cut black paper which represent historical narratives from an African-American perspective. She was included in 'Into the Light, 1992 Nexus Biennale, Nexus Contemporary Arts Center, Atlanta (1992) and 'No Place (Like Home)', Walker Art Center, Minneapolis (1997). Solo shows include San Francisco Museum of Modern Art, San Francisco (1997), and Walker Art Center, Minneapolis (2007).

Kate **WALKER** [b. Leeds, England] lives in London. An artist and teacher, from 1972 she was active in the Women's Art Movement, involved in initiating collaborative projects such as A Woman's Place at the South London Women's Centre (1974). Her career in education has included serving as Curriculum Organizer for Arts in a men's high security prison.

Gillian **WEARING** [b. 1963, Birmingham] lives in London. Working primarily with video and photography, her work uses an approach superficially similar to TV documentary to explore, with participants, the boundaries of public and private life. She was included in 'Incertaine Identité', Galerie Analix B & L Polla, Geneva (1994). Solo shows include 'Western Security', Hayward Gallery, London (1995), Kunsthaus Zurich (1997) and Serpentine Gallery, London (2000).

Carrie Mae **WEEMS** [b. 1953, Portland] lives in Northampton, Massachusetts. Her photographic works and books focus on African-American representation, using the genres of reportage and self-portraiture. Often ironic humour is used to uncover the ideological underpinnings of attitudes both within and across cultural divides. She was included in 'Black Male: Representations of Masculinity in Contemporary American Art', Whitney Museum of American Art, New York. Solo shows include the Contemporary Arts Museum, Houston (1996).

Rachel **WHITEREAD** [b. 1963, London] lives in London. A sculptor, she casts directly from familiar, everyday objects. She makes manifest spaces in, under, on and between things, examining structures among which we live. She was included in 'Doubletake: Collective Memory and Current Art', Hayward Gallery, London, and Documenta IX, Kassel (both 1992). Solo shows include 'Ghost', Chisenhale Gallery, London (1990) and 'Rachel Whiteread: Shedding Life', Tate Liverpool (1996).

Faith **WILDING** [b. 1943, Primavera, Paraguay] lives in Pittsburg, Pensylvannia. She was an important member of the Calfornian women's movement in art in the 1970s, making performances and installations, teaching and writing critical texts. She was included in 'Sexual Politics: Judy Chicago's *Dinner Party* in Feminist Art History', UCLA/Armand Hammer Museum of Art, Los Angeles (1996). Solo shows include 'Embryoworlds', State University of New York, Old Westbury (1999).

Hannah **WILKE** [b. 1940, New York; d.1993, Houston] lived in New York. Originally a sculptor, she invented her own iconography based on vaginal imagery, using clay, latex and then chewing-gum. Her own body became increasingly the focus of her work, and featured in 'performalist portraits'. Her posthumous exhibition 'Intra-Venus' was shown at Ronald Feldman Gallery, New York (1994), and the Santa Monica Museum of Art, California (1996). A retrospective of her work was held at the Copenhagen Contemporary Art Centre and Helsinki City Art Museum (1999).

Sue **WILLIAMS** [b.1954, Chicago Heights, Illinois] lives in New York. She is a painter whose early 1990s work addressed violence towards women with a disturbing combination of rage and humour. Later paintings comprise abstract, lyrical patterns that explore female eroticism. She was included in 'Sex Show', Cable Gallery, New York (1985) and 'Bad Girls', Institute of Contemporary Arts, London (1993). Solo shows include San Francisco Art Institute, San Francisco (1993).

Martha **WILSON** lives in New York. Primarily working in performance, she has enacted the personae of many prominent political figures including Barbara Bush and Tipper Gore. She is Founding Director of Franklin Furnace Archive, New York, which since its inception in 1976 has presented and preserved documentation of ephemeral art: artists' books and multiples, temporary installations and performance art.

Francesca **WOODMAN** [b. 1958, Denver Colorado; d. 1981, New York] lived in New York and Italy. Most of her work was produced while a student at the Rhode Island School of Design, Providence, and while working in Rome, and features black and white photographs of her own body in decaying interiors. Retrospectives include Wellesley & Hunter College Art Gallery (1986), and the Fondation Cartier pour l'art contemporain, Paris (1998), and touring.

Marie **YATES** [b. 1940, Leigh, England] lives in Greece. Originally an abstract painter, since the late 1960s she has made conceptual work, engaging with feminist critiques of representation and the possibilities for social change. She was included in 'Issue: Social Strategies by Women Artists', Institute of Contemporary Arts, London (1980) and 'Difference: On Representation and Sexuality', New Museum of Contemporary Art, New York (1984).

BIBLIOGRAPHY

Adams, Parveen, *The Emptiness of the Image: Psychoanalysis and Sexual Differences* (London and New York: Routledge, 1996)

Allara, Pamela, *Pictures of People: Alice Neel's American Portrait Gallery* (Hanover and London: Brandeis University Press, 1998)

Anderson, Laurie, *Stories from the Nerve Bible: A Retrospective 1972-1992* (New York: HarperCollins, 1994)

Appignanesi, Lisa (ed.), *Desire: ICA Documents* (London: Institute of Contemporary Arts, 1984)

_____ (ed.), *Identity: The Real Me* (London: Institute of Contemporary Arts, 1987)

Applebroog, Ida, 'The I Am Heathcliffe, Says Catherine, Syndrome', *Heresies*, 2 (May 1977) 118-24

Atkinson, Ti-Grace, *Amazon Odyssey* (New York: Links Books, 1974)

Baert, Renee, 'Desiring Daughters', *Screen*, 34 (Summer 1993)

Banes, Sally, *Greenwich Village 1963: Avant-Garde Performance and the Effervescent Body* (Durham and London: Duke University Press, 1993)

Barry, Judith, *Public Fantasy: An Anthology of Critical Essays, Fictions and Project Descriptions*, ed. Iwona Blazwick (London: Institute of Contemporary Arts, 1991)

Battersby, Christine, *Gender and Genius: Towards a Feminist Aesthetics* (Bloomington and Indianapolis: Indiana University Press, 1989)

Betterton, Rosemary, *Looking On: Images of Femininity in the Visual Arts and Media* (London: Pandora, 1987)

Bird, Jon; Isaak, Jo Anna; Lotringer, Sylvère, *Nancy Spero* (London: Phaidon Press, 1996)

Blocker, Jane, *Where is Ana Mendieta?, Identity, Performativity and Exile* (Durham: Duke University Press 1999)

Boffin, Tessa; Gupta, Sunil (eds.), *Ecstatic Antibodies: Resisting the AIDS Mythology* (London: Rivers Oram Press, 1990)

Braidotti, Rosi, *Nomadic Subjects: Embodiment and Sexual Difference in Contemporary Feminist Theory* (New York: Columbia University Press 1994)

Brennan, Teresa (ed.), *Between Feminism and Psychoanalysis* (London and New York: Routledge 1989)

Brett, Guy, 'To Rid the World of Nuclear Weapons: Greenham Common', in *Through Our Own Eyes: Popular Art and Modern History* (London: GMP Publishers, 1986)

_____ ; Archer, Michael; de Zegher, Catherine, *Mona Hatoum* (London: Phaidon Press, 1997)

_____ ; Herkenhoff, Paulo, et al., *Lygia Clark* (Barcelona: Fundació Antoni Tàpies 1997)

Broude, Norma; Garrard, Mary D., (eds.), *The Power of Feminist Art: The American Movement of the 1970s, History and Impact* (New York: Harry N. Abams, Inc., 1994)

_____ ; Garrard, Mary D. (eds.), *Expanding Discourse: Feminism and Art History* (New York: Icon Editions, 1992)

Buchloh, Benjamin H.D., 'Allegorical Procedures: Appropriation and Montage in Contemporary Art', *Artforum*, 21:1 (September 1982)

Buhler Lynes, Barbara, 'Georgia O'Keeffe and Feminism: A Problem of Position', 1991, published in *The Expanding Discourse: Feminism and Art History*, ed. Norma Broude and Mary D. Garrard (New York: Icon Editions, 1992) 437-49

Burgin, Victor, *Between* (Oxford: Basil Blackwell, 1986)

Butler, Judith, *Gender Trouble: Feminism and the Subversion of Identity* (New York and London: Routledge, 1990)

_____ , *Bodies That Matter: On the Discursive Limits of 'Sex'* (New York and London: Routledge, 1993)

Calvert, Gill; Morgan, Jill; Katz, Mouse (eds.), *Pandora's Box* (London: Trefoil Books, 1984)

Carr, C., *On Edge: Performance at the End of the Twentieth Century* (Hanover and London: Weslyan University Press, 1993)

Carter, Angela, *The Sadeian Woman: An Exercise in Cultural History* (London: Virago Press, 1979)

Chadwick, Helen, *Enfleshings* (New York and London: Aperture, 1989)

_____ , *Still Lives* (Edinburgh: Portfolio Gallery, 1996)

Chadwick, Whitney, *Women Artists and the Surrealist Movement* (Boston: Little, Brown and Company, 1985)

_____ , *Women, Art and Society* (London: Thames and Hudson, 1990)

_____ ; de Courtivroon, Isabelle (eds.), *Significant Others: Creativity and Intimate Partnership* (London: Thames and Hudson, 1993)

Champagne, Lenora, (ed.), *Out From Under: Texts by Women Performance Artists* (New York: Theatre Communications Group, Inc., 1990)

Chave, Anna C., 'Minimalism and the Rhetoric of Power', *Arts Magazine* (January 1990)

Chicago, Judy, *The Dinner Party: A Symbol of Our Heritage* (New York: Doubleday, 1979)

Cixous, Hélène, *The Hélène Cixous Reader*, ed. Susan Sellers (New York and London: Routledge, 1994)

Corris, Michael, 'Fuzzy Bourgeois', paper delivered at the Museum of Modern Art, Oxford (1995)

Cottingham, Laura, *How Many "Bad" Feminists Does It Take to Change a Lightbulb* (New York: Sixty Percent Solution, 1994)

Crow, Thomas, *The Rise of the Sixties: American and European Art in the Era of Dissent, 1955-69* (London: Weidenfeld and Nicolson, 1996)

Cullum, Jerry, 'Landscape, Borders and Boundaries', *Artpapers* (1995)

Curiger, Bice, *Meret Oppenheim: Defiance in the Face of Freedom*, trans. Catherine Schelbert (Zurich: Parkett, 1989)

Davis, Angela Y., *Angela Davis: An Autobiography* (New York: Random House, 1974).

_____ , 'Afro Images: Politics, Fashion and Nostalgia', in *Names We Call Home: Autobiography and Racial Identity*, ed. Becky Thompson and Sangeeta Tyagi (New York and London: Routledge, 1996)

Deepwell, Katy (ed.), *New Feminist Art Criticism: Critical Strategies* (Manchester: Manchester University Press, 1995)

_____ (ed.), *Women Artists and Modernism* (Manchester: Manchester University Press, 1998)

de Lauretis, Teresa, *Alice Doesn't: Feminism, Semiotics, Cinema* (Bloomington: Indiana University Press, 1984)

_____ , *Technologies of Gender: Essays on Theory, Film, and Fiction* (Bloomington: Indiana University Press, 1984)

Dexter, Emma; Bush, Kate, *Bad Girls* (London: Institute of Contemporary Arts, 1993)

de Zegher, M. Catherine (ed.), *Inside the Visible: An Elliptical Traverse of 20th Century Art* (Cambridge, Massachusetts: MIT Press, 1996)

DiMassa, Diane, *The Complete Hot-Headed Paisan: Homicidal Lesbian Terrorist* (San Francisco: Cleis Press Inc., 1999)

Doane, Mary Anne, 'Film and the Masquerade: Theorizing the Female Spectator', *Screen* 23:3-4 (September-October, 1982)

Dumas, Marlene, *Sweet Nothings*, ed. Mariska van den Berg (Amsterdam: Galerie Paul Andriesse, Uitgeverij De Balie, 1998)

Duncan, Carol, 'Virility and Domination in Early 20th-Century Vanguard Painting', *Artforum*, 4 (December 1973)

_____ , *The Aesthetics of Power: Essays in Critical Art History* (Cambridge: Cambridge University Press, 1993)

Dunn, Nell, *Talking to Women* (Bristol: McGibbon & Kee, Ltd, 1965)

Dworkin, Andrea, *Our blood: prophecies and discourses on sexual politics* (London: The Women's Press Limited, 1982)

_____ , *Intercourse* (London: Arrow Books, 1988)

Dyer, Richard, *Now You See It: Studies on Lesbian and Gay Film* (London and New York: Routledge, 1990)

Echols, Alice, *Daring to be Bad: Radical Feminism in America, 1967-1975* (Minneapolis: University of Minnesota Press, 1989)

Ecker, Gisela (ed.), *Feminist Aesthetics* (London: Women's Press, 1985)

Elwes, Catherine, 'The Pursuit of the Personal in British Video Art', *Diverse Practices: A Critical Reader on British Video Art*, Julia Knight ed. (London: Arts Council of England, 1996)

Export, Valie, 'Interview with Ruth Askey', *High Performance*, 13 (1981)

_____ ; Nesweda, Peter, 'In Her Own Image: Valie Export, Artist and Feminist', *Arts Magazine*, 65 (September 1991)

Faludi, Susan, *Backlash: The Undeclared War Against Women* (London: Vintage, 1992)

Féminin-Masculin: Le sexe de l'art [cat.] (Paris: Gallimard/Electra, Editions du Centre Pompidou, 1995)

Fer, Briony, 'Bordering on Blank: Eva Hesse and Minimalism', published in *Art History*, 17:3 (September 1993)

Ferguson, Russell; De Salvo, Donna; Slyce, John, *Gillian Wearing* (London: Phaidon Press, 1999)

Firestone, Shulamith, *The Dialectic of Sex: The Case for Feminist Revolution* (New York: William Morrow & Co. Inc., 1970)

Frueh, Joanna; Langer, Cassandra L; Raven, Arlene (eds.), *New Feminist Criticism: Art, Identity, Action* (New York: Icon Editions, 1994)

Fusco, Coco, *English Is Broken Here: Notes on Cultural Fusion in the Americas* (New York: The New Press, 1995)

Fuss, Diana, *Essentially Speaking: Feminism, Nature and Difference* (New York and London: Routledge, 1990)

Gallop, Jane, *The Daughter's Seduction:*

Feminism and Psychoanalysis (Ithaca: Cornell University Press, 1982)

Garrard, Rose. *Rose Garrard : Archiving My Own History, Documentation of Works, 1969-1994* (Manchester: Cornerhouse, 1994)

Gever, Martha; Parmar, Pratibha; Greyson, John (eds.), *Queer Looks: Perspectives on Lesbian and Gay Film and Video* (New York and London: Routledge, 1993)

Goldin, Nan. *The Other Side*, eds., Liz Heron and Val Williams (London and New York: I.B. Taurus, 1996)

Graham, Dan. *Rock My Religion: Writings and Art Projects, 1965-1990*, ed. Brian Wallis (Cambridge, Massachussets: MIT Press,1993)

Greer, Germaine. *The Obstacle Race: The Fortunes of Women Painters and Their Work* (London: Secker and Warburg, 1979)

Grubb, Nancy (ed.), *Making Their Mark: Women Artists Move into the Mainstream, 1970-85* (New York: Abbeville Press, 1989)

Guerrilla Girls. *Confessions of the Guerrilla Girls* (London: Pandora, 1995)

Hall, Doug; Fifer, Sally Jo (eds.), *Illuminating Video: An Essential Guide to Video Art* (Aperture; Bay Area Video Coalition, 1990)

Harris, Ann Sutherland; Nochlin, Linda, *Women Artists, 1550-1950* (Los Angeles: Los Angeles County Museum of Art, 1977)

Harrison, Margaret. 'Notes on Feminist Art in Britain 1970-77', *Studio International*, 193:987, (London, 1977)

Hart, Lynda (ed.), *Making a Spectacle: Feminist Essays on Contemporary Women's Theatre* (Ann Arbor: University of Michigan Press, 1989)

Hart, Lynda; Phelan, Peggy (eds.), *Acting Out: Feminism Performances* (Ann Arbor: The University of Michigan Press, 1993)

Heath, Stephen. *The Sexual Fix* (London: Macmillan, 1982)

Heck-Rabi, Louise. *Women Filmmakers: A Critical Reception* (Metuche, New Jersey: The Scarecrow Press, 1984)

Hess, Thomas B; Baker, Elizabeth C. (eds.), *Art and Sexual Politics: Women's Liberation, Women Artists, and Art History* (New York: Collier Macmillan Publishing Co., 1973)

hooks, bell. *Ain't I a Woman: Black Women and Feminism* (London: Pluto Press, 1982)

_____. *Art on My Mind: Visual Politics* (New York: The New Press, 1995)

_____. *Black Looks: Race and Representation* (Boston: South End Press, 1992)

_____. *Outlaw Culture: Resisting Representations* (New York and London: Routledge, 1994)

Indiana, Gary. 'Ex-Model Found in Wall', *Artforum*, 9 (May 1985)

Jaudon, Valerie; Kozloff, Joyce. 'Art Hysterical Notions of Progress and Culture', *Heresies*, 4 (1978)

Johnston, Jill. *Lesbian Nation: The Feminist Solution* (New York: Simon and Schuster, Touchstone Books, 1973)

Jones, Amelia. *Postmodernism and the En-gendering of Marcel Duchamp* (Cambridge: Cambridge University Press, 1994)

_____ (ed.), *Sexual Politics: Judy Chicago's Dinner Party in Feminist Art History* (Berkeley: University of California Press, 1996)

_____. *Body Art/Performing the Subject* (Minneapolis: University of Minnesota Press, 1998)

_____; Stephenson, Andrew (eds.), *Performing the Body/Performing the Text* (London and New York: Routledge, 1999)

Juno, Andrea; Vale, V. (eds.), *Angry Women* (San Francisco: Re/Search Publications, 1991)

Kappeler, Susanne. *The Pornography of Representation* (Cambridge: Polity Press, 1986)

Kelly, Mary. *Imaging Desire* (Cambridge, Massachusetts: MIT Press, 1996).

Knight, Julia. *Women and the New German Cinema* (London and New York: Verso, 1992)

Koedt, Anne; Levine, Ellen; Rapone, Anita (eds.),'Radical Feminism', *Quadrange* (New York: The New York Times Book Co., 1973)

Kotz, Liz. 'The Body you Want: Interview with Judith Butler', *Artforum* (November 1992)

Kozloff, Joyce. 'Negating the Negative (an answer to Ad Reinhardt's "On Negation"', *Heresies* (May 1977)

Krauss, Rosalind E.. *Bachelors* (Cambridge, Massachusetts: MIT Press, 1999)

Kristeva, Julia. *Desire in Language: A Semiotic Approach to Literature and Art*, ed., Leon S. Roudiez; trans. Thomas Gora, Alice Jardine and Leon S. Roudiez. (Oxford: Basil Blackwell Ltd, 1981)

Lachowitz, Loclie. 'Evolution of a Feminist Art', *Heresies*, 6 (New York: 1978)

Lacan, Jacques. *Feminine Sexuality*, (eds.) Juliet Mitchell and Jacqueline Rose, trans. Jacqueline Rose (New York and London: W.W. Norton and Co., 1982)

Lanchner, Carolyn. 'The Later Adventures of Dada's Good Girl', in *The Photomontages of Hannah Höch* (Minneapolis: Walker Art Center, 1996)

Langer, Cassandra L.. *Feminist Art Criticism: An annotated bibliography* (New York: G. K. Hall, 1993)

Lavin, Maud. *Cut With the Kitchen Knife: the Weimer photomontages of Hannah Höch* (New Haven: Yale University Press, 1993)

Lingwood, James (ed.), *Rachel Whiteread: House* (London: Phaidon Press, 1995)

Lippard, Lucy R. (ed.), *Six Years : The Dematerialization of the Art Object from 1966 to 1972* (New York and Washington: Praeger Publishers, 1973)

_____. *Eva Hesse* (New York: New York University Press, 1976)

_____. *From the Center* (New York: E.P. Dutton, Inc., 1976)

_____ (ed.), *Issue: Social Strategies by Women Artists* (London: Institute of Contemporary Arts, 1980)

_____. *Get the Message? A Decade Of Art For Social Change* (New York: E.P. Dutton, Inc.,1984)

_____. *The Pink Glass Swan: Selected Essays on Feminist Art* (New York: The New Press, 1995)

_____. *The Lure of the Local: Senses of Place in a Multicentered Society* (New York: The New Press, 1997)

Loeb, Judy (ed.), *Feminist Collage: Educating Women in the Visual Arts* (New York and London: Teachers College Press, 1979)

Lloyd, Fran (ed.), *Contemporary Arab Women's Art* (London: Women's Art Library, 1999)

Lovelace, Carey. 'Weighing In On Feminism', *Art News* (New York, May 1997)

'Lusitania: A Journal of Reflection and Oceanography', 6, *Vulvamorphia* (New York: Lusitania Press, 1994)

Mama Collective. *MAMA* (Birmingham, undated: photocopy at the Women's Art Library, London)

McQuiston, Liz. *Suffragettes to She-Devils: Women's Liberation and Beyond* (London: Phaidon Press, 1997)

Marks, Elaine; de Courtivron, Isabelle (eds.), *New French Feminisms: An Anthology* (Amherst: The University of Massachusetts Press, 1980)

Mellencamp, Patricia. *Indiscretions: Avant-Garde Film, Video and feminism* (Bloomington and Indianapolis: Indiana University Press, 1990)

Merck, Mandy (ed.), *The Sexual Subject: A Screen Reader in Sexuality* (London and New York: Routledge, 1992)

Meyer, Melissa; Schapiro, Miriam. 'Femmage', *Heresies*, 4 (Winter 1977)

Miller, Lynn F; Swenson, Sally S.. *Lives and Works: Talks with Women Artists* (New Jersey and London: The Scarecrow Press, Inc., Methuen, 1981)

Millett, Kate. *Sexual Politics* (Garden City, New York: Doubleday, 1970)

_____. *Flying* (St Albans: Paladin, 1976)

Minh-ha, Trinh T.. *Woman, Native, Other: Writing, Postcoloniality and Feminism* (Bloomington: Indiana University Press, 1989)

_____. *When the Moon Waxes Red: Representation, Gender, and Cultural Politics* (New York and London: Routledge, 1991)

_____, 'Speaking Nearby: Interview with Nancy N. Chen, *Visualizing Theory* (New York and London: Routledge, 1995)

Mitchell, Juliet. *Woman's Estate* (New York: Pantheon, 1971)

_____. *Psychoanalysis and Feminism: Freud, Reich, Laing and Women* (London: Vintage Books, 1975)

Moi, Toril (ed.), *French Feminist Thought: A Reader* (Oxford: Basil Blackwell Ltd, 1987)

Moore, Suzanne. 'Getting a bit of the other: The pimps of postmodernism', in *Male Order: Unwrapping Masculinity*, (eds.) Rowena Chapman and Jonathan Rutherford (London: Lawrence and Wishart, 1988)

Morgan, Robin (ed.), *Sisterhood Is Powerful* (1970); revised edition: *Sisterhood Is Global* (New York: Feminist Press, 1996)

Morris, Meaghan. *The Pirate's Fiancée: Feminism, Reading, Postmodernism* (London and New York: Verso, 1988)

Moser, Mary Anne; MacLeod, Douglas (eds.), *Immersed in Technology: Art and Virtual Environments* (Cambridge, Massachussets: MIT Press, 1996)

Mulvey, Laura. *Fetishism and Curiosity* (London: British Film Institute, Bloomington, Indiana: Indiana University Press, 1996)

_____; Wollen, Peter. 'Frida Kahlo and Tina Modotti', in *Frida Kahlo and Tina Modotti* (London: Whitechapel Art Gallery, 1983)

Munro, Eleanor. *Originals: American Women Artists* (New York: Simon and Schuster, 1979)

Nead, Lynda. *The Female Nude: Art, Obscenity and Sexuality* (London and New York: Routledge, 1992)

Nemser, Cindy. *Art Talk: Conversations With 15 Women Artists* (New York: Harper Collins, 1995)

Next Generation: Southern Black Aesthetic [cat.] (North Carolina: Southeastern Center for Contemporary Art (SECCA), Winston-Salem, 1990)

Nochlin, Linda, *Women, Art and Power, and Other Essays* (New York: Icon Editions, Harper & Row, 1998)

O'Dell, Kathy, 'The Performance Artist as Masochistic Woman', *Arts Magzine*, 62:10 (June 1988)

O'Grady, Lorraine, 'Olympia's Maid: Reclaiming Black Female Subjectivity', *Afterimage* (Summer, 1992)

Oh Boy, It's a Girl! Feminismen in der Kunst [cat.] (München: Kunstverein, 1994)

Olsen, Tillie, *Silences* (New York: Delta/Seymour Lawrence, 1989)

Orenstein, Gloria Feman, 'Women of Surrealism', *The Feminist Art Journal*, Brooklyn, New York (Spring 1973)

Paglia, Camille, *Sexual Personae: Art and Decadence From Nefertiti To Emily Dickinson* (New Haven: Yale University Press, 1990)

Pane, Gina, 'Interview with Ezio Quarantelli', *Contemporanea* (1988)

Parker, Rozsika, *The Subversive Stitch: Embroidery and the Making of the Feminine* (London: Women's Press, 1984)

_____; Pollock, Griselda, *Old Mistresses: Women, Art and Ideology* (London: Routledge & Kegan Paul, 1981)

Passages de l'image (Barcelona: Centre Cultural De La Fundacio Caixa De Pensions, 1990)

Peabody, Richard (ed.), *A Different Beat: Writings by Women of the Beat Generation* (London: Serpent's Tail, 1997)

Penley, Constance, *The Future of an Illusion: Film, Feminism and Psychoanalysis* (London and New York: Routledge, 1989)

Phelan, Peggy, *Unmarked: The Politics of Performance* (London and New York: Routledge 1993)

_____, *Mourning Sex: Performing Public Memories* (London and New York: Routledge, 1997)

_____; Lane, Jill (eds.), *The Ends of Performance* (New York: New York University Press, 1998)

Pollock, Griselda, *Vision and Difference: Femininity, Feminism and Histories of Art* (London and New York: Routledge, 1988)

_____ (ed.), *Generations and Geographies in the Visual Arts: Feminist Readings* (London and New York: Routledge 1996)

Potter, Sally, et al., *About Time: Video, Performance and Installation by 21 Women Artists* (London: Institute of Contemporary Arts, 1980)

Pribram, E. Deidre (ed.), *Female Spectators: Looking at Film and Television* (London and New York: Verso, 1988)

Puerto, Cecilia, *Latin American Women Artists: Kahlo and Look Who Else* (Westport, Connecticut: Greenwood Press, 1996)

Rainer, Yvonne, *Work 1961-73* (The Press of the Nova Scotia College of Art and Design, and New York University Press, 1974)

_____, *The Films of Yvonne Rainer* (Bloomington and Indianapolis: Indiana University Press, 1989)

_____, *A Woman Who … Essays, Interviews, Scripts* (Baltimore: Johns Hopkins University Press, 1999)

Raven, Arlene, *Crossing Over: Feminism and Art of Social Concern* (Ann Arbor: UMI Research Press, 1988)

_____; Langer, Cassandra L; Frueh, Joanna (eds.), *Feminist Art Criticism: An Anthology* (Ann Arbor: UMI Research Press, 1988)

Reynolds, Simon; Press, Joy, *The Sex Revolts: Gender, Rebellion and Rock 'n' Roll* (London: Serpent's Tail, 1995)

Rich, B. Ruby, *Chick Flicks: Theories and Memories of the Feminist Film Movement* (Durham: Duke University Press, 1998)

Richard, Nelly, 'The Rhetoric of the Body', *Art & Text*, 21 (1986)

Ringgold, Faith, *We Flew Over the Bridge: The Memoirs of Faith Ringgold* (Boston: Little, Brown and Co., 1995)

Riviere, Joan, 'Womanliness as a Masquerade', *The International Journal of Psychoanalysis*, 9: 303-313; reprinted in *The Inner World and Joan Riviere: Collected Papers, 1920-1958*, ed. Athol Hughes (London and New York: Karnac Books, 1991) 90-101

Robinson, Hilary (ed.), *Visibly Female: Feminism and Art, an Anthology* (London: Camden Press, 1987)

Robbins, Trina, *From Girls to Grrrlz: A History of Women's Comics From Teens to Zines* (San Francisco: Chronicle Books, 1999)

Rose, Jacqueline, *Sexuality in the Field of Vision* (London and New York: Verso, 1986)

Rosler, Martha, 'The Private and the Public: Feminist Art in California', *Artforum* (New York, September 1977)

Rubinstein, Charlotte Streifer, *American Women Artists: from Early Indian Times to the Present* (Boston, Massachussets: G.K. Hall & Co., 1982)

Ruddick, Sara; Daniels, Pamela (eds.), *Working It Out: 23 Women Writers, Artists, Scientists and Scholars Talk About Their Lives and Work* (New York: Pantheon Books, 1977)

Schneemann, Carolee, *More Than Meat Joy*, McPherson, Bruce R. (ed.) (New York: Documentexts/McPherson & Co., 1997)

Schneider, Rebecca, *The Explicit Body in Performance* (London and New York: Routledge, 1997)

Schneir, Miriam (ed.), *The Vintage Book of Feminism: The Essential Writings of the Contemporary Women's Movement* (London: Vintage, 1995)

Schulman, Sarah, *My American History: Lesbian and Gay Life During the Reagan/Bush Years* (London and New York: Routledge, 1994)

Semmel, Joan, 'Sex to Hang Art On', *New York Magazine*, 7:6 (1974)

Siegel, Jeanne (ed.), *Art Words 2: Discourse on the Early 80s* (Ann Arbor, Michigan: UMI Research Press, 1988)

_____ (ed.) *Art Talk: The Early 1980s* (New York: Da Capo Press, 1990)

_____ (ed.), *Mutiny and the Mainstream: Talk That Changed Art, 1975-1990* (New York; Midmarch Arts Press, 1992)

Silverman, Kaja, *The Acoustic Mirror: The Female Voice in Psychoanalysis and Cinema* (Bloomington: Indiana University Press, 1988)

Sims, Lowery Stokes, 'The Mirror of the Other', *Artforum* (March 1990)

Smyth, Cherry, *Damn Fine Art: By New Lesbian Artists* (London: Cassell, 1996)

Speak Art!: The Best of BOMB Magazine's Interviews with Artists (New York: New Art Publications, Inc., 1997)

Spivak, Gayatri Chakravorty, *In Other Worlds: Essays in Cultural Politics* (New York: Methuen, 1987)

Stiles, Kristine, 'Between Water and Stone: Fluxus Performance: A Metaphysics of Acts', *In the Spirit of Fluxus* (Minneapolis, Minnesota: Walker Art Center, 1993)

_____; Selz, Peter (eds.), *Theories and Documents in Contemporary Art: A Sourcebook of Artists' Writings* (Berkeley: University of California Press, 1996)

Stoops, Susan M. (ed.), *More Than Minimal: Feminism and Abstraction in the '70s* (Waltham, Massachussets: Brandeis University, Rose Art Museum, 1996)

Suleiman, Susan Robin, *Risking Who One Is: Encounters with Contemporary Art and Literature* (Cambridge, Massachussets: Harvard University Press, 1994)

Tickner, Lisa, et al., *Difference: On Representation and Sexuality* (New York: New Museum of Contemporary Art, 1984)

_____, *The Spectacle of Women: Imagery of the Suffrage Campaign, 1907-1914* (London: Chatto and Windus, 1987)

Tucker, Marcia, et al., *Bad Girls* (New York: New Museum of Contemporary Art, 1994)

Tutti, Cosey Fanni, 'Prostitution', *October/December Bulletin* (London: Institute of Contemporary Arts, 1976)

Vance, Carole S., (ed.), *Pleasure and Danger: Exploring Female Sexuality* (London: Routledge and Kegan Paul, 1984)

Wagner, Anne Middleton, *Three Artists (Three Women): Modernism and the Art of Hesse, Krasner and O'Keeffe* (Berkeley: University of California Press, 1996)

Walker, Alice, 'In Search of Our Mother's Gardens', *Ms.*, 2:2 (New York, May 1974)

Wallace, Michele, *Invisibility Blues: From Pop to Theory* (London and New York: Verso, 1990)

Waller, Susan (ed.), *Women Artists in the Modern Era: A Documentary History* (Metuche, New Jersey: Scarecrow Press, 1991)

Warner, Marina, *Monuments and Maidens: The Allegory of the Female Form* (London: Weidenfeld and Nicolson, 1985)

Wedge Number 6, 'Sexuality: Re/Positions (New York: Wedge Press, Winter/Spring 1985)

Wedge, 7/8, 'The Imperialism of Representation, The Representation of Imperialism' (New York: Wedge Press, Winter/Spring 1985)

Wilding, Faith, *By Our Own Hands: The Women's Art Movement, California, 1970-1976* (Santa Monica, California: Double X, 1977)

Wittig, Monique, *Les Guérrillères*, trans. David Le Vay (London: Peter Owen Limited, 1971)

_____, *The Lesbian Body*, trans. David Le Vay (Boston: Beacon Press, 1975)

Witzling, Mara R. (ed.), *Voicing Today's Visions: Writings by Contemporary Women Artists* (London: Women's Press, 1994)

Wollen, Peter, *Raiding the Icebox: Reflections on Twentieth-century Culture* (Bloomington: Indiana University Press, 1993)

Zelevansky, Lynn, 'Sense and Sensibility: Women Artists and Minimalism in the Nineties' (New York: The Museum of Modern Art, 1994)

INDEX

Page numbers in italics refer to illustrations

PUBLISHER'S ACKNOWLEDGEMENTS
We would like to thank all those who gave their kind permission to reproduce the listed material. Every effort has been made to secure all reprint permissions prior to publication. However, in a small number of instances this has not been possible. The editors and publisher apologize for any inadvertent errors or omissions. If notified, the publisher will endeavour to correct these at the earliest opportunity.

We would like to thank the following for their kind assistance: 303 Gallery, New York; Eija-Liisa Ahtila, Helsinki; American Fine Arts, Co., New York; David Teacher and The Barbican Centre, London; Judith Barry, New York; Ute Meta Bauer, Stuttgart; Vanessa Beecroft, New York; Dara Birnbaum, New York; Galerie René Blouin, Montréal; Mary Boone Gallery, New York; Louise Bourgeois and Cheim & Read, New York; British Film Institute, London; Leo Castelli Gallery, New York; The Estate of Helen Chadwick, London; Cheim & Read, New York; Abigail Child, New York; Cinenova, London; Lygia Clark Collection and Museu de Arte do Rio de Janeiro; Sadie Coles HQ, London; Maureen Connor, New York; Paula Cooper Gallery, New York; Betsy Damon, Saint Paul, Minnesota; Deitch Projects, New York; Linda Dement, Sydney; Anthony D'Offay Gallery, London; Jeanne Dunning, Chicago; Cecilia Edefalk, Stockholm; Mary Beth Edelson, New York; Catherine Elwes, London; Valie Export, Vienna; Ronald Feldman Fine Arts Inc., New York; Rose Finn-Kelcey, London; Coco Fusco, New York; Gagosian Gallery, New York; Anya Gallaccio, London; Rose Garrard, West Malvern, Worcestershire; Marian Goodman Gallery, New York; Nan Goldin, New York; Gorney Bravin + Lee, New York; Ann Hamilton, Columbus, Ohio; Barbara Hammer, New York; Harmony Hammond, Galisteo, New Mexico; Margaret Harrison, Carlisle; Mona Hatoum, London; Galerie Hauser & Wirth, Zürich; Pat Hearn Gallery, New York; The Estate of Eva Hesse and Robert Miller Gallery, New York; Susan Hiller, London; Lubaina Himid, Preston; Rhona Hoffman Gallery, Chicago; Jenny Holzer and Cheim & Read Gallery, New York; Maureen Paley/ Interim Art, London; Joan Jonas, New York; Tina Keane, London; Mary Kelly, Los Angeles; Sean Kelly Gallery, New York; Nicole Klagsbrun Gallery, New York; Yves Klein Archive, Paris; Karen Knorr, London; Alison Knowles, New York; Robert Koch Gallery, San Francisco; Sylvia Kolbowski, New York; Yayoi Kusama, Tokyo; L.A. Gallery, Frankfurt am Main; Suzanne Lacey, Oakland, California; Maya Lin, New York; Yve Lomax, London; Luhring Augustine Gallery, New York; Anne Marchand, Paris; Marlborough Fine Art, London; Matt's Gallery, London; The

Estate of Ana Mendieta and Galerie Lelong, New York; Annette Messager, Paris; Metro Pictures, New York; Metropolitan Museum of Art, New York; Middlesbrough Museums and Galleries, Middlesbrough; Kate Millett, New York; Trinh T. Minh-ha, Berkeley, California; Mary Miss, New York; Moderna Museet, Stockholm; Linda Montano, Kingston, New York; Aimee (Rankin) Morgana, New York; D.C. Moore Gallery, New York; The National Gallery of Art, Canberra; The Estate of Alice Neel and Robert Miller Gallery, New York; Shirin Neshat, New York; New Museum of Contemporary Art, New York; Cady Noland, New York; Yoko Ono, New York; The Organization for Visual Arts Ltd., London; Orlan, Paris; PaceWildenstein, New York; Irene Perez, Oakland, California; Kathleen Petyarre and Gallerie Australis, Adelaide; Howardena Pindell, New York; Adrian Piper, New York; P.P.O.W., New York; Yvonne Rainer, New York; Regen Projects, Los Angeles; Catherine Richards, Ottawa; Su Richardson, Birmingham; Galerie Thaddaeus Ropac, Paris; Ulrike Rosenbach, Bornheim-Rosberg, Germany; Michael Rosenfeld Gallery, New York; Salander O'Reilly Gallery, New York; Doris Salcedo, Bogotá, Columbia; Carolee Schneemann, New Paltz, New York; Mira Schor, Provincetown, Massachusetts; Joan Semmel, New York; Robert J. Shiffler Foundation Collection and Archive, Greenville, Ohio; Katharina Sieverding, Düsseldorf; Brent Sikkema Gallery, New York; The Gilbert and Lila Silverman Fluxus Collection Foundation, New York; Monica Sjöö, Bristol; Sylvia Sleigh, New York; The Jo Spence Memorial Archive and Terry Dennett, London; Nancy Spero, New York; Monika Sprüth Galerie, Cologne; Bernice Steinbaum Gallery, Miami; Jana Sterbak, Montréal; Mitra Tabrizian, London; Richard Telles Fine Art, Los Angeles; Through the Flower Archives, Belen, New Mexico; Jack Tilton Gallery, New York; Cosey Fanni Tutti, King's Lynn, Norfolk; Michelangelo Vasta, Florence and Emi Fontana Gallery, Milan; Video Data Bank, Chicago; VNS Matrix, Sydney; Kate Walker, London; John Weber Gallery, New York; Galerie Barbara Weiss, Berlin; Jay Jopling/ White Cube, London; Faith Wilding, Pittsburgh; The Scharlatt Family, Hannah Wilke Collection and Archive, Los Angeles; Martha Wilson, New York; Betty and George Woodman, New York; Marie Yates, Kissamou, Crete; Zeno X Gallery, Antwerp.

PHOTOGRAPHERS
Leslie Barany: p. 149(top); Kelly Barrie: p. 90; Ray Barrie: pp. 91, 93; David Bourdon: p. 4; Marcia Bricker: pp.28(right), 128(middle); Paula Court: p. 120; Peter Dako: p. 176; D. James Dee: pp. 107,

132(below); Érro: p. 62; Allan Finkelman: p. 59(top); David Goddard: p. 127(top); Arthur Gordon: p. 102(top); Al Giese: p. 64; Hans Hammarskiöld/ Tiofoto p. 55(top); Lloyd Hamrol: p. 86(top); eeva-inkeri: p. 112; Marin Karras: p. 126; Kleineffen: p. 144; Jennifer Kotter: p. 150; Ellen Labenski: p. 33(left); Steve Lehmer: p. 140; Raphael S. Lobato: p. 76; Louis Lussier: front cover, p. 135; George Maciunas: p. 65; F. Masson: p. 101(top); Dona Ann McAdams: p. 148; Anthony McCall: p. 82; Robert McKeever: p. 46; J. McPherson: p. 133; Klaus Mettig: p. 108(below); Peter Moore: p. 59(below); Sue Ormerod: p. 164 (below); Mitchell Payne: p. 83; Adam Reich: pp. 43, 136; David Reynolds: back cover; Werner Schulz: p. 64(middle); Harry Shunk: pp. 28(middle), 52(below); Felix Tirry: p. 159; Esther Thylmann: p. 157(top); Markus Tollhopf: p. 166; Stephen White: pp. 42(left), 125(top); Donald Woodman: pp. 37, 97(below), 111; Helen Chadwick and Edward Woodman: pp. 142, 143; Edward Woodman: p. 164(top).

AUTHOR'S ACKNOWLEDGEMENTS
Working outside an academic institution poses particular challenges to the researcher. I am grateful to all those who helped make my job easier, including librarians at the Atlanta College of Art; Emory University; Georgia State University and the University of Georgia at Athens in Georgia; the British Library; the Institute of International Visual Arts; the Tate Gallery Library and the Women Artists Slide Library in London.

I have been lucky to work with a crack team at Phaidon Press. I was commissioned by Iwona Blazwick and was grateful for the enthusiasm of someone who has done so much, as a curator and publisher, to promote feminist work. Working on this project took me longer than I had anticipated and I thank Gilda Williams, who took over from Iwona as commissioning editor, for her patience. I am grateful to Elizabeth Manchester, for research on the Documents, Mo Throp, for researching the captions, and Maria Walsh, for compiling the valuable artists' biographies. As Project Editor, Audrey Walen worked with dedication on the book and I appreciate all her efforts. I am also indebted to Ian Farr, who succeeded Audrey, for his consistently sensitive editorial guidance and for the informative captions written in collaboration with Clare Manchester. Picture researcher Clair Joy excelled in tracking down hard-to-find images. John Stack and Ariella Yedgar secured the numerous text permissions. Phaidon's reputation for innovative design can be seen in the superb work of designers Stuart Smith and Adam Hooper, and production controller Veronica Price.

Jo Anna Isaak provided critical responses to an early outline and also acted as outside reader for the book. I would like to thank Peggy Phelan for her riveting Survey; I continue to learn much from Peggy's writing about feminist ethics and aesthetics. I owe a debt to all the critics, curators and art historians who have kept the records of feminist art, including individual writers and art historians such as Lucy R. Lippard, Rozsika Parker and Griselda Pollock, and contributors to feminist art journals. I thank the authors who have given permission for their work to be reproduced here, sometimes in abbreviated form. My biggest debt is to the artists in the book. It has been inspiring, to say the least, to work in such company.

I became a feminist before knowing the word, through friendship and play with my sister and subsequent best friends – Laura Brindley, Ruth Noys, Sophie Braimbridge and Yvonne Kuprat. My instinctive feminism was bolstered by the discovery of feminist literature and theory. Theory was put into practice working with the all-female cast and crew of Medusa Theatre Company. I have had numerous feminist role models such as Jane Armstrong at Routledge and the late, lamented Linda Brandon at the Institute of Contemporary Arts in London. Collaborations with colleagues in the ICA Talks Department – Jo Labon, Alan Read and John Zeppetelli – were exhilarating; John's sense of humour and aesthetics forever changed me. I have learnt much from the work of former ICA colleagues including Kate Bush, Emma Dexter, Nicky Gallani, Lisa Haskell, Lois Keidan, Shelley Malcolm, Sholto Ramsay, Deborah Salter, Andrea Tarsia and Catherine Ugwu.

In Atlanta I have valued the advice of Teresa Bramlette and James Meyer. Felicia Feaster's sassy feminism and powerful friendship have been a shot in the arm. Rob Baird, Rebecca Dimling Cochran, Ruth Dusseault, Nancy Floyd, Miriam Peskowitz, Chris Scoates, Debra Wilmer and all at the Atlanta Contemporary Art Center have shown that Southern hospitality is alive and well. Friendships with Paul Allain, Julian Barlow, Leila Bouheiry, Sophie Braimbridge, Miranda Carter, Nicole Eisenman, Mai Ghoussoub, Albyn Hall, Sallie Hudson, Helen Markey, Jessica Pearce, Jane Shaw, and Stephen Woolford have sustained me.

Thanks to my sister, Josephine Reckitt, my father, David Reckitt and his wife, Rosie Reckitt, for their love. My mother Gillian Reckitt's joie de vivre seems limitless; to say she has been supportive is an understatement. At home, Scooter, Boris, Ruby and Tang provided all-too much playful distraction. Above all I thank Diana Klein who lived with me throughout this project's gestation. I owe her more than I can say.

Phaidon Press Limited
Regent's Wharf
All Saints Street
London N1 9PA

Phaidon Press Inc.
65 Bleecker Street
New York, NY 10012

www.phaidon.com

First published 2001
Reprinted in paperback 2006
Abridged, revised and updated 2012
Reprinted 2013, 2014
© 2001 Phaidon Press Limited
All works © the artists unless otherwise stated.

ISBN 978 0 7148 6391 7

A CIP catalogue record of this book is available from the British Library.

All rights reserved. No part of this publication may be reproduced, stored in a retrieval system or transmitted in any form or by any means, electronic, mechanical, photocopying, recording or otherwise, without the written permission of Phaidon Press Limited.

Designed by: SMITH
Printed in Hong Kong

cover, Francesca Woodman
Untitled (New York)
1979
Black and white photograph
20 x 25.5 cm [8 x 10 in]

pages 2-3, Ana Mendieta
Untitled (Glass on Body Imprints)
1972
University of Iowa

page 4, Lynda Benglis
Fling, Dribble and Drip
1969
Poured pigmented latex
Dimensions variable
Work in progress, Bykert Gallery, New York